ALRIGHT, ALRIGHT, ALRIGHT

HARPER

An Imprint of HarperCollins*Publishers*

THE ORAL HISTORY
OF RICHARD LINKLATER'S
Dazed and Confused

ALRIGHT, ALRIGHT, ALRIGHT

Melissa Maerz

HarperCollins books may be purchased for educational, business, or sales promotional use. For information, please email the Special Markets Department at SPsales@harpercollins.com.

FIRST EDITION

Designed by Leah Carlson-Stanisic
Title page image adapted from photograph © Dan Winters

Library of Congress Cataloging-in-Publication Data has been applied for.

ISBN 978-0-06-290850-6

20 21 22 23 24 LSC 10 9 8 7 6 5 4 3 2 1

For my family:

Chuck, Silas, Hope, Jennifer, Mat, Eska, Mom, and Dad

Contents

Part I The Inspiration

Part II The Shoot

Part III The Comedown

Part IV The Legacy

Author's Note

Oral histories often make it seem as if dozens of interconnected people happened to sit down at the same table, in the same bar, on the same night, and, rather spontaneously, started exchanging stories while the bartender secretly recorded them. Obviously, that's not how it works. This book is the result of one-on-one interviews that I conducted with nearly 150 people, several of whom were interviewed multiple times between July 2018 and February 2020. Many of those interviews happened in person. Some were conducted over the phone. Some quotes were sent over email. Occasionally, people responded directly to others' quotes, but only after I read those quotes to them. Most of these interviews were edited and condensed for the sake of brevity and clarity.

I've also relied on letters, memos, drafts of the script, and other archival documents that were provided to me by the interviewees. In a few of the introductions to individual chapters, I've quoted outside sources—they're cited at the end of the book. Where I've pulled quotes from video footage, I've sometimes condensed them. All of the other quotes came from my own reporting, with one exception. *Dazed and Confused* producer Jim Jacks passed away four years before I started working on this book. Journalist and author Brian Raftery graciously allowed me to quote from an interview he recorded with Jacks in 2003. None of the quotes I've used from that interview have ever appeared in print before.

In the years since *Dazed* was first released, many of the women in this book have gotten married and changed their last names. I've referred to them by their current, married names throughout the book, except in the chapter introductions, when I'm talking about the early 1990s.

There are still a few voices missing from this book. Shawn Andrews and Milla Jovovich were unavailable to be interviewed in time for my deadline, according to Andrews's publicist and Jovovich's manager. A few of the interviewees in this book reached out on my behalf to *Dazed and Confused* co-producer Anne Walker-McBay and director of photography Lee Daniel, but they both declined to participate. Second assistant cameraman Clark Walker sent a single email, from which I reprinted a single, essential quote.

Lastly, despite repeated attempts to contact the actor Jason O. Smith, who played Melvin in the movie, I was not able to reach him. Jason, if you're reading this, I'd still love to talk to you. Email me at alrightalrightalright93@gmail.com.

Cast of Characters

 Richard Linklater: writer, producer, director, actor, "Should Have Stayed at Bus Station," *Slacker*; writer, director, producer, *Dazed and Confused*

Main Cast of Dazed and Confused

 Joey Lauren Adams: "Simone"

 Ben Affleck: "O'Bannion"

 Shawn Andrews: "Pickford"

 Rory Cochrane: "Slater"

 Jeremy Fox: "Hirschfelder"

 Adam Goldberg: "Mike"

 Chrisse Harnos: "Kaye"

 Cole Hauser: "Benny"

 Christin Hinojosa-Kirschenbaum: "Sabrina"

 Sasha Jenson: "Don"

 Milla Jovovich: "Michelle"

 Nicky Katt: "Clint"

**Jason
London:**
"Pink"

**Deena
Martin-
DeLucia:**
"Shavonne"

**Matthew
McConaughey:**
"Wooderson"

**Catherine
Avril
Morris:**
"Julie"

**Parker
Posey:**
"Darla"

**Esteban
Powell:**
"Carl"

**Anthony
Rapp:**
"Tony"

**Marissa
Ribisi:**
"Cynthia"

**Michelle
Burke
Thomas:**
"Jodi"

**Mark
Vandermeulen:**
"Tommy"

**Wiley
Wiggins:**
"Mitch"

Everyone Else

Sandra Adair: editor, *Dazed and Confused*

Wes Anderson: director; screenwriter; producer

Gary Arnold: former film critic, *Washington Times*

Autumn Barr: actor, "Stacy," *Dazed and Confused*

Chris Barton: former staff writer, *Daily Texan*

Marjorie Baumgarten: film critic and contributing writer, *Austin Chronicle*

Burt Berman: former Senior VP of music, Universal Pictures

S.R. Bindler: director; Matthew McConaughey's high school friend

Louis Black: co-founder and former editor, *Austin Chronicle;* actor, "Paranoid Paper Reader," *Slacker;* co-director, *Richard Linklater: Dream Is Destiny*

Robert Brakey: apprentice editor, *Dazed and Confused*

Mark Brazill: co-creator, *That '70s Show*

Lisa Bruna: casting assistant, *Dazed and Confused*

Jonathan Burkhart: first assistant camera, *Dazed and Confused*

John Cameron: first assistant director, *Dazed and Confused*

Peter Carlson: former reporter, *Washington Post*

Jay Clements: Huntsville High School alum; son of Richard Linklater's late football coach, Joe Clements

Shavonne Conroy: Huntsville High School alum

Kahane Cooperman: director of the behind-the-scenes documentary *Making Dazed;* Richard Linklater's former girlfriend

Douglas Coupland: author, *Generation X*

Bill Daniel: artist; brother of Lee Daniel

Lee Daniel: actor, "GTO," *Slacker;* director of photography, *Slacker;* director of photography, *Dazed and Confused*

Sean Daniel: producer, *Dazed and Confused*

Brett Davis: Huntsville High School alum

Valerie DeKeyser: production assistant, *Dazed and Confused*

Scott Dinger: former owner, Dobie Theatre

Don Dollar: Huntsville High School alum

Katherine Dover: costume supervisor, *Dazed and Confused*

Erika Geminder Drake: actor, "Freshman Girl #2," *Dazed and Confused*

Jay Duplass: actor; director; screenwriter; producer

Mark Duplass: actor; director; screenwriter; producer

Jesse James Dupree: lead singer of the band Jackyl

Roger Earl: founding member of the band Foghat

Greg Finton: second assistant editor, *Dazed and Confused*

Keith Fletcher: actor, "Cafe Card Player #1," *Slacker*; extras wardrobe supervisor, *Dazed and Confused*

Melanie Fletcher: extras set costumer, *Dazed and Confused*

Richard "Pink" Floyd: Huntsville High School alum

Heyd Fontenot: graphic designer, *Dazed and Confused*

Kim France: former staff writer, *Sassy* magazine

John Frick: production designer, *Dazed and Confused*

Sheri Galloway: assistant editor, *Dazed and Confused*

Harry Garfield: music supervisor, *Dazed and Confused*

Holly Gent: production coordinator, *Dazed and Confused*

Mike Goins: Huntsville High School alum

Roderick Hart: Matthew McConaughey's former professor, University of Texas

Samantha Hart: former creative director of advertising, Gramercy Pictures

Ethan Hawke: actor; writer; director

Lydia Headley: Huntsville High School alum

J.R. Helton: scenic painter, *Dazed and Confused*

Terry Hoage: Huntsville High School alum

Tracey Holman: grip, *Slacker*; wardrobe assistant, *Dazed and Confused*

Don Howard: emc2 editor, *Dazed and Confused*

Steven Hyden: journalist

Jim Jacks: producer, *Dazed and Confused*

Nina Jacobson: former senior VP of production, Universal Pictures

Robert Janecka: property master, *Dazed and Confused*

Katy Jelski: script supervisor, *Dazed and Confused*

Tom Junod: journalist

Jeff Kerr: director, *The Last of the Moonlight Towers*

Priscilla Kinser-Craft: actor, "Freshman Girl #1," *Dazed and Confused*

Kim Krizan: actor, "Questions Happiness," *Slacker*; actor, "Ms. Stroud," *Dazed and Confused*

Julie Irvine Labauve: Huntsville High School alum

Sam Lawrence: Matthew McConaughey's friend during the '90s

Jason Lee: actor; Marissa Ribisi's former boyfriend

Tricia Linklater: Richard Linklater's sister; assistant to Richard Linklater, *Dazed and Confused*

Michael MacCambridge: former film critic, *Austin American-Statesman*

Alison Macor: author, *Chainsaws, Slackers, and Spy Kids*

Peter Millius: former recording engineer and music producer; Deena Martin-DeLucia's former boyfriend

Kari Jones Mitchell: Huntsville High School alum

D. Montgomery: art department and sound department, *Slacker*; actor, "Having a Breakthrough Day," *Slacker*; assistant art director, *Dazed and Confused*

Christopher Morris: extra, *Dazed and Confused*

Chale Nafus: Richard Linklater's former professor, Austin Community College

Kelly Nelson: assistant hair stylist, *Dazed and Confused*

Justin O'Baugh: extra, *Dazed and Confused*

Tony Olm: Huntsville High School alum

Tommy Pallotta: production assistant, *Slacker*; actor, "Looking for a Missing Friend," *Slacker*

Vincent Palmo Jr: second assistant director, *Dazed and Confused*

Deb Pastor: art department, *Slacker*; actor, "Wants to Leave Country," *Slacker*; set decorator, *Dazed and Confused*

John Pease: Huntsville High School alum

Kari Perkins: additional costume designer, *Dazed and Confused*

Don Phillips: casting director, *Dazed and Confused*

Keith Pickford: Huntsville High School alum

John Pierson: former producer's representative; author, *Spike, Mike, Slackers & Dykes*

Tom Pollock: former chairman, Universal Pictures

Gary Price: actor, "Watching Early Morning TV," *Slacker*

Brian Raftery: journalist; author, *Best. Movie. Year. Ever.*

Charles Ramírez Berg: professor, University of Texas

Mike Riley: Huntsville High School alum

Jason Reitman: director; screenwriter; producer

Melina Root: costume designer, *That '70s Show*

Russell Schwartz: former president, Gramercy Pictures

Jason Davids Scott: unit publicist, *Dazed and Confused*

Shana Scott: Texas casting assistant, *Dazed and Confused*

Greg Sims: Shawn Andrews's former manager

John Slate: actor, "'Conspiracy A-Go-Go' Author," *Slacker*

Andy Slater: Huntsville High School alum

Kevin Smith: director; screenwriter; producer

Frances Robinson Snipes: Huntsville High School alum

Steven Soderbergh: director; screenwriter; producer

Kal Spelletich: actor, "Video Backpacker," *Slacker*

Don Stroud: actor, "Recluse in Bathrobe," *Slacker*; stand-in, *Dazed and Confused*

John Swasey: actor, "Beer Delivery Guy," *Dazed and Confused*

Teresa Taylor: drummer for the band Butthole Surfers; actor, "Pap Smear Pusher," *Slacker*

Heidi Van Horne: actor, "Freshman Girl #3," *Dazed and Confused*

Clark Walker: assistant camera and dolly grip, *Slacker*; actor, "Cadillac Crook," *Slacker*; second assistant camera, *Dazed and Confused*

Anne Walker-McBay: casting and production management, *Slacker*; co-producer, *Dazed and Confused*

Deenie Wallace: extra, *Dazed and Confused*

Leslie Warren: Huntsville High School alum

Don Watson: Huntsville High School alum

Scott Wheeler: Matthew McConaughey's former roommate

Monnie Wills: Matthew McConaughey's former roommate

Bill Wise: extra, *Dazed and Confused*

Bob Wooderson: Huntsville High School alum

Linden Wooderson: Huntsville High School alum; son of the late Bob Wooderson

David Zellner: actor; director; screenwriter

Nathan Zellner: actor; director; screenwriter

Renée Zellweger: actor, "Girl in Blue Truck" (uncredited), *Dazed and Confused*

ALRIGHT, ALRIGHT, ALRIGHT

If I Ever Start Referring to These as the Best Years of My Life, Remind Me to Kill Myself

*I*n 2011, Richard Linklater lost everything.

From September to October of that year, the most destructive wildfire in the history of Texas burned through the middle of the state. Strong winds from Tropical Storm Lee had merged three separate fires into one massive blaze that ripped through the small historic town of Bastrop, nearly 30 minutes southeast of Austin. Bastrop State Park, a lush, 6,600-acre area teeming with pine trees, white-tailed deer, and armadillos, was reduced to a charred wasteland. The only sign of life was the sound of katydids singing from somewhere beyond the billowing smoke. Two people were killed, and more than 1,600 homes were reduced to ash, including the one that belonged to the writer-director of *Dazed and Confused*.

Linklater and his family were unharmed, but nearly everything he owned was destroyed. Not long after *Dazed* was released, he'd bought a 38-acre piece of land in Bastrop and slowly built a compound, doing some of the construction himself. It featured a sports field, tennis court, and almost every artifact he'd amassed from his entire career as a filmmaker: personal prints of his films, early drafts of scripts, production materials, publicity documents, and a

museum's worth of memorabilia that included the famous KISS statues from *Dazed*. Just a few years before, he'd hosted a 10-year reunion party for *Dazed* here, and the place was haunted with memories of the cast just hanging out. Matthew McConaughey had hit a home run in the trees. Parker Posey swam in the pool. Deena Martin got in trouble for racing around the grounds in one of Linklater's go-karts. Those go-karts were now melted to the ground.

"Everything went up in flames," Linklater's friend and collaborator Ethan Hawke recalled. "Thirty years of work. He lost everything. And when I called him to say how sorry I was, he was already thinking about how grateful he was for the fire for teaching him not to be materialistic. This makes him sound like Saint Rick. He's not. He's his own mysterious entity."

After hours of interviews and visits with Linklater, who was unfailingly patient and cooperative as I persistently asked him to revisit an experience that brought back unwelcome memories, I agree that Linklater is a bit of a mystery. Even his friends characterize him as someone who is hard to get close to. Still, Hawke's story captures a fundamental contradiction about the director: he's the master of exploring the concept of nostalgia in his films, but he often seems actively intellectually opposed to the very *idea* of it. He makes period pieces that vividly capture bygone eras, and romantic tributes to childhood and early adulthood. The most important theme of his work is the passing of time. And yet when his entire history was swallowed by a fire, he seemed determined not to dwell on the loss.

"Obviously, I draw a lot of creative inspiration from the past, what people would call nostalgia," says Linklater, who is surrounded by classic movie posters in his office in Northeast Austin. "But when I was making *Dazed*, I was thinking about how nostalgia can be a dangerous thing. People are nostalgic for times that never fucking existed. When you think about the past, you have to try to remember what was really going on. When people say, 'Oh those were the good times!' I always have to remind them, 'No, that time *sucked*.'"

This was the surprising goal behind *Dazed and Confused*: he wanted to show how much the '70s sucked.

As a thoughtful teenager growing up in the East Texas town of Huntsville in the late 1970s, Linklater was disgusted by adults' nostalgia for the 1960s. "What a great time," he says, laughing. "Rioting, war, assassinations!" But his generation ended up having the same feelings about the 1970s. That's just the way nostalgia works: It is not a collection of memories, but a reinvention of memory itself. It's misremembering your own life on purpose.

Linklater intuitively distrusted that type of sunny, revisionist thinking, even when he was too young to fully understand it. "I remember my football coaches being like, 'These are the best years of your life!' and me being like, *Fuck, I hope not. There's gotta be something better*," he says. "That scene in the movie where Pink says, 'If I ever start referring to these as the best years of my life, remind me to kill myself.' That's me reminding my younger self."

The film is set on the last day of high school in spring 1976, in a small, unnamed Texas town. Its main character, Pink (Jason London), is the quarterback, the popular kid, the guy that multiple hot girls want to make out with. In a different kind of movie, he would be having the time of his life. Instead, he's acutely aware that he's stuck in this place, surrounded by small-minded adults, and determined to avoid becoming one of them. Pink is a stand-in for Linklater, who played quarterback in his junior year. Mitch, the skinny, awkward freshman played by Wiley Wiggins, is also a stand-in for Linklater. "Whenever Pink talks to Mitch, that's me talking to my younger self," he points out.

It was 1992 when Linklater started production on *Dazed*. He was 31 years old. He'd spent most of the previous decade unemployed, with no college degree and a stack of unpaid credit card bills. This had always kind of been the plan. Linklater was a deeply antiestablishment guy who'd never wanted a day job, a marriage, or any of the other trappings he viewed as distractions from making movies. His 1991 breakthrough film, *Slacker*—a shaggy-dog story about young

misfits killing time in Austin, much as Linklater had in his 20s—established him as a major talent and a generational voice, but it also left him deeply in debt. His plan was not exactly foolproof. If Universal Pictures hadn't green-lit *Dazed,* he might have been forced to take a far less creative path in the corporate world. This was not only his first shot at making a studio film, it was likely his last.

Once the film came out, the message many people took from it was the opposite of what Linklater had originally intended. There was a disconnect that surprised and sometimes dismayed the director, but in retrospect, after talking to the cast and crew, it's easier to understand. The cast didn't actually remember the '70s. Jason London was four years old in 1976. Wiley Wiggins was born that year. Many of the others—Ben Affleck, Joey Lauren Adams, Parker Posey—thought growing up in the '80s and '90s sucked. Once they got past the ridiculous costumes, everyone thought the '70s sounded kind of great. They'd all end up marveling at the opening scene in *Dazed,* when a Creamsicle-orange 1970 Pontiac GTO Judge pulls around the corner into a high school parking lot to Steven Tyler's soaring vocals—"*Sweeeeeeeet!*" They couldn't share Linklater's cynicism. They likely didn't even recognize it. How do you open a movie about the '70s with "Sweet Emotion" and still claim the decade sucked?

Most of the actors had come from New York or Los Angeles. They were shooting in Austin, which felt as exotic as a lunar outpost. Isolated from their friends and family, they grew unusually fond of Linklater, who entrusted them with a level of creative freedom they'd never experienced before and would rarely encounter after. They also grew incredibly close to one another. Some fell in love. Some fell into bed. Some became friends for life—or at least the next 10 years, which is a lifetime in Hollywood. Some still pine for each other decades later. Almost everyone had a blast. And that changed the tone of the movie. They couldn't hide how much fun they were having, and it bleeds through the screen.

Linklater's own memories of the summer of '92 are more fraught. "I gave this introduction to *Dazed* recently where I said, 'I'm kinda

sick of this movie,'" he admits. "I don't think it's my best movie. I think it's middling. I don't know why people latch on to it. To this day, I'll be on a movie set, and I'll get this little shiver thinking of what I went through then, and I'll be so happy with how smooth things are going now. I still have PTSD from making that movie."

Almost from its inception, *Dazed and Confused* was a war. Linklater fought with Universal over budgeting, scheduling, casting, and tone, and things got particularly heated over the soundtrack. Most artists who battle corporate entities end up with work that's compromised. What's crazy is that *Dazed* was a war that both sides ultimately won. In the face of all logic, Linklater emerged with a movie that perfectly captured the moment-to-moment reality of being a teenager, and somehow also achieved precisely what Universal had signed him to create: a classic film that makes every new audience feel good about the worst time of their lives.

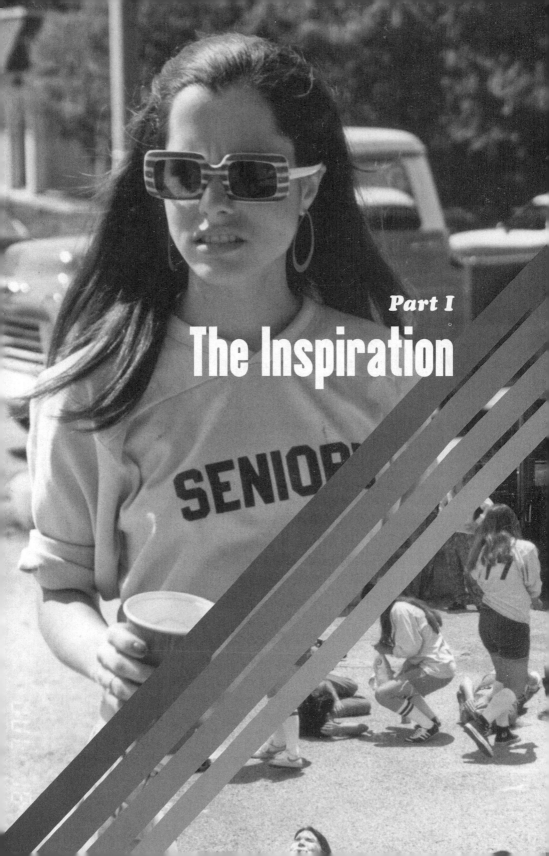

Part I

The Inspiration

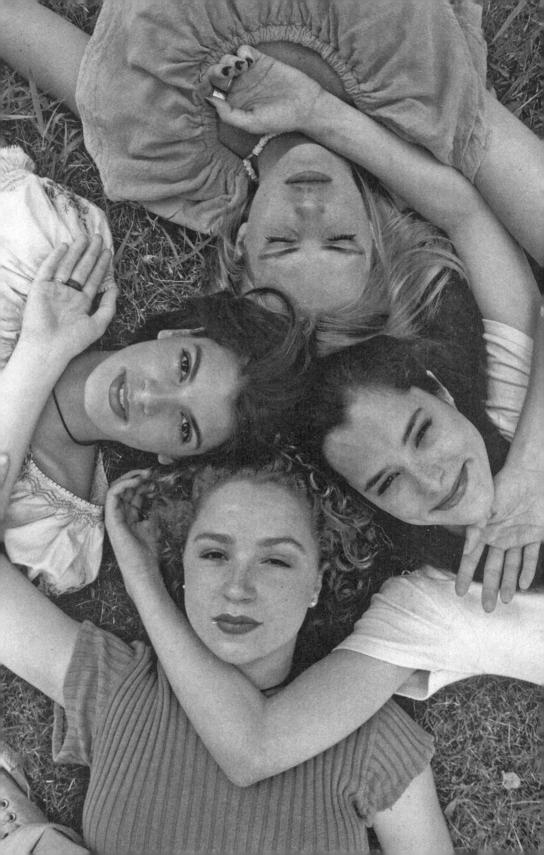

Chapter 1

Oh My God, This Movie Is My Life!

"Am I watching this, or am I remembering this?"

*W*hen you think about high school, what do you remember? Regardless of who you were as a freshman or what you did as a senior, it's nearly impossible not to find something about *Dazed and Confused* that reminds you of your own past. That's pretty surprising, considering how closely the film reflects Richard Linklater's own life at a particular time in a particular Texas town. You might assume the details would be too arcane to translate to anyone else, yet the opposite is true. The year that you graduated is irrelevant. Your hometown doesn't matter. "This movie is hyperspecific," says journalist Steven Hyden, "and yet the more specific it gets, the more universal it feels."

"My whole working premise was that nothing really changes in teenage worlds," Linklater has said. "There's a continuum that goes from the entire postwar era through the present day. The dilemmas are the same. The relations are very similar. The pop culture landscape changes, but what it's like at that age, in relation to your parents, friends, school, that's a constant."

Linklater focused not on the things that alienate teenagers but on the qualities that quietly unify them: boredom, horniness, a lack of

power, fear of rejection, and the endless optimism that, once night falls, *something* cool might happen. He knew that you didn't need to attend high school in Texas in 1976 in order to remember the first time you drank stale beer from a red plastic cup, the first time your mom caught you sneaking back into your bedroom after curfew, or the first time you made out with someone on an itchy blanket. He believed everyone knew a stoner like Slater (Rory Cochrane) and a mean girl like Darla (Parker Posey) and a charismatic creep like Wooderson (Matthew McConaughey). This movie is a period piece, but the period isn't the '70s—it's the period in everyone's life from age 14 to 17. That's why so many people consider it their favorite movie, and it explains why it holds up over multiple viewings: everyone who sees *Dazed and Confused* thinks it's about *them*. The experience is illogically personal. We watch it, and we feel what anyone who's ever been a teenager wants to feel. We feel *seen*.

Matthew McConaughey: Look, when people go, "What's your favorite film?" I always have to bring up *Dazed and Confused*.

Michelle Burke Thomas: *Dazed* will go down as one of the greats because everyone can relate to it.

Kevin Smith: Every once in a while, as a filmmaker, you think, "Maybe I should make a movie about what it was like when I was growing up." And then I remember, "Oh, wait, *Dazed and Confused* exists. There's no need."

Ben Affleck: Rick showed the joy, the sense of freedom, but also the profound sense of inadequacy and pain and fear and insecurity of high school. He rang the tuning fork, and it was exactly in tune with a lot of people's experience.

Richard Linklater: I wanted this teenage movie to play in shitty little towns and malls and drive-ins. I wanted a 16-year-old to stumble into the movie somewhere and see his own life.

Renée Zellweger: I remember reading the script and thinking, "Wow. This is my people. It's my decade. This is my music. Gosh, if being in this movie doesn't work out, that's a big sign that I should just hang it up and call it quits!"

Michelle Burke Thomas: I grew up in Ohio, but it was like, *Oh my god, this movie is my life!* That opening scene with "Sweet Emotion"? When my sister was a junior and I was a freshman, she took me to my first huge high school party, and there were massive speakers outside and they were playing "Sweet Emotion." It was just like a scene from *Dazed and Confused.*

Joey Lauren Adams: I grew up in Arkansas, and that's exactly how I grew up. We'd cruise around and have keg parties in the woods and listen to Southern rock.

Jay Duplass: In New Orleans, we had our own version of the moon tower. It was called "the lagoon," and it was in a park, and people would go there to get in fights and make out and get drunk.

Sasha Jenson: Driving around, hitting mailboxes with a garbage can? That stuff is familiar to me. I grew up in the Hollywood Hills, and we'd go up to Runyon Canyon in 4x4s and drive around. We had these giant bumpers, and if there was a stop sign, we'd knock it down.

Bill Daniel: Cruising culture—that's a Texas thing. I recently stopped in Fort Stockton on a Saturday night and pulled into a Sonic to get something to eat, and there's a bunch of teenagers hanging out there, just as they have for *40 years.* Some older teenagers had their younger brothers and sisters in tow. It was a beautiful thing seeing the older teenagers on one side and the junior high kids next to that. I saw that in the movie, and thought, god, that is so timeless!

Matthew McConaughey: Your car was your identity in high school—that was true. I was a truck guy. I'd get on the PA, duck down in the floorboard and flirt with some of the girls over the PA while hundreds of kids are walking to school. "Oh, look at Kathy Cook's pants she's got on today! Nice jeans, Kathy!" Everyone is turning around going, "Who's saying that?" Then I'd pop up. "You son of a gun!"

Jason Davids Scott: I grew up in suburban L.A., and *Dazed and Confused* was my high school. Aside from the music that was on the radio. And the cars. And the fashion. And we didn't do the bullying thing.

Jason Reitman: There's a specific type of nostalgia that Linklater's brilliant at, and that's the tonal nostalgia of what being young *feels* like. That's the kind of nostalgia where someone who's had a completely different life experience watches the film and they still connect with it.

Adam Goldberg: I went to a private college-prep high school in the '80s in the [San Fernando] Valley, with a bunch of famous people's kids. It was so different from *Dazed*. When I saw the thing about the kids getting paddled in the movie, I was like, this is a science fiction movie!

Rory Cochrane: I'm from Jamaica, Queens. There were guys bringing guns to my school and selling crack and throwing kids off of buildings. We had gangs, and they beat people with hammers. That whole thing with the hazing in *Dazed*? Getting ketchup squirted on you? You wouldn't try to do that in New York. Some kid would just punch you in the face.

Jason London: None of us had ever heard of anything like that before. There were things that I was like, "Is this true?" And Rick Linklater was like, "This is from my life, man."

Richard Linklater: Different places had different things, but there was some universal aspect to subjugating others to humiliation.

Wiley Wiggins: My mom got rolled through cow patties in Bryan–College Station. That's a Texas thing, I think.

Parker Posey: My aunt Peggy had gone through a hazing ritual [in Louisiana] where someone tied a piece of dental floss around oysters and made the girls swallow them and they'd pull them back up.

Steven Hyden: When you watch the movie, it's like, "Am I watching this, or am I remembering this?" You know the scene in the end when they're making out and "Summer Breeze" is playing in the background? I've never made out with anyone while listening to "Summer Breeze," but I've been in situations that *feel* like that, when you've been up all night talking and there's all that tension be-

tween you and you finally kiss and how amazing that is when you're a teenager. It's so sweet and real.

Jeremy Fox: *Dazed and Confused* is a time piece, but it transcends time. Some films, you watch them a decade later, and they are out of sync with the way the culture is currently. This one is set in the '70s, but there isn't a whole lot of stuff in it that isn't something you would see, day-to-day, throughout different generations. The first kiss when you're in high school. The first dance. The time you got so stoned, you think a lighter is fucking rainbows and unicorn shit. All that stuff transcends generations. We're going on about 30 years since the movie came out and it's still relevant.

Ben Affleck: It resonates with people because a lot of people have a profoundly hard time in high school. For many people, high school is the most stressful time in their lives. And all these neural pathways that are getting laid down stay with you in one form or other for the rest of your life.

Richard Linklater: Everybody has some relation to the high schooler they once were. They're still fighting the same battles. Or they're compensating for them. It's formative shit. I think, with *Dazed*, I was belatedly working through that stage of life, how odd my town was, how brutal the initiation rituals were. I still don't know what I think about it.

Heyd Fontenot: I think that's part of why people still love that movie. We spend the rest of our lives trying to figure out the first 18 years.

Chapter 2

Old People in Your Face,
Fucking with Who You Are

"If you're a nonconformist and an anti-authority person, it's just kind of like, School's not gonna be the key to my future."

Whether you were smart or dumb in high school, a popular kid or an outcast, you probably felt oppressed. That's the defining experience of being a teenager, and it's a feeling Linklater captures really well in *Dazed and Confused*.

When the film begins, on May 28, 1976, summer vacation is start-
ing. These kids should feel free. Instead, everyone feels like they're
being controlled by someone older or stronger or dumber than them.
Pink (Jason London) gets yelled at by his football coach, who threat-
ens to kick him off the team if he doesn't sign a pledge to abstain
from drugs. The incoming freshman boys are whacked with wooden
paddles by a demented senior named O'Bannion (Ben Affleck). The
incoming freshman girls get sprayed with ketchup and mustard by
a group of senior girls and their merciless ringleader, Darla (Parker
Posey). Even the more laid-back adults kind of treat the kids like pris-
oners. When naïve freshman Mitch (Wiley Wiggins) comes home
late from his first real party, his mom tells him, "This is your one
'Get Out of Jail Free' card."

Dazed might be viewed as a party movie, but when Linklater wrote
it, he was still processing some of the less fun memories of his own
high school years in Huntsville, Texas. To some people who knew
him back then, that's surprising. He was an all-American kid: a for-
mer student council member, a star player in both baseball and foot-
ball, a promising writer for the school newspaper, someone who was
generally well-liked. None of this is lost on Linklater. In the movie,
when Simone (Joey Lauren Adams) accuses Pink of acting like he's
"so oppressed," even though he and his friends are the "kings of the
school," it sounds like Linklater's poking fun at himself. "In some
ways, I was privileged," he admits. "I was an athlete, I was popular, I
was dating. And I'm a white male, for fuck's sake."

Still, that didn't make the worst feelings he had as a teenager
seem any less real to him. On July 13, 1992, the day before princi-
pal photography began on *Dazed*, the filmmaker Kahane Corn (now
known as Kahane Cooperman) interviewed Linklater for *Making
Dazed*, a behind-the-scenes documentary about the movie. In an
outtake from her film, Corn asks Linklater where he's getting his
energy for the project. He says he's working from a complete teenage
mind-set. "It's as if a 17-year-old was making this movie, with all the
knowledge of filmmaking I've got, but I've cut out all the emotional

development in between. So I feel in a pretty weird state of mind right now."

Linklater felt he was an adult, reflecting from a safe distance on his adolescence. The distance was smaller than he thought. *Dazed and Confused* would eventually become a classic, regarded by many as eternal and beloved. But when he was making it, he'd have to contend with impatient producers, unimpressed studio executives, and a marketing system that reduced his subtle movie to a series of stoner gags. That same sense of oppression he'd felt back in high school would come to define his experience making the movie.

Richard Linklater: I saw *Dazed and Confused* as a story about authority trying to rein in youthful passion. That's what it felt like to be young: there's old people in your face, fucking with who you are. That's what growing up is. It doesn't change much when you're older, but when you're on the losing side of that, the disempowered side, it sucks. I guess that was a theme of those years in Huntsville.

Tony Olm: Rick moved to Huntsville, Texas, in fourth grade. His parents divorced and he moved there with his mom and his two sisters, Tricia and Sue. Trish was the more social of the two. She was like Mitch's sister in the movie.

Tricia Linklater: We came from Houston, where we were living out near NASA. My mother was offered a job as a professor in speech pathology at Sam Houston State University in Huntsville, so we left Houston, which was a big city, and we moved to a more rural city. People had cattle, and families owned gas stations and car dealerships. It was a little city with 15,000 people. It literally had one stoplight when we moved there, and a historic main square that had had an opera house at the turn of the century. It was very country.

Richard Linklater: When I moved to Huntsville, it was like going back in time. East Texas is a generation behind.

Tony Olm: Huntsville was very much run by the white folk and the church, and the Baptist churches resisted change for as long as they could, on all fronts. It was kind of stuck in the pre–sexual and political revolutions.

Mike Goins: It was a small-town culture, but it was also shaped by the culture of the prison.

Linden Wooderson: There's two things to do for work in Huntsville. You're either involved at Sam Houston State University or with the prison system. It's the headquarters of Texas Department of Criminal Justice, so there's tons of prison units.

Mike Goins: When they execute people in Texas, they do it in Huntsville, at the Walls Unit.

Terry Hoage: That was the joke: you would end up in one of two prisons, either the Walls or Sam Houston State. When you went to another town, they'd all ask us, "Oh, did you escape?"

Richard Linklater: The prison wasn't far from where our high school practice field was. If you jogged up a hill and went across a street, that's where they do the executions. *Real* close to home. I wanna look through my varsity roster, because I know friends where it's like, "That guy ended up on fucking death row. That guy is doing time. That guy is dead."

Gary Price: At one point, many years later, Rick was working on a movie about a football team in a town like Huntsville, and I think one of the players ends up becoming a prison guard or something. He told me, "That could've been a possibility for my life if I hadn't started making movies."

Excerpt from Dazed and Confused
Seventh Draft, April 19, 1992

```
                    SHAVONNE
Do you ever think like, what's the guy I'm going
to marry doing right now?

                      KAYE
The guy you're going to marry is probably just go-
ing to prison.
```

Lydia Headley: Rick had a stepdad who worked at the prison. I had friends whose dads were wardens. There was a "gotta control people" kind of perspective in Huntsville.

Richard Linklater: I had a series of male figures in my life—coaches, teachers, principals, and definitely stepfathers—who were just kind of in my face, fucking with me, and I wanted to be free of that. Like, god, how can I set up my life and not have somebody alpha-maling me?

Brett Davis: I think a lot about what shaped us at the time, and I think it's military culture. In the '70s, we had the benefit of not having to fight in Vietnam, but our teachers had most likely come out of the military. They had probably been in the Korean War, and that affected how they treated us. Sports were about: you don't drink water during practice, you gut it out. And you got hazed, which had some military implication.

John Pease: I remember reading Roger Ebert's review of *Dazed and Confused*, and he praised the film a great deal, but made the comment that the paddling did not seem realistic. He was wrong about that.

Keith Pickford: The principal actually paddled your behind when you had discipline problems. If you got caught fighting, you didn't get expelled. You went down to the principal's office and you got licks.

Terry Hoage: The principal had a little gorilla statue on his desk. You had to lean over and put your hands on the desk, and he would say, "Tell me if the gorilla blinks."

Andy Slater: One of my nerd friends had a notebook of how many licks people got [by high school officials], and I had 80 in one year. It wasn't like I was cursing the teacher out, or starting fights. It was mostly for having long hair, or not having my shirt tucked in, or having holes in my jeans.

Terry Hoage: Because licks were part of our school, it wasn't so far-fetched for upperclassmen to be giving underclassmen licks, too.

Lydia Headley: We called it "freshmanizing." It wasn't called hazing.

Don Watson: In today's world, it's just physical abuse, but we had a safer name for it.

Jay Clements: Hazing is not just a Texas thing, but the paddling element, and the community acceptance of it, that's what was unique.

Keith Pickford: I made a paddle in the woodshop. Guys would engrave their name in it and drill holes in it, so that when you swung the paddle, the wind gets to flow through it, and it would leave marks on the butt.

Excerpt from *Dazed and Confused* Shooting Script, June 25, 1992

Out in the hallway, Benny proudly shows his board to Don as they start to walk down the hall.

BENNY

Check it out. I just drilled a series of small holes . . . to cut down on the wind resistance and create more of a sting on impact.

Katy Jelski: When Rick told me that guys hit each other's asses with paddles when he was in high school, I said, "Isn't that kind of homoerotic?" I thought I was pointing out the obvious to him, but he's such a guy's guy, he was totally taken aback. He'd never seen it that way. It was just a thing everybody did in his town.

Richard Linklater: I played on the varsity baseball team as a freshman, and there were a lot of seniors on the team. After practice one day, I was going to my car, and a guy comes over, and tells me one of my teammates wants to meet me at his car. And he gave me licks! A teammate!

I got invited to high school parties because I was friends with older guys. And they're like, "Hey, were having a party at Thompson's

house Saturday night. Come on by." And I'm like, "Older girls? Yeah, I'll be there!" Word got out that I was at this party, and a bunch of them rounded me up and gave me licks. My butt was bruised that whole summer, off and on.

Keith Pickford: While the seniors were out strolling around in their cars looking for freshmen, they would tell them, "Air raid, freshmen!" And they had to hit the deck.

Kari Jones Mitchell: It was different for the girls. We had to "air raid," but the girls were also saturated with the grossest things possible. We buried eggs for weeks to throw on our girls, to make them rotten so they stunk. I had one friend who could never eat Thousand Island dressing because the smell reminded her of that day. It was mustard, mayonnaise, ketchup, relish, cooking oil, oatmeal, flour, honey. And they poured it all over you. And the whole town came out to watch! It was a socially accepted rite of passage.

"Freshmanizing" in Huntsville, 1976

Julie Irvine Labauve: They made you push a penny on the concrete with your nose. Many times when you were pushing it, you'd scrape your nose on the concrete, so many of the girls had bleeding noses.

Kari Jones Mitchell: A senior girl would befriend a freshman girl as their "big sister." If they were making you do embarrassing things, big sis could step in and pull you back, so you had somebody who's got your back. Somebody put a condom on the end of my little sister's nose. So I went over there and pulled it off.

Don Dollar: They made girls walk around with a pacifier, and made them propose to guys.

Julie Irvine Labauve: I had to propose to a guy named Carl, and he said, "What will you do for me?" The answer was always "Anything you want."

Kari Jones Mitchell: You had to say the specifics of "What will you do for me?" Like, "I would do blow jobs and 'in the butt.'" Some of the guys would drag it out and make you say the most disgusting things until they finally said yes, they'd marry you.

Excerpt from Dazed and Confused
Shooting Script, June 25, 1992

SHAVONNE
Propose to Mr. Dawson.

 Freshman Girl #1 gets down on her knees.

FRESHMAN GIRL #1
Will you marry me?

DON (SMILING)
Well, I dunno . . . what'll you give me?

FRESHMAN GIRL #1
Anything you want.

DON
Anything?

<pre>
 FRESHMAN GIRL #1
Anything

 DON
Do you swallow or spit?
 She's not even sure what he's talking about.

 FRESHMAN GIRL #1
Uhh, whichever you like.

 DON
Okay, I guess I'll marry you.
</pre>

Lydia Headley: All the freshmen, we went to a car wash to get cleaned up afterward. Then I went to my house, undressed in the backyard, and threw my clothes in the trash. I walked naked back to my house, and I didn't even care. We spent the whole night consoling one another, washing each other's hair, trying to get the motor oil out. We couldn't get our hair clean, it was so oily.

I'll be honest with you, the first time I saw *Dazed and Confused,* I couldn't watch it. I was a little angry that Rick had captured it so well. It was so personal, especially the scenes about the hazing of the girls. I knew it had been billed as a comedy, and I thought, "This is not funny, people!" It was so raw and so real for me.

Richard Linklater: Whenever you're fighting for your physical safety, it's traumatizing. It's nothing like the abuse many other people have suffered, but I know there's often a delay with abuse survivors. Twenty years later, you're going, "Hey, wait a second. That was fucked up!" It takes a while, because so many of us are just trying to survive, so we repress all this stuff. But I did look back at the hazing and go, "What the fuck was that? That was *sanctioned.*"

We were the first class ever that took licks but didn't dish them out. Because I was kind of a leader in high school, I said, "I'm not

gonna give licks to any of these eighth graders, that's fucking stupid." So we didn't do it. But I think the next class picked it back up.

John Pease: The year after I got out of high school, a girl got something in her eye that required hospitalization. That put an end to it.

Terry Hoage: Rick was the child of divorced parents, and because of that, he had the freedom to make his own choices about what was right and what was wrong. His mom couldn't watch everything that he did.

Richard Linklater: My mom is kind of Mitch's mom at the end of the movie, where she catches him coming home drunk. I came home drunk my freshman year and she was like, "Okay, I'm going to let you do that *once*, but if you start making a habit of this, I will start clamping down."

I had a single mom who couldn't keep up with me. Later, I wondered, "Would my life have been different if I had had a dad around the house, saying, 'No'?"

Terry Hoage: Rick was really unafraid of authority.

Tricia Linklater: I've read that Nobel Prize winners typically have a strong mother and an absent father or a weak father. I think when there's a vacuum of power, the sons tend to rise up and fill it. When there isn't a man in the house, they do what they want.

Richard Linklater: I never saw it that way. I still saw my dad on weekends. But yeah, he wasn't the one there, like, "Hey! Get your homework done." The "manly" chores fell to me—mow the yard, take out the trash—but I was the youngest, and my older sisters say I didn't do shit.

This anti-authority thing definitely kicked in for me around eighth grade. Up to that point, I was like, I'll run for class office! I thought there was some carrot on a stick about doing everything right. Then that began to change when my California uncle came and lived with us for an extended stretch with radical ideas and lots of great music. And a lot of it had to do with who my mom was hanging out with. She had these radical friends who'd stay with us for a few months and then disappear, and then later you'd find out

that they were with Students for a Democratic Society, and they'd just blown up a bridge in some other state. You see a little of that in *Boyhood*. Those people would bring these radical conversations to our dinner table. That must have meshed with a certain sensibility on my part.

Brett Davis: Rick is a very principled person. I think you saw that in the drug agreement that our football team had to sign. Rick was really good at football. He actually played quarterback on the junior varsity team. My freshman year, they hired a new football coach, Coach Clements. One of the first things he did was ask us to sign an agreement that we wouldn't use drugs. That's a perfect illustration of Rick's principles. I'm probably like 99 percent of the people, like, "Oh, hell, just sign it and then let's go party!" Not Rick.

Richard Linklater: I don't remember a drug pledge at our school, but they had drug and alcohol pledges everywhere. At another school, they kicked six guys off the varsity baseball team because they had been at a party on Saturday night. That was yet another way to discipline *these damn kids*.

If you're a nonconformist and an anti-authority person, it's just kind of like, *School's not gonna be the key to my future.*

Frances Robinson Snipes: I got the feeling that there was some kind of "mindless establishment" that Rick didn't want any part of. I had a brand-new Camaro that my dad bought me, which was pretty hot stuff in 1978. And Rick said to me, "You stand for everything I despise."

Brett Davis: Rick has a heart for people who are struggling, and a distaste for unearned wealth.

Richard Linklater: I'd seen my mom struggle financially. What I learned is, you don't need all this shit to make you happy. Keep your costs low. Don't have your first kid as a teenager. And don't have three kids you need to support.

Tricia Linklater: Mom was a college professor, but money was tight at our house. She was paid barely anything, and she didn't get paid over the summers, so she kept on doing odd jobs.

Richard Linklater: Growing up kind of poor, you see that it's not a level playing field. You see injustice everywhere. I had no qualms about beating the system. I'd join the Columbia Record Club under assumed names and get all the records and not fulfill my obligation financially. I was like, fuck them!

Tony Olm: Sophomore or junior year, a bunch of us decided we liked playing poker. We met a couple times a month, usually at my house. Rick played sometimes, but he mostly hung out. He didn't like losing money.

Richard Linklater: Hey, man, the Linklaters are Scottish, so they're very frugal. It's different than being cheap. Frugal is just spending money wisely. My poker buddies always accused me of being "nickel blackjack Rick." But I didn't have much money, so I wasn't going to lose it playing cards.

Lydia Headley: In general, no one in Huntsville had a lot of money. You develop in your own mind the sense of poverty, and that you lack what others have, and you develop this sense of, "I'm different than everyone else." I wonder if Rick has that same perception. I think it created a sense of a greater purpose for him than staying in Huntsville.

Brett Davis: There wasn't a whole lot to do in Huntsville. You could go sit in the Piggly Wiggly parking lot and eat a 10-pound bag of ice for entertainment. We had to create our own activities.

Terry Hoage: Friday and Saturday night, you got in the car with your buddy and drove down to the Sonic. Right next to the Sonic was Little Italy Pizza, so you'd stop there. Get out. Talk to people. You'd hop back in the car. Get back on the road. Then head down to the Emporium, which was the place to play pool, and then head back to the Sonic.

Excerpt from Dazed and Confused
Seventh Draft, April 16, 1992

TONY

Aren't we having fun now. The promised party long
since cancelled, we've been condemned to driving
around endlessly. The masturbatory cycle contin-
ues: through the Sonic, then by the Emporium where
we don't go in because we feel out of place, then
back to the Sonic where we don't ever actually stop.

Kari Jones Mitchell: The way Sonic was set up, you drove
in one side, and there was parking, but that was the uncool side.
You *never* parked on that side. You made the U around the building
where all the food was prepared, and you came up the other side,
and the number one parking space was the very last one closest to
the street, so you could see everybody that drove by. If there wasn't a
spot on the cool side, you didn't stop. The uncool side, that's where
the parents park.

When the bell rang at 3:30 at high school, everybody would race
out to their cars and jump in, because you wanted to get a strategic
parking space. This happened every afternoon.

Richard Linklater: A lot like the movie, I was always trying
to fit in and be cool. By the time I hit freshman year of high school,
I felt like, "Okay, it's on."

Tony Olm: Rick was the guy every guy wanted to hang out with
and every girl wanted to date. He was across all social groups, too:
the jocks, the preps, the kickers.

Don Watson: The kickers were the cowboy kind of people. The
shitkickers.

Ethan Hawke: He loves the jocks and loves the geeks, he loves
women and men, scientists and space cadets—he relates to them all.
I've never heard him waste a second of his life disparaging anyone.
This shows in his work. He loves people.

Shavonne Conroy: The only thing that didn't seem real to me about *Dazed and Confused* was that there weren't many black people in the movie. Our school was about half black, half white. But I guess Texas was still pretty segregated, even in the '70s.

Brett Davis: *Brown v. Board of Education* was in 1954. Desegregation in Texas was not an overnight process. Starting in September of 1966, African Americans were asked if they wanted to come over from the black school in Huntsville to the predominantly white school.

My dad was the principal, and he was put in charge of desegregation. We had to move out of our house because there were threats from white people who didn't want to comingle with the African Americans, and threats from African Americans who didn't want to comingle with the white people. On top of that, the NAACP and the Student Nonviolent Coordinating Committee felt like the school board was stonewalling, so they came into town and organized protests where you had a cauldron of people blocking the town square. And then you toss the white extremists into the pot, and it was a very difficult time. The FBI, the Texas Rangers, everybody got on this because it became a real flashpoint.

My dad died during that period. He had a cerebral hemorrhage and collapsed on the football field in October of '66. I don't know whether that had to do with stress over desegregation or not. But by the time I started high school in '74, white kids and African American kids were in the same school, but we didn't socialize together.

Kari Jones Mitchell: We had a separate black and a white homecoming court. We had black and white "Most Likely to . . ." This is '76, '77, '78! That's a thing people can't wrap their head around.

Richard Linklater: On my football team, I was always the only white guy in the backfield, but after practice and on weekends, we'd go home to different neighborhoods and socialize separately. There was a little crossover, like the one black dude who would find it fun to hang out with the white boys. In my group, that was Leslie Warren. That's why there's one black guy in *Dazed*. The movie only really represents what "white Huntsville" was doing.

Leslie Warren: From kindergarten on, I was with white kids. We had [tracking] levels. All the way through school, we had level 1 through 13, and how high you were was based on how smart the teachers thought you were. I was always in level 12, so that's how I became friends with those guys. There was about four or five black students who were always in level 12 or 13, and you knew that you were being shunned by the other black kids because they thought you were "acting white." That's how they described it. Me and one other guy may be the only ones that hung out with other races.

I never got the sense that racism against African Americans was a bigger issue in Huntsville when I was growing up, because all my friends were Caucasian. But the more I think about it over the years, I'll remember going to a store and not being waited on for 10, 15 minutes. You didn't see it back then, but now you think, *Hmmm.*

Richard Linklater: In the very early drafts, I had a subplot where this African American guy comes out with them, but he doesn't want his brother to see him hanging out with a bunch of white guys.

Excerpt from Dazed and Confused
Draft as of February 20, 1992

The car pulls up near a black nightclub called Elizabeth's Soul Power.

TONY
I can't believe you're bailing out on us, Royce. Just think of how you could be cruising around endlessly all night from the Sonic to the Emporium back to the Sonic and then to the Emporium . . .

ROYCE
A little too WASP-y for my taste . . . Drop me off here, man.

*Tony keeps driving and is soon right in front of the
club. The guys milling around in front check out
this car of white people. Royce ducks down a little.*

ROYCE

Shit. Pull up farther.

> *Tony finally snaps to Royce's
> dilemma and pulls up a ways.*

TONY

Oh . . .

> *Royce is a bit amused at all this by
> the time he gets out of the car.*

ROYCE

What are you trying to do, get me killed?

> *He walks away toward the club.*

Leslie Warren: I did have a brother who was a senior when I was a freshman. Outside of school, you didn't see black kids and white kids hanging out together much. There was the Emporium, and then there was another pool hall called Pete's. My brother would hang out at Pete's. I think Rick and those guys hung out at the Emporium.

Richard Linklater: My freshman year, I was like, "I wanna be wherever the party is going on." There were two categories: Are you cool or not? There was never pressure to smoke pot. It was just, are you cool or not? And when I started learning that, like, the cool athlete I look up to smokes pot? Well, fuck! It was okay for me to do it.

My football coach did pull me aside once, like, "We've had some reports of your indulging in marijuana." And I was like, "Me? More than anybody? Come on, I'm just a weekend toker! In the off-season!"

Andy Slater: There was pot *everywhere*. There were several big drug dealers in town. There was a pool hall that was the adult version of the Emporium, and that's where you went for your serious drugs. Woody Harrelson's dad, Charles Harrelson, was involved with some people in Huntsville, and he ended up in some bullshit where he killed a judge. We had our own little East Texas mafia going on.

Keith Pickford: A lot of people grew weed, because it was East Texas and there was a lot of woods and it's the right climate.

Matthew McConaughey: East Texas is behind a big thicket in the piney woods. They call it the Pine Curtain. It had many names that mean people don't get out from behind it.

Jay Clements: Early in high school, a student was interviewed in the local paper, and they said that 75 percent of the student body at Huntsville High School was either using or abusing drugs or alcohol. It became a big controversy, as you can imagine. If you look back, statistically, they say drug use almost peaked in the '70s. And it was happening in small towns, not just big cities.

Don Watson: I don't know how we got away with this, but one year, the school talent show was called "The Bong Show." I mean obviously, we tried to convince the teachers that we were knocking off on *The Gong Show*, which was a popular TV show at the time. But surely the teachers weren't that naïve.

Richard "Pink" Floyd: I worked at the Emporium part-time. That was the place to obtain drugs.

Don Watson: The Emporium was the center of the universe. This was before cell phones, before email, so if you wanted to know what was going on around town, you had to go to the Emporium. I think the soundtrack for *Dazed and Confused* came from the jukebox in the Emporium. I remember it playing Foghat's "Slow Ride" and Bob Dylan's "Hurricane."

Richard Linklater: Oh yeah, I walked into the Emporium more than one time with "Hurricane" blasting out of the jukebox. I have a story for every song in that movie. "Low Rider" was my CB radio handle in high school. I saw Ted Nugent in concert multiple

times, in Houston, and he'd swing out on a vine, and he'd have some kind of animal tail, and it looked like he'd stepped out of *The Flintstones*. I went to an Aerosmith concert in '77 and they opened with "Sweet Emotion." All of these songs were personal to me.

Andy Slater: Next door to the Emporium was a head shop, and they sold beer.

Brett Davis: The scene where they go into the convenience store, and Mitch is buying the beer? That's hilarious, because the drinking age was 18 in 1976, and nobody really cared, so that was accurate.

Excerpt from Dazed and Confused
Seventh Draft, April 16, 1992

CLERK

You're 18, right?

MITCH (QUICKLY)

Oh yeah, just graduated.

The clerk bags it up and gives him change.

Richard Linklater: That was based on me buying beer for the first time my freshman year in high school. A guy at the Emporium gave me five bucks and said, "Hey, go get me a six-pack." And I was like, "Could I do that?" They were selling to minors and they didn't even care.

Andy Slater: Everybody showed up at the Emporium on Friday, and then we'd pool our money and buy a keg or two or three right next door.

Don Watson: You talked to people in the Emporium parking lot to find out where's the beer bust. The movie used the words "beer

bust," which I thought was unique to Huntsville. Most people called them "keggers."

The beer bust was usually at the fire tower. We had a fire tower in Huntsville, not a moon tower. There are moon towers in Austin. That was Rick's shout-out to Austin in the movie. The fire tower was out in the national forest, and it truly was a tower where the forest rangers would climb up into the crow's nest at the top and spot wild-fires.

Andy Slater: The fire tower was a notorious hangout for high schoolers: a little box up in the air on four iron poles, way up above the tree line, and it had a spiral staircase that went all the way up to the top.

Julie Irvine Labauve: This fire tower was probably 80 years old, and it hadn't been repaired. We would dare each other to crawl up.

Andy Slater: The structure was iron and the stairs were wood, so you had to climb up the iron poles and skip around the rotten stairs and stuff. It was a challenge to get up in it, but that's what made it even more fun.

Julie Irvine Labauve: We'd climb up and Ricky Floyd would tell me, "Watch out, there's a board missing on this next step." You didn't see it. It was dark. I heard afterward that a couple fell through the slats, and they eventually took the fire tower down because of that.

Transcript from *Dazed and Confused* Final Film, 1993

MITCH
Why's it called a "moon tower" anyway?

PINK
I guess they just decided to put it up out here whenever they were buildin' the power plant. Ac-

tually, it's a good idea. I mean, you get a full
moon out here every day of the year, you know?

PICKFORD
Yeah, but nothing's ever been repaired, so this
whole place could fall down at any time. So you'd
better watch your step, junior. Whoa!

SLATER
This place used to be off-limits, man, 'cause some
drunk freshman fell off. He went right down the
middle, smacking his head on every beam, man.
I hear it doesn't hurt after the first couple
though. Autopsy said he had one beer, man. How
many did you have?

MITCH
Four.

SLATER
You're dead, man. You're so dead.

Don Watson: You went to the fire tower to get drunk, get laid, or get in a fight. I knew a guy who had a Les Paul, which is a big, heavy solid-body guitar. At one of these beer busts, I'm hanging out with this guy. Next thing you know, some fight's starting and he runs to his car, opens his trunk, and gets out his Les Paul. And I said, "Oh, you going to play music and calm everybody down?" He goes, "No. This is my bat!"

Richard Linklater: It was a crazy, volatile time. In eighth grade, two of my classmates held up the principal at gunpoint after school, stole his car, and were arrested going 100 miles an hour down the highway. Shortly after, another couple of guys thoroughly vandalized the school and burned down a part of it. And there were a

lot of fights in Huntsville. The principal called an assembly once because the fights on campus had gotten out of hand. He chastised the school, and he said, "The people who have been in the most fights this year are: first, white girls, then black girls, and then white guys, then black guys." He actually listed the stats! And it wasn't the order you might think. The girls were first.

But the guys did it plenty, too. A guy had recently moved to town, and one of the overly aggressive tough guys, Johnny, was challenging him. We knew these guys were going to tangle, and before school one day, they were suddenly just tumbling down the auditorium stairs, going at each other. The new guy ended up on top of Johnny, just punching him in the face over and over again. It took a long time for someone to come and break it up. Some people were excited, because the bully was getting the shit beat out of him by the new guy in town. I think I modeled the fight in the movie after that one.

Lydia Headley: Rick was an *incessant* notetaker. He was always writing stuff down. That's how he sees life, sort of, "Oh, that's a good story! I'm going to put that in something one day."

Richard Linklater: François Truffaut is one my heroes. There's often him and two other screenwriters on his films, and he would send the other screenwriters out to do research, to get real stories that were relevant to the subject. He was obsessed with the notion of truthfulness—not necessarily that it had happened to him, but that it really happened to *somebody*. And I think I take a similar approach, to some degree. Anything's fodder.

Lydia Headley: He was always a good observer, because he was a bit of an outsider. There was a sense of, "I'm not a true Huntsvillian because I wasn't born here." He was smart, and funny, and easy to talk to, and good at sports, and most girls wanted to date him just because he was so cute. But he was also kind of quiet and reserved, difficult to get close to. He would date often, but he didn't have long-term girlfriends.

Richard Linklater: I had an undiagnosed attention deficit disorder. Not hyperactivity, but trouble concentrating on things I'm not totally into. Maybe that bled over into relationships with girl-

friends. I had girls I dated on and off, but it was never sustained for lengthy periods. I was always drifting.

Lydia Headley: You always got the sense that Rick wasn't rooted in Huntsville. He was always on his way to somewhere else.

Richard Linklater: My family moved to different schools a lot. It would be a Wednesday, and we'd pick up and move to a new school, midweek. We did that a few times. You see that in *Boyhood*, too. In Huntsville, it was all one school system, but every nine months, we'd still move to a new apartment, or new house. As soon as you settled in, put all the posters on your wall, and felt at home, it was like, "Oh, we're moving." So you go do it again.

Looking back, my mom was probably undiagnosed bipolar. She had these brilliant qualities, but there was a fundamental instability there that kind of puts you on edge. I was probably looking for stable environments that I could control. And I was itching to get out of Huntsville.

My dad lived in Houston, and he was zoned to Bellaire High School, which happened to have the best baseball program in the state. I was a good all-around athlete, but it was clear by then that baseball was my best sport. I was shorter than most of the other athletes at my school—I'm 5'9"—but I was fast, and I was known for stealing bases. One of my friends used to say, "If you got to first, we knew you'd already gotten to second." The summer after junior year, I got a job in Houston and was playing on a very competitive summer league team, dating a cool girl from work, going to concerts and fun big city stuff. I was like, I'll stay here, live with my dad for the first time since first grade, keep having fun, and, oh yeah, play on the best baseball team in the state, which had a fall program, so I was in heaven. I saw the opportunity and took it.

Mike Goins: Heading into our senior year, Rick was going to be the starting quarterback for the football team. So think about how important that is in high school, and how central a figure he was. And for him to be able to say, "Nope, I'm going to go to Houston and play baseball instead." That was something we marveled at.

For the starting quarterback to quit the team, it was hard to get

our minds around. Coach Clements was devastated. He was an offensive-minded football coach. Once he had good quarterback talent, he was able to take the team all the way to state and win the championship. So he might have seen Rick as a solid entry into the 1978 season. And then Rick just left.

Richard Linklater: My heart was less and less in football, and Coach Clements knew it. I was always battling a dual loyalty between football and baseball. My allegiance was more to baseball, but Huntsville was a football town. Football was too serious. My friend and I would walk around making fun of it, going "Game face! Game face!" You've got coaches watching you all the time, keeping you in line.

Excerpt from Dazed and Confused
Shooting Script, June 25, 1992

BENNY
So tell me the truth: you're not really thinking about quitting football. You're just not into signing that pledge, right?

PINK
Maybe I'm not into any of it anymore.

BENNY
No one quits in their senior year. We're going to kick ass this year, man—we got a shot at state. It's what we've been working toward all these years. You gotta be part of it.

PINK
See, no one can comprehend someone quitting something they're good at. If everyone says you are

good at something and keeps patting you on the
back, it's like there's a law you have to do that
forever. But what if you DON'T LIKE doing what
everyone thinks you're so good at? See, whatever
your parents, teachers, and everyone else wants
you to do is usually wrong, it's mediocre, because
it's usually what everybody else is doing.

 BENNY
But you can't quit. Because it ain't just about
you, it's about us. You'd be fucking US over. Your
little waste-o friends might think you're cool,
but the whole team and everybody else in this town
will never forgive you.

 PINK
You think I care what anyone in this town thinks?

Lydia Headley: When Rick left, there were hard feelings in
our group of friends. It was like, "Rick, you're abandoning us! We've
been together all this time. You're not gonna graduate with us? How
could you do that to us?"

Richard Linklater: I just felt like I was kind of done with
Huntsville at that time, and I ended up having a very memorable,
crazy fun senior year in Houston. The bowling ball incident you see
in *Dazed*? That happened in Houston that year. My senior year, I was
driving, and my friend had a bowling ball he was carrying around
and he just rolled down the window and flung it out, driving 60
miles an hour. It hit a curb and went like 40 feet in the air and dis-
appeared into a neighborhood. I was like, "Holy shit!" And he's just
laughing. So it was like, okay, let's see if we can find it. And it had
gone through a car windshield. Like, we could've *killed* somebody.

Another night, I was once again fucking around with a couple

friends, busting mailboxes, and a guy came after us. He started chasing me. I was driving my friend's Challenger, and I got in a dangerous car chase. He would peel out in front of me, and we were at a red light, and he's like, trying to cut me off, *vroom vroom*. I'm like, I have to lose this guy. He either has a gun or he's gonna try to hold us until the police come.

He was behind me, so when the light turned green, I somehow pulled in front of two other cars and went the other way. And he followed me! I was driving 100 miles an hour at one point, just trying to lose this fucker. He rammed us, and he made a dent in the back of the car. Eventually, we lost him, but we had to lie to my friend's father because it was like, "Oh yeah, this dent was there, and we don't know where it came from!"

Keith Pickford: Rick was in Houston when he graduated in '79. After high school, he came back to Huntsville and went to college at Sam Houston. He got a scholarship to play baseball, starting centerfielder, because he was a great player in high school.

Richard Linklater: Oh, you want me to brag? I think I led the city of Houston in hitting that year.

Keith Pickford: Then in his sophomore year, he had a heart murmur, and that was the end of baseball.

Richard Linklater: It was called "atrial fibrillation." Now they can correct it fairly quickly. Back then, they really didn't have a cure for it. Even if I walked up a second flight of stairs, I would get lightheaded, much less running out to the outfield or running the bases. It was kind of an overnight thing, like, "Oh, you can't run!" At that moment, I was craving more reading and writing time, and now I had it.

Looking back, it was a good thing. You don't grow up until you stop playing sports. You're playing a kid's game. You're in a uniform. And the most toxic thing about it is, if the coaches are telling you how important this is, you can let a lot of other things slide, like thinking of what you're going to do with your life.

Jay Duplass: Rick knew when college was over, he wasn't going to be a major league baseball player. The moment you realize that is a big turning point. If you're into sports, you're just like, oh,

right, there's a cap on what I'm capable of here. Whereas in other places in life, there are no caps.

Richard Linklater: I never got that major league at-bat. I never did! Every now and then, I think about that, but it took me years to realize I didn't actually have the right mentality to be a professional athlete. I would never have made it, and thankfully, I didn't have the opportunity to spend crucial years trying. I *did* have the right mentality to be a film director.

Brett Davis: I didn't see Rick again until about six years after graduation. I was going back to Huntsville around Christmas, to the local beer joint, and I saw Rick. I was wearing a Ralph Lauren button-down Polo shirt. It was the Reagan era, and I probably represented everything Rick hated in life. So Rick asked me what I was up to, and I was like, "Well, I went to Texas A&M and I'm going to graduate school, getting my MBA. What are you doing? Did you finish at Sam Houston?"

As you can imagine, this is the period of time where you start to see people you knew in high school, and their paths start to go in different directions, and some of them are not good directions. And by now, Rick had dropped out of college, and he was like, "I'm working on this screenplay. It's called *It's Impossible to Learn to Plow by Reading Books.*"

I was like, "What the hell, man? Dude, you need to pull your shit together!" And, classic Rick, he came at me hard.

He was like, "You yuppie, Beamer-driving asshole! You're probably one of those dudes who's going to live behind a gated community or something!"

Driving back after Christmas, I was thinking, "Man, that Rick! I'm worried about that dude. He seems *lost.*"

Obviously I was wrong as hell about Rick Linklater.

Chapter 3

The Hardest Working Slackers in Austin

"If anybody asked, we said we were making a mayonnaise commercial."

*I*f you were an aspiring filmmaker during the 1980s, you might have followed an obvious path: go to film school, move to Hollywood, get a job as a production assistant, work your way up through the system. But Linklater always resisted obvious

paths. After he graduated from high school in 1979, he went to Sam Houston State University in Huntsville, to study English, but he spent only two years there before he dropped out. It was an unexpected decision, one that no one wanted him to make, he told *Reverse Shot* in 2004. But, he said, it "set a tone for the rest of my 20s. Maybe the rest of my life. Stay in school was the advice from everyone. I learned early on: listen to all the advice, get a consensus, and then kind of do the opposite."

During what would have been his junior and senior years of college, he worked on an offshore oil rig in the Gulf of Mexico. He was confident but adrift, smart but uncredentialed. At an age when others were applying for internships and entry-level jobs, he spent his free time watching as many movies as possible. He had planned on becoming a writer until he was about 20: That's the year he saw *Raging Bull*, the film he now credits with changing his life and inspiring him to pursue filmmaking. After losing his job on the rig, Linklater moved to Austin with intentions of applying to film school. But he was rejected by the Radio-Television-Film program at the University of Texas (UT), and also by UCLA. His only option was to teach himself.

During his early years in Austin, Linklater discovered a vibrant scene of artists, film freaks, and musicians working outside the corporate world. "The '80s were a great time to be underground," he has written. "The natural response to the Reagan years was to just zone out, ignore and withdraw from that ugly/repressive/materialistic yuppie culture that, despite the phony optimism, shades, and thumbs up, was permeated by this cold war apocalyptic undertone. Fuck that—there was this more compelling, hidden from the mainstream, parallel world to enter into, to rejoice in and resist from."

Linklater's breakthrough feature, *Slacker*, captured the ethos of that time. Shot in 1989, when he was still 29, it focused on nameless local characters who didn't have jobs or aspirations. The plotless narrative was a collection of theories deftly disguised as unconnected conversations: JFK conspiracy arguments, global warming's relation

to space travel, the possibility of a bronze age coming in the '90s, the commercial value of Madonna's Pap smear. "*Slacker* is a work of divine flakiness," Hal Hinson wrote in his *Washington Post* rave review. "Perhaps the special insight Linklater has into the muddled psyches of these disenfranchised, mostly white, mostly college-educated kids contributes to the film's lackadaisical poise. He knows his turf, and he identifies with the unstructured, going-nowhere lives."

Of course, the man who made *Slacker* was not a slacker at all. "Rick was the most driven of all of us," says Teresa Taylor, who played Pap Smear Pusher in the movie. He might not have had careerist ambitions, but he had a singular goal—to make films—and he had a knack for rallying some of his closest friends to help: his roommate, Lee Daniel, the local artist D. Montgomery, and the married couple Clark Walker and Anne Walker-McBay were all part of the crew. "In a sense, we were all slackers," Clark Walker has said. "Aside from a consuming passion for cinema, what we held most in common was a desire not to work for a living, if work meant doing anything we didn't love."

For many people outside Texas, *Slacker* was a first glimpse of bohemian Austin, long before the South by Southwest Music Festival, the "Keep Austin Weird" marketing campaign, and a national craze for BBQ put the city on the map. To some, it must have seemed as fantastical as a Wes Anderson film looks today. Yet the originality of its perspective translated instantly, connecting with audiences who barely understood what they were seeing. Its pass-the-baton structure—the camera followed one person only until a more interesting one arbitrarily grabbed its attention—aligned with the sensibilities of postmodern moviegoers who'd been raised with remote controls and MTV. And its portrait of the overeducated and underemployed helped establish the Gen X archetype.

Ironically, Linklater wasn't even a member of that generation: He was born in 1960, a fact he was advised to hide. "When *Slacker* came out, some publicity person told people Rick was 29, not 30, about to turn 31, because they wanted to be able to say that he was in his 20s," his sister Tricia Linklater recalls. In reality, he was a natural-

born baby boomer, team-oriented and goal-centric. He had always wanted to work with a studio one day. And after *Slacker*, a studio finally wanted to work with him.

Richard Linklater: When I moved to Austin in '83, everybody I met was an artist. No one talked about what they did for their day job. They were painters. They were musicians. When you're in high school, you think the lead singers of bands are rock gods. In Austin, you'd go see them play, and the next day, you'd be at the library and they'd be the ones checking your book out for you. Everybody had *ideas*. Everyone was writing something. And *Slacker* really grew out of that energy.

Kal Spelletich: One day, I was riding my bicycle and I hear this roaring racket coming out of my friend D. Montgomery's house, so I pull over and peek in the front door, and there's D. on the floor, hunched over all this electronic equipment with Teresa Taylor, the drummer for the Butthole Surfers. They're making this beautiful, roaring industrial noise sound composition. I knock on the door, and they're like, "Oh, hey, Kal." They barely look up. They point to some equipment. I get down on the floor, and we just fucking jammed for two, three hours.

Another time, I'm over at D.'s and there's a knock on the door, and this young, goofy, pudgy kid comes in the door with a guitar strung around his back and a shoebox full of like 50 Super 8 films. Everyone in Austin was shooting stuff and projecting it on a translucent sheet up in the corner of a room, so I just start projecting the films. I go, "What are these?" and he says, "That's my mom," and he starts imitating his mom. He gets up, swings the guitar around, and starts banging out very simple three-and four-chord songs, kind of narrating the movies that he remembers from his childhood. We go through the whole box of them.

We're just in stitches on the floor, howling and laughing, helping him narrate the films or just singing along with them, and halfway through it I go, "Wait! That's [late Austin singer-songwriter] Daniel Johnston!"

This is the kind of stuff that would happen in Austin, especially if you were at D.'s house.

Teresa Taylor: There was a real thriving punk rock community in Austin of musicians and fans, freaks and weirdos, and D. was kind of the ringleader of that. And then there were the cineastes. Rick was a cineaste. Well, *everyone* was a cineaste.

Deb Pastor: It was a beautiful time. All the different cliques overlapped. If you went to the Black Cat to see live music, the punks were there, the country people, the rockabilly people—all the people were there. If you wanted to know what was going on, you had to actually walk outside and look at a telephone pole with a poster on it, and then you'd go to Inner Sanctum, the record store, and you had to actually *talk to somebody.* And you'd have heated discussions. If you didn't agree with them, it didn't fucking matter. You were still friends, unless someone punched you in the fucking face. What you were thriving upon was all the ideas flowing. And those ideas motivated you to make stuff. That's how I think of those days. The scene was all about DIY—do it yourself.

Gary Price: Austin was so cheap. Everybody I knew at the time was living in a house where it was like $300, total—to rent the entire house! That's why Austin had so many musicians and artists. It has the University of Texas, which elevates the intellectual pursuits, but it's still a lazy place, because you don't have to make money to live there. People said Stevie Ray Vaughan could play like that because he only had to pay $60 a month in rent. How could he *not* come up with great songs when he could just play guitar all day and not work?

Anthony Rapp: One of the stats I heard was that Austin had the highest per capita PhD waiters. Because it's such a nice place to live that people would study there for years, get their PhD, and just wanna hang and stay there.

Jonathan Burkhart: They called Austin the Velvet Rut because it's so cushy, you never want to get out.

Richard Linklater: When I moved to Austin, I'd gotten laid off from my job, so that qualified me for unemployment. In my two

and a half years working offshore, I'd saved $18,000. It was a little disingenuous for me to collect unemployment, since I technically didn't need it, but that was my "beat the system" ethic. The unemployment checks were my unofficial grant as an artist, whether the government knew it or not. I wasn't supporting the bureaucracy. The bureaucracy was investing in *me*.

Now, the bigger question was how I could survive. My trick was to not live like I had $18,000. I had a room in this house in West Campus that was $150 a month, all bills paid. I had a shitty car. And I was like, outside of film stock and processing, I'm going to live on $300 a month, total, for everything. My friends in Austin were like, "Wait a second. You don't work. You're not in school. Are you a trust fund kid?" I'm like, "No, I have a savings account." Everybody had a part-time job, except me, until I had to. I had a pretty good run from '83 to '87 when I wasn't employed.

I had strong ethics about staying out of the nine-to-five grind. Maybe this sounds paranoid, but I think the goal of the greater world is for you to have a mediocre life, not realizing what you want in the world. That's the story of my parents' generation. Hardly any of them realized their dreams because they were young parents and fell into the trap of working.

I saw the world as a big trap. I think that's why I was able to save my money when I was in my 20s. I was buying freedom to live in the kind of world I wanted to live in.

Tony Olm: Rick lived several years in Austin off that money, just going to movies, learning about editing, buying film equipment. He was able to do that because he was good with money. He had journals where he would write, down to a can of caffeine-free Pepsi, everything he spent money on, every movie he saw. He would see 500 movies a year. That was his full-time job.

Tommy Pallotta: I was the manager at this movie theater called the Dobie, and I just started letting Rick in for free. I think he befriended me because he wanted free movies.

Gary Price: We'd go see a lot of movies, and sometimes I'd buy potato chips and Rick would yell at me. "Why are you spending that

kind of money?" When Rick was low on money, I would watch him scrape the bottom of an iron skillet with a knife, trying to get enough stuff off to put some flavor onto a tortilla.

Don Howard: I was Rick's roommate for a summer in an old hippie house right off campus called the Fingerhut. It had this finger pointing upstairs. You can see it in *Slacker*.

Richard Linklater: It was also called "the Janis Joplin house," because she had actually lived there.

Don Howard: Rick and our other roommate, Lee Daniel, had very little money, and it was hot as hell. One day I couldn't get the hot water to come on in the shower and I asked Lee about it and he was like, "Yeah, it's really hot, man. Rick and I figured we didn't need hot water." It was like, "Wow, you guys are hard-core, man!"

Richard Linklater: Lee was my roommate for five years. He was my filmmaking buddy. We bonded over shooting Super 8 films. He had come through the UT film program, and when I met him, he had made an experimental student film—a short—that was really great, and he would come over and I'd show him films I was making, too. He wanted to be a DP [director of photography], but he wasn't a crazy film buff like I was. I mean, he liked movies, and he was an obsessive camera guy, but he was also kind of a cool skateboard, art guy.

Kal Spelletich: Lee Daniel and Rick were always the anchor tenants at the Fingerhut, keeping the bills paid, but that was where all the film freaks lived.

Richard Linklater: We had a revolving set of roommates. Our front door was broken and thus forever unlocked, so I would come in, and there would be people in my living room. There were always people dropping by, like Daniel Johnston, Gibby Haynes and Teresa Taylor from the Butthole Surfers. You never knew. It was a pretty fun run. People would come by and watch a movie projected on the wall. My first two films came out of that location.

I didn't really touch a camera until I was 22, 23. Kind of late by most standards. I guess, growing up in Texas when I did, you didn't

think, "I'm going to grow up and be a filmmaker." It was not an option.

David Zellner: There wasn't a filmmaking scene in Texas at the time. If you were a New York City person or a California person, it seemed like it was something doable, but it didn't seem within the realm of possibility outside of that. In the '80s, I knew about independent filmmakers like Spike Lee and John Sayles and Jim Jarmusch, but they were all from New York. It felt like something far away.

Brian Raftery: Regional film scenes had started popping up. John Waters was working in Baltimore, and that was one of the first times that I remember a really interesting filmmaker being identified with a city he didn't want to escape. Instead of fleeing your hometown and running to the West Coast or to New York, there was a new idea of staying put and broadcasting your hometown out to the rest of the world.

When you had a movie like Waters's *Pink Flamingos,* you were looking at this completely cuckoo version of Baltimore. And George Romero turned the rest of the world on to Pittsburgh in a very strange way. Thanks to movies like Romero's *Night of the Living Dead* or *Dawn of the Dead,* a lot of people's perception of Pittsburgh was that it was a place where the malls were overrun with either zombie fans or actual zombies.

David Zellner: Occasionally, we'd hear about stuff that was made in Texas, but it was usually people coming into Texas from somewhere else, and it always seemed like it was something from the past.

Holly Gent: There were a lot of Westerns. It was this old guard of cool people like Bill Wittliff, Bud Shrake, Willie Nelson. The projects were all about, like, "Oh, we got Kris Kristofferson, we got Rip Torn," or it was something to do with Pancho Villa or *Lonesome Dove.* I worked on a remake of *Gunsmoke.*

Jay Duplass: Austin was a very small place at that point in time. If you made films, you made them yourself, and you distributed

them on your front lawn. People would have screening parties in their backyards, and other people would record the tape of your movie and pass the tape around and it would get shown at other screening parties. That's how you got traction as an artist.

Richard Linklater: I had done maybe 20 shorts and an 89-minute Super 8 film on a $3,000 budget called *It's Impossible to Learn to Plow by Reading Books*. That taught me a lot. I did it all alone. I was cameraman, I did sound, I edited, I was in it, I wrote it, directed it. I just did *everything*.

Brett Davis: There's maybe 50 words of dialogue in his first feature, *Plow*. It's just Rick taking a trip on an Amtrak train. But when I watch it now, what I see is a guy who is caught in that limbo-land a lot of us are in in our 20s, where you're on the borderline between greatness and homelessness, and you're not sure which way it's going to go.

Richard Linklater: When I was finishing *Plow*, I ran out of money. I needed to pay my rent, so I flirted with a more professional path. At this point, I'm 26, 27 years old. It's the age where you should be accomplishing something. My mom had a boyfriend, and there was a bullshitty sales job with his company. I went to the interview, thinking, "Okay, I can make a lot more money." And then it was not a good interview. I was starting to think, *I can't live like this forever.*

Tommy Pallotta: I'd heard that he'd made a Super 8 film, *Plow*, and I was amazed. I thought, "Who the fuck is this dude who's making an entire feature in Super 8?" I knew people in film classes, and I knew they spent *all year* trying to get a short film made, collectively. And this guy made a whole feature in Super 8, *on his own*. I thought, "I really want to know what this guy is up to."

Then one day I ran into him, and he had an 11-inch-by-17-inch piece of paper with a bunch of notes. I didn't know much about film, but I knew that a film script didn't usually look like that.

Richard Linklater: In a 24-hour period, I sat down and wrote the whole road map to *Slacker*, from five years of notes I'd been taking. I figured out the baton passes between the characters. Only

some of the scenes had dialogue, but that wasn't the first order of business. The first order was the flow of the story.

John Slate: The structure of the film is what's kept it fresh all this time, the fact that it's 24 different scenes. The film's been compared to the 1950 film *La Ronde*, because that's also a series of stories that run into each other, where one character from one episode walks into the next one.

Chale Nafus: [Robert] Bresson was one of Linklater's favorite filmmakers, and Bresson's 1983 film *L'Argent* was about a 50-franc note that passed from person to person, from scene to scene. *Slacker* is very reminiscent of *L'Argent* in that regard.

Richard Linklater: My money was long gone, but I had credit cards, so I used them to buy anything we needed for the movie. It became a credit float, which I couldn't pay. I went into active debt. That's really risking the rest of your life. I don't know what I was thinking. Maybe I thought, "Fuck it, maybe I'll just declare bankruptcy." I just knew I had to finish the movie.

Gary Price: There wasn't GoFundMe or Kickstarter or any of that stuff. You had to figure out how to fund it. And who wants to fund an off-the-wall movie? I "invested" $1,000. I offered Rick more, and he wouldn't take any more. I don't think he wanted any one person to control too much.

Richard Linklater: I had seen my sister Trish get married, and then she got divorced a couple of years later. So there I was, in my late 20s, telling my parents, "You know those thousands of dollars you paid for Trish's wedding? Well, you could just give me that money for *Slacker*. Think of it as the marriage I'm never going to have." That was my pitch, and it worked. And I still haven't had that wedding.

Don Howard: For many years, the only equipment rental house in Austin was a place called Deer. It was owned by this guy Richard Kooris, and it only had two employees: Lee [Daniel] and one other guy. Richard Kooris told Lee that any time someone's not using the equipment, you can borrow it. So *Slacker* had a truckload of professional equipment. That's important when you think about it. The

movie is funky, but it still looks like a real movie. *Slacker* wouldn't have happened without Lee.

Kal Spelletich: We all worked for free. The irony of all that was, *real* slackers wouldn't fucking show up for three days of work for nothing but old bagels and some cream cheese.

Don Stroud: *Slacker* was such a hands-on, original, DIY kind of experience. Usually on a film, there's 180 people in the crew and 10 in the cast. This was like 10 in the crew and 100 in cast.

You know the union phrase, "Time and a half after 10"? You work 10 hours and then your overtime kicks in? Well, Rick and his friends made jokes about that. They said, "We made *Slacker* in one summer on credit cards, and it was taco and a half after 10." Because when you got cast in the film, they would buy you a taco. That was your payment. It was a great experience, but nobody thought it was going to *be* anything.

Richard Linklater: Anne [Walker-McBay] helped me organize casting for the movie, and then, through sheer organizational skills and enthusiasm, worked her way up to production manager, too. Some people work hard and you take it as a sign, like, "Hey, we're meant to be working together." I had other friends I thought for sure would step up and fill these roles, and guess what? They didn't. It was like, "Who wants to work for nothing, on a film that no one will ever see?"

Don Stroud: The auditions were very Austin. You didn't really audition. You just talked.

Kim Krizan: My audition basically consisted of me telling them about my master's thesis, which was on Anaïs Nin, the diarist.

Teresa Taylor: I was under the influence of crystal methamphetamine when I auditioned.

Jay Duplass: *Slacker* starred real people you'd see on a daily basis around town, because Austin was such a small place at that time. Rick put them in the movie because he liked how weird they were, and because that was part of the ethos of Austin at the time, this fierce independence as to who you are and what your point of view

was. Rick would talk to these people, and then he'd be like, "Hey, could we have this conversation on film, on Friday, with this other character?" And he'd write a scene around them.

Chale Nafus: One night, I went to Rick's house to see a film of some sort, and this fellow was there. My friend George Morris was like, "There's that asshole who talks about UFOs!" And then this fellow ended up in *Slacker*, talking about UFOs.

John Slate: The discussion of "Conspiracy A-Go-Go" in the movie is funny because that was a real publication I'd worked on. It was the 25th anniversary of the JFK assassination, and I had friends in Dallas that I visited regularly, and we realized that there was kind of a vacuum in Dallas for JFK-related tours, so we concocted our own humorous tour and produced a little booklet to go with it called "Conspiracy A-Go-Go" that we would give to attendees.

Teresa Taylor: Rick knew that I was the biggest Madonna fan in the world. When I heard about John Hinckley's desire for Jodie Foster and his plan to kill Reagan for her, or how Mark David Chapman waited outside John Lennon's apartment and got his autograph and then killed him, I thought, if you want to be viscerally attached to someone in the media, that's one way for your name to go down in history with the person you love.

So I said in an interview, "I love Madonna so much, I just want to kill her." I was joking, but I wanted it in quotes. And then Rick was like, "She'll do the Madonna Pap smear part in the movie!"

Kal Spelletich: I *was* my character. I was the weirdo media artist guy who sat around and videotaped everything on TV, trying to figure out what to do with the stream of media that really was poison. So, in that scene, I'm talking about that, and I'm surrounded by TVs. That was my studio.

Rick had given me this script, and I was like, "What the fuck? I'm not gonna memorize these lines." At that point, I was chain-smoking weed, so my short term memory was fried. So I typed up my own script, 10 minutes before we were gonna shoot, and D. showed it to

Rick, and to Rick's credit, he sat there with me and D. and he let me essentially rewrite my whole scene.

Richard Linklater: Kal's scene is actually one of the most faithful to the original script. But after hearing some others had a hand in rewriting or originating their scenes with me, I don't think anyone wanted to be the one who'd done basically what was in the script.

Tommy Pallotta: The interesting thing about Rick's process is that even though he didn't have a traditional script, by the time they were shooting, everything was completely scripted. He makes sort of an outline, a conceptual idea, and then he talks to the actors, and then there's a lot of rehearsal. A lot of people don't realize it, but there's not a lot of improv in his movies. All the improv happens before the cameras start rolling, and then everything is scripted almost to the letter. And he's worked that way ever since.

Douglas Coupland: At one point, I met the people from the movie, and I thought they were the most entertaining group of people I'd ever hung out with. They all had *theories*. Maybe that's just Texas. People in Texas are a little bit crazier than elsewhere.

Gary Price: Reagan had started defunding mental hospitals in the '80s, so that was definitely a big presence in Austin at that point. Austin had a legendary mental hospital, Rusk State Hospital. That's where they sent [psychedelic rock musician] Roky Erickson. So you'd see people like that around.

Richard Linklater: *Slacker* is the great portrait of Austin in the depression-era late '80s. Texas was in a huge financial slump. Oil prices had dropped. There were boarded-up buildings there, which is great, because you could get away with anything. We would just pick a corner, set up dolly track, pull up our little shitty van, and we'd shoot a scene all day, and no cop would come around and ask for a permit. Some onlooker might come around and say, "Hey, what are you guys doing?" And we'd just lie.

Tommy Pallotta: If anybody asked, we said we were making a mayonnaise commercial. Just something that would not interest

anybody, not bring any expectations. When I saw the first cut of *Slacker*, I thought, *This is a great time capsule. I'll look back at this 20 years from now and be glad we had this.* But it was hard for me to understand that people outside Austin would be interested.

Scott Dinger: Austin was really a character in the film. So much of it was just about walking around, getting a feel for this really unique place that came out of a mix of cosmic cowboy culture, rednecks, and hippies. I think that weirdness was fueled a lot by the music scene, and also by these students that came from all over Texas to go to UT and never left.

Bill Daniel: *Slacker* is loaded with Austin references. 709 is one of those things that points to Austin's counterculture.

Richard Linklater: There's a famous Austin band called the Uranium Savages, a performance-art rock group in the '70s. They had a thing with 709. It was just a talismanic number. The rumor always had it that Nixon, who they hated, resigned at 7:09 p.m. central time. You'll see 709s floating around in Uranium Savages posters, or in certain music venues that are long gone. It became a joke between all of us. I think we put it on a house in *Dazed*. We made an address out of it. In *A Scanner Darkly*, it's everywhere.

Bill Daniel: At one point in *Slacker*, Louis Black is eating at the diner, and he's saying to somebody there, "Quit following me." In that shot, there's a sign behind him that says "Plate o' Shrimp: $7.09."

Richard Linklater: I give Lee, Anne, Clark, and D. a lot of credit for even thinking *Slacker* could be a commercial movie. Once we were done, I had low expectations. But they were going, "No, I think we've got something here." They were highly invested in it, because they'd put in their time. They weren't going to just let it go.

Kevin Smith: Rick showed *Slacker* as a work in progress at the IFFM [Independent Feature Film Market] in 1989.

Chale Nafus: After that, he sold *Slacker* to a German TV show [for $30,000] and got some of his production money back.

Richard Linklater: When German tourists started coming by the Fingerhut, I knew it was time to get a new place to live.

Louis Black: I had no expectations for *Slacker*. I was invited to be in it and I almost didn't go. When Rick gave me the finished film, I fast-forwarded through it, and I watched my part. It wasn't until someone wrote a review for the *Chronicle* that I thought, "Wait a second. This movie is *about* something?" We ran that review on the front page.

EXCERPT FROM *SLACKER* REVIEW BY CHRIS WALTERS

Austin Chronicle, July 5, 1991

Few of the many films shot in Austin over the past 10 or 15 years even attempt to make something of the way its citizens live. *Slacker* is the only one I know of that claims this city's version of life on the margins of the working world as its whole subject, and it is one of the first American movies ever to find a form so apropos to the themes of disconnectedness and cultural drift.

Scott Dinger: Back then, the *Chronicle* was how everyone would get their information. Local reviews would make or break a smaller film that didn't have that marketing push from Hollywood. And the review from the *Chronicle* was four out of five stars.

Tommy Pallotta: I sold the tickets the night it premiered, because I was the manager at the Dobie. Scott Dinger, who owned the Dobie, wasn't sure how it would do, so initially Scott made a deal with Rick and said, "I'll take half, you get half." And then it opened and it sold out like crazy.

Scott Dinger: *Slacker* was bringing in people that normally would never come to the Dobie. This was an older crowd. Some people would come out scratching their heads.

Holly Gent: I went to *Slacker* at the Dobie, and as I was walking out, [Texas governor] Ann Richards was also walking out, and

she stopped in the lobby and was speaking at large about the movie. She was glowing. She thought it was amazing.

Wiley Wiggins: *Slacker* was a cultural touchstone. It was super unlike anything else I'd ever seen. It was exciting to see something that came from an authentic place that I immediately recognized as my own community. That was a pretty unusual thing to see on the big screen. I'd seen *Giant*. I'd seen *The Last Picture Show*. And when I made associations between Texas and cinema, that's what I would think of: this grandiose thing that reminded me more of my grandparents than, you know, the kind of people who had been let out of the state mental hospital in the '80s—which was, like, most of my experience.

Tommy Pallotta: *Slacker* had been rejected from Sundance when it opened at the Dobie. I don't think anybody wanted to distribute it. But when it started selling out, people started to take notice. There were articles in *Time* magazine about "What is Generation X?" And Rick and *Slacker* became part of that national conversation about a new generation.

Scott Dinger: At that time, there were just a handful of arthouse distributors. A director would take a film to a film festival, and that's where it would be seen and shopped around. Rick must have had a contact to be able to get a distributor so quickly.

Tommy Pallotta: John Pierson is the one who sold *Slacker* to Orion. He was a producer's representative, and he worked with Errol Morris, Kevin Smith, Spike Lee—at that time, he was *the* indie dude. Rick wrote him a letter, and sent him some articles about why he thought *Slacker* would do well. John's the one who saw *Slacker*'s potential.

John Pierson: The initial letter Rick wrote to me lays out how keenly he saw the possibilities of what could happen to *Slacker*, which showed a really astute awareness of business and what audiences and critics might respond to. I mean, it wasn't like he said, "I'm gonna be a spokesperson for a generation!" But it's a sharp analysis of, hey, there's prospects here.

EXCERPT FROM RICHARD LINKLATER'S
LETTER TO JOHN PIERSON

July 23, 1990

We had a screening here in Austin for cast, crew, and friends (about 250) that went great . . . The overwhelmingly positive reaction makes me think once again that *Slacker* is a definite crowd-pleaser for a particular niche of the population. I'm enclosing a recent *Time* magazine article about this "twentysomething" audience which I would further define as: urban, educated (anyone who made it past their sophomore year in college), and one that usually reads up on movies before they see them. I feel it can also attract a slightly older audience with beatnik or hippie sensibilities—basically anyone in the entire post–World War II period that has felt at all marginalized or at odds with their society.

Marjorie Baumgarten: Rick never invented the word "slacker," but he became the spokesman for that generation. There would be all these big debates where people would say, "Oh, but people have used that during World War II, for recruits who weren't pulling their weight." But Rick was the one who put that word into everyone's vocabulary.

Tommy Pallotta: *Slacker* ended up playing Sundance, and Orion released it theatrically, and it was very with the zeitgeist at the time. Douglas Coupland's book *Generation X* had just come out.

Douglas Coupland: *Gen X* published in March of 1991, and someone had pointed out that three of anything means a trend. I think that the book, Rick's movie, and I'm not sure what else came up. Maybe grunge? Anyhow, suddenly it was a thing. I honestly never thought anyone would understand the book except maybe 11 and a half people that I went to high school with, so it was like writing something that was effectively invisible. Then suddenly—*pop!*—it all exploded so quickly.

John Pierson: *Slacker* was indisputably a theatrical success with $1.2 million box office—$2.5 million today adjusted for inflation—much of that coming from college markets.

Slacker was somehow speaking for an alternative audience. From the moment it caught fire and sold out months of showings in Austin, prior to its pickup and national release, the evidence is pretty clear that *Slacker*'s audience had been unrepresented and underserved.

Richard Linklater: We got a $100,000 advance from Orion for *Slacker*, which was *so much money*, but the film owed money to the lab, and I owed my family and friends. It was a great day when I was able to pay people back, to give them their $1,000, or their $3,000. I paid the whole cast and crew, and myself, but I only netted $6,000. And it didn't go at all into knocking out my $23,000 in debt.

Teresa Taylor: I never got paid for *Slacker* when we were making the movie. They were going to take a shorter version of it to the New York Film Festival in the category of short films, and Anne [Walker-McBay] went to Rick in hysteria and said, "I have permission from every single member of this fucking long movie to release their image, but the one I don't have is Teresa's."

I was going to hold out until I got paid. I said, "Everybody at the New York Film Festival mentioned my scene! I'm on the poster! That's what John Pierson is paying for!"

But D. Montgomery said, "They'll just chop you out of the film." I was torn, but I signed the release because, of course, I wanted to be in it.

Richard Linklater: Absolutely not true! Everybody got $100 for each day they worked. Teresa ended up being the poster girl for the whole film, but she worked only about a half day, so she was in the group of the lowest paid. But she was definitely paid, and more than once—everyone who worked one day on it has a proportional piece of it, so we do these disbursements to like 165 different people when we get up to $100,000 in revenue.

Teresa Taylor: About 10 years after *Slacker* was released, Rick's secretary called and I was helping her locate some of the stray

old actors, so everyone could get their money just before Christmas. I did receive $100 then, just before I appeared on the special features of the Criterion double-disc DVD.

Kal Spelletich: By the time *Slacker* started taking off, I was completely broke. You know, literally shoplifting food. Living out of a van. I got a sublet shared apartment in San Francisco, and someone's like, "Wow, man. That movie you were in is screening. Some big, fancy theater." I was like, "What?" I don't know anything about it!

Then it was on the cover of the weekly San Francisco paper. And then, at that point, I was living with a guy, Seth Malice, who was also in the film, and I was like, "Seth, we should go out front of the theater and panhandle! Say, 'Hey, we're in the movie. Give us some money!'" We're like, that would be a great performance piece! Of course, we never did it. We're slackers.

Jay Duplass: I would see Rick walking around in jeans and a T-shirt, eating crackers at the student union, because he didn't have money. And it was a true *a-ha!* moment of, this guy made a movie! I could make movies, too. He wasn't wearing a beret. He wasn't the child of Francis Ford Coppola. He was just a dude.

Wes Anderson: When we lived in Austin, Owen Wilson and I watched *Slacker* filming behind Mad Dog & Beans, where we used to have lunch. A few months after that, we saw the finished movie showing at the Dobie Theatre. The next year, we snuck our way onto the set of *Dazed and Confused* but were eventually asked to leave. I didn't meet Rick until more years had passed, but he has always been there ahead of us, leading the way for us to follow.

Kevin Smith: Amy Taubin had done an interview with Richard Linklater in the *Village Voice* that said, "Richard Linklater is the filmmaker most people want to be." And it talked about how *Slacker* had been shown as a work in progress at the IFFM and how it had come back to the IFFM as a case study panel, because it had been picked up by Orion Classics by then. I always considered that article to be a road map, Richard Linklater's coded message of, "*This* is how you do it."

I have that article framed. I still have it in my office! It's in the same dopey-ass frame that I bought at Kmart when I was a kid. I took that with me when I went to film school in Vancouver and then dropped out and subsequently came home and started writing *Clerks*. It stayed above my desk wherever I was. It's what I'd look at for inspiration.

Jason Reitman: I grew up on big studio movies of the '80s, and when I saw *Slacker,* I was like, "Oh, there's a different kind of filmmaking. We can tell stories about ourselves that are small and quirky and interesting." Because I think, in my head, an art film or an independent film was something just incomprehensible, and, frankly, boring. And *Slacker* was the first time I had thought of film-makers as being punk rock.

Richard Linklater: I had the indie film success to some degree. And one night, Gus Van Sant was in town, showing *My Own Private Idaho*, and one of his producers told me, "You're going to say a lot about yourself in your next film. You're going to tell everybody where you see yourself. Are you the weird indie guy, doing weird films? Or do you belong in the studio system?" And I took that to heart. If I was ever going to do that, now might be the right time.

Chapter 4

How to Pitch an Unpitchable Movie

"That's always the correct Hollywood order—
money, money and then maybe a decent movie."

*L*inklater released *Slacker* at the ideal cultural moment. The Sundance Film Festival was just emerging as a launching pad for a new style of American movie. In 1989, Steven Soderbergh's debut, *Sex, Lies, and Videotape,* had taken home an Audience Award, landed a deal with Miramax, and grossed $25 million. Its budget was $1.2 million. The moment marked what journalist Peter Biskind called "the big bang of the modern indie film movement." Suddenly, there was an actual market for films that existed outside the mainstream.

By 1991, the festival was starting to change the way independent films were sold. "It was an incredible year," says *Making Dazed* director Kahane Cooperman, who was there with her own short film. "*Slacker* was there. *Paris Is Burning* was there. Hal Hartley's *Trust* was there, and so was Todd Haynes's *Poison*. Alexander Payne had a short film called *The Passion of Martin*." Of the 16 dramatic films selected for the Grand Jury Prize competition, about half were released. "The indie film scene was finally picking up steam," says Cooperman, "and there was a lot of buzz around *Slacker*."

Jim Jacks, a VP of production and acquisitions at Universal Pictures, saw Linklater's film at the festival. Jacks was thirteen years older than Linklater and had an industrial engineering degree from Carnegie Mellon. He was hardly a hipster, and he later admitted he didn't totally get *Slacker*. But something about it stuck with him. It made him laugh.

From Sundance, Jacks called his colleague Sean Daniel, a second cousin of Steven Spielberg who had worked for five years as production president at Universal. Jacks and Daniel were starting a production company, Alphaville Films, which would have an exclusive production and distribution deal with Universal, and they were searching for their first project. Jacks had broken into the industry at Circle Films in Washington, D.C., where he had executive-produced the Coen brothers' *Raising Arizona*. He'd come to Universal with the remit of launching new filmmakers. He'd worked with Sam Raimi (*Darkman*) and Spike Lee (*Do the Right Thing, Jungle Fever*), and now he wanted to work with Linklater.

The two producers thought they could get Universal to finance Linklater's next film for somewhere around $6 million—not a huge risk for a studio, but a significant boost for a filmmaker whose previous film was made for $23,000. They sent Linklater a first-class ticket from Austin to Los Angeles—the only first-class flight Linklater had ever taken in his life. "I didn't even know how to put the tray up," he later admitted.

Jacks put him up at Chateau Marmont, the legendary hotel where

Old Hollywood royalty often stayed, and sent a limo to take Linklater around town. Such luxuries weren't really Linklater's style, but when he met Jacks, he thought they might work well together. "Jim looks the exact opposite of what I thought a Hollywood executive would look like. He's large, no tie, not well-dressed—my kind of guy," Linklater wrote in "*Dazed* by Days," a month-by-month diary that chronicled his experience making *Dazed*. (It was published in the *Austin Chronicle* in 1993.)

Jacks and Daniel were just as excited about the idea of a partnership. "They seem to really like the project and think it will be fun," Linklater wrote in the diary. "But why do so many of the movies that come out of this system suck so bad? I'll find out along the way."

Richard Linklater: I never wanted to work on the fringes of the industry. You hear about these directors who work their way up from being a PA [production assistant], but I thought, heaven forbid I become a good editor or something. I'd never get my own films made! By the time I was doing it, the path was much more open to make your own weird indie film, and then go make a low-budget studio film after that. I was born at the right time.

Russell Schwartz: American independent cinema had started really booming in the mid-'80s. We had Spike Lee's first movie, *She's Gotta Have It*. We had Luc Besson's first movie, *Subway*. *Kiss of the Spider Woman* was a big movie. There was a whole birth of young filmmakers that were starting to come out, and all of a sudden, they became big award contenders. People started realizing film festivals might be the way to go to get your independent movie out there. I think Sundance had a lot to do with that, particularly in the late '80s and early '90s. It became a place where filmmakers would aspire to be.

John Pierson: There was a modest way to prove yourself as you moved up the ladder into the studio world. You had to take a leap of faith when you gave Bryan Singer the money to go from his little Sundance film [*Public Access*] to *The Usual Suspects*, or Spike from *She's Gotta Have It* to *School Daze*, or Rick from *Slacker* to *Dazed and Confused*. Those were still tremendous leaps, but it wasn't like, "Here's a hundred million." And Jim Jacks was a hero for giving

numerous people their first studio chance after they'd made their mark independently or at Sundance. Jim had a long trail of those $6-million-dollar-type second features that marked the true beginning of some really impressive, sustained careers.

Jim Jacks: What happened with *Dazed* was, I was talking to a good friend of mine, Gary Arnold, who was a film critic for the *Washington Times*, and he mentioned that he had met Rick.

Gary Arnold: Rick had been on a promotional tour for *Slacker*, and I interviewed him. I asked if he had any projects brewing, and the first thing he mentioned was the concept that became *Dazed and Confused*. That little bit of history is on tape.

TRANSCRIPT FROM RICHARD LINKLATER'S INTERVIEW WITH GARY ARNOLD

August 8, 1991

Richard Linklater: *It all takes place in one night, like the last day of school. And the music's right, but I kind of want to capture the moment-to-moment reality of being a teenager. Everything's a big deal. It's like junior high kids going into high school and juniors becoming seniors in high school; there's a lot of bullshit going on. This is kind of what I remember of this high school I went to. You know, give teenagers a little room, that they're not all stupid, that there's a lot of thought going on there, a lot of urgency. It's all in your mind, too. Your mind's about to explode but you're kind of stuck in the same town, you live with your parents; it's just all the oppressiveness of that environment, but you kind of have to create your own environment, too.*

Kahane Cooperman: He also had a movie about guys working a drywall job, and he was working on an adaptation of a [Knut Hamsun] novel, *Hunger*, and he'd always wanted to do a baseball movie. There was always other stuff brewing.

John Pierson: Whenever you're coming off a festival success, you're always told to have that next thing ready to pitch to people. And if you've got a whole script for it, better yet. *Dazed* had a pretty commercial sound to it—or *potential* commercial sound to it. If Rick had brought in *Before Sunrise,* they would have not done that. That's clear.

Richard Linklater: Within a week of being interviewed by Gary Arnold, maybe even days, I got a call from Jim Jacks. He was like, "I saw your movie *Slacker* at Sundance. I thought it was charming, but . . ." He said *Slacker* was a weird, arty film, but the one I'd told Gary I wanted to do next sounded like it could be a "real movie." So that started that relationship of Jim trying to short-rope me up into more commercial thinking.

I never had any bias against the studio world. In my ideal world, I'd be like Spike Lee: you make your $6 million film, it does great, and then you make more, and the budget goes up a little. I *wanted* a rich benefactor!

Jason Davids Scott: Jim was the "studio guy," even though he worked independently. He looked like Michael Moore, but way more schlubby. He was a portly guy with glasses. Generally a little uptight.

Richard Linklater: He was a card-carrying nerd with all the usual tropes. He would wear the same shirts, the same pants, every single day. Someone saw his closet once, and it was all the same shirt, just a bunch of them.

John Cameron: Jim was a larger-than-life character in Hollywood. He was quirky and loud and a super-messy eater, but it was because he was talking the whole time about movies. He could be crazy and irritating, but the number one fundamental essence of Jim was that he loved movies.

Nina Jacobson: I worked under Jim Jacks at Universal. I have always done well working with prickly men, and I was the only junior executive who could tolerate his eccentricities. One thing he loved to do was to recite large chunks of dialogue from movies. By memory. Verbatim.

Richard Linklater: Quentin Tarantino says the guy in *Inglourious Basterds*—the German who loves films so much—was based on something I said about Jim. I said, "How can you hate a guy who loves movies so much?" And Quentin made that into a thought about a Nazi.

Sean Daniel: Nobody except Jim spent all weekend, every weekend, at the movie theater, sitting in that same seat, down on the right. Every single Friday, Saturday, and Sunday! In the same seat! To watch *every movie* opening that weekend!

Nina Jacobson: He was the type of executive that honestly doesn't exist anymore. It was a very different time at Universal. There was no Searchlight or Focus or anything like that for indie films, so you had a major studio making a variety of movies, including these very indie movies. Universal wouldn't have made those indie movies without a relentless figure like Jim Jacks pushing for them. He was a bull in a china shop.

Russell Schwartz: Jim was the auteur-driven producer. Sean was the commercial guy. That's why they probably did so well together.

Richard Linklater: Jim was emotional and Sean was practical. So they were a good partnership.

Sean Daniel: When I was an executive at Universal, I was in charge of a number of movies that were part of what became defined as "youth culture": *Animal House, Sixteen Candles, Breakfast Club, Fast Times at Ridgemont High*. Because I'd been an executive for so long and president for five years, Jim and I had a deal with Universal that allowed us to operate somewhat independently with the studio's funds. We had a development fund. So we said, "We want this guy Richard Linklater to come to L.A."

Richard Linklater: I wrote about our first meeting in my diary.

The first-class ticket, the limo, the Chateau Marmont . . .

I'm having lunch at the Universal dining room with Jim Jacks. We're going to have a more official meeting with more people later but, for now, we're just shooting the shit . . .

"This sounds like it could be fairly low-budget, like eight or so?"

That's millions. "Yeah, it shouldn't have to cost more than that," I say nonchalantly.

"That's good. At that price the studio can't really lose money, but (glancing around the plush surroundings) the studio isn't in the business of breaking even. Anyway, can't wait to hear your pitch."

Uh-oh. My pitch.

Of course it's Hollywood—they're expecting me to hop up on the desk, get all serious, squint my eyes and peer through the rectangular movie screen ratio I've formed when I put my thumbs to my index fingers and then declare, "I see . . ." I can talk forever about this film, I just can't act like some goofy salesman or cheerleader. I end up not having to do too much of a song and dance as we just kind of discuss the story.

We're joined by producer Sean Daniel, who used to be head of production at Universal for many years (The Player position) and now has his own company within the studio. I sense what everyone wants to talk about is the film's inherent commercial potential and then hear me tell them how much it means to me personally. That's always the correct Hollywood order—money, money and then maybe a decent movie that might mean something to you too.

We talk about teen movies we've liked—I soon have to drop Over the Edge, River's Edge *and certainly* Los Olvidados *from my list of favorite teen movies. Rule No. 1: never like or discuss in positive terms a movie that didn't make lots of money. A great movie that,*

maybe, breaks even isn't any good until a decade later. And never mention that you might like foreign films—you're an immediate suspect. So, for now, it's the obligatory American Graffiti/Fast Times at Ridgemont High/Breakfast Club *references. I kind of like being in a genre. It's working for me.*

These guys are probably about as cool as it gets here in this town and I have to admit I wasn't looking forward to shopping the project around endlessly. They seem like guys who could get this thing pushed properly through a studio—they were (are) the studio. Sean talks about how they did Animal House *when they were all very young and the studio just gave them a little money and said "What the hell, we don't really get it, but go do it."*

Something seems like it's meant to be. We decide to proceed. I'll get them a finished script as soon as I can.

Richard Linklater: We had just had lunch when Jim introduced me to Tom Pollock, the head of Universal. We walked over to his table, and he was like, "Oh yeah, *Slacker*. That made some money, right?" I don't think he'd seen it, but he recognized the title from looking at *Variety*.

And I was like, "Yeah, it was a success! I'm Mr. Money. When you think of me, think of positive box office money!"

Meeting the head of the studio was like seeing Jesus. Those were the days when you'd still see [former MCA chairman] Lew Wasserman walking by, and executives were like, "My job was to take Alfred Hitchcock out to lunch once a week." It was New Hollywood, but it still had a whiff of Old Hollywood.

Gosh, it would have been great to be a studio director in the '40s and '50s and have one of those careers, to be an A-list director at MGM or something. There was a handful of people—Vincente Minnelli, John Huston, Billy Wilder, Howard Hawks, Victor Fleming—

who had these incredibly supported careers from the heyday of studios where you could be a studio man and get a lot of films made. But that was two generations past by the time my generation was coming of age. By the time I got there, you were on your own.

The first script I sent to Jim was the 165-page version of *Dazed*, and he was like, "It's long, but it's good. Congratulations."

I got a check for $25,000 for the script. I owed a lot of money after *Slacker*. So when I got paid for *Dazed*, I wrote checks for $24,000 in one afternoon and paid off all the accumulated debt I owed. I had horrible credit. I wanted to get a loan to buy some equipment for *Dazed*, and I told the banker, "When you put it in my name, smoke's going to come out of the machine, but I assure you, I don't owe any money anymore. And I just got a contract for $6 million that will be running through your bank."

Jim Jacks: Rick had told me he wanted to make an *American Graffiti* for the '70s. I thought that was a good idea.

Sean Daniel: All of us were inspired by *American Graffiti*. Tom Pollock had been George Lucas's lawyer, and was instrumental in getting the financing for *American Graffiti* as a young attorney.

Richard Linklater: Tom thought that's the best movie ever made. So we were like, great! We will be the *American Graffiti* of the '70s. Whatever Tom wants to hear, tell him. And Jim was such a persistent guy. Whenever he talked about *Dazed*, he was like, *"Graffiti, Graffiti, Graffiti!"*

Robert Brakey: Sean was the cool guy that didn't talk that much, and Jim was *always* talking.

Ben Affleck: He was one of those guys who had one annoying phrase that he would repeat *all the time*: *Like, you know. Like, you know. Like, you know.*

Richard Linklater: We seemingly leapfrogged over 35 other projects that were in development. Jim said every time he ran into Tom Pollock in the elevator, he'd bring up *Dazed*. Knowing Jim, Tom was probably like, "Okay, Jim, if you just shut up and go on location, we might do it, just to get you out of our face."

Robert Brakey: If they wanted a 1970s *American Graffiti*, I don't understand why the guy who did *Slacker* would be the candidate to do that? *Slacker* was this nontraditional film that drifted from character to character. The whole point was that it doesn't have to have a point, and it was so original that way.

Richard Linklater: Unfortunately, Tom Pollock saw *Slacker* at one point, and he was like, "What the fuck?" He thought *Slacker* was this weird, arty film.

Jim told Tom, "How do you know *Slacker* isn't Rick's *THX 1138*? That was George Lucas's weird art film that didn't make any money, and he made *American Graffiti* after that." Jim could still throw that out as a possibility. You only get one empty promise, until you prove you're not the next George Lucas.

Tom Pollock: We thought *Dazed and Confused* would be much more mainstream than *Slacker*.

Sean Daniel: Because I was the executive on *Fast Times at Ridgemont High* and *The Breakfast Club*, Tom said to me, "Come on, get it to be like that!" And it was like, "No!"

Marissa Ribisi: In film, it's always like, "What's your big moment? What's the catalyst? What's it about?" And I think Rick was like, "It's not about anything. It's about people existing."

If you look at *Dazed and Confused*, there was the A-story, which is, "Is Pink gonna take the pledge with the football team?" But really, they're just hanging out. How do you pitch that film? "It's the 1970s, it's the bicentennial, the music is gonna be great"? "Here, let me give you millions of dollars!"

Jason Davids Scott: The John Hughes version of the movie is, Pink breaks up with Jodi at the beginning of the movie and has to win her back. And you'd throw up if you had to sit through that, right? Or, like, *Tony's gonna lose his virginity!*

Tom Junod: John Hughes movies were about people in high school sort of acting like adults. One of the most beautiful things about *Dazed and Confused* is that it's about kids. It's not like there's a James Spader character in the movie who is naturally sophisticated

and evil. There's not a patina of sophistication about anybody in that movie. The movie's villains are kid villains. You almost feel sorry for them.

Brian Raftery: All those '80s teen movies were frankly about rich kids' problems. The John Hughes movies were all about idolizing rich kids. When you watch *Risky Business* now, it's shocking how much that movie is about going to an Ivy League school and becoming rich. It's that whole Alex P. Keaton era. I think what made *Dazed* so appealing was that it didn't have that weird '80s ambition hanging over everything.

Jim Jacks: When we finally had a script that we liked, the studio was still like, "Eh, I don't know . . ."

Richard Linklater: There was a meeting where they get assigned scripts, and they sit in a big room, and they've all read the scripts, and apparently in one of those meetings, someone was like, "Why are we even doing this movie?" And Nina Jacobson, who was the executive on that movie, stood up for it.

Nina Jacobson: You can see absolutely why a studio head would say, "Why would we make this independent movie?" It wasn't a studio movie! But it was an amazing voice, and I thought a studio ought to be in the business of cultivating these singular voices because, in an optimal world, those people become long-term relationships. And the studio that's there in the beginning has much more credibility later on than the people who all rush over after you've had a big hit.

Sean Daniel: Because of my years as an executive, I had a clause [in my contract] that you don't get in many deals, and which I don't think anybody at Universal ever got since. I had the ability to, under a certain budget, "put" a picture—as in, I could decide to commit the studio's money if it was under $6 million. When I started my life as a producer with the studio, there was always the question, what movie would make me put all the chips in the center of the table? And it was *Dazed*.

Richard Linklater: Sean *threatened* to put the film, which

was big. He ultimately didn't have to, but he hinted that he was going to do that.

Jim Jacks: There was another studio, Paramount, that was interested in doing *Dazed*. Universal had to either make it or send it back to us. One of the executives at the other studio was a friend of mine, and she asked to read the script, and she said, "We'd make this. This is exactly what we're looking for, for our MTV kind of movies."

Sean Daniel: No studio wants to see a movie they developed go to another studio and then get made. Studios live in fear of that moment.

Jim Jacks: To their credit, Universal decided at the last second they'd make the movie. But they weren't jumping up and down about it.

Richard Linklater: I don't think Universal ever really wanted to make the movie.

Chapter 5

Don't Lead with Your Ego

"When you were making it, it was us, us, us. And as soon as the film comes out, it's all me, me, me!"

inklater never really wanted to work in Hollywood. When he started crewing up for *Dazed*, he had already started his own film production company, Detour Filmproduction, in

Austin, and his friends who'd worked on *Slacker* were still around, looking for (and mostly not finding) their next gig. He figured, why not hire them?

Working on *Dazed* wasn't exactly what some of his friends had planned. When they were making *Slacker*, some had assumed their next project would be another independent film, helmed by a different member of the group. "I think our hope was that one of us was going to do a film, then another of us would do a film—we just would all help each other finish our first features in the same semester-based fashion that we learned from college and booking film series," *Slacker*'s assistant cameraman, Clark Walker, told Alison Macor, author of the 2010 book *Chainsaws, Slackers, and Spy Kids*. (Walker and his wife, Anne Walker-McBay, would both end up signing on for *Dazed*, Clark as second assistant camera and Anne as co-producer.)

Linklater's roommate Lee Daniel, the cinematographer on *Slacker*, was surprised that Linklater even wanted to make a coming-of-age film. He confided to Macor that when he first heard about the pitch for *Dazed*, he thought of Linklater as a "fucking sellout." Daniel and Linklater had mostly talked about their shared love of European directors like François Truffaut, Andrei Tarkovsky, and Vittorio De Sica, and Daniel thought American high school movies had been done a million times before. "To me we were so much more of a team," he told Macor. "That's the way I saw it. He had bigger ideas. He never let on that he was going to do anything remotely Hollywood at all."

Linklater also thought of that group as a team—but it was *his* team. And others were starting to see it that way, too. "They had all worked together on *Slacker*, and *Dazed and Confused* was a test of that, really: Who could rise to the occasion? Who could let tensions go?" says Macor. "Rick kept his eye on the prize, and maybe that bothered some people."

Richard Linklater: I didn't want to go to Hollywood. I was building something in Austin. I couldn't just leave.

Nathan Zellner: The whole history of Texas being its own country and fighting for independence? That seeps into everything. A lot of Westerns are set in Texas because Texans are supposed to be go-getters—they're the ones who tame the land. It's the same with music. The outlaw country scene in Texas was very much anti-Nashville. Willie Nelson and Waylon Jennings and those guys were like, we'll go to Texas and we'll do it our own way. There's a lot of examples of that. And with *Dazed*, it was really inspiring to see somebody from Austin making a movie outside of Hollywood.

Nicky Katt: Someone once wrote that Rick treats L.A. like a low-level radiation site. He'll fly there in the morning, have a meeting, then fly home. It's like, put on the Hazmat suit, shake hands, then go back to Austin.

Richard Linklater: Well, that's overstated. Some people just want to go to L.A. and focus on their careers and money and stuff, but I was like, no, I like my cultural life in Austin. I like my friends. And L.A. was not that creative for me. My brain doesn't work well there.

Bill Daniel: Rick's dedication to his hometown is really heroic, but it creates its own set of problems.

Chris Barton: Many people in Austin were eager to see what he was going to do next after the successes of *Slacker*. People were calling the next film *Slacker 2: The Prequel* or *Slackerbabies*. Some people needed to assume that this movie was a lot like *Slacker*, but it was actually very different, especially in terms of budget.

Richard Linklater: The definite upside of working on a bigger film where you can pay everyone is it clarifies the hierarchy and establishes the boundaries along professional lines.

Shana Scott: There was a lot of resentment that Rick got to helm a big studio movie like *Dazed and Confused*. It was a big deal, because *Slacker* was a very collaborative effort, and Rick got all the credit. I heard it from *everyone*.

Kal Spelletich: Look, I love Rick. I am so proud of what he's done. Having said that, there's no *Slacker* without D. Montgomery.

D. knew everyone in the movie, and she got everyone to show up for free to work our asses off to make it. And so did Lee.

Teresa Taylor: I always thought that D. was the ringleader, and that her name would certainly be as high or higher than Rick's on *Slacker*. See, Rick didn't know any of the punk rockers. He didn't know the freaks. He didn't know the weirdos. D. did. She even came up with the construction of the film: the relay race. You pass the baton on, and who you're passing the baton to has nothing to do with the person who passed you the baton.

Richard Linklater: My dear friend D. was like, "Hey, all those story meetings, *we* all had that idea for the baton pass. *You* didn't." I said, "D., I presented the movie to everybody! I didn't say, 'Hey, what kind of movie do you guys want to make for the summer?' I said, 'Here's the movie I want to make, and I've scraped up enough to pay for it.'"

In every movie I've done, it's like, "Could that have possibly been what you had in mind?" I was like, "It's exactly what I set out to do!"

Kim Krizan: Some people were frustrated because the script was solely attributed to Rick. A lot of people felt their contributions had been greatly minimized.

Richard Linklater: *Slacker* was an all-volunteer effort, so I wanted everyone to have a good time, feel a part of it, and invest enough to work hard. Maybe it's my way of manipulating everyone to do what I want, or maybe it's my introverted, behind-the-camera personality, but *Slacker* felt to me like a super subtle benevolent dictatorship. I had absolute final say on everything, and everyone was collaborating with me on every detail, but I always want to be on a team, so I always referred to the film as "our film," never "my film." And that's how I felt.

There's that great Obama quote about what amazing things can be accomplished if you don't care who gets the credit for it. You don't lead with your ego. You sublimate. I was trying to build a community, and I subsumed myself so thoroughly in what I was doing, I didn't get anything out of making it all about me. By not really taking

credit for it in the moment, I left a big piece of the credit pie for others to get a bite out of and feel the time they spent was worthwhile. Cultivating that cooperative team atmosphere wasn't that hard for me, but I was glad to never have to do it again to that extent. And technically, I couldn't anyway. The cat was out of the bag.

Slacker getting national distribution and being such a cultural phenom truly freaked out a lot of the people who'd either worked on it or were near it. Especially when it was me, the subtle quiet guy, getting most of the attention. It was classic case of success having many parents. The more some folks thought about it, *Why, they wrote everything! In fact, the whole movie was their idea!* I remember Lee and D. being like, "Yeah, when you were making it, it was us, us, us. And as soon as the film comes out, it's all me, me, me!" I'd go way out of my way to give everybody credit on everything. But when they ask where'd the idea come from? I'm telling them. And it wasn't us, us, us. I'm not going to lie and say, "Oh, I sat around all summer and had no ideas for what the film should be about." No. I'd been making it in my head for about five years. I knew what I was fucking doing!

Bill Daniel: *Dazed* was a studio film, and it caused a lot of strife, because a lot of the people in the *Slacker* group were like, "Wait a minute, I thought we would make a cool art film now. I thought we would make something on Super 8. I had these other ideas of where it was gonna go."

Alison Macor: Lee wanted to make *Hunger* after *Slacker*. It was this Knut Hamsun book, dark and Norwegian. How Lee conveyed it to me was that he felt Rick was selling out. But that's something Rick has that maybe others in that early group didn't have: he really had a sense of what could be marketable and what wasn't.

Louis Black: I've always thought, if Rick had done *Hunger*, right now you'd be saying to everybody, "Hey, let's go to McDonald's and visit Rick."

Alison Macor: Rick told me that he was never that serious about making *Hunger* and that he and Lee had talked enough about the

Lee Daniel

idea for *Dazed* that he doesn't understand why Lee was surprised. And Rick got him a position on *Dazed* as a DP.

Richard Linklater: Jim Jacks said Lee wasn't qualified to shoot a studio film. That was probably a given. But he had some good impulses. He's a gifted cameraman and good at lighting. I remember having to stick up for him.

A lot of people, for their second film, they work with the same DP as the first film, whether he's good, bad, or indifferent. You do one film together, and you just think, "Okay, that guy's got my back," and you're paranoid that the studio is going to hire someone who's working for *them*, not for *you*. So I tried to bring along as many of my *Slacker* cohorts as possible, not just for them, but because I didn't have to question where their loyalty lies. That's a paranoid way to see it, but that's where I was at the time.

Alison Macor: Rick had to fight to keep Lee on.

Richard Linklater: As a DP, you're the head of three departments: grip, electric, and camera. You have a lot of people you need

to communicate with and he's not a good communicator. Besides *Slacker,* he had only DP'd one other movie, a super low budget black-and-white feature. But we'd been roommates for five years, watched a ton of movies together and had a vocabulary—it felt completely natural for me and I didn't question it.

Clark Walker and Anne Walker-McBay

Louis Black: It was a little awkward because Rick made sure the *Slacker* people had jobs on *Dazed*, but they were all used to being a collective, and when they all talked it through, somebody was, like, assistant wardrobe.

Richard Linklater: Even as we were crewing up, [production manager] Alma Kuttruff was like, "Do they have a professional résumé?" I was like, "They worked with me on *Slacker.*" And she's like,

"Uh, so are we talking a must-hire?" I'd just grimace and go, "Yeah. We've got to put them in this thing." I felt I owed these people. I thought that was karmically correct.

It definitely embattles you. It was like, "Okay, you rehired all your friends. Do you know what you're doing?" I think some of the pros involved saw us as these indie, *Slacker* amateurs, but we'd all earned it. We were ready.

Bill Daniel: Rick said, "We've got an opportunity to do this with studio money. We're gonna do a real film and do it big, and it's gonna be great. We'll still make it weird and make it our thing."

Richard Linklater: We brought our little *Slacker* punk spirit to everything we did on *Dazed*. And then the actors picked up on it, and they had that attitude, too.

Chapter 6

A Truffle Pig for Talent

"We were on the Universal backlot, with tons of people around, and Rory Cochrane busts out a joint."

No one was making high school movies in the early '90s. When Richard Linklater began casting *Dazed*, he called an agent in New York to ask if there were any good teenage actors left. She told him there wasn't a single one. Teen movies had peaked in the '80s, thanks to films like *The Breakfast Club* and *Sixteen Candles*, but by 1991, even John Hughes, who'd basically invented the genre, had moved on to features that were aimed at a broader audience, and many of the teen stars of the previous decade were too old to play these parts anymore.

Still, Linklater believed there had to be undiscovered talent out there. "There's no way there's not tons of interesting young actors in this country—it's just that not many are big stars yet and agents can't make a big 10% off them," Linklater wrote in his "*Dazed* by Days" diary. "We're determined to find them."

He enlisted *Dazed* co-producer Anne Walker-McBay, who had helped cast *Slacker*, to search all over Texas for teenagers who might have a '70s look. He also hired Don Phillips, a loud-talking, name-dropping, vodka-swilling casting director who'd worked on *Animal*

House, Serpico, and *Melvin and Howard.* Phillips was known for being especially passionate about his work. When studio executives refused to submit *Melvin and Howard* to film festivals, Phillips remembers, he dropped his pants, cupped his "hairy balls," and threatened to expose himself unless they relented. The movie went on to win multiple Oscars.

Together, Linklater and Phillips proved the New York casting agent wrong. They booked (and even turned down) several of the next decade's biggest stars. And Phillips was just the kind of comically vulgar, self-mythologizing bigwig who amused the young actors and convinced them they were headed for greatness. It wasn't long before the whole cast was referring to Phillips as "Uncle Don."

Joey Lauren Adams: You know how characters in movies have origin stories? For a lot of us, getting cast in *Dazed and Confused* is our origin story.

Jay Duplass: There has never been a movie more prophetic of future greatness in terms of finding those up-and-coming young stars. I mean, Ben Affleck is, like, 16th billing in the movie!

Nicky Katt: You've got to give credit to Don Phillips. He's a truffle pig for talent.

Kevin Smith: He's the absolute unsung hero of an entire period of film, from the '80s through the early aughts.

Parker Posey: I had heard that Don was the inspiration for David Rabe's play *Hurlyburly,* which I went on to do like 20 years later in New York. Ethan Hawke played Don.

Don Phillips: *Hurlyburly*—that's me. I'm "Eddie." I've got this guy named David Rabe—who is a Tony Award–winning playwright—living with me in L.A. At the time, David was doing a rewrite of *First Blood,* the Rambo movie, and I said, "Stay at my place." I had a little guesthouse with a spiral stairway, it was really darling. And, of course, I was acting like Uncle Don, so I had all these New York actors living with me, sleeping on the floor, and we were having parties. We smoked a lot of grass. We raised a lot of hell. There were girls. I think Dave was writing all this stuff down.

Cut to 1985. All of a sudden, my partner, Mike Chinich, tells me, "You would not believe this play *Hurlyburly*. It's you and I!" I go to New York and I walk in, and I see my apartment. The spiral staircase. Bill Hurt's playing me. Chris Walken's playing Chinich. Candice Bergen's playing one of my girlfriends. We had a little 15-year-old girl staying with us. She's played by Cynthia Nixon. And I'm a big asshole. Un-redemptive. I was furious. I walked out of the play in the middle of it. First act in, I said, "I'm not watching this. This is disgusting. I'm never gonna talk to David Rabe again for the rest of my life."

Tom Pollock: Don Phillips and Mike Chinich had a casting company, and they are really good, especially when they're finding newcomers.

Don Phillips: Kevin Bacon, we put him in *Animal House*. First movie.

Lisa Bruna: Don cast one of my favorite movies of all time, *Dog Day Afternoon*.

Don Phillips: *Dog Day Afternoon*. Chris Sarandon. First movie. *Dog Day Afternoon* was from a *Life* magazine article, and they had pictures of the real Sonny, the real Leon, whatever, and I used to keep the article on my radiator. So, in walks Chris Sarandon. Nobody knows him. And there's this transsexual part, and we auditioned every transsexual in the city. Every transvestite. Ballet dancers. You name it.

So, Sarandon comes in to play Sal, [the John Cazale role], and I look over at *Life*, and there's a picture of a transvestite who looks exactly like Chris Sarandon. Exactly! So I say, "Now listen, Chris. You can't play Sal. Think about playing this other character." He says, "Fuck! You crazy? *Me?*" Like, *macho*. I said, "Yeah. You're an actor! Come back and read." Fourteen times, he came back. Of course, he got the part. And he got the Oscar nomination. The rest is history.

Tom Pollock: Who would have thought to put Sean Penn in *Fast Times at Ridgemont High?* It's an iconic role, but he's never done anything like it since.

Don Phillips: Do you know the Sean Penn story? We were going to do *Fast Times at Ridgemont High*, and Art Linson was producing with Irving Azoff. So in comes Sean Penn. The only movie he'd done at that point was *Taps* with George C. Scott.

So I say to him, "What'd you play?" He said, "I play the conscience of the film." Most actors just say, "I played George the bartender." Not Sean. I went, "This boy's interesting!" By the end of our time together, I immediately know he's going to be Spicoli.

Four or five days later, Sean comes to my office to read. Well, he was *terrible*. It was the most awful performance I've ever seen in my life. Art kicks me in the shin and says, "Get this kid off the lot!" So I walk Sean out, and I say, "Listen, I got another office upstairs. You go sit in that office, you study the part, and I'll get you back in at 7:00 when we're done, but *don't leave*." That's six hours sitting alone in a blank office next door.

So we go back at 7:00, and Sean walks in, and without missing a beat, he did that famous surfer thing where you take your T-shirt off with one arm, by pulling it over your head, and he starts in with "Gnarly!" and "Dude!" and he's fucking brilliant! He blows everybody away. He gets the part. He becomes Sean Penn.

Sometime later, I said, "You know, I've never asked you. What did you do for six hours in that office upstairs?" Sean goes, "I climbed out the window, went to a buddy's house, got stoned, came back, and climbed in the back of the office to pretend that I hadn't left the whole time." Isn't that classic?

Tom Pollock: Obviously, one of the great things about *Dazed and Confused* is the cast of newcomers they put together.

Richard Linklater: If Tom thought they were so great, why didn't he have confidence in selling that cast as a positive thing, an actual selling point, instead of "a bunch of actors nobody knows"? I remember saying, "Isn't it the Hollywood way to *make* stars? And you've got some here."

Alison Macor: Don was 52 when he was brought on as casting director for *Dazed and Confused*. He told me he saw *Dazed* as a challenge to himself to "duplicate"—and that's his word—"the suc-

(left to right) Wiley Wiggins, Richard Linklater,
and Don Phillips

cess of *Fast Times*." They were looking to find the next Sean Penn or
Phoebe Cates.

Richard Linklater: I had to not even tell Universal to what
degree we were fishing around for nonactors. We auditioned in L.A.,
New York, and Chicago, but the nonprofessional actor thing was
based in Austin. And we did what we did on *Slacker*: We handed out
cards.

Wiley Wiggins: I was in front of Quackenbush's—that's the
coffee shop that's in *Slacker*—and Anne had been handing out little
cards saying, "We're making an independent feature film. Give us
a call if you want to audition." So I did that. Anne seemed really
excited to find me because I had long hair and a funny name. It's a
family name. There's been two other Wiley Wigginses on my dad's
side of the family.

Richard Linklater: Catherine Morris, who ended up play-
ing Julie in the film, Mitch's girlfriend, she was helping us. She was
handing out cards at her school.

Catherine Avril Morris: I must've been 14 going on 15. Anne was going around to all the high school theater departments, saying, "We need someone to go around to parties. We're gonna cast hundreds of extras, so we want you to go pass out cards to anyone that has a '70s look." So I did that for six months and they paid me $100 a month. Cash! Christin Hinojosa was one of my best friends back then, and she ended up playing Sabrina. And I was friends with this guy Justin O'Baugh, who ended up playing a senior boy.

Shana Scott: Anne and I also went to Dallas and Houston to cast the other speaking parts that Don didn't cast out in L.A.

Heidi Van Horne: There was no audition. We just talked.

Richard Linklater: Some of my theories about acting are, like, for certain roles, you don't necessarily have to be a professional actor, you just have to be an interesting person.

Justin O'Baugh: They asked me, "What is my high school experience like?" I told them, "I play on the football team, but I don't like the coaches. I hang out with all the stoners, and I really like rock and roll." I basically gave them the plot to their movie without knowing the plot to their movie.

They asked if I smoked pot. And of course I was like, "Nope! *Never!*" And they're like, "Look. We're not the cops. You won't be in trouble. It's relative to the movie."

And I was like, "Oh! You wanna buy a bag, then?"

Wiley Wiggins: They asked me about partying and teen life. I think I might've revealed that I had done LSD, but I hadn't drank any alcohol. That's pretty fuckin' Austin for you. I did acid before I got drunk. Sorry, Mom! Sorry, God!

Priscilla Kinser-Craft: We were talking about algebra and how I didn't get it. I didn't understand that x could be a number, which made them laugh.

Mark Vandermeulen: They asked basic life questions, like, "What are your grades like?" I'm gonna confess: I lied. I got really good grades, but I said, "I get Bs and sometimes a C." I knew they were looking for not-stereotypical kids.

Jeremy Fox: I went into the interview and I showed them a magic trick with two rings and a coin.

John Swasey: I just started recollecting old stories, like getting high and climbing the water tower. The crazier and more stupid the story was, the more they were gonna be entertained. I left there thinking, well, that was one of the weirdest auditions I've ever been on.

Lisa Bruna: Don said, "I don't want 30-year-olds playing 17-year-olds! I want the real deal." We found out later that some of the agents had slipped some older ones through on us.

Deena Martin-DeLucia: I was 21 or 22, and I played 17. My agent told me to dress like I was young. I wore a tight purple sweater, and I reminisced about things I did in high school instead of talking about what I was doing in New York City at the time.

Joey Lauren Adams: I think I was 23 when I did *Dazed*. When I was 22, I was playing a 16-year-old on television. My lines were like, "You know I don't like boys, Mama!"

Richard Linklater: The average age was probably 20, 21. Sasha was probably the oldest.

Sasha Jenson: I was 26. And I think I told everybody I was 19 or 20. Rory found out later that I was older, and he was pissed.

Rory Cochrane: I wasn't pissed. It was like, hey, good for you, buddy, you lied, and you got through.

Richard Linklater: In high school, it's so weird, there are guys whose hair's already thinning and they look 28, and then there's young women who look 25 and date college guys, and then there's people who are 17 who look 14. So it was just like, do I believe the ensemble? It was a mix of young adults and underage.

Cole Hauser: I just remember being 17 and going, I was the right age!

Adam Goldberg: Cole seemed like he was fucking 30!

Ben Affleck: I had just turned 20, and I'd been in L.A. for a few years, struggling as an actor. I had been in a Danielle Steel TV movie of the week called *Daddy*, and I had a few lines in a movie called *School Ties*. But mostly, I was just going to auditions. I

auditioned to be a guest star on *Beverly Hills, 90210* and all that goofy stuff that was going on in the early '90s.

Sasha Jenson: There was a lot of stereotypical casting in movies. It was like, you're the fat kid, or you're the character kid. And *Dazed* kind of fuzzed the edges. No one really fit into the John Hughes role, or the traditional high school jock role. Everything was a bit more textured. So, honestly, at that time I was like, I don't know if this movie will ever be seen! Because none of us were archetypal characters. We were just real.

Rory Cochrane: Don Phillips's process is that he meets actors and talks to them, and if he gets a vibe off someone that he feels is a good fit, he'll call them back.

Adam Goldberg: I was sitting in Don's office, and I don't know exactly what we were talking about, but I saw my father's truck. My dad had a wholesale food business called Goldberg and Solovy Foods, and his trucks were all over the place. They were probably delivering food to Universal. And, as if in slow motion, the truck sort of glides by the window, and I said, "That's my father's business truck, and if I don't get this job, that's what I'm going to be doing for the rest of my life." And apparently this really struck a nerve for Don, because he told Rick.

Jason London: You'd go in and meet with Don Phillips, but in the back, there was what looked like an assistant. Little Dutch Boy haircut. Real quiet. I just assumed, that's Don Phillips's assistant.

Ben Affleck: Rick seemed really young to be a director, like they let the wrong guy be in charge. I thought, "*This* is the director?"

Jason London: Maybe Rick was playing that role so that you didn't think about that guy. Most of the time you're going into some big studio thing, and it's like, I'm gonna go into some bigwig's office and they're intimidating. And Rick just made you completely feel totally comfortable.

Richard Linklater: Everybody came in for an audition. *Everybody.*

Jason London: We go into the waiting room for the audition in

Don Phillips's office, and there's a beautiful girl sitting there and she just keeps *looking* at me. And I'm like, man, this girl is just *smoking* hot! But I didn't have the *cojones* at that point to start flirting, so she started talking to me and asking me questions, and then she got called in. She's in there for 20 minutes, and I'm just sitting there, waiting. And she comes out and gives me a *look,* and then walks out.

Don Phillips: Jason comes into my office and says, "Who's that girl that was just in here? I'm crazy over her!" And I said, "Her name is Ashley Judd." Ashley had never done a movie. She was so green that I decided that she was not ready to do this movie.

Jason London: Uncle Don goes, "If you don't go out there and get that girl's phone number *right now,* you don't come back into my office. All she *fuckin' did* was talk about the cute guy in the lobby!" I ran out and caught her just before she got in her car, and got her number. We talked on the phone a few times, but then the miracle of getting the job happened.

Lisa Bruna: It was a *huge* audition process. Don saw quite a few more people than he was used to, because he was looking to discover new talent. I pulled out all the casting sign-in sheets and all of Don's notes on the actors who came through. I'd forgotten some of them. Mark Ruffalo. Hilary Swank. Wil Wheaton. Mackenzie Astin. I mean, the list goes on!

Richard Linklater: I think we floated it to Brendan Fraser because he was in *Encino Man,* and he was a name. That was kind of a studio thing. I suspected he wouldn't want to do it because he was a little older, and sure enough he liked the script but did not want to play another high school kid, because he was actually like 22 or 23. So I could be like, "Well, I tried!"

Lisa Bruna: Jared Leto auditioned. I don't see him on any call-back lists.

Don Phillips: I love Jared, but Jared's a real piece of work.

Richard Linklater: Claire Danes came in. She was in sixth or seventh grade. It was like, "You're one of the best actors I've met! But you're just too young." The next year when she got *My So-Called*

Life, I wrote her a note, like, "I'm the least surprised person in the world."

Don Phillips: Reese Witherspoon came in. She'd done *Man in the Moon*. I really dug her. But I asked Jason about Reese, and he said not to do it.

Jason London: When I did *Man in the Moon* with Reese, she was a baby! I probably just thought she was too young.

Richard Linklater: Jennifer Love Hewitt came in. And Mira Sorvino. Ron Livingston.

Lisa Bruna: Elizabeth Berkley was auditioning for Shavonne.

Richard Linklater: I remember Elizabeth Berkley! The cameraman who was shooting the auditions was like, "Oh man, she's so hot! Call her back!"

Lisa Bruna: Denise Richards was also up for Shavonne. Vince Vaughn was up for two roles, Benny and O'Bannion. The notes Don took were very brief. For Vince Vaughn, he wrote "big." Alicia Silverstone auditioned for Sabrina. Also, I have a very early headshot of Kirsten Dunst in the folder, so I have to assume that she was being considered.

Don Phillips: Parker auditioned in New York. She was so fuckin' great. She was still at SUNY Purchase [State University of New York at Purchase], and she had done a soap opera, but she hadn't really done anything else. Anyway, she came in and she blew Rick and I away. She reminds me of Katharine Hepburn.

Parker Posey: I really liked the character Cynthia who hangs out with the guys, because I have a twin brother and I hung around his friends, so that was the first part I felt really right for. But then there was Darla, the bad girl. Rick and Don had described Darla as being like Rizzo from *Grease*.

Richard Linklater: Parker walked through the door, and from the moment I heard her say, "Oh, heyyyy!" it was like, *Who is this?* Darla was originally a little more tough-girl character, like some girls I remember from Huntsville. We're talking pretty country bumpkiny, tough, mean-girl types, a little chunky. But then

Parker came in, and I was like, oh no, this is much better! That will be funny rather than just ugly.

Shana Scott: I found Renée Zellweger. She was the last person auditioning that day.

Don Stroud: Renée was just a girl from some small town in Texas. She was living in Austin and she had connections to the *Slacker* folks because of her boyfriend [Sims Ellison], who played in an Austin band called Pariah.

Tracey Holman: He was really pretty and he and his twin brother were in one of Madonna's videos, the black-and-white one for "Deeper and Deeper." He was playing a Joe Dallesandro type from the Factory.

Renée Zellweger: I was living with Sims and Kyle Ellison, and they played in a band, so there were always different musicians around the house. We lived in this little artistic haven. And I was finishing up school, and running around Texas, doing auditions. I had done little parts in a lot of things, like a film called *Eight Seconds*, and something about [the murderer] Charlie Starkweather, with Tim Roth. I was a day player, but they were definitely speaking roles. The only one where I didn't speak was *Dazed and Confused*.

Shana Scott: She had her dog with her when she came in and read. I thought she was *insane*. I mean, *amazing, amazing, amazing, amazing*. I called Rick immediately and he goes, "That's too bad. We've already cast the main senior girls out of L.A."

Richard Linklater: Renée probably would've gotten a bigger part, but we had her as kind of a Darla, and Parker had that role.

Shana Scott: Rick goes, "Give her a role as a senior girl. That way I can kick her a line and maybe she can be part of the cast."

Renée Zellweger: Somebody I worked with told me not to do it. It was like, "You're not going to learn a lot. And after taxes and agency fees, you're going to be pretty poor." But I'm so glad that I did do it, because I learned how a set worked, and what different departments did. It was invaluable as a professional educational experience.

Richard Linklater: She had no resentment for not getting a bigger part. Another person could go, "Hey, fuck those guys," but Renée wasn't like that. She was like, I'm gonna get some experience. She played the long game.

Adam Goldberg: There were three meetings: the Don Phillips meeting, the Rick meeting-slash-audition, and the pizza party.

Don Phillips: We were under some time constraints when we had to go back to L.A. So I said, "Why don't we meet on a Saturday, at Universal, and we'll give pizzas, 'cause it's Saturday?"

Joey Lauren Adams: The pizza party was so awful. I *hated* it. They were trying to make it like, "This is fun! It's a pizza party! And we're all hanging out!" But it's all your competition. It just felt fake. And you had to watch people get called back in while you just sat there. I don't think any of us had ever been through anything like that. Auditioning is hard enough.

Wiley Wiggins: That was a *pizza party*? I didn't get any fucking pizza!

Richard Linklater: The pizza party was grueling. We wasted so much of people's time. It was unorganized. And I felt really horrible about it.

Chrisse Harnos: Normally, you go into an audition, and it's just you and the casting director—and eventually the director, if they think you're right for the part. But this was like a round-robin. Like, you and I will do a scene together, and then you do a scene with this person. And you're there all day.

Wiley Wiggins: They'd done such a good job of making the audition so casual in Austin, and when I got to L.A, it was suddenly like, oh, this is a serious thing. There's gonna be money involved. I didn't come from money. I think I got maybe $13,000 for *Dazed*, which isn't a lot, but when you're 15, that's like, "Holy shit! I might be able to go to college for a little bit!" It suddenly got real. And scary. I started to clam up during the L.A. auditions, which worried Anne [Walker-McBay], because she was rooting for me.

Rory Cochrane: Everybody read for the Pink role, and for the women, it was Michelle's role.

Jason London: They said, all the potentials for the cast, we're gonna divvy them up for a scene between Pink and Jodi. It's the one where I grab her breasts.

Michelle Burke Thomas: I did have to kiss Jason, yeah. I mean, I'm a total sucker for a good kiss, so it didn't bother me at all.

Christin Hinojosa-Kirschenbaum: I didn't go to L.A. for the pizza party. There was another girl reading my part there.

Jim Jacks: Who was that little girl? Her first part was in *Dune*, she played the little sister? Alicia Witt! Yeah. She was a finalist for the young girl, Sabrina. There was something slightly creepy but beautiful about her.

Jason London: We had a little 30-minute break, and we were on the Universal backlot, with tons of people around, and Rory Cochrane busts out a joint. I'm like, "Dude! What are you *doing*?" And he's like, "I'm getting into character!" We ended up going back in and doing the rest of our auditions a little high.

Joey Lauren Adams: They started coming out and telling people they could leave. Like, "Thank you . . ." So it's getting to be fewer and fewer people, and then you're just hiding in the corner. Like, if they don't see me, they can't tell me to go home! It was finally like: Screw this! This is horrible. So I left. I went to 7-Eleven and bought an iced coffee. But something in me was like, "You have to go back."

Wiley Wiggins: I got in trouble for walking off. I followed Milla Jovovich to a Subway, because she was hungry, and I got pretty scolded by Anne when I got back. She was like, "Wiley, I know Milla's very beautiful, but you need to be *here* right now!"

Richard Linklater: Milla Jovovich had been in *Return to the Blue Lagoon*, so she was kind of a name. It was always like, "Get some names!" Well, there weren't really any other names.

Ben Affleck: It was very stressful. It was a massive audition, and you thought, "I'm never going to get this part, this is a waste of time." I read for the role of Pink, and right away they were like, "Why don't you read for something else?" I was a little bit oversized and still had a lot of baby fat and the roles that I was playing were bullies.

Throwing people against lockers was my specialty, if a 20-year-old kid can be said to have a specialty. So I read for the O'Bannion part.

Don Phillips: It was between Vince Vaughn, Cole Hauser, and Ben for that part. And Ben's part was the asshole, right? Vince Vaughn, we didn't think he was enough of an asshole. So we gave it to Ben.

Richard Linklater: At the end of the day, it really came down to, *Who of these people do I want to be around all summer?* And Ben, just as he was leaving, gave me this look, and I was like, Oh, he's kind of a soft soul! I'll work with him.

I liked Ben. He's got that wicked humor. It reconceptualized the part. Like, Oh, play a bad guy who brings a certain joy to it.

Vince Vaughn gave a great audition! But I had Ben. I offered Vince Vaughn stuff later and it was just like, "Pass, pass, pass, pass." It was like, "Does he hate me?"

Ben Affleck: The idea of doing the movie was certainly exciting, because I really liked *Slacker*. But I was vaguely disappointed that I was playing O'Bannion. Like, "Oh, it's another bully role. This is all I'm ever going to play."

Jason London: If you were still at the pizza party at the end of the day, you were in the cast.

Don Phillips: Jason London was an athlete. He was handsome. He was Pink! He was just *right*.

Jason London: I originally auditioned for the part of Tony. I don't know at what point I became a Pink. I was such a little goody-goody in high school. But then I moved to L.A. and got into the devil's lettuce. Me starting to smoke weed ended up being the best thing for that character, and for my career.

Deena Martin-DeLucia: I had to wait until the very end. Me and Joey Adams were up for Shavonne, and then it was so close between me and her, and we both got roles, so we were having a little bit of competitiveness.

Joey Lauren Adams: Don told me I didn't have the tits to be Shavonne. There's a demeaning of women that goes on that's just

Jason London

normal. It's like, the sky's blue, and men are going to say shit like that. It happened so much, it's like stubbing your toe.

You go into a room, and you can just feel the men looking at you, and you knew you didn't get certain parts because your tits weren't big enough, but they don't say that. They say, "Yeah, she just wasn't right for the role." So in a weird way, I think there was probably some relief of Don just saying, "You just didn't have the tits for Shavonne, Joey, but I love you! And I'm going to get you in this movie." There's an honesty to it.

Don Phillips: Bullshit! I never said that. Well, I might've said that *after Dazed and Confused*, when I was being Uncle Don, and everyone would come out to my house in Malibu. I gotta tell you, I was drunk most of the time back then, so I don't remember. But I wouldn't have said that during the audition. I was sober when I was working. And *I'm* the one who wanted her in *Dazed and Confused*!

Sasha Jenson: I was reading for Adam's part all the way up to the very end. And it was like, "Oh, you got the part of Donny!" And I was like, Who's *that*?

But we all know a person who's just that alcoholic disaster who will probably get in a fight at the end of the night when the sun's already coming up, like, *Oh my god, really? There goes Donny again!* At the time, I had a roommate like that who was like the Energizer Bunny of disaster, so that's kind of the guy I was aiming for.

Don Phillips: For the young girl, Rick liked Christin Hinojosa, who was from Austin. Claire Danes should have gotten that part, I still say. And it would have been great, because she would have gone on to become Claire Danes!

Richard Linklater: I think Don Phillips thought that people from Texas naturally couldn't be as good as the kids we were meeting in New York and L.A. So I always felt it was my job to stick up for them. There's talent everywhere, but not necessarily opportunity. So I had to fight harder for Christin, Wiley, and other locals. Christin was innocent enough, but there was a strength to her, too, and she had to stand up to Darla toward the end, so she was perfect for Sabrina.

Christin Hinojosa-Kirschenbaum: It's funny, I have a sister named Sabrina. And did you see Rick's daughter Lorelei in *Boyhood*? She reminds me of myself at the same age. I thought, "Did he cast me because he knew that, in the future, I'd look like his kid?"

Richard Linklater: A lot of these people I liked a lot, I had to make other people like them.

Rory Cochrane: That day, they kind of told everybody *except* for me that they had the part. The studio wanted another actor to play Slater. I believe it was David Arquette. And Rick wanted me. But I went back to New York thinking . . . I didn't know what to think. I'd put it out of my mind, really. And then I got a call saying, you want to go to Texas for the summer?

Richard Linklater: Rory, the first audition, everyone was like, "Oh, there's this guy who's going to be a great Slater!" And every callback, he got worse and worse. I was having trouble selling him to everyone based solely on what he showed that first time.

Fortunately, he'd been in another film called *Fathers & Sons*, and

he'd played kind of a druggie guy. Jon Kilik was the producer on that, and he told Jim Jacks he thought Rory was going to be a star. At the last minute, a recommendation from Jon Kilik came in. I was like, "Thanks! Whew!"

Anthony Rapp: Rick had to really fight for me. A lot of the movies I've done, like, *Adventures in Babysitting*, Chris Columbus had to convince the studio to cast me. *School Ties*, the original director did not cast me. His replacement cast me. I'm a little bit of an odd duck in some ways.

Even in *Road Trip*, I was cast in a smaller role because Crispin Glover was cast in my role originally, and he shot for one day, and they were like, "This isn't going to work." All these movies that I've done, there's been some weird way that came to be.

Michelle Burke Thomas: Richard said the role of Jodi was modeled after his sister. At the time, my hair was really short, and I thought, *I don't really look '70s right now*. But I think they saw past that because I reminded Rick of his sister.

I wasn't like, "Ooh, I'm gonna get this role!" It didn't even cross my mind until the moment they said, "You've got the part." And then I just fucking *freaked out*. I was *screaming*.

Joey Lauren Adams: I called my mom and told her I was gonna be in a movie. I don't know if I truly believed it. I couldn't even imagine what being in a movie would be like. It just seemed unfathomable.

Adam Goldberg: It was this cloud nine thing. I never really experienced that ever again. It was just like, "Oh wow, your life's gonna fucking *change*."

Chapter 7

I've Never Worn Underwear

*"How could you not have looked at him and been like,
This motherfucker is going to be a star!"*

efore *Dazed and Confused* came along, Matthew McConaughey was just a popular kid from a middle-class family, born in the small town of Uvalde, Texas, and raised in Longview. His mother, Kay "K-Mac" McConaughey, was a kinder-

garten teacher and a former beauty queen. His father, Jim, was a former NFL draft pick of the Green Bay Packers. Jim ran an oil pipe supply business. The two older McConaughey brothers worked for their dad, and Matthew originally planned to become a lawyer. When he tells the story of how he got cast in his first movie, he makes it seem like a matter of randomness and good fortune. But pretending that he just got lucky is a good way to disguise his own cunning and resolve.

The more you learn about how McConaughey ended up in *Dazed*, and how he developed the character of Wooderson, the more it seems like his path was not only intentional, it was the result of savvy choices. He brought a nonthreatening charm to Wooderson, an ancillary character that could've easily skewed dark. He's a sleaze-ball, but you can't easily dismiss him as a predator. He's the kind of guy who has located the tipping point between bad jokes and actual dangerous behavior and has decided to stay just on the right side of that line.

McConaughey's approach to Wooderson helped transform the character from a tiny role into the movie's single most memorable personality. The character would change the arc of McConaughey's life as an actor. Now, it's often hard to imagine anyone other than McConaughey playing Wooderson, but that connection wasn't immediate. When he first auditioned, he seemed wrong for the role.

Matthew McConaughey: I didn't want to come to UT [the University of Texas]. I wanted to go to SMU [Southern Methodist University] because I thought Dallas was a better city to get out of college and automatically have a job. But my older brother Pat calls me and goes, "Look, man, Dad's not going to tell you, but the oil business is shit right now. We're going broke. SMU is going to be like $18,000 a year, and Texas is going to be like $4,000 or $5,000. You'll love Austin. You'll walk in there in your bare feet, no shirt, and you can saddle up at the bar and there'll be a cowboy to the right of you and an Indian to your left and a lesbian on the other side. Man, it's your kind of place!"

So I come to UT. I'm taking liberal arts classes, headed toward law school. My family always said, "You need to be a lawyer, so you can come get us out of trouble." But the end of my sophomore year, I'm a little restless of what my future career path's going to be. I don't really have the confidence to tell my family, hey, what I'd really like to do is tell stories, and film school might be a way to get into the storytelling business.

Well, right before my sophomore exams, I go over to my friend Braden's house, and there's a stack of *Playboys* sitting there. About seven *Playboys* deep, there's a paperback: *The Greatest Salesman in the World*. And I said to myself as I grabbed it, "Who is that? Let the title speak now." And I start reading.

I get to the first chapter and it says, "Okay if you're going to take this journey, there's 10 scrolls here. You got to read each one three times a day for 30 days before getting to the next one." And I looked up, like, "Whoa! I gotta do this!" And my friend Braden, I'm shaking him awake, saying, "Hey, man, can I borrow this?" And without missing a beat, this cool cat goes, "No, you can't. You can *have* it." It was something that was passed to him that he was supposed to pass on.

So I go home and start that night: I read the first scroll, I read the second one the next afternoon. I read the third one that night. It was the first book ever that no teacher told me I *had* to read. It was like divine intervention. That book is all about finding your philosophy for what you want your life to be, and it gave me a lot of courage to mark my own path.

That night, I got the courage to call my mom and dad and tell them I wanted to go to film school instead of law school. I did not think that call was going to go well. I thought that call was going to be, "You want to do *what?*" Instead, after a good five-second pause, my dad goes, "That what you want to do?" I said, "Yes, sir." He goes, "Okay. Well, don't half-ass it." I'll never forget: *don't half-ass it.*

And then I was having tears of joy. It felt like, "Ah, now I can go mark my own path!" You know? That was a very big rite of passage.

So I apply to film school. Well, I don't have any film, but I had a badass GPA. And that's why I got in.

Roderick Hart: I was the director of the honors program in the college. It was a selective program that let in 30 students a year. We usually had 120, 150 applicants. They had to have a minimum grade point average of something like a 3.5 to get in. Many had much higher. But we were trying to get the kids who could think out of the box.

Matthew was a very out-of-the-box thinker, very thoughtful, but also a little bit intellectually undisciplined, in the best sense of the word. He could come at things from a different point of view.

The most vivid example is, early in the semester, they had an exercise to capture something in a video format and make a case that this object should be put into a time capsule to send out signals of what our times were like in 1992. So Matthew's video was of him.

Matthew McConaughey: They were gonna send the time capsule out in a spaceship. So I got up there and said, "The one item that's going is *me*. I'm going to tell 'em on America." And they said, "You have to have one *item*!" And I said, "What you didn't see as I got on the spaceship is that I had this great paperback book called *The Greatest Salesman in the World* right between my butt cheeks. And I snuck it on. And this is going to be our bible."

S.R. Bindler: Matthew's reputation preceded him even when I was 15 years old. I was at a country club in East Texas with the best tennis player in East Texas, a guy named Kirk, and Kirk was buddies with Matthew. And I was sitting with Kirk after playing tennis, and Matthew walked by. Tan, good-looking, and so confident. And so Kirk says something like, "Hey, McConaughey, how'd it go Saturday night?" And they're talking about girls, and Matthew's like, "Oh, I kissed her *here*, I kissed here *there* . . ."

He was everything an introverted 15-year-old wants to be, and I was not. I had, like, dark hair, and dark eyes, and was Jewish in a very blond-haired, blue-eyed, Christian Baptist town. And so I was just like, "Ah, *this guy*, man!" But that was the beginning of a lifelong friendship.

About two years after high school, I was going to film school. And I thought Matthew would be a terrific actor, because he was such a great storyteller and so interesting to watch work a room or to flirt with a girl. Interesting to watch on a visceral level. I obviously had no idea that he'd have the career he'd have, but I was like, "Hey, man, I think you should get some headshots. You know what a headshot is?" "No." "Okay. Find the phone book. I almost guarantee that you could put yourself through college doing commercials and stuff." And within two weeks, he was booking big commercials.

Monnie Wills: He had posed for a headshot in bicycle shorts, and his hair was dyed blond. He looked kinda like Iceman from *Top Gun*. We had a lot of shitkickers in our fraternity. You wore Red Wing boots and khakis and that was it. So somebody put that picture up on the public wall in our fraternity and Matthew got *a lot of shit* for it. But he was like, "Yeah, laugh *now* . . ."

Matthew McConaughey: I'm finding out even today how much I actually was wanting to be an actor back then but was not able to admit it. I had done an *Unsolved Mysteries* at this point. I had been cast in a Trisha Yearwood video, "Walkaway Joe," in Austin. I had been on a local ad at UT, about the *Austin American-Statesman*, speaking about the sports page, like, "Well, how else am I going to find out about my Horns?" I got a hand-modeling job and made $220 and got my first manicure and quit biting my nails because of the vanity of going, "Oh, I can get *paid* for that." I was dabbling.

Sam Lawrence: He'd done a number of ads. Do you remember that campaign for Miller Lite where it was like sweaty porn shot in amber light? He was in one of those ads. And he was like, "I don't want to do that. I'd rather be *making* this stuff. I really want to be a director."

Matthew McConaughey: I was the only frat guy in film school. I'm wearing jeans, belt, button-down tucked in, boots. Everybody else is pretty gothicked-out and wearing all black, hadn't seen the sun.

I'm kind of on the outside, but I'm confident enough to try to get my own point of view, which I was still obviously finding.

Robert Brakey: In the film department, we all acted in each other's films, and it was a very small community. Matthew was never in anybody's student films. No one knew who he *was*, really.

The school used to have a seminar that happened during spring break where students that were interested could pay money, come out to Los Angeles for a week, meet casting directors, and producers, and all kinds of people working out here that gave you advice on how to get started. McConaughey and I were there at the same time, and he had a video camera and was walking around *videotaping* everybody, just walking up to people and asking them questions about the industry, and they were like, "Please turn that off!" He was definitely not making friends, sticking a camera in their face, but he didn't care.

Sam Lawrence: One night, he came over to my house, and he was like, hey, this film's shooting in town, will you help me write letters to them? So we were writing letters together to try to get him into directing.

Richard Linklater: At first, Matthew thought maybe he could be a PA on *Dazed*.

Tracey Holman: I think someone had actually asked McConaughey to be production assistant. Then they ended up switching him over to the acting role. I'm not sure exactly how that happened.

Matthew McConaughey: Everyone has a different story about how they got into this business. What I did, I went into the right bar at the right time and met the right guy.

Sam Lawrence: You gotta put yourself back a long time ago. You know how there was a phase when, like, the top floor of a hotel would be a bar/restaurant with glass that looked over the city, and that was a cool place to go? That was the Hyatt in 1992.

I was 22, and there was a cocktail waitress named Toni Soteros, and she said to me one day, "I'm dating a guy named Matthew. He's coming in tonight. Don't be a dick." So I'm bartending, and this guy walks in and I instantly hate this motherfucker, because he is *gorgeous*. He just immediately makes you feel not attractive because of how attractive he is.

I was totally ignoring him and somehow I mentioned something at the bar about *Raising Arizona*, and her boyfriend just immediately launches into this thing. He had memorized most of the fucking movie!

We start talking and he's like, "Yeah, I'm finishing up film school." And I was like, okay, he's not a dick. We just hit it off. We started hanging out that summer like a shit ton. You know when you're a kid and you just spend a ton of time together over the summer and then you go back to school and everyone goes into another world? It was that kind of relationship. He can't remember it, though.

Matthew McConaughey: Geez, really? I don't remember that.

Sam Lawrence: One night, a guy comes up to the bar and sits down. He was a drinker. He got really wasted the first night he was there. As he's talking with me, he just starts bragging. Like, "Oh, I'm a casting agent . . ." And I was just like, *Blechhhh, really?*

Don Phillips: I'd always stay at the Four Seasons. Wherever I went, I always went to the best hotels and flew first class. I really felt like I deserved it! I had already been to Austin to interview a lot of the local talent, but we still had small parts that needed to be cast locally. So I fly back to Austin, and the Four Seasons says, "There's no room in the inn. It's graduation weekend at UT. So we're going to have to put you up at the Hyatt." If I'd have been at the Four Seasons, I'd have never met Matthew.

Sam Lawrence: Don's like, "I'm working on a movie. It's gonna be this generation's *Fast Times at Ridgemont High*." And I'm thinking, that sounds like a stupid plan. And he's like, "I've got almost all the parts cast, but there's a couple of remnants that we're looking for."

I called Matthew at home, like, "Hey, dude, there's a guy in here that you should probably meet. He's casting for a movie." And he was like, "Nope, I'm stoned. I'm in my underwear."

Matthew McConaughey: No. I've never worn underwear. I think Toni and I just went to the bar because we could get free drinks there.

Don Phillips: In walks McConaughey with this absolutely drop-dead gorgeous girlfriend. I didn't give a shit about *him*. I don't

look at guys. I like women. So I said to the bartender, "Wow! That's a beautiful girl there." And he says, "Oh, that's my friend Matthew McConaughey's girlfriend."

Well, that's nice! I'll have another drink. Then about 15 minutes later, Matthew saunters down to the bar. "Hi! I'm Matthew McConaughey, and this is my friend the bartender. He told me that you're in the movie business?"

Sam Lawrence: Matthew asked lots of questions about what being a casting director is like, but Matthew is pretty good about just letting the conversation happen and not having the other person feel like he's trying to *get* something. He was more mature in some ways than your average interested-in-Hollywood person. He wasn't just like, "Oh my god, you're a casting director?" He kind of relaxed into it and listened.

Matthew McConaughey: Was I going at him sort of opportunistically? Sure. But was I also interested in what he was doing? Yeah. If he's in town producing a film, that was a big thing to be doing in Austin.

Don Phillips: When you're guys and you're drinking, you talk about two things: girls and sports. Just so happens that I'm a major golfer and Matthew's a major golfer. So we start talking about golf. And I talk *loud*.

What happens with guys, when you're talking about golf, it's like measuring the size of your dick. What you're really doing is talking about how great you are. And each drink, you get better than the last drink, you know? You drive the ball further. You putt better.

So Matthew and I are telling these great freakin' golf stories, and we're just enjoying the shit out of each other, and all of a sudden a couple of hours goes by, and that poor girlfriend was sitting at the end of the bar all by herself.

Matthew said to me, "Excuse me . . ." and then he went down and gave her money for a taxi. He sent her home.

Matthew McConaughey: Some three or four hours later, we are mock-playing a 17-hole golf course we had both played. And we're doing it very demonstratively and loudly. And *lubricatedly*.

Sam Lawrence: They were making a scene, showing the mechanics of their golf swing and knocking stuff around, and I think my manager, Herb, may have said something to Don like, "I need you to go down to your room *now*."

Don Phillips: He kicked us out, and I said, "Why don't you come to my room and we'll smoke a joint?" So we go to my room and Matthew goes, "The nerve of that guy, throwin' you out of the bar! You know what I'm gonna do? Gimme the phone." So he picks up the phone, calls the manager, and says, "You know what you just did? That's *Don Phillips!* You kicked him out of the bar! You owe him an apology."

And of course the manager says, "We'll send you a bottle up, sir." And he sends us another bottle of vodka.

Matthew McConaughey: No, I didn't call the manager. The truth is, there's what Don said, what he said I said, and what really happened.

Don Phillips: Anyway, I'm saying to myself, this good-looking kid is defending me? I never had anybody stick up for me like that. And this is the way my mind thinks: If you do something for me, I immediately want to do something back for you.

Matthew McConaughey: We're driving home. I think he's going to drop me off at my place. I'm pretty sure we pulled out a joint on the way home, in the cab, and it was around then that he's like, "Hey, you ever done any acting?" And I said, "A little bit."

And he goes, "Well, tomorrow morning"—or *this* morning, because it was already in the a.m.—"Come by this address, I'll have a script waiting for you. It's a small part in here, but it's about this guy who's older and he's still hanging out in high school; he likes the chickies. And you might be just right for the part."

Monnie Wills: Those guys came back to the house at 4:00 in the morning and woke me up. They were wasted and bumping into shit and looking to see if they had any more liquor.

Scott Wheeler: I'm in bed, and they're being loud and crazy, and I'm just like, "What the fuck is going on?"

I go down there, and Matthew's like, "This is Don Phillips. He did

Fast Times at Ridgemont High." I'm just like, *What is this old guy doing hanging out with a bunch of 20-year-olds?*

I remember Don saying, "I'm gonna make this boy *famous.*"

Richard Linklater: The story of Matthew getting discovered, it's so different than, like, the story of Lana Turner getting discovered at Schwab's drugstore. People think Matthew was in a bar and he just happened to be talking to a guy who happened to be a casting director. But it's like, no. Matthew knew Don was in town casting movies, and Matthew went over to *him.* He's the one who introduced himself. He grabbed that opportunity. Matthew has a very methodical side to him. He's a very clear thinker in how to go from A to B to C. He's not just bouncing around. People want to believe it was just like, "Hey, you! You should be in movies!" because they want to believe it could happen to them.

Bill Wise: Casting directors are always trying to find those sirens. They're like, "I'm in the coal mines down here. Where the fuck are my diamonds?" And Matthew was a cocky shitbrick in college anyway. He's homespun. He's bone-handsome. Good skin, nice teeth. How could you not have looked at him and been like, "This motherfucker is going to be a star!"

Matthew McConaughey: Well, I went down, 9:30 that morning, and there was the script waiting for me with a handwritten note from Don. At that time, I have a buddy who was at New York University film school, Robb Bindler, who ended up directing *Hands on a Hardbody.* I went and worked with my buddy Robb on this part, which was, as I remember it, three lines.

S.R. Bindler: Most people call me Robb, but I go by S.R. Bindler professionally. I was in Dallas for summer break, and Matthew drove up from Austin. My memory is, the audition was one line: "Say, man, you got a joint? Well, it'd be a lot cooler if you did."

Richard Linklater: From my travels, I knew a guy in Montana who used to say that: "It'd be a lot cooler if you did."

S.R. Bindler: Matthew was behind the wheel of a car, so I just set up a chair and told him to play like he had one hand up on the steering wheel. And we started to run it, and it was good, but it wasn't *it.*

I was like, "Okay, when you think about pot, when you think about *Mary Jane*, think about sex, like you're physically turned on by it." And he just got this little grin, and he did the line, and when I picked myself off the floor, 'cause I was cracking up, I go, *"Bingo."*

Matthew McConaughey: It was in that two weeks workin' with Robb that I found who Wooderson was. Wooderson was who I *thought* my brother Pat was.

When I was 11, his Z28 broke down, so Mama was gonna pick him up from high school, and I'm in the back of the car. We're drivin' around, lookin' for him, and I look out the back window, and I see this iconic silhouette of this guy leanin' against the wall, knee kicked up, in the shade, smokin' a cigarette. And I almost said, "There's Pat!" when it hit me that, oh, I'd better not tell Mom that's him 'cause if she turns around and sees him smokin' a cigarette, he's gonna get his ass whooped.

But that image of him, in my 11-year-old eyes, he was 10 feet tall. Nothing cooler. That's who Wooderson was.

S.R. Bindler: What year was *Dazed* set in? Seventy-six? Pat came from that generation. He listened to that music.

Matthew McConaughey: When Mom and Dad would go outta town, he'd let me drive his Z28, and we'd rock out to his system. To this day, I've never heard a better-sounding system than it sounded to my 11-year-old ears in my hero's car.

He'd get home at midnight and come wake me up, and I'd run out there in my underwear and get in his car in the driveway, and we'd listen to Nugent, Judas Priest, AC/DC, Zeppelin 'til about three in the morning.

Mike Wanchic was the guitarist for Mellencamp on the album *John Cougar*, and if you listen to that album in the very beginning, maybe the first song, you hear in the background, "Hey, what the fuck?" He's in the back, and one of his amps came unplugged or something. You could hear it very faintly. And Pat would sit there like, "Did you hear what he said, dude?" And we'd rewind the cassette. "Hey, what the fuck?" And we'd be like, "Oh, man!" This is like we've uncovered

something. This is like running to the barn and looking at *Playboys*, you know what I mean? We'd listen to tunes and laugh.

S.R. Bindler: I'll tell you this, Pat could've walked out of his house onto the set of *Dazed* without passing through hair and makeup.

Matthew McConaughey: He had that great part down the middle, throw his hair back—*man*, cock of the walk! Shoulders back, kinda leaned back a little bit, the pelvis pushed forward, preceding the chest and the head.

P-A-T. You know, *Hey, hey, hey, watch the leather, man!*

He had hot cars. He was funny. He was a great big brother. He's actually my adopted brother.

S.R. Bindler: There was Pat, and there was Matthew's other brother, Rooster, who was much older than us.

Rory Cochrane: Rooster's great. He named his kid Miller Lyte! He got a lifetime supply of beer for it.

Monnie Wills: And then there's Jim and K-Mac, his parents. They got divorced and remarried and divorced and remarried again.

S.R. Bindler: They were a family of characters, in the best possible way. For the longest time, I didn't know Pat was adopted. I just flat-out assumed that he was McConaughey blood, because he had a lot of the same characteristics and attributes.

Matthew McConaughey: Pat's nickname was White Lightning, 'cause he was really fast and he was good with the ladies. And we moved to Longview when the oil boom hit, so he shows up, new school, and the coach is like, "So, what's your sport?" "Well, I run track. My nickname's White Lightning." And he says, "Okay. Meet me down at the track this afternoon."

Here comes this guy next to him, about six foot two. Big Afro. He lines up with him. Pat's five nine, five ten at this time. He looks over to this guy and he goes, "Hey, bud." This guy looks down at him. He goes, "I hope you got your wood screws in, big boy, because I'm about to blow your doors completely fucking off." And *bang!* Pat goes off.

It's a 100-yard dash. Well, the guy beats Pat by like 12 yards. Turned out, the guy got all the way to the final trials in the Olympics

for the 100-meter. So Pat, telling this big black guy, "I hope you got your wood screws in, because I'm about to blow your doors completely off." When I say that when we're racing in *Dazed and Confused*? That's where that comes from!

Jason London: McConaughey calls his car "Melba Toast" in the movie. That was the name of his brother's car when McConaughey was a kid.

Monnie Wills: Patrick was a fantastic golfer. Could've went pro. Pat was able to get a long way on his natural ability, but there's a point when you gotta have discipline. You've gotta work at it. You've gotta be willing to put the time in. I don't think Pat did.

There certainly comes a time where there's an expectation that you're gonna do this, and then you just *don't*. So I think in some ways Pat was perpetually in that high school era when he was the big shit. I think you see some of that reflected in Wooderson, the sense of, let me try to hold on to this part of life as long as I can.

Shana Scott: I was there when McConaughey auditioned. I *hated* him. He came in with such swagger, like he owned the joint. And he did, I guess! But at the time, it was very off-putting.

He was good-looking, and he knew it. And it's like, "We're all Texans here! Stop it with this accent!" I mean, honestly, just take a step back: if you bumped into him and he acted like he does now, but he wasn't famous yet? *Ugh*.

Matthew McConaughey: That first audition, it was like I was going in for a job interview. I'd better shave. I better put on a button-down and tuck my shirt in, and give a firm handshake and say, "Yes, nice to meet you, Mr. Linklater."

Richard Linklater: He was clean-cut. I was like, that's not Wooderson *at all*. I need an asshole. Rough around the edges. I mean, Wooderson has his charms, but I wanted a little more sleazy. You can't say that I cast Matthew for his looks, because his looks almost kept him out of the movie.

Sam Lawrence: The thing that's disarming about him is that, back then, he didn't realize he was so attractive. He just kind of was a cool personality who happened to be wildly good-looking. When

Matthew was practicing Wooderson's lines in my living room, I said something to him about the part, and he said, "You know, I really want to be like Brad Pitt."

Cool World had come out and we were making fun of *Cool World* a lot, and he was like, "Look, man, at least Brad is taking these roles! That's what I want my path to be. I want to take roles where it's about the character and not my looks."

Richard Linklater: I had imagined Wooderson as a creepier guy, just kind of predatory. But there was no dark edge to Wooderson when Matthew came on. He was just a sad older guy.

Sheri Galloway: Matthew made that guy likable. He had a twinkle in his eye.

Richard Linklater: Matthew just set the tone for the party.

Rory Cochrane: When I first saw Matthew, he was wearing a pink Izod shirt, tucked into khaki shorts, with a belt and brown loafers. He looked like he was on his way to pick up his golf clubs.

Adam Goldberg: He looked completely different in real life. I was like, *That's* the guy?

Jason London: Rick says, "Hey, everybody, this is Matthew. He's gonna be playing Wooderson." And we're like, "Oh that's right, he's the character who hangs out with the high schoolers and stuff, cool cool." And all of the sudden, Matthew slinks down in a chair, his eyes droop, and he goes into character, and we're all just like, "What the *fuck*?"

Marissa Ribisi: Matthew transformed himself more than anybody else. He was this innocent, sweet Texas boy, and he transformed himself into a pot-smoking, subdued, jaded character.

Richard Linklater: He told me, "I ain't this guy, but I *know* this guy." And I thought, that's interesting. That's an actor thinking. And then he *became* that guy, right in front of me.

Matthew McConaughey: To this day, my brother is like, "You say I inspired that character? God dang. Guy's still hangin' out, tryin' to pick up high school chicks? Thanks, dude."

Part II
The Shoot

Chapter 8

All of These Attractive Children, Unsupervised

"We were driving along Seventh or Eighth Street, just asking randos for bud."

When Cole Hauser left his audition for *Dazed and Confused*, Richard Linklater called after him: "It's gonna be like summer camp in Austin!" With those words, the director shaped how the cast viewed their experience making the movie, and what the vibe would be behind the scenes. Many of them still describe making *Dazed* as "summer camp," whether they consciously remember Linklater's words or not.

When they weren't shooting, they were swimming, boating, running around barefoot, and getting into trouble. Linklater didn't try to rein anyone in. No one did. *Dazed* was about '70s kids coming of age at a time when adult supervision was sporadic, and behind the scenes, these kids were unleashed. Long before he became an actor, a 22-year-old Jason Lee—future star of *Almost Famous* and *My Name Is Earl*—agreed to be the legal guardian of his 17-year-old girlfriend, actress Marissa Ribisi, and he ended up partying even harder than she did. It was summer camp, for sure. But it was summer camp with alcohol, weed, and locked doors.

Adam Goldberg: You heard about the flight there, right? We had a horrible flight, the people coming from L.A. to Austin for the first week of rehearsal. I was sitting next to Michelle Burke. I met Mi-

chelle by holding her hand. It was *crazily* turbulent as we came into Austin. I think lightning hit the wing or something? We thought we were gonna *die*.

Michelle Burke Thomas: It's not just turbulence. It's *whoooo zhooooo brrrrrrrr*! I mean, we were in the middle of a lightning storm. It was the scariest flight I've ever been on. We were definitely praying. We were all clapping and screaming when we landed.

Marissa Ribisi: My sister [Gina Ribisi], my brother [Giovanni Ribisi], and my boyfriend, Jason Lee, took me to the airport in our '68 Chevy Caprice that had no brakes and no gas gauge. My mom worked, and I was 17 and I wasn't emancipated. Jason lived with us, so my mom was like, "Okay, he'll just have to be your legal guardian."

Jason Lee: I was a professional skateboarder. *Dazed and Confused* was my first time being exposed to moviemaking. I had done a one-scene, no-dialogue day of work on *Mi Vida Loca*, Allison Anders's film, but I really got the scope of the process of moviemaking when I was there in Austin. You can't help but get really excited when you're behind the scenes on a movie set, and you wonder what it would be like to be an actor.

Rory Cochrane: It was the first time I'd flown first class, and the plane was delayed for like *five hours* on the runway, but I didn't care because they were giving me champagne. It was probably shitty champagne. But to me it was *amazing*.

Someone was supposed to pick me up from the airport, but because of the delay, there was no one there to pick me up. So I get off the plane, and I don't know what to do. And I literally had 10 bucks on me. I used it for the taxi from the airport to the hotel.

Jason Davids Scott: I arrived on the first day of shooting, which was right after the Fourth of July, 1992. I was 22. And they put me up in the same hotel as all the actors. It was called the Crest hotel, on Congress, right by the bridge that goes over Town Lake.

Cole Hauser: It was this crappy hotel by the river. Austin now is glamorous, but this place was a *dump*.

Ben Affleck: Everybody called it "the Crust." But the only other hotels I'd stayed in were the Motel 6s I'd stayed in driving

cross-country when I moved out to L.A., and at home, I shared a room with a roommate. So I thought, "Look at this! I can have my own room for my own private life!"

Esteban Powell: I was checking into a hotel room at 16 years old, and the people behind the desk were like, "Are you for real?" I'm like, "Yeah, I'm for real! Also, I can't drive and my mom's not here." McConaughey was having drinks at the bar. It was like living an adult dream at 16.

Matthew McConaughey: I don't think I was a presence at the hotel. I lived in Austin, and they had their own thing.

Ben Affleck: Rick created this three-month-long party environment for the cast that mirrored the energy of the movie itself, just letting all these 19-year-olds hang out and get drunk and get stoned and run around the hotel and cause trouble. That now strikes me as incredibly risky.

Richard Linklater: For the most part, they all bonded. Later, there were little rifts amongst them, but it doesn't work well when you try to control people's social behavior. That's one strain through the movie: the Man is trying to control your extracurricular behavior. I always hated it when coaches tried to do that with us, or when they tried to get involved in who we should date. Everybody deserves autonomy in their private life.

And I didn't encourage drinking or smoking. I was strictly there for rehearsals. I couldn't really control that. I was only at the hotel for rehearsals.

Marissa Ribisi: I honestly think *we* destroyed that hotel.

Joey Lauren Adams: We bought candles and different bedspreads and decorated our rooms. And we bought these lacy slips and we took all of these photos together. Some were of us in bed.

Don Stroud: Parker [Posey] and Anthony [Rapp] and Joey were rolling around in their underwear and taking pictures. I think the three of them were pretending to do a sexy Calvin Klein photo shoot or something.

Wiley Wiggins: There definitely was something in the air with all of these kids. All of these attractive children, unsupervised!

Sasha Jenson: Jason London's room was the drug den. He encapsulated the '70s in that room. Walking in there was like walking into Jimi Hendrix's greenroom.

The first day I got there, I was kind of nervous because I didn't know anybody and we're all supposed to be best friends. Somebody told me, "You've gotta come up to Jason's room." So I go there, and it was literally like walking into a Vietnam drug den. I mean, like, red lights, the biggest, scariest stereo system. I get out of the elevator and blasting down the hall is the soundtrack, because Rick gave us these tapes. And the minute I walked in, London is walking around with his shirt off, like Jim Morrison. And Rory was almost in this Groucho Marx rant. And then everyone shoves joints in each other's faces, and it's like, "Here we are! This is gonna be so great!"

Jason London: Everyone came in my room to smoke weed. I guess I'm similar to Pink in the sense that I don't imagine myself as part of a clique of any sort. Never did. I moved to so many different schools growing up, I'd have to adapt to new cliques, but eventually I was like, there's none of these clubs I want to be a part of. So I think that's why my room was the room you could go to and just be yourself.

Esteban Powell: The first time I ever had a reaction from cannabis was during *Dazed*. I was with Jeremy Fox, who played Hirschfelder. We had to take apart the sink drain and borrow the screen from the hotel sink because we forgot to buy one because we didn't know any better. And I think somebody at the hotel had some herb? I know we were able to get our hands on some and were walking around Sixth Street, just giggling our heads off.

Jeremy Fox: Yeah, at one point, we were so stoned, we ended up rolling down this hill, laughing our asses off.

Esteban Powell: My love of weed grew out of that movie.

Jason Davids Scott: Esteban really wanted to get weed, so he had me driving him around to head shops. And he was like 16 years old! But he was like, "I'll just go ask people if they can hook us up." And I'd be like, "Okayyyyy. I'll be waiting in my car."

Esteban Powell: We were driving along Seventh or Eighth Street, just asking randos for bud. Jason was just like, "Okay, here's

60 bucks!" Then the guys took off and never came back. We waited for like 20, 25 minutes until we realized we got juiced. But Jason was super casual about it.

Jason Davids Scott: Everyone was named Jason. There was a bellboy there whose name was also Jason, who got us weed.

Adam Goldberg: Are you sure he didn't think Jason Lee was a bellboy?

Joey Lauren Adams: The bellboy? He was probably *somebody's* weed hookup. Probably Rory's.

Rory Cochrane: I didn't really smoke that much pot because, ironically, I wanted to be more clearheaded while *playing* stoned. But it's not like I didn't smoke pot *ever.* It just wasn't as frequent. For some of those other guys it was just, you know, *constant.*

Peter Millius: Rory liked to smoke a lot. Rory probably smoked more than . . . well, *nobody* smoked more than Shawn Andrews, the guy who played Pickford.

Marissa Ribisi: I would hang out with Shawn Andrews and Milla at times, but it was just a lot of pot smoke and both of them in the room. And she was like 16! Milla brought me to a head shop to buy a bong.

Wiley Wiggins: No one was getting *me* high. I never got to do any of that fun partying shit! The closest I got was, the night before we started filming, they took us to Hole in the Wall to play pool, and I'd never played pool before, and I shot the cue ball off the table. I think Milla asked me to dance with her at one point and I went and hid in the bathroom.

Rory Cochrane: I was 20 years old, and I was able to have a running bar tab at the hotel, and I thought that was the coolest thing in the world.

Marissa Ribisi: I could drink at the bar, because in Texas, if you were married and your spouse was underage, they could drink. And I had a ring on, so I'd just be like, "Oh yeah, Jason and I are married," and they never asked for a marriage license or anything. I didn't drink that much. One day, I had two piña coladas and it *destroyed* me.

In the end, my hotel bill was $1,500 from the bar, and I slid it right over to Jason. I was so fuckin' mad at him! I was like, "I think I had *two* piña coladas out of that!"

Joey Lauren Adams: Jason Lee was funny as hell.

Adam Goldberg: Jason was a hipster of his day. He was in Sonic Youth videos.

Jason Lee: Spike Jonze was filming me skateboarding, and I started improvising a song, and it sort of became a famous song that people would quote. It was called "Video Days," made for [the skateboard company] Blind, and that led to Spike getting noticed by Tamra Davis, and then she was directing a Sonic Youth video, and she hired Spike to shoot all the skateboarding footage from that video. From that, he went on to start directing music videos.

Marissa Ribisi: Even my mom, when she first saw that Blind video, she was like, "Jason, oh my god, you are *amazing*. You *have* to be an actor." And he'd be like, *No no no no no.*

Jason Lee: I was happy with my career as a professional skateboarder, but *Dazed* helped get the gears going.

(left to right) Jason Lee, Cole Hauser,
and Rory Cochrane

Wiley Wiggins: Jason Lee is the one who yells "Fuck her! I did!" during that drive-by scene in *Dazed*.

Marissa Ribisi: Jason had everybody rapping. He would do these off-the-cuff, really funny, dorky rap songs about what was going on.

Adam Goldberg: Jason got his guitar and we made a song for [game show host] Chuck Woolery, which Jason recorded—I hope to god he still has it. We both had a Chuck Woolery obsession.

Nicky Katt: There were sing-alongs in the lobby.

Ben Affleck: Jason London wrote and played a song called "Rosemary" that I really liked that I heard in my hotel room, stoned, during that movie. Let me see if I remember: it was "Put your bags away / We'll stay home tonight / There's no reason you should be alone." I fucking remember the song lyrics from a stoned night 30 years ago! He was that talented.

Rory Cochrane: People would get too drunk and not have shoes on. It was collegiate.

Sasha Jenson: We overtook *two* hotels. We overtook our hotel and then there was a hotel next to us.

Peter Millius: One night, we went to the Four Seasons hotel next door. There must've been eight or 10 of us. We were bored and looking for things to do, and they had those nice, big Texas longhorns on display, and we grabbed them all off the mantelpiece and put them on our heads and started running into each other like we were a bunch of bulls that were fighting in the lobby. We did that until we got thrown out.

Sasha Jenson: It would blur into almost spring break–like episodes, where groups would get a day off or two days off and all of a sudden it was like, "Did you hear what happened last night to so-and-so?" One night, we went from one hotel to the next, swimming naked. I don't know why we wanted to swim naked, but we did.

Jason London: We were not old enough to go to the liquor store and buy beer, so that's why it was great to have Deena Martin's boyfriend, Pete, there. I don't mean to throw you under the bus, pal, but Pete would provide alcohol for us, and we'd pay him our per diem.

Peter Millius: I was a recording engineer and producer in New York. I recorded "Walk This Way" by Run DMC, and I worked with the Stones, KISS, Foreigner—lots of records. So I was an older guy, and some of the kids weren't quite drinking age yet.

When Deena was filming, I would go out with the guys. I had rented a car and we would pile eight people into my Jeep, and we would go find a bar that would let everyone in to drink. Sometimes we wouldn't get in, so we'd find another bar. There was always that ID issue. But we always stuck together. We went out drinking until the bars closed, and then we would get more beer. There was lots of drinking and getting thrown out of various places.

Ben Affleck: I'd never been to Austin before. I'd been in Boston and Los Angeles—really, that was the extent of my travel. So I felt like I was somewhere really exotic.

Marissa Ribisi: Being in Texas felt like being on Mars. Everything was so flat and so spread out. It was *wild*.

Catherine Avril Morris: The L.A. people acted like they were just in Bumfuck, U.S.A. Like they were in the most backwoods place. Like there was nothing to do. We Austin kids all thought Austin was pretty cool, and they all came with this attitude like, *Uck, where are we?*

Adam Goldberg: I went to the Continental Club and was slightly annoyed, because Austin was supposed to be a big music town, but the music was a really specific kind of music. I was a jazz freak and an alt-rock freak. I used to play Dinosaur Jr. on the way to work. I went to the Continental Club, and the guitars were like, *b-dang b-dang b-dang!* It wasn't this explosive thing that I thought it was gonna be.

Marissa Ribisi: I got a chigger bite. Oh my god, it was just the most intense pain, because it's a bug that goes inside your skin! You have to put nail polish on it. I still have a scar from that. Yeah. *Texas*.

Parker Posey: We went to Good Eats at like 5:00 a.m. and ate so many tacos. I heard on NPR that there was a diet where you eat tacos every day for 30 days. We were eating tacos for 30 days.

Joey Lauren Adams: We went two-stepping at the Broken Spoke.

Marissa Ribisi: Anne [Walker-McBay]'s husband, Clark, would take us line dancing at this place on South Congress. And I remember going to Clark and Anne's place one night, and that's where I got my first real exposure to guerrilla filmmaking and independent filmmaking. I was so young, and they were film buffs, and they'd be like, "Have you seen this film? Or this film?" Clark showed us *Slacker*, which was amazing, and I just learned about so many different filmmakers that I made a little list of the ones I liked. I wish I still had that list. I'm in my 40s now, and now I know film, because of that experience.

Wiley Wiggins: Anne was a really sweet, cool, kind lady who I definitely felt maternal attention from. She was great at talking to kids.

Anthony Rapp: Our hotel was right on Town Lake, and it wasn't that far to walk to the cafés on Sixth Street. I used to be a big in-line skater, so I did that a lot around Austin, and I found an LGBT youth center that had a really cool vibe. I was the only queer person in the cast, as far as I knew. I was out-ish, but not totally. I wasn't that close to everybody.

Adam Goldberg: The only one of us who wasn't trying to be cool all the time was Anthony. He was more himself than the rest of us. He was *rollerblading*, for Christ's sake.

Joey Lauren Adams: I fell in love with Austin. I'm from Arkansas, and when I first moved to California, I didn't feel like I had an identity. And then being in L.A., that was amplified, because everybody has an identity. I knew a beautiful girl who had dyed her hair gray, and this was way before girls were doing that. I was dating an artist and meeting all of these different people who dressed different. I was really struggling, like, "Who am I?"

So, at one point, I decided that I was gonna be country. I bought a bumper sticker that said, "Clean up the South, buy a Yankee a bus ticket." And I got belt buckles. It felt authentic to me. So being in Austin was a perfect fit. My cowboy boots *worked* there.

Sasha Jenson: For me, talking about that summer feels the same as if you were in the schoolyard with your friends many years ago and you just were playing around with a bunch of people, and you never really paid attention to the moment, because it didn't feel special at the time. And then many years later, people were like, "Remember when you were on the swing set? That was so awesome!" And you're just like, "Huh?"

It didn't feel like we were making a movie, you know? It just felt like we were all playing together, and there happened to be cameras there. That's the thing that's so unique about this movie. I go back to other high school movies and the relationships feel contrived. But Rick was trying to build real-life chemistry with these kids. And I think he got it.

Chapter 9

Maybe the '70s Didn't Suck?

"Oh my god, I've re-created my high school."

Somehow, we only remember the good parts of some decades and the bad parts of others. The '60s are now often viewed as the golden age, largely because the boomers wrote and control that history. Every decade since has been held up in comparison, and usually found (by boomers) to be lacking. The '60s, in

this simplified scenario, are the Beatles, JFK, birth control, and civil rights. *Wow!* By comparison, the '70s are disco and wide lapels and gas shortages. *Sucks!*

There's a scene in *Dazed and Confused* that captures this received wisdom perfectly. "The '50s were boring," argues Cynthia (Marissa Ribisi). "The '60s rocked, and the '70s—oh god, well, they obviously suck."

Of course, Cynthia's wrong, and Linklater knows it. He was smart enough to realize the mythologizing of the '60s was a lie perpetrated by boomers. He didn't want to glorify the '70s, either. But in 1992, it seemed like he was the only person of his generation who even thought about the '70s at all.

Dazed and Confused isn't just set in 1976, it looks and smells like 1976. Linklater understood that era, and he got the details right. Before *Dazed*, the '70s felt uniquely uncool, underestimated, and embarrassing. For many late boomers who graduated around the same time as Linklater, this was the first film that even attempted to accurately represent their generation on-screen, flaws and all. They saw it and they felt loved.

The cast of *Dazed*, who were mostly Gen Xers, came to the film from a different perspective. To them, Linklater's vision of the '70s felt like a fantasy of free-range youth. "You want me to tell you what's interesting about this movie?" Ben Affleck told Kahane Corn on the set of *Dazed* in 1992. "Nowadays, there's a moral push on everything: not smoking, not drinking and driving, safe sex . . . The '70s were a time when there was an ashtray on every table of every restaurant, [but] there's no talk about secondary smoke. Every time I'm in my car in this movie, I have a beer. And it doesn't foreshadow death. It's just a fact. Only recently could you, like, not buy a beer in Texas and drink behind the wheel."

To Affleck, these seemed like good things. The '90s were safer, for sure, but the '70s were the last decade in which teenagers were largely unsupervised, unscheduled, and footloose.

Richard Linklater: When I was in high school, our school had a '50s day, where you could dress up 1950s and roll cigarettes up

in your sleeve. My uncle had been a teenager in the '50s, and he was like, "You guys like the '50s, but let me tell you, the '50s *sucked*." I took that in for *Dazed*, like, yeah, the '70s kind of suck, too.

Tom Junod: Many people who grew up in the '70s felt that they had missed out on growing up in the '60s. Linklater nails that so accurately. The second-phase baby boomers, the people who came of age in the '70s, were almost Gen X precursors, because we felt that the real meat of the revolution had happened before we got there. In the '60s, people had protested. They had stopped a war. They had pioneered using drugs. They had pioneered rock music.

By the time that stuff made its way to us, it was simply as lifestyle choices. You weren't making a political statement by smoking a joint. The few times we did protest, we were already self-aware enough to look at it ironically. The movie nails that with perfection.

Chris Barton: By the time you get to 1976, when *Dazed* takes place, the Beatles are done. The Rolling Stones haven't had a great album in years. The economy was not great. In a couple of years, Carter would use the word "malaise" in his televised speech from the White House. I could see how you might think the best stuff has passed you by.

Tom Junod: My generation was guilty of nostalgia way before they got old. I was class of 1976. When I think of my own experiences in the '70s, it's like, *Happy Days* was on. Sha Na Na was an act that people my age went and paid money for, even though it did not in any way memorialize their own time. *American Graffiti* was a really popular movie with people who graduated high school in 1976 rather than in 1962. And it was the same way with *Dazed* being popular with people who graduated in the '90s.

Brian Raftery: When they were making *Dazed*, I don't think they realized there was '70s nostalgia on the horizon. By the early '90s, the '60s revival had reached a saturation point. We had *The Wonder Years*. We had Oliver Stone relitigating the entire '60s, whether it was Vietnam or the Doors. I think the height of the '60s

nostalgia was an infomercial for a record set called *Freedom Rock*, with two grizzled hippies who were like, "Turn it up, man!"

There was a weird rewrite of the '60s because the boomers had taken over the media, and these guys were like, "Hey, we were the second-greatest generation!" and it became insufferable by the end of the '80s. So *Dazed* was definitely a turning point. It was like, the '70s? That sounds cool.

Richard Linklater: I think teenagers are looking to escape the misery of their own time, whatever that time is. It's like, "It *had* to have been better back then."

Parker Posey: When I got the call about this movie, it was like, "Oh my god! The '70s!" The '90s had a '70s nostalgia. I was walking around in bell-bottoms. I listened to disco. I was a child of the '70s. And then the '80s happened and there was Reagan and "Just Say No" and that time was gone. So it was great going back there with *Dazed*.

Tom Junod: The '70s were arguably the freest time that this country had ever had until then. It was post-pill, post–*Roe v. Wade*. Cops were not really busting people, because there was a tacit decriminalization going on. I'm sure younger people looked at *Dazed and Confused* and were like, "Really? You could just throw a bowling ball out your window? You could get beer when you were 14?"

Jason London: I was born in '72, so those were formative years! I'd walk by my parents, and I'd hear a bubbling sound, and I had no idea that they were smoking weed, but it sounded cool and it smelled really good. People just did what they felt like back then. My babysitter and her friend took a bath while they were watching my brother and me, and all I remember was big bush. The '70s were an out-of-control time, man. And it probably stayed that way until that first case of AIDS came out.

Rory Cochrane: Growing up in New York, I was terrified of AIDS. In the '70s, you didn't have to worry about unprotected sex.

Wiley Wiggins: When Kahane was making her documentary, she was asking some of us what we liked about the '70s, and more

than one of those older boys were like, "You didn't have to wear condoms back then!" Yeah. That's why everybody had herpes, dude. That's not a plus.

Peter Millius: Not many of those kids really knew what it was like to be in the '70s, but they captured it, and Rick cultivated that. That wasn't by mistake. It was by design.

Jason London: Rick was saying, "Don't turn on the TVs! I don't want you watching anything modern. Don't listen to any modern music, either." So all we could do was smoke weed, have sex, and listen to '70s music, I guess. When we were out on the boat, when we were tubing, that's the music we played. That was a really good way for Rick to get us into the groove. You really felt like you were part of that time period.

Chrisse Harnos: My character was supposed to be this feminist character. When I first got there, Rick gave me *The Feminine Mystique* and said, "I think you should read this." I was born in '68, and the message I got from my mother, who was born in the late '40s, was that you attach yourself to a man and somehow your value and your power lies with that. I read the book, and I was blown away by it.

It was nice that Rick cared enough to do that. And imagine, he was doing that for *20 of us*. I mean, it almost makes me want to cry for Rick! It's like, no wonder you look tired!

Jason Davids Scott: Everybody trusted Rick. He gave them so much in terms of helping them build their characters. He was a great big brother who was helping them dress up in these cool outfits and immerse themselves in those characters.

Jason London: Rick even had a joint-rolling class. I think I was one of the teachers. When I was a kid, my dad would be driving with one hand, and with the other hand, he would deseed his weed, take the stems out, roll a joint, and smoke that shit in the car. My dad was basically my inspiration for Randall "Pink" Floyd.

And Rick also taught us how to talk in a '70s way. He wouldn't let us say "dude"—it was always "man." But you know how people

stereotype the '70s, like, *Groovy, man, right on, high-five, baby?* I'm glad Rick didn't put that shit in there.

Richard Linklater: As soon as Rory got off the plane, he was like, "Hey, Rick, man, I was thinking that every time someone says something, I'm going to say, 'That's what I'm talking about.'" I just melted. I was like, "I was going to tell you the same thing! I remember guys always saying that in the '70s."

Nicky Katt: When I got to set, Rick came up like, "Hey, man! You wanna pick out your car?" They had so many different '70s muscle cars, and I was like, "I'll pick the Trans Am." It was a dream come true.

Richard Linklater: My only crazy purchase with my *Dazed* money was my '68 GTO. I bought it for $6,500. That ended up being the GTO in *Boyhood*, the one that Ethan drives. We used that car to shoot some inserts of a hand shifting a gear and punching the gas in *Dazed*, in the scene when the guys are busting the mailboxes and they get confronted in the parking lot, and I was like, "Wait, that car's beautiful!" It was love at first sight. So I said, "Oh shit, I'm going to buy the muscle car." I could never afford it in high school. That was the one time I felt like, okay, I'm rewarding myself.

Rory Cochrane: Those cars were so amazing. The Chevelle, which I could've bought for $6,000 back then, is worth probably $200,000 today. It was so fast that the teamsters had to make it run on six cylinders rather than eight cylinders. And the truck that Cole drove? The engine in that thing alone was like $12,000 back then.

Cole Hauser: When you're 17 and you've got that kind of power, you're like, "Fuck yeah, let's do this!" And it's not *your* car, so if you wreck it, you're just like, "Take it away!"

Nicky Katt: The cinematographer on *Dazed*, Lee Daniel, was a real gearhead and knew a lot about '70s cars. You know the scene where Matthew and I are talking about our cars? That scene was not in the script. The cars pulled up and Matthew said, "What's some stuff we would say?" And Lee said, "Say 'pop-up pistons' and 'four-

over-one compression.'" He was off-camera, feeding him these lines that he didn't know anything about.

Katy Jelski: This boy culture where you know all the vintage cars was so foreign to me. We were doing a dolly track down the front of the cars, and it's supposed to be the end of the school year, summer '76, and in the middle of shooting this thing, one of the extras ran up to me, really upset, like, "You've got to stop! The grille on that car, that didn't come out until December of '76." I looked at him like, you have got to be kidding me! But then I thought, this is the audience for the movie, these young nerdy guys.

Catherine Avril Morris: The first night I got to set, they showed me the car that I would be driving, and I was like, "Oh, I can't drive standard." And they were like, "Oh, okay, we'll get you another car."

Two weeks later, it's the same car. And they were like, "Okay, let's have a driving lesson." So we go out for literally an hour in the neighborhood, and we go back to set, and they wanted me to drive slowly through the Top Notch drive-in and park and then pull back out and around. The entrance to the parking lot is on a ramp, and I kept stalling out. So then they put sandbags behind the wheel, and I tried to feather the clutch and it was like, *ka-chunk ka-chunk ka-chunk* through the entire scene. They ended up cutting it.

Renée Zellweger: When we did the car wash scene, I was driving the truck, and I think it was like "three-on-the-tree" [manual transmission], and I was really trying to not go in reverse when I meant to go forward. There was a lot to think about.

Jonathan Burkhart: You know that scene where they're cruising around in those '70s cars and they throw a bowling ball out the window? Well, Shawn Andrews was driving, and in the back seat are Wiley Wiggins and Jason London. We were in a residential neighborhood south of Austin, and Wiley was supposed to pretend he threw the bowling ball. On the first take, he actually threw the ball out the window! The look on Wiley's face and Jason's face is real, because he wasn't supposed to do that. We were on a tow rig, and we were trav-

eling at 20 miles an hour going downhill, and the ball just started rolling faster and faster, crashing into trashcans, rolling into lawn after lawn.

Robert Janecka: The ball is going 100 miles an hour down this steep-ass hill, and it went right through this guy's garage door.

Louis Black: The story was that the house belonged to Jimmie Dale Gilmore, one of the great singer-songwriters from Texas, who plays with the Flatlanders. He says the bowling ball just appeared in his yard, out of nowhere.

Jonathan Burkhart: All of those kids had trouble with the driving scenes. There's this shot at night when Ben Affleck is racing away in his truck, and sparks come out of the bottom. That was our one and only take. For some reason, the road was not even, so even though he was going totally straight, the truck was bouncing up and down, and it bounced so hard that it bottomed out and all these sparks came out of the back. It's in the movie, and it's fucking *beautiful*. I remember saying, "Man, visual effects could never pull that off!"

Ben Affleck: That movie was my introduction to great '70s muscle cars. After that movie, I bought Cole's '69 Cadillac Sedan de Ville off of him. My brother and I split it and restored it. I still have it to this day in my garage.

Steven Hyden: One of the points the movie is trying to make is that being a teen always feels the same, no matter what era it's in. You can tell that from the costumes. If you shoot an audience at a rock show in the '70s, it still looks like the crowd at a rock show now. There's certain kinds of people that just look like *rock people*. The long-haired guy who's kind of disheveled. The girls in the flowing skirts. There's certain archetypes. So when I look at *Dazed and Confused*, there's certainly elements of it that are very '70s, but Randall "Pink" Floyd? He just looks like a kid from any era.

Michelle Burke Thomas: When we first got there, they sent us to a big warehouse that was like a Best Buy full of racks and racks of '70s clothes, and we got to pick our own costumes.

Kari Perkins: The actors were so young, and really didn't understand the way people wore their clothes back then. In the '70s, it was all about tight, and in the '90s, it was loose and baggy.

Marissa Ribisi: Well, in the '90s, every girl was *skinny skinny skinny*. Kate Moss ruined it for a lot of us.

In the audition, Anne said to me, "Cynthia's gotta be the intellectual. She can't be pretty. You could be *too* pretty." So I thought, okay, I'm just gonna really go for this. I ate waffles and fried chicken every day, and I put on 10 pounds, which wasn't a lot. It was just enough to fill me out a bit. But I was real! We all had to try on the clothes together, and I was trying on pants that were bigger than everyone else's, and I filled them out.

Deena Martin-DeLucia: That scene where my little sister's pulling up the zipper on my jeans with pliers? That pair was a size one. The rest of the filming, I had a size seven, so I wouldn't be so uncomfortable. The size ones were *very* tight.

Jason London: I was dead set on going for the most outrageous thing. So when I got those tight bell-bottoms, I was like, "I'm gonna wear these nuthuggers!" To sit down in my chair, I would have to unbutton and unzip my pants because it hurt so bad!

Sasha Jenson: I wanted to wear dirty overalls the whole time. I literally wanted to be Pig-Pen! I wanted to be that guy who's kind of in the beginning stages of becoming an alcoholic, and at the end of the night, you look at his dirty overalls and you're like, "What *happened?*"

The wardrobe people were like, "No, you have to look better than that." But I'm still a piggy asshole in the movie.

Kari Perkins: To make the film the way Rick wanted it to look, he had provided all these yearbooks from 1976 from Austin and the surrounding area. One of the junior high kids had a T-shirt on that said "Lookin' Good." That was directly from the yearbook.

Keith Fletcher: Anne was going, "We're gonna go all bell-bottoms and crazy T-shirts!" And I'm going, *Who was wearing that stuff then?* I grew up in Connecticut. In '76, we were into the Ramones

already. But everyone was still a hippie in Texas in 1976. Still! There was no punk rock overtones. It was all long hair, bell-bottoms.

Matthew McConaughey: I was called in for a hair, makeup, and wardrobe test, and I came out of the trailer, and Linklater, as he's approaching, he does that great laugh. "This is *great,* man! What's this here, a black panther tattoo? Yeah! The pipe around the neck! Oh look, the comb-over hair! The Ted Nugent T-shirt! How do you feel?" I said, "Yeah, man, I *dig* it."

Katherine Dover: Matthew walked into his costume fitting and he *loved* Ted Nugent. He was like, "I *am* Ted Nugent!" I said, "I have a perfect outfit for you." That Ted Nugent shirt fit his personality in the film as well as Matthew himself. He was obnoxious and brilliant. You couldn't help but love him.

Kari Perkins: I had taken a Ted Nugent album [*Tooth, Fang & Claw*] to Kinko's and signed a form saying I wouldn't sell it, and they shrunk the image and they made a T-shirt transfer and I ironed it on T-shirts. And I didn't even have a pre-fit with Matthew McConaughey at all. He just came to set and put it on like magic. Everything fit him like a glove.

Bill Wise: Matthew's character had a Ted Nugent and the Amboy Dukes T-shirt. Especially with the tight jeans, there's a little old-school macho, shithead grandstanding. Nugent was such an egocentric ding-dong! So when Matthew's character steps out to smoke his cigarette and he's got Ted Nugent on his shirt? It's like, "This is how I roll, baby. You better deal with it, cause I'm gonna be here all fucking night."

When he stands up and sells the peach-colored pants that only a few men can get away with, the comb-over, and the imaginary Yoohoo chocolate mustache, you could really make that character look small and empty and stereotypical. But the way Matthew played it, you're sitting in the audience going, "I went to high school with that guy."

Parker Posey: I saw his Polaroid and it was like, "Wow! I haven't seen that guy before, but I *know* that guy!" [Makeup artist] Jean

Black and I, we were like preacher ladies, just screaming, "Ahhhh-hhh! Oh my god! This Polaroid is so good!"

I called my agent that night and I said, "You gotta sign this guy. He's going to be a big fat movie star."

Tracey Holman: McConaughey stayed pretty much in character for the whole shoot. His hair was done perfect, and he had that mustache and the tinged-with-marijuana attitude.

Scott Wheeler: He would be *in character* when he came home at night. He had the mustache and the hair and he would talk just like Wooderson.

Michael MacCambridge: The costume design was superlative. It was not like what you see in *That '70s Show,* where everybody's got bright, shiny clothes. It was very much mid-'70s, mid-America, faded blues, T-shirts. It got one of the things right that people so often get wrong in period pieces, which is that not everybody went out and bought new clothes at the same time. There was older stuff.

Jason London: A good buddy of mine grew up in the '70s, and he gave me his puka shell necklace. He was like, "Dude, if you're doing a movie that takes place in the '70s, you have to have one of these. We all wore 'em."

And Rick said, "I've got a very special piece for you." And he pulls out this killer belt buckle that was also a smoking pipe. And it still works! Quentin Tarantino, the one time I got to meet him, he says, "Jason fuckin' London! Please tell me you have the belt buckle. I'll give you $200,000 for it *right now*." But I didn't sell it. I still have it.

Kari Perkins: The belts the cast wore with bell-bottoms were unique to Texas. There was more regionality in that time period. The stores were local department stores. They weren't big chains. So the way people wore things was different in Austin compared to West Texas or Chicago. Nowadays, everything is so homogenized that everything looks exactly the same. But back then, the belt buckles, the peasant blouses, the tight T-shirts, the snap Western shirts, all those were very much of this region.

Keith and Melanie Fletcher were just going out and shopping

everything from all these small towns, getting all the good '70s stuff, which, at that time, nobody wanted. The thrift stores and vintage stores were full of it.

Keith Fletcher: You'd wander into an old store and ask what they had kicking around, and they would take you down to the basement and they would literally have '70s clothes with tags, still in their original packaging. It was amazing what was out there. We would drive 40, 50 miles outside of Austin and hit little towns, and you would be like, "Oh, this old store has 1980s Air Jordans sitting on the shelves!" Just crazy stuff.

Jason Davids Scott: The costume and wardrobe people were like, "I had this exact same piece when I was 16 or 17."

Kelly Nelson: We were all reliving our childhoods. When I was 14, I lived in Ardmore, Oklahoma, for a while and there was a particular leather store there that made purses, so I had a purse that was custom-made. I carried it forever. And when I moved to Austin, I probably gave it to Goodwill or Salvation Army. I saw that purse in the movie, on one of the actors. I was like, Are you kidding me?

Keith Fletcher: It wasn't just vintage. A lot of big companies were reissuing their '70s stuff then, like Hang Ten, Converse, and Adidas. The junior high kids were wearing reissued stuff. Usually, if things like that were reissued, the colors would not be right, but Hang Ten and Converse were two companies that were totally authentic to the time.

Kari Perkins: That psychedelic-looking shirt that Wiley wore, I actually found that here in Austin. I think it was Neiman Marcus. I recall seeing those when I was in junior high in that time period.

Vincent Palmo Jr.: The shirt that Wiley wore, I literally had the same shirt when I was a junior in high school. I think I may have used it in my yearbook photo. It blew my mind.

Kim France: I visited the set to write something for *Sassy*. I grew up in Texas, and I thought Rick got Texas right in such a meaningful way. Even Affleck's button-down shirt that had a quilted pattern on it, and his hair! It was parted down the middle, feathered back. That was the ideal boy in the '70s.

(left to right) Joey Lauren Adams, Sasha Jenson, and Parker Posey

Shana Scott: It was actually pretty hard to find kids in Texas with long hair. In '91 and '92, no one in Texas had it. If you look closely, the eighth graders have wigs. The only one who doesn't have a wig is Wiley Wiggins.

Wiley Wiggins: Before I did that movie, I had the haircut of the backup bully from *The Simpsons*, with one-sided bangs over your entire face. I was used to always pushing it back. That's why I'm always futzing with my hair in the movie. People still give me shit for that.

Ben Affleck: I hated my fucking haircut. The irony is, I basically reprised that haircut for *Argo*, because it was a similar period, but by that time, my hair had thinned and grayed enough where it looked a little bit more passable. For *Dazed*, they were ironing down my hair every day because I have wavy hair. I looked awful.

Joey Lauren Adams: Parker had a wig. Rory had a wig. It was almost like, if you're more important, you get the wig. If you didn't, you weren't that important.

Rory Cochrane: When I went for the first meeting with Don Phillips, he was like, "Don't cut your hair." Of course, I did cut my hair, because I had other auditions. So that's where Slater's whole hat thing came in. I wore that hat to the final audition to cover up my hair.

Jason Davids Scott: Rory Cochrane is so unlike Slater. He had really short hair and he's kind of a slight person. You look at him and you see Jack Kerouac. He's quiet and introspective.

Rory Cochrane: I had a friend, and his mom was a super-big hippie in the '60s. She had the same hair as the character, and she did so much acid that her and her ex-husband thought that they were rowing in a boat and trying to get to shore, and they were in Central Park, you know what I mean? So I based the character on her.

I drew a marijuana leaf on my shirt, and just walking around Austin, I would ask to wear the clothes and the hair. Austin's a lot more progressive now, but there were still some very conservative people that would throw beer cans at you and call you a hippie, and if you got in an elevator they would put their kids behind them, like they were protecting them from you.

Jason London: That first day, getting in wardrobe, all of us were looking at each other like, "Oh my god!" I remember seeing Adam Goldberg with his big 'fro, and just *dying*; it was so perfect. I don't think we thought, like, "Okay, we have to act '70s." But as soon as we put the clothes on, we did.

Michael MacCambridge: When '76 came, I'd just turned 13, so it felt almost like an out-of-body experience when I visited the set. I was writing a feature for *The Austin-American Statesman*, and when I walked out there and saw the cast, these feelings whooshed over me, like, "Hey, isn't that the guy that wanted to kick my ass? Didn't I have a crush on that girl?" I really felt like I'd gone back in time.

Richard Linklater: I'd stand on the set and see people in the flare pants and the shirts, and the girls dressed a certain way and the music, and it was like, "Oh my god. I've re-created my high school." It sent a shiver down my spine.

Chapter 10

If You Don't Like Your Character, Change It

"He never made you do it. He always somehow got you to do it."

efore the cast showed up in Austin, Linklater sent everyone a letter. "Come to Austin WITH SOMETHING," he wrote. "Know this movie. Know your character so we can forget about it and build something new, something special, in its likeness.

As I've said before, if the final movie is 100% word-for-word what's in this script, it will be a massive underachievement."

Linklater wanted the actors to bring their own backgrounds to their roles, and they did. Judging by how the actors described their roles at the time, they saw a little of themselves in their characters.

Jason London viewed Pink as a kid who was sick of "small-town-ness." "Dad was probably a high school football player, his mom's probably a churchgoer, and he's faced with the decision of whether he can play football, because his goals are higher than playing football," he told Kahane Corn at the time. London had spent much of his own childhood in Wanette, Oklahoma, a churchgoing town with fewer than 400 residents, where a lot of people's lives revolved around football. Like Pink, he hadn't wanted sports to be his future.

"He probably fears his old man," Ben Affleck told Corn about his character, O'Bannion. "He has the kind of family where his dad gets pissed and whacks him occasionally." Affleck's own father was a severe alcoholic, and he'd later admit that "it was very, very difficult and scary to live with him."

Cole Hauser also imagined that his character, Benny, was scared of his dad. "His father's probably a drunk," he told Corn at the time. "He probably used to slap me around a little when I was younger." Hauser is the great-grandson of Warner Bros. founder Harry M. Warner, and the son of Wings Hauser, an actor best known for playing violent, psychologically unhinged bad guys. Cole declines to discuss his homelife, beyond admitting that it "haunted" him while he was making *Dazed*. (He became an emancipated minor at age 15.) But he says he was a jock in high school, and he always saw Benny as someone who channeled his rage at his dad into sports. "The aggression of football, and the aggression of paddling kids, it all kind of lines up," he says.

Allowing the actors to help shape their characters was generous and unusual for a director. But it also shows a keen emotional intelligence on Linklater's part. He was 31. He knew he needed younger people's input to make this high school movie feel authentic. So he

treated the ensemble as if they were a team he was coaching. He guessed that the more everyone felt like they were participating, the more invested they would be in achieving greatness. But moviemaking, like sports, is not a democracy. The people who excel get to play the most, while the others have to watch.

Richard Linklater: If there's one thing that defines me more than anything else, it's probably being a teammate.

Tommy Pallotta: Knowing that Rick was a baseball player is a key to understanding how he approaches directing. Baseball is an endurance sport. It's a 10-month season. You travel a lot. You strike out a lot. You lose a lot. You show up and you keep on grinding away. He's the master of creating an environment on set where people aren't afraid to fail.

Richard Linklater: A lot of directing is like being a coach. You bring a team together with a common goal, no competition between them. And the coach wants you to be great, to maximize your potential, not just for yourself, but maybe because he gets a victory and he wins the championship and then he gets hired at the next job up the line. I want you to be great because I wanna make a good movie and I want you to be proud to have been in it! That's just been the way I've gotten the best results. Cooperative, collaborative atmosphere, but one goal.

Ethan Hawke: There are very few artists who come to the arts with the mind-set of an athlete, but baseball is the key to understanding Rick. At its core, baseball is a very zen game—it's patience intersecting with spontaneity—and Rick is the most naturally zen person I've ever met. He is genuinely present. He invites actors to offer their true self, and in return, he gets the best of them. I'm not saying he sits around reading the *Dhammapada* or the *Tao Te Ching*. He's just slightly detached, and he observes.

Chrisse Harnos: As an actor, you often feel an authoritarian thing with directors. There's something in actors that we want to please the director. It's almost part of our job. But Rick was one of us. And we knew that right from rehearsal.

Joey Lauren Adams: We were there for like three weeks rehearsing, which was very rare. I don't know if I've ever had that.

Ethan Hawke: Hollywood filmmakers are terrified of rehearsal because all they care about is the camera. Rick makes the actors feel like he couldn't give a shit about the camera. He cares about life.

Matthew McConaughey: Look, it starts when Rick and Don Phillips throw this pizza party to look around and see, how do these young men and women get along in real life? How do they move? What are the conversations? Who gravitates to who? And then Rick would be like, "Show up, and be doing what you would be doing, with who you would be doing it with."

Adam Goldberg: When we got the part, Rick sent us these letters about how to attack the rehearsal process.

Marissa Ribisi: The letter basically said, "You are these characters, and these characters are you."

Tracey Holman: That's the way Rick seems to work. In *Slacker*, some people really weren't acting. They did it naturally. There was a lot of themselves in the role.

Joey Lauren Adams: I just remember Rick's letter saying, "If you don't like your character, change it. Just *know it* when you get to Austin." Most movies aren't like that. There's not that freedom. It's just a bunch of older white men writing it, and there's not a connection to the material.

Richard Linklater: As a filmmaker, you can't take yourself that seriously as a writer. If there's a very specific dialogue, and you don't change it, and it's all in the cadence, like David Mamet or Aaron Sorkin—that's more of a theater thing. It usually doesn't work in film at all. I was always going for a much more lived-in thing.

Adam Goldberg: The actors were part of the rewrite of the script. Now, I'm not saying that should be a part of every movie, but for a movie like *Dazed*, it should've been. I didn't have any frame of reference for a movie like that. *Slacker* had a very rigid, dogmatic structure, so while it was not "about" anything, the experiment was dogmatic and clear. With *Dazed*, I was like, I don't know what the

fuck this is about! But I know that it's high school and it's gonna have a texture and a tone. And that was worked out in a rehearsal.

Nicky Katt: I've heard Rick quoted as saying, "The rehearsals aren't necessarily for you. They're for the filmmaker. Because I don't know what I'm doing! I'm exploring this thing."

Russell Schwartz: Oh, Richard always knew *exactly* what he wanted. He never *made* you do it. He always somehow *got* you to do it.

Richard Linklater: I want to empower you to collaborate with me. I *do* know what I want, but if I say that, we'd have a confrontation. Directors are arch-manipulators, there's just different ways to do it.

Bill Wise: Rick gives you free rein up to a point, but it's always Rick's vision. If it isn't happening, it's, "Try it again, but differently." You never hear the word "no" on a Richard Linklater set.

Ben Affleck: There are filmmakers who really believe that suffering is tied to good art, and maybe they have a point. But what I saw in Rick was, that wasn't the only way to do it. It could be collaborative. It could be respectful. It could be joyful.

Jason London: I look at my experience doing that movie much more fondly than I look back on my experience in high school. We were the poor kids in a school of snobby rich kids. My experience in high school wasn't fun.

Joey Lauren Adams: I was never the popular girl in high school. I didn't make the cheerleading team. I hated high school. I was always ready to quit and get my GED and move to L.A.

Marissa Ribisi: I hated school so much, I didn't go. My brother was already a successful actor in television, and he wasn't going to school, so I felt like, why do I have to school? And my dad was like, "Well, he has a job." So I had to get a job. I was acting in a movie about high school so that I didn't have to go to school.

Parker Posey: *Dazed* was the dream high school experience that we were all able to live out. I was a good Southern Catholic girl in high school. To get to play Darla and express all my repressed feelings was liberating.

Jason London: I got to play the quarterback, and I never got to be a quarterback in real life. When I was 15, I lived in DeSoto, Texas, and during the summer, we worked construction with my dad. I was bringing home $300 a week. For a poor kid from a trailer park, I was *rollin'*. But one day I got my foot caught in the lift mechanism on the forklift and got two of my toes cut off on my left foot. My whole life at that point was all about sports, and the only way I was gonna get to go to college was through scholarships in sports or the military. All of the sudden, that path was gone. I thought it was the worst thing that could've ever happened to me. But then I decided to take drama. I guess it was destiny. I had to think about a life beyond sports, just like Pink.

Adam Goldberg: My high school was pretty different from *Dazed*, but making that movie felt like my college experience, because I didn't really go to college. My college experience: I had a chronic 99-degree temperature. I was laying under the sink, crying, calling my mother. And then I dropped out. So partying with the *Dazed* cast was as close as I ever got.

Jonathan Burkhart: Adam Goldberg and Anthony Rapp together, their role was to not totally fit in. And that's the way they were off-camera as well.

Jason London: As the dynamics of the movie are, it played out the same way in real life, the sense of, like, Anthony Rapp wasn't gonna be the guy getting hotboxed in my hotel room.

Anthony Rapp: I always felt like an outsider, because I was never a bro. I wasn't a frat guy at all. I was the nerdy weirdo, and the people I was drawn to were weirdos. Adam's a weirdo, but he's the weirdo who wants to fit in. It was sort of like in the movie. He's sick of being a nerd.

Marissa Ribisi: The dynamic between Adam and Anthony and me completely changed in rehearsal. Adam became the alpha among us because he's so angsty. He was always popping Advil. I'm like, "Why are you taking Advil every day?" And he'd be like, "I just got off the phone with my therapist." He was just very heady. An-

thony would jab him and make fun of him, and then I existed as sort of a buffer. The characters became more us.

Adam Goldberg: It wasn't until the movie came out that I was like, Oh, these three characters are the *nerds*? I know that seems crazy, because it's so obvious, but I didn't think of it that way. I wore steel-toe boots and a flannel shirt in the movie because that's how I was dressing in real life. It's not like I was dressing like Anthony Michael Hall in *The Breakfast Club*.

Mark Duplass: The three dorks in the car? That is the utterly unique portion of this film for me, because they're not your typical nerd stereotypes. They're kind of cool. They're sitting in the car philosophizing, but they also get invited to the party. To me, those conversations in the car are the closest thing to *Slacker* and *Before Sunrise*. That's the closest to the true Linklater form.

Parker Posey: I flew back and forth to a soap I was working on, so I had to miss the two weeks of "bonding rehearsals." I missed the talk that the rehearsal bonding would've elicited, and I wish I'd been there. I was new to the game of this kind of working experience. We all were. That's what was so perfect and pure about it. It felt like an unknown ensemble experiment that was created.

Adam Goldberg: People who were comfortable doing improvisation ended up staying in the movie more. And the people who weren't, didn't. I felt bad about that, but also impatient with people who couldn't keep up.

Joey Lauren Adams: One night, Shawn [Andrews] improvised a scene about his character wanting to drive drunk, and Milla trying to take the keys, and it was like, that wasn't an issue in the '70s! I remember feeling embarrassed for them, like, I don't want to make that same mistake. I want my improv to be good.

Ben Affleck: Rick was saying that people could write their own scenes, which was such a radical idea. At the time, I thought, "Oh, that's cool and permissive and welcoming and open." Now that I know more about production and the way things have to be prepared for in advance, I just think that's fucking crazy. You can't just

have 25 actors show up and start handing you scenes they want to shoot throughout production!

Richard Linklater: It wasn't risky at all. I'm the director. If something doesn't work, I don't put it in the movie. I have final cut. I'm trying to let the movie be its best version of itself, but I hold the cards. I just don't tell the actors that. I want them to think that they have dominion over their character.

Ben Affleck: Rick was long-haired, and free-spirited, and very laconic and easygoing, and he somehow seemed stress-free. And I just thought, like, "God, this is the kind of guy I would like to be one day. He can direct, and write, and maybe I could do that, too."

Joey Lauren Adams: There was a remarkable freedom to Rick's way of working. We all knew it was special, even at the time. You just couldn't believe it that you could be so lucky to be in Austin, working with Rick, doing your first film with all of these people. It was what I left Arkansas for. It was that experience.

The New Kid Versus the Old Guard

"It was like, 'Jesus is coming!' . . . you had to put your weed away."

Dazed and Confused was definitely not Universal's highest priority. When Linklater started principal photography, the studio was also working on *Jurassic Park* and *Schindler's List*. That didn't prevent them from micromanaging Linklater's decisions. The previous year, Universal had watched as some of its bigger-budget films flopped, including the Babe Ruth biopic *The Babe* and the Tom Cruise/Nicole Kidman romance *Far and Away*. Linklater sensed that everyone at the studio was scared of getting fired.

"They've determined to do their little jobs all the better and tighten their belts," he wrote in his *"Dazed* by Days" diary. "Experienced directors with track records would tell them to get fucked, so it's easier for them to focus on *Dazed* and the new kid, even though that film has less than one-quarter of the budget of their average film."

Linklater also felt that some of the more experienced crew members didn't trust him because he worked differently than other directors who'd worked their way up through the studio world. Tensions emerged between those who understood Linklater's process, those who seemed to be working against it, and anyone who fell into both categories. "By the time we're in production," Linklater wrote, "we're at war."

Bill Wise: Before we started working on *Dazed*, amongst Rick's friends, it was like, "Are you gonna work on Rick's little '70s movie?" Then all of a sudden, you're there. The first day on set, you see six semis, and you see all the period cars lined up in that one little area, and the lights coming down, the 2Ks and the 4Ks. You inhale and you realize, "Oh, this shit is *real!*"

Kim Krizan: What was the difference between *Slacker* and *Dazed*? We had trailers on *Dazed*. We had makeup artists. There was a first assistant director, and a second assistant director. We were escorted onto the set. There were blow-dryers in case we were sweating through our clothes and someone needed to dry our clothes. The day we shot our scene for *Slacker*, the two other women and I just sat in a booth at the café where we were filming and hung out until it was time to shoot our scene. With *Dazed*, I sat in a trailer, alone. Everything was totally different.

Michael MacCambridge: With *Slacker*, what Richard was doing was, to borrow a phrase from Spike Lee, "guerrilla filmmaking." It was very much insurgent, and very much outside the mainstream. But what he was doing with *Dazed and Confused* was still audacious. He was making a film with a studio, in many of the most difficult ways possible: with a large ensemble cast, a period piece, doing it away from Hollywood and the studios but still relying on their money. When I visited the set, I thought, "This is a proper film!"

The pressures that were attendant upon him because of that were also much greater. Yet Richard was dressing exactly the way he dressed for *Slacker*. He still had the Prince Valiant haircut. He was playing in the big time, but he seemed totally unaffected by the changes in his life.

Tricia Linklater: Rick wore the same cutoffs every day to set, and drove my grandmother's ancient Cutlass from the '70s. Anthony Rapp asked if Rick was okay, financially. Like, in the sweetest way possible.

Richard Linklater: When I got paid for *Dazed*, I put a down payment on a condo, but I still drove the same shitty car. Sean Daniel visited Austin, and he said, "Rick, you can get a new car now!" But I didn't care. I'd sit back and think, okay, what makes me happy? New clothes or a brand-new car won't necessarily make me happy. To me, money equals freedom. Keep a low overhead, and you don't ever have to do anything for money. You won't have to whore yourself out.

Katy Jelski: I came from L.A. I thought the script was fantastic and the casting was fabulous, but there was a young director, a green DP, and this laissez-faire Austin crew. It wasn't like working in L.A., where it's like a factory. It was a bunch of hippies.

J.R. Helton: Well, some of the Austin people had worked on *Lonesome Dove* and a bunch of other movies. We were a professional crew, and it seemed like there was this new, indie-film, lower-budget, amateur hour thing going on.

Jonathan Burkhart: I had come from New York, where it's like, "Shut up. Do not speak unless you're spoken to, and never speak to anyone who's above you."

Deb Pastor: We always called D. [Montgomery] "the art department ghost," because no one in that department would listen to anything she said. She'd say something, and they'd just ignore her. And it was weird, because she was going through cancer treatment at the time, and it was like, "Oh my god, this woman's fighting for her life, and she's totally invisible."

Tricia Linklater: Everybody on set knew more than Rick did about proper 150-person crew behavior, because he had come

from seven people on *Slacker*. This was this huge jump, going from "do everything yourself." I mean, when he was doing *Slacker*, Rick was driving the film to the bus to send it to a lab in Dallas to get it developed. And now, on *Dazed*, there were *all these people*.

People would say, "We're going to do the read-through," or "We're going to do the text out," or whatever. Rick certainly knew filmmaking, but not these little vocabulary things. It was my job, as his assistant, to be protective of him, so everybody doesn't go, "He doesn't know what he's doing!"

John Frick: Rick had a real crew and teamsters and wardrobe truck and grip electric truck, and those trucks take up a lot of space, and the last thing you want is to have them in a shot.

The teamster coordinator said, "Where can we park all of our trucks so we won't be in shot?" Rick looked at Lee [Daniel] and they both had this look of, "We don't really know?" It was like, oh my gosh, what are we getting ourselves into here?

Ben Affleck: Usually, when you shoot a movie, well in advance, you've done a tech scout, you know where the generators are going to go, you know where the porta-potties are going to go, you know where the trailers are going to go, and where the scenes are going to be, and what direction you're looking at, and where the lamps get unloaded. You can't change stuff in the middle. But Rick didn't have a shot list. He did not have storyboards. He would change scenes.

Richard Linklater: I did have storyboards for the "action scenes," like the car chase. And I did have a shot list! Every day. I just didn't share it with the actors.

Robert Janecka: Normally, you would block all your shots. Well, Rick would come in and say, "No, I wanna shoot this scene over here," and everyone's like, "Well, we're set up for this one over here!" It was just kinda whatever Rick and Lee felt like doing.

On the first day of shooting, they had an articulating jib arm for the camera on a dolly, so we're shooting at the high school in the hallways, and Rick and Lee made up the most ridiculous shots, just

because they had a new toy, and they were all so infatuated with this new jib arm. And we're like, "Oh my god, c'mon, we've got to go!"

Sasha Jenson: Our first day filming, Rick was tracking Jason London and me walking down the hallway at the school. That was a fun day for me, because half of the morning was Rick like, "Okay, Sasha, what would Donny do? Let's walk over here. Let's say hi to this person. Let's take a punch at this guy." I would walk down the hall and grab my crotch, like, "Eat me!" We were doing the type of character exercises that you would see in an off-off-Broadway play in New York, or in an acting studio. It's old-school, Method-acting stuff, but we were playing teenagers, so a lot of it was just crude! I'll bet Universal was like, "What are you doing? I don't want to see that!"

Don Howard: I'll give you an insight into Rick's willingness to let Lee do whatever he wanted early on. You know the car wash scene in the movie where that old-fashioned, rickety sprayer thing is going around the car? Lee literally rode that nozzle! He put the camera on the right side of it so that, as it went by the girls, it revealed each one getting sprayed, and it looked brutal. Lee was the ultimate documentary camera guy. That was Lee Daniel right there.

Richard Linklater: There was a definite camaraderie amongst Lee and Clark and Anne—the whole *Slacker* gang. And sometimes it was them against the others. Jim [Jacks] was always pissed at Lee for one thing or another. And Lee was making technical mistakes.

J.R. Helton: Lee almost got fired after the first time the dailies came back.

Richard Linklater: After the first week, there were errors, like, "Oh, that's unusable." You don't notice that while you're shooting. Lee was like, "The light shifted at the last minute and there was a reflection in the windshield, and I thought it was cool!" Lee was an experimenter. I was like, "No, Lee, that's a mistake! We can't use that!" The camera department are the Green Berets. They can't fuck up. They have to be perfect.

But I thought Lee was my best bet to get the movie I wanted, shot by shot. If you're inexperienced and some superstar DP comes in, then it's *their* movie. It's *their* set. Everyone's looking to the DP for the choices, like, "Where is the camera going to be and what's the shot?" I never wanted to be in that category. This was my movie.

Ben Affleck: The image of Hollywood as "the suits versus the creatives" was still very present in the early '90s. In the '80s, blockbusters and cocaine had kind of ruined the movie business, and I thought people like Rick were getting it back to where it needed to be.

Jason Davids Scott: The joke was, when Rick and Lee were talking about anyone close to the studio, they'd refer to them as "the VanPattons of the VanPatton family."

Bill Wise: When anyone—Jim Jacks or Sean Daniel or anyone from Universal—would come through, it was kind of like, "Jesus is coming!" The word would go out that the VanPattons are on set, and that meant you had to put your weed away.

Jason Davids Scott: The opposing baseball team in the movie is sponsored by VanPatton Plumbing.

Bill Wise: John Cameron was the first AD [assistant director]. He was from the studio system. He was from the VanPattons.

Richard Linklater: At that time, I was thinking, Universal is going to assign some AD who's going to want to make *Dazed* look like we're making a fucking TV commercial. I mean, we hired John Cameron, but he ultimately felt like more of a studio guy. We weren't on the same wavelength.

John Cameron: It was, "Oh you're from *Hollywood*. You work for the studio"—which I never had in my entire life! But I can see from Rick's perspective that, "Oh, this guy's here to restrain me and control me." As an AD, you're the one in the director's face, saying, "Hey, we have to break for lunch" or "We can't start the day until 8:00 a.m. tomorrow because of the actors' turnaround." Rick doesn't want to hear that. There was an instance where he kicked a bucket at me.

Jim Jacks: The Austin crew didn't get along so well with the L.A. people because they looked at them as studio people. But they

were mostly people who worked with the Coen brothers and Sam Raimi, so they were hardly "L.A. people." They were independent people.

Bill Wise: John Cameron had his own ideas about how to make a movie. There would be times when he would be tapping his foot and wringing his hands, like, "Waiting for *you*, Mr. Linklater." Rick would just be looking at a light, or walking by himself, lost in the poetry of making a film and really enjoying it. And John's kind of like, "Okay, dreamer, what's the shot? I've got 75 people out here in Cuban heels. We need to figure something out!"

Ben Affleck: Rick would say, "I don't know exactly what we're going to shoot today." To the small mind, that sounds like ineptitude, or inexperience, or both. But to the open mind, it was easy to see that, actually, what he was doing was creating a creative environment, making people feel free and open, and that's one of the biggest challenges of directing.

Deb Pastor: John Cameron was openly disrespected by the kids. Not all of them. Not Matthew. Not Anthony Rapp. But there were some who openly disrespected him. It was humiliating to watch. This bunch of kids, who are inexperienced, are having the time of their lives, running around, and Rick is letting them throw whatever they want into something. So, if somebody has an idea, everything stops so an actress can talk about how she *feels* about what she's saying. Understood. It's important! But he was giving them a lot of free rein. You can see why somebody would go, "What? We have 20 shots to get done today!"

Jason London: The AD, we had a real problem, because in his mind, he's like, fuck, I've gotta wrangle 20 fucking kids. From the minute we got to the hotel from the airport, that dude started talking down to us like we were six-year-olds, and we had to put that motherfucker in his place real quick.

John Cameron: Rick would tell the actors, "Hey, it's us against them." And that's the movie, right? The kids against the establishment? So, creatively, that made a lot of sense.

Ben Affleck: Like a lot of really brilliant people who break molds, Rick had to face a lot of resistance from status quo–oriented people who believed in a fixed way of doing things. Somebody in the production department, who I won't name, went around saying openly, "Rick is the worst director I've ever worked with in my life." And he was somebody with a significant position, in a place to really influence how people saw Rick.

That guy went on to be successful and work with some extremely talented filmmakers, and my guess is that now he would see what Rick was doing. But at the time, his was a principal voice of dissent, and there were other murmurs of dissent, too:

"This kid doesn't know what he's doing."

"This is film-school bullshit."

"This isn't a real movie."

Richard Linklater: It was like, I am Mitch. I'm the new kid. And they're hazing me. I've just got to make it through this gauntlet of abuse and disrespect.

Chapter 12

We Were All Hormonal

"It was like a relationship where you're too much in love. And that's going to burn itself out."

People hook up on film sets all the time. That's what tends to happen when beautiful people leave their boyfriends and girlfriends (or husbands and wives) at home to go on location with other beautiful people and perform a job that requires them to create realistic chemistry with one another.

Hookups likely happened even more often in 1992, when there were fewer legal ramifications to prevent you from making out with your co-workers, and before everyone had cell phones, so actors had to find more creative ways to kill long stretches of downtime.

Still, there's something almost sweet about most of the hookups that happened during *Dazed*. Somehow, the romances seem more innocent. For many of the young actors, this was the first time shooting a film away from New York or L.A. Most of them didn't know anyone else in Austin. Long-distance calls to loved ones back home were expensive, so they saved their most intimate conversations for one another. And, according to Christin Hinojosa-Kirschenbaum, who played Sabrina, the excitement of embarking on something brand-new, together, bonded them: "It was kind of like the feeling of a first love."

Meanwhile, Linklater was trying as hard as possible *not* to be in a relationship. In September 1991, just a few days before he flew to L.A. to pitch *Dazed*, he met a young University of Texas graduate student named Tina Harrison, who had moved to Austin from the Bay Area to study art history. One of Linklater's friends was attracted to Harrison's roommate, and this friend dragged Linklater to a show by the Austin punk band Moist Fist, hoping he'd find the young woman there. Once they got to the show, Harrison and Linklater ended up hanging out instead. She thought he was cute, she later said, even though he had "weird hair."

Harrison is still his partner today, nearly 30 years later. But at the time, Linklater wasn't ready to be in a committed relationship, unless it was with his own film.

Jonathan Burkhart: I'll tell you why there were a lot of hookups on *Dazed*. There was a lot of flirting within the script. It was like: It's summertime. School's out. Let's make out!

Wiley Wiggins: You're stuck with a bunch of other young, horny people. We all had our confidence bolstered in a way that maybe it hadn't been before. And they put makeup on you. Somebody does your hair. You look good!

Adam Goldberg: You take a group of really interesting, talented people in this really seminal period in their lives, and you stick them

in a hotel together, and suddenly, there's a fine line between sexuality and creative fulfillment.

Marissa Ribisi: We were all fucking *hormonal*. We couldn't help it!

Wiley Wiggins: I had a crush on everybody on that set. I had a crush on Parker. I had a crush on Chrisse.

Parker Posey: I had a crush on Cole Hauser. Rory, he's another one I had a crush on.

Wiley Wiggins: I was an unstoppable ball of hormones. I had a crush on Marissa. She was a sweet lady, and I have a curly hair fetish.

Marissa Ribisi: I was so in love with Jason [Lee] at the time, even though he made me crazy. I compare every relationship I have to that relationship, because he was such a *good guy*. He made me feel ways that every person should get to feel. It's the first time, so there's no jadedness, and you give yourself over completely. We went through every emotion, like a baby snake who can't control their venom. So I didn't have crushes. I just loved him so much.

Nicky Katt: You'd be going back to your room, and you'd see one of the cast members coming out of somebody else's room, when the sun's coming up.

Jonathan Burkhart: Milla Jovovich and Shawn Andrews were always stoned and staring into each other's eyes. They were always making out. *Always.*

John Swasey: We had an 8:00 a.m. call, and I went down to the lobby at 7:00 a.m., and there's Shawn and Milla, sitting on a chair, making out. He had his shirt undone and no shoes on, and they were kissing and *fondling*. And I was like, Who the fuck are these people, and why are they doing this in the lobby?

Tricia Linklater: Oh my god, they were just nuts. We were rehearsing at a hotel, and they were on top of each other on the floor. Not even on a chair! And fully clothed, but some women's group was having tea, and I'm like, "There are proper ladies here! Get off each other!"

Catherine Avril Morris: They had a long row of individual cast member trailers, and Milla and Shawn were just doin' it *every*

night. Because all of our trailers were connected, they would all be rocking.

Lisa Bruna: All the minors had to have guardians with them. That was the rule. Milla was 16 at the time, and her mom was always around, but I guess they found ways to sneak off.

Marissa Ribisi: Anthony and Parker were also really tight on the film. I think they had a *thing.*

Parker Posey: We had a little tryst. I adored him. He was bi at the time. Starting out, it's so much about, "What's your inspiration? What kind of films do you like? What kind of theater do you like?" I was a real nerd in that way, and so was Anthony.

Parker Posey *(left)* and Anthony Rapp *(right)*
with stand-in Stella Weir

Jason Davids Scott: Parker's boyfriend was an indie guy who worked for a film production company in New York.

Anthony Rapp: She shared with me some of the difficulties she was having with that relationship. She felt to me like a safe haven, not that I was aware of needing it, but she was somebody that I really connected with, really quickly. Maybe we were able to connect so much because she was outside of that relationship. So, when she was back in it, there wasn't as much room for me, you know?

Tracey Holman: Ben Affleck really had a thing for one of the production assistants, Valerie. She had a boyfriend, and she kept saying, "No." He kept coming over and talking to her anyway.

Valerie DeKeyser: There were so many hotties on the set. I was like, why is he paying attention to *me*? He's got a whole gaggle of women that he can choose from!

But he wooed me. He sent letters, jokingly: "To the only woman I could ever love . . ." He would see me and run across the set and pick me up and swing me around. And the funny thing is, I was not sold. And he was like, "I'm really much better looking than this! I gotta be this big football player with bad hair. This isn't who I am."

Ben Affleck: Everyone was having sex with each other, except me. I didn't sleep with anybody the whole time!

Tricia Linklater: There were all the guys from L.A., and then there are all the extras. And I'm saying, "Do not date the extras! They are underage. And their daddies have shotguns. You have never been to Texas before. Get off the extras!"

Sasha Jenson: I had the biggest crush on Christin, but she was so young. And I was just like, *That's bad.*

Christin Hinojosa-Kirschenbaum: Sasha and I had a *thing.* I was 16 and he was 26, I found out later. Not cool, dude! He told me he was 22.

Sasha Jenson: I had lied to everybody in the beginning, to get the job. If I had told the truth, I would've lost the job. So this was a conflict for me. What happened between me and Christin was very, very, very limited. We kissed. I don't even know if I would call it "making out." I knew it was wrong. But it was still sweet, and I feel like I still am holding my head high.

Christin Hinojosa-Kirschenbaum: He's a good guy. A gentleman. Nothing too untoward happened.

Deena Martin-DeLucia: Once Sasha found out I had a boyfriend, he pursued me. And I didn't go for it.

Sasha Jenson: In my mind, I was like, I'm playing the kind of guy I never was in high school: the drunk, belligerent womanizer.

So I gave myself permission to flirt. All of our relationships were pretty accurate on-screen, and, in theory, Deena was my girlfriend in the movie. I did meet her boyfriend, and we were flirty, but I was flirty with *everybody*.

Peter Millius: Well, *everybody* flirted with Deena. She was gorgeous. From time to time I'd ask, "Hey, is there anything for me to worry about here?" and if she said no, I said, "Cool." She liked to flirt, too, but most of that flirting was innocent.

Ben Affleck: You know Deena, the blonde girl? I'd never seen a woman that looked like that before. She was so sexy and so confident and so empowered. I was deeply impressionable, and totally in awe of all these sexy, awesome people.

Deena Martin-DeLucia: Before Peter got out there, Matthew asked me out on a date. And I turned Matthew down! I wasn't gonna mention it, because who would turn down Matthew McConaughey? It was at rehearsal, and he was like, "Do you wanna go have lunch?" and I just said, "I have a fiancé, and I don't know if he would want me to do that."

Matthew McConaughey: I couldn't have known she was with Peter at the time. That's probably another reason Peter and I got along. We've got good similar taste in ladies.

Jason London: While everyone else was trying to hook up, Chrisse and I were already taken care of, from the audition. They say love at first sight is BS, but it's not. We started doing the scene, and she grabbed my hand, and she said, "You have the most beautiful hands I've ever seen." And I was just thinking, "Well, trust me, you have beautiful *everything*."

Chrisse Harnos: We didn't have cell phones at the time, and I was so broke, I was living in a friend's living room and using the pay phone downstairs. So, after the audition, I gave Jason the number of the pay phone, and I was gonna wait there for him to call. And apparently, he had inverted some of the numbers and wasn't getting to me. When he finally got through, he was like, "I've been trying every combination!"

Jason London: Is that true? I thought I remembered going home with her *that night*, from the audition. I feel like it was immediate. I can't imagine waiting that long to call her. When we got to the hotel, it was like, not only do I get to play the coolest character in the world, but I've got this beautiful girlfriend that I get to sleep with every night.

Jason Davids Scott: Jason and Chrisse were very sweet together. She was a couple of years older than him, and she was from New York, and she was kind of an intellectual.

Michelle Burke Thomas: Chrisse was the smartest person I'd ever met.

Jason Davids Scott: She didn't seem like the kind of woman who'd like a guy like Jason. She had been a model and she'd traveled around the world. He was living in L.A., but he'd grown up in Texas and Oklahoma, and he wasn't very worldly. I remember his family coming down to visit him, and his dad was a very Oklahoma person, with a cowboy hat and a drawl. He was just very small-town.

Jason London: I came from a poor family. They called us the "Beverly Hillbillies." My dad had a pickup with a camper on the back, and we would crawl out of that and go to school. I wore Walmart "Rustlers" instead of Wranglers, and kids made fun of me for my Payless shoes.

Chrisse Harnos: When Jason and I were together, we were just so, *ughhh*. I mean, like, telling people, "We're so in love!" It was a new feeling. I wish we'd had a little more subtlety. I'm sure we made a lot of people gag, because there were other romances and jealousies going on.

Sasha Jenson: Joey and Rory were in love.

Rory Cochrane: I thought Joey was cute. At the pizza party, she was wearing a red country shirt and little cutoff jean shorts. And I was like, if I get this movie, I'm gonna go to Austin and *get that*.

Joey Lauren Adams: There wasn't a need to define much between me and Rory. We were in a magical world, and *Dazed* was such an amazing experience and we were young and we were *artists*.

He would bring cassettes and introduce me to music. We could sit in the hotel room and listen to music for hours. I don't do that anymore. My husband and I don't stay up until 4:00 a.m. listening to music, you know?

Chrisse Harnos: Rory's different from his character. He's very refined and delicate. He's sensitive. He was open with me about his relationship with Joey.

Rory Cochrane: I was 20. She was a few years older, and she had more life experience. I wasn't that sexually active in high school. I mean, I'd lost my virginity and I'd had a girlfriend, but Joey was more mature than I was. Women are supposed to be more mature than men anyway. She definitely had the upper hand. I was infatuated with her. She probably thought she was just dating a kid.

Joey Lauren Adams: I love Rory. He's such a sweet kid!

Jason London: The girls were seeing certain guys, and Michelle would go out of her way to overtly flirt with them. So that pissed people off.

Michelle Burke Thomas: I had a crush on Rory, for sure. I thought Rory was one hot little number. For some reason, I felt that I

Jason London and Michelle Burke

was totally not his type. He seemed more interested in the Joey Lauren Adams kind of thing. I was a simple small-town girl. I probably still had an Ohio accent. I was not "city" at all, and that's a turnoff to some people.

Jason London: Michelle didn't realize she was coming on strong to pretty much every guy the girls liked. It was like, the nerve of this girl! I don't know that Michelle would remember it that way, though.

Michelle Burke Thomas: Oh, I would agree with that. Now, my husband is always like, "Michelle, you can't call people 'sweetie.' You can't touch them, or grab their hand while you're talking to them. They think you're hitting on them." But that's just the way I was raised! I'm from the Midwest. That's the farm girl mentality in me.

I can say this: everybody's got their type, and most of those guys weren't my type. Ben wasn't my type. Jason wasn't my type. Adam . . . well, Adam was sweet! I feel bad saying he wasn't my type.

Adam Goldberg: My girlfriend back home was [actress] Clea Lewis. We worked at a bookstore together. There was all this intense sexual energy on *Dazed*, all these beautiful girls and all these good-looking guys, and I had just started a relationship. There was this feeling of not being able to be there in the same way everyone else was, because most everyone else was single. So if you couldn't fuck around, then it really felt like, *bad*.

I'm a very faithful guy. But I remember things getting a little too close for comfort, to the point where I was confessing to my shrink about feeling like I was on the verge of straying.

Chrisse Harnos: We were at a restaurant, having amazing food, and then we were all dancing and definitely something transpired between Michelle and Adam on the dance floor. Adam was looking at me like, *What?!*

Adam Goldberg: Man, I must've been so drunk, because I don't dance, but I remember dipping Michelle, and her coming up and kissing me.

Michelle Burke Thomas: Well, I do like to kiss, so I wouldn't be surprised if I kissed him! But it was probably just for fun.

Sasha Jenson: Michelle was a very flirty person. I was always flirty with Michelle, but she was in love with someone else.

Michelle Burke Thomas: I'm laughing about the fact that everybody thought I was flirting with them, because I had my own drama going on. I was still married to my high school sweetheart at the time, but we were definitely on the outs. We had moved to Hollywood not even a year before that, and he wasn't super excited about moving to Hollywood, and I had been modeling and traveling the world, and then I was doing *Dazed and Confused*. I was asking him to move his things out, so that when I got back from filming the movie, I would be on my own. The last thing I was thinking about was everybody else's boyfriends!

Ben Affleck: I had a really intense crush on Michelle. I thought I had a chance! And then, all of a sudden, she hooked up with Cole. And was my friend!

Michelle Burke Thomas: I was falling in love with Cole, but Cole and I were both in other relationships.

Adam Goldberg: It'd be hilarious if you A/B'd my interview with Cole's interview. I doubt Cole was on the phone with his shrink talking about how guilty he felt about the fact that there was sexual tension between him and Michelle.

Cole Hauser: Oh yeah, Michelle was definitely my chick during the whole time. She had a great smile, which she still has. She's a wonderful person, and you could see that coming out of her.

Michelle Burke Thomas: We became friends during that scene in the movie when Cole whacks me on the butt. I had a bruise *this big* on my bottom the next day. He's a strong boy. So even though he was trying not to do it very hard, he had to do it 15 times.

I was like, "You bruised me!"

And he was like, "I'm sorry!"

And then we started hanging out. The first time that I really felt butterflies was when we were in his hotel room listening to Jimi

Hendrix really loud, closing our eyes. I had never heard Jimi Hendrix that way before.

Jason London: Michelle was so blatant in that flirtation. Cole said something like, "She called me to her room, and when I went in there, she was taking a shower." He walks in and she's like, "Hi! Oh, sorry, I'm in the shower. Just sit on the bed." And he's like, "Yep!"

Deb Pastor: I'm sure a lot of people were talking about Rick's personal life, too.

Katy Jelski: One of the women Rick was seeing during *Dazed* was the woman who's now his partner.

Richard Linklater: Tina and I had been hanging out a little bit in the spring before the movie started, but I didn't want to be anyone's boyfriend, so I just said, "I'll see you in September."

When I was making films back then, it was such an intense process that I would get all monk-like in redirecting all my life energy solely into the film, like there would be no other needs or desires. There had always been that thing in athletics, like, "Should athletes be having sex before games?" Remember Jake LaMotta in *Raging Bull*? He won't have sex before a match. He's dumping cold water on his crotch. I took that to heart. When I was in my early 20s, working offshore, I was celibate for almost two years, because I was like, I need to read, I need to write, there are so many movies to see, I'm not going to spend any time chasing that. You can actually turn that off and on.

So for *Dazed*, it was like, No, I'm off the market. But then, there was always that one day off a week, where I could maybe get a beer and spend some quality time with Kahane.

Wiley Wiggins: I think Rick was also dating Kahane while he was making *Dazed*, which is probably a none-of-my-business situation.

Melanie Fletcher: Kahane is the pregnant lady buying vodka and cigarettes in the movie. She had a little cameo in *Dazed*.

Richard Linklater: Kahane and I had met at Sundance, two years before *Dazed*.

Kahane Cooperman: Rick was there for *Slacker*, and the film that I made was *Cool Water*. It was a "young-ice-sculptors-in-love" story. They carved Jimmy Page out of ice because they loved Led Zeppelin. Ultimately, I saw a little metaphor in this young love of this couple, and the fact that they put so much into these 300-pound blocks of ice with their chainsaws, only to have it melt away.

Richard Linklater: Kahane and I dated for some time. I really liked her. But it was a long-distance thing—she lived in New York—and it was not in the best spot when I started on *Dazed*. I was making a movie. I didn't want to be dating anybody. But she was cool. I think she understood that.

Kahane Cooperman: We were young and our relationship was definitely complex but full of intensity and adventure. I was game for that at that point in my life.

Katy Jelski: Obviously, Kahane is an ambitious, talented person, and she wanted to make a documentary about *Dazed*.

Kahane Cooperman: Every instinct of my filmmaker self was telling me there was a compelling story here. And it turned out, my instincts were right, and I'm so glad to have captured this seminal experience of making this now classic film at such an interesting time in the trajectory of Rick's career, the earliest experiences of some superstars-to-be, and of a real moment when indie met studio film.

Ben Affleck: I remember Rick being kind of frustrated with her being there, but he was also like, "Well, I agreed to let her do this."

Richard Linklater: I didn't bring Kahane out to make the documentary. I didn't want her to do it. *She* wanted to do it. She was like, "Oh, I can stay at Deb's."

Kahane Cooperman: One of my best friends from high school, Deb Lewis, was living in Austin. She was a cinematographer. We worked on the documentary together.

Richard Linklater: It just seemed like an extra level of pressure, and I was under enough pressure.

Katy Jelski: Kahane kind of got fucked over, because she came down, and Rick had all these other girlfriends. He would shoot these incredibly long days, and then go rewrite stuff, and then hang out with all these different women. I don't know when he slept!

Richard Linklater: What the fuck is she talking about? I wasn't with anyone that whole summer, except Kahane, and that was in a "not enough to be a very good boyfriend" way. How would Katy—the script supervisor—know anything about what I was doing later at night after dailies, which was simply planning the next day's shoot, with barely time to do that? The gossip she's describing might apply to other, less strenuous times in my life back then, but definitely not anywhere near the making of the film.

My personal life was not very orderly, put it that way. But I wasn't interested in a relationship. There was just that full-on, crazy commitment to *Dazed.* It was like a relationship where you're too much in love. And that's going to burn itself out.

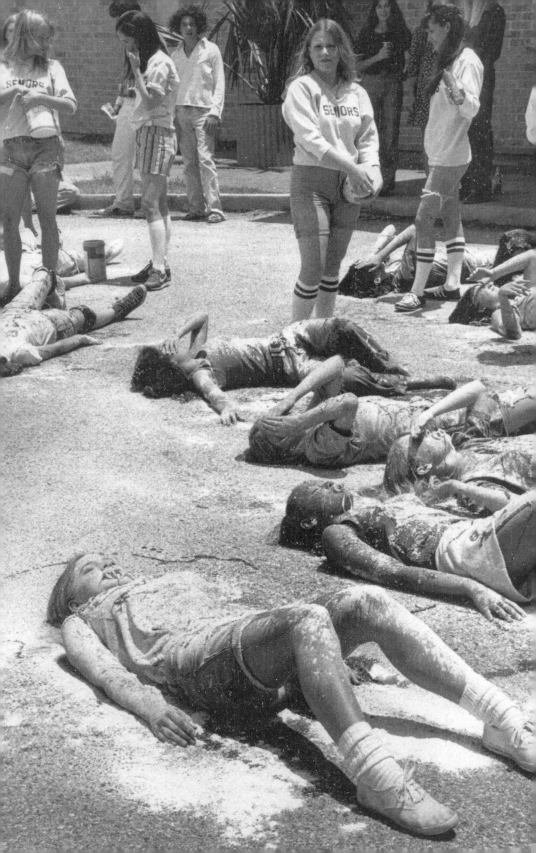

Chapter 13

Air Raid!

"You get to torment younger people . . .
It gets a little screwed up."

sk any woman, and she's likely to tell you that her closest friendships during high school were pretty intense. Parker Posey and Joey Lauren Adams were only pretending to be high school girls in *Dazed*, but the bond between them was just as strong as the real thing.

Both had come from unglamorous backgrounds in the South. Posey grew up with a twin brother in Louisiana and Mississippi. Her father sold cars. Adams grew up in Arkansas with three siblings. Her father owned a lumber yard. Posey was dark-haired and ironic, while Adams was blonde and direct, but Posey says they were "two sides of the same coin." Both women considered themselves tomboys in a cast full of "girlie-girls," and both viewed themselves as outsiders who didn't have many friends back home. Their first big scene together was the infamous "aid raid" scene, where their characters haze the incoming freshmen, with help from the other senior girls. (You can spot Renée Zellweger among them. She's at the far left in the photo opposite this page.) The chemistry between Darla (Posey) and Simone (Adams) was immediate and natural. Over time, it would become the movie's most memorable female friendship.

On the page, Darla was just your average bitch. But Posey made her *that* bitch—the hilarious sadist who's feared and admired by freshmen forever. She played Darla like a ruthless queen from the Old Hollywood era, amplifying the melodrama and relishing her role as torturer. When she shouts, "Smile! You love us!" she's not just commanding the freshmen—she's commanding the audience. Adams is right there beside her, but she's the sunnier, perkier second-in-command. "I kind of felt like Parker's sidekick in real life, too," Adams admits.

Together, the two actors improvised some of the film's best lines, bringing a tangible charisma to characters that could have been one-note bad girls. It's a tricky balance: Play a mean girl with too little charm, and it's hard to understand how she got popular in the first place. Play her with too much charm, and you risk making the whole film look latently cruel. On screen, Posey and Adams both found the perfect middle ground between likable and sinister. But according to a few other actors, it was sometimes hard to tell whether to love them or hate them even when the cameras weren't rolling.

Joey Lauren Adams: At first, I didn't like Parker at all. At the callback auditions, she already had the part, and she was smoking and smacking her gum.

I was very into being Southern. That was sort of my identity. I tried to be like, "Oh, you're from Mississippi? I'm from Arkansas!" And she was like, "I don't know where that is." I just felt dismissed, like, "You're denying your Southernness? You're so New York now? You're from Mississippi, girl!"

Parker Posey: Oh my god! Well, my parents would play geography with me in the car, and they were like, "What's the capital of Denver?" They got me a map of the United States and a puzzle and I was like, "I don't care where anything is! I will know where it is when I get there." So yeah, it was like, "Where's Arkansas?" "Well, it's a hundred miles . . ." and I'm like, "You know what? I'm not interested."

Joey Lauren Adams: I was probably a little envious, too, because I still felt like a fraud. Like, "Who am I to be here?" I watched *Fame* when I was growing up, and I was like, god, how great would it

have been to have gone to school like that? Parker was living in New York, and she went to drama school. It felt like somehow Parker deserved it more. I didn't go to acting classes, so I'm sure I was a little intimidated by that.

Parker Posey: Drama school was hard. I was on probation almost the entire time and almost kicked from the program for my attitude.

Joey Lauren Adams: Parker and I got teamed together, which at first, I was like, Oh my god . . . But then of course I fell in love with her.

Parker Posey: She was like a sister to me. I think Joey having come from Arkansas, that connected us. And we both had strong fathers. And we were both outsiders. We didn't grow up with money. I think if you grow up with money, and you didn't have to struggle, you are really different from people who are middle class or lower middle class. When you have to create something for yourself on your own, it's just a different game.

Joey Lauren Adams: My father had a hardware store, and I worked there when I was younger. So I knew, like, plywood comes in four-by-eight sheets and what a two-by-four is. That helped when I first came to California and tried to get into acting. I was dating an artist who grew up in Topanga, and there was an area right where Topanga comes down and hits the ocean, and all these kind of weirdo people ended up leasing out these little lots and building these little shanty houses down there. Our friend rented a place for us, and it was literally a shack, and I added on a bedroom myself.

Parker Posey: Joey's not what she appears to be. You think she's, like, this pretty girl, but she seemed like an outsider to me.

Anthony Rapp: Like I said, weirdos are drawn to other weirdos. Parker was definitely a weirdo, and Joey was a secret weirdo.

Joey Lauren Adams: Parker was that drink of water I'd been so thirsty for. In L.A., a lot of people I thought were cool, I realized later were posers. To be surrounded by that, and then meet Parker, who is so authentic, and so *who she is*? It was amazing. Parker was larger than life. How can you *not* be attracted to her?

Parker Posey

Marissa Ribisi: Oh, yeah, Parker was the life of the party!

Wiley Wiggins: Parker had cultivated this almost drag queen–like personality that's super larger than life. She wasn't referring to herself in the third person yet at that point, but she was getting there. You know: "Mother needs a drink!" I love her.

Jason Lee: Parker was very punk rock in her attitude. Very confident. Very uninhibited.

Tracey Holman: We used to hang out at the Carousel Lounge in Austin, and it used to have an old guy named Ray who played the organ. Parker was dancing on top of the table, holding a slice of pizza for Ray, who was blind.

Jeremy Fox: I got high with Parker on top of a 24-hour doughnut shop. We climbed a ladder to the top and got baked and ate a bunch of doughnuts.

Joey Lauren Adams: Parker was getting recognized on the street.

Parker Posey: Right around the time that *Dazed* happened, I got cast as a love interest for Andy Kavovit, who played Paul, on *As the World Turns.* My character was kind of a podunk Sammy Jo Carrington—like, Heather Locklear from *Dynasty.* She was conniving and manipulative. I don't remember much about that experience except, like, sitting on rocks made of papier-mâché and learning that I shouldn't project my voice like I did in theater. I love melodrama. To me, that stuff is so funny!

Catherine Avril Morris: Her character was some young hick ingenue girl with the fakest Southern accent.

Parker Posey: My character was from Kentucky. I was like, I'm supposed to be from the backwoods? But we just went to Saks Fifth Avenue to buy my silk wardrobe!

Joey Lauren Adams: People hated her character on that soap, so they'd yell mean things at her as she walked down the street in Austin. She just laughed: "Ah ha HA HA HA!" I mean, she's Parker! She loved it.

Deenie Wallace: Parker Posey was *everything.* She had so much charisma. Just watching her walk around set, I thought: Who is this woman? How can I be just like her? My whole body froze up any time she was around. I don't think I had a single conversation with her the whole time, because my brain would just glitch off any time she got nearby. I couldn't talk. It was like when you have a crush on someone and everything just starts rattling and your brain is empty and you don't know how to even say your name.

Erika Geminder Drake: Parker sort of took the "freshman girls" under her wing. We went out to a bar with her, even though I was 13 and I had no business being in a bar. And she lent me one of her dresses and she just kind of hung out with me like I was like a little sister.

Catherine Avril Morris: Honestly, I hated Parker. She was really bitchy to me. My mom was a single mom, working really hard to raise her daughters, and one time she came to visit me on set, and we go to the makeup trailer and I'm showing her around,

like, "Here's the makeup person!" And Parker's sitting there and she looks over at us and says, "*Ughhhh*, showbiz moms." Like *really loudly*, so we both heard. And it was just completely untrue! That was not our life! My mom and I were both just like, "Dang, bitch!"

Parker Posey: I was being a snarky high-school bitch. That was the job. I was in character and being obnoxious. I'm truly sorry it landed flat and hurt her feelings. But who's to say, when boundaries blur, how this affected the performances? Weren't we "at work"? In the sets of the '90s, which were improvisatory in nature, [this level of working] was not only permissible but encouraged.

Jason London: When Parker would go into that mode of Darla, we'd all be dying. It was amazing how she could turn from being such an angel to such a bitch, and then right back to angel.

Priscilla Kinser-Craft: When the senior girls were loading us up in the truck to go do the hazing thing, Parker was stuffing our mouths with the pacifiers, and she literally shoved it in my mouth as hard as she could. It *hurt*. And I gave her a dirty look. And Rick said, "I love that look that you gave her!" It was because I was like, "Do it again and I'm gonna jump out of here and pull your wig off!"

Parker Posey: There was something fun about the hazing thing. Like, "Oh yeah! This is when I play a badass bitch!" You get to torment younger people, and you know the boundaries, but people get carried away and it gets a little screwed up.

Jason Davids Scott: The first day I was on set was the "Air raid!" day. In the script, it's like, "Darla, angry senior, comes out and says, 'Air raid, you freshman bitches!' and they get on the ground." So I'm like, okay, they'll do this setup with this one little actress and then they'll move on. But the second Parker opened her mouth, everyone was like, "Oh my god, who is that?" They ended up spending *half a day* on Darla, and that was all driven by Parker just stepping up and saying, "This is *my* scene."

Parker Posey: Rick said, "The crane is going to come down, and it's going to land on you, screaming, "Air raid!" The crane cam-

era looked like this alien thing coming out of the sky, and it was going to land on me in a medium shot, so I thought that bigness was what was called for. I was like, "Okay, I can really scream!"

Excerpt from Dazed and Confused
Shooting Script, June 25, 1992

The freshman girls are in a circle with the senior girls walking around them. The attitude of the senior girls varies from fun-loving to sadistic. Darla seems to have assumed the role of tyrannical drill instructor.

DARLA
You disgusting little freshman sluts . . . AIR RAID!

The freshman girls are on their stomachs immediately.

DARLA
That was pitiful! On your feet, you lazy little bitches!

As soon as they are all up, she yells again.

DARLA
Air raid!

They drop again.

DARLA
How did you pre-pubes ever make it out of junior high? The future of our high school is doomed with

losers like you coming in. Now, let's try it one
more time . . .

> Most don't know exactly what she wants
> and don't get up very quickly.

DARLA

That means GET UP you worthless little bitches!

> They all get up immediately.

DARLA

Air raid!

> They all are on the pavement quicker than ever.

DARLA

Well, we tried, we gave you a chance. But because
you little prick teases can't quite follow in-
structions, we're going to have to try something
else.

> She signals to several of the others who bring over
> "the supplies." Soon they are dumping rounds of flour,
> syrup, ketchup, and vegetable oil all over them.

Parker Posey: I tapped into the stories I remembered of wild
girls from the South. Like the Farrah twins. They were these twins I
knew of back home who keyed a boyfriend's car because he cheated
on one of them. They had feathered hair and drove fast cars and
they were acting out. They were my inspiration for Darla. It was all
unprocessed rage.

Melanie Fletcher: The hazing in the parking lot was a hor-
rible, horrible experience. It was blazing hot and the girls were lying
on asphalt. We didn't have an adequate budget. So, we didn't have
enough money for everybody to have enough sunscreen.

Deenie Wallace: A lot of the freshman girls had sunburns on the parts of our hair, from keeping our hair parted down the middle and having to stand out in the sun all day.

Don Stroud: The prop crew couldn't find the right match, tint-wise, for the condiments. So they used real mustard and real ketchup. Those girls smelled like a hot dog stand.

Renée Zellweger: I felt so bad for those girls. I remember thinking, "That cannot feel good to have mustard on your skin in this heat. That's gotta hurt."

Priscilla Kinser-Craft: We *wore* that food. Literally. For *hours*. It started baking on us. I had tan lines where the lines of the food were. The smell of ketchup has never been the same for me after that.

Robert Janecka: Parker would stand over those girls and spit and hold it two feet below her, and then suck it back into her mouth. I'd never met anyone who could do that before.

Parker Posey: My brother used to do that to me. He'd be watching wrestling on television and I'd walk into the room and he would jump on me from the couch and pin me down onto the floor and do that thing.

Wiley Wiggins: Parker improv'ed one of the best lines in the movie: "Wipe that face off your head, bitch!"

Parker Posey: I had done a play in college, a Brecht play called *In the Jungle of Cities*. And the mistranslation from one of the lines was "Wipe that face off your head."

I was going out dancing and seeing RuPaul at the Love Machine, a party in New York. And RuPaul was like, "Work it, bitch! Yesssss, bitch! Come on, bitch!" in that way of not really meaning "bitch." Being like, "Yeah, you tough bitch! You're tough! Get on the pavement and fry like bacon!" So "bitch" was positive.

Joey Lauren Adams: We were shooting all the hazing stuff, and we were running behind. We finished what we shot-listed, and Rick was like, "I want to do this thing with Joey." And it's like, "We don't have time!" And Rick's like, "No, I want to do this thing with Joey." And everyone's just looking at me like, *Grrrrrr.*

(left to right) Freshman girls Priscilla Kinser,
Heidi Van Horne, and Erika Geminder

Rick says, "What do you need?" And I said, "Two girls." So he got two freshman girls and he was like, "Where do you want the camera?" And I said, "Right there." And he was like, "Alright, let's go!" He didn't even know what I was gonna do! And I did that scene where I say, "Fry like bacon, you little freshman piggies!"

That "fry like bacon" line came from a real thing. I went to the University of Arkansas, and my sister was a Tri Delt, and my mom was like, "You have to pledge! Please!" So I pledged Tri Delt and I was miserable. They'd be like, "Come on girls, you're going to go sing 'I'm a Little Teapot in front of the Sigma Nu house!"

I was walking to class one day with my friend, and one of her

sorority sisters walked by, like, "Fry like bacon!" And my friend got down and fried like bacon! And I was like, "What are you doing? That is so humiliating!" And that's when I de-pledged. Watching her fry like bacon was the last straw.

Ben Affleck: I would watch these scenes unfold, like the senior girls hazing the younger girls with the ketchup, and I'd watch them add dialogue and make it better. I'd always thought the ideal was, you have a scene and you try to get as close to that scene as you can. And here they were, like, "No, forget about that. Just take the scene and make the actual scene itself better." That was revolutionary to me.

Adam Goldberg: Parker and Joey both really understood that we were supposed to be doing an improvisational thing. Maybe that's part of the reason they were so close. Not everyone understood that.

Michelle Burke Thomas: Jocy and Parker glommed on to each other fast, and that was that. And no one else was part of that. And it's sad, because there could've been other lifelong friendships there, at least between me and Parker. I don't know about Joey. Joey can't stand me. Never has, never will.

Joey Lauren Adams: You can't be friends with everyone. You click with certain people. You just do! This probably sounds harsh, but I don't know if I felt that Michelle had much to teach me. It's like, you're searching for a specific thing, at a specific moment, and at that moment, I'd found what I was looking for in Parker.

Jason London: There ended up being a lot of inter-turmoil between the girls.

Richard Linklater: It was so high school. The only thing I could wrap my head around was like, "Okay, well, it's a film about high school, so maybe it'll feed into that."

Chapter 14

The Next Marlon Brando Probably Wouldn't Call Himself "the Next Marlon Brando"

"Save my sheets, I'm gonna be famous."

Remember Shawn Andrews, the often bare-chested actor in *Dazed* with the lustrous alt-rock hair and pouty lips? He played Pickford, the stoner whose house party gets busted

when the beer delivery man unwittingly tips off his parents. Nobody knew who Andrews was before he got cast in *Dazed*. And yet, everyone says that he already took himself pretty seriously as an actor.

Andrews was born Shawn Milgroom in Littleton, Massachusetts. Not a lot is known about his life before *Dazed*. According to the biography that appeared in the movie's press materials in 1993, he lived in New York for a while, starred in an off-Broadway production called *Pretty Sue*—"A powerful story of disenfranchised youth"—and wrote and starred in a short film called *Marky Boy* about "heterosexual AIDS" (whatever that means) that was featured on the E! network. According to his IMDB page, he quit the American Academy of Dramatic Arts in Pasadena, California, by storming into class wearing a trench coat and sunglasses, lighting a cigar, and flipping off the whole room. As he turned and walked out, his teacher deadpanned, "That was his best performance all year."

When he was cast in *Dazed*, Andrews's handlers were positioning him as a future leading man. And who knows? With his looks and his confidence, maybe he could've been one. *Dazed* was a crapshoot, or maybe a lottery ticket—some of its principals became stars, while others completely dropped out of acting. But the cast believes there's a good reason why you haven't seen Andrews much since.

Richard Linklater: *Dazed* was about high school, and it *was* high school. Factions were starting to form.

Jason Davids Scott: There were lots of little cliques. But Shawn and Milla were completely on their own.

Jason London: Listen, there's a reason why we all called him Prickford. I never had any behind-the-scenes drama with anyone, except with Shawn.

Ben Affleck: Shawn's part was written as the main stoner in the movie, and in a '70s movie, the stoner is, like, Sean Penn in *Fast Times at Ridgemont High*. He's the hero.

Greg Sims: I was Shawn's manager at the time. Don Phillips wasn't particularly interested in seeing Shawn for *Dazed and Confused*,

but I told him I had a gut feeling he would be a good choice, and to Don's credit, he brought him in.

Don Phillips: Shawn was a showboat. He was kind of nice-looking, but he was so over the top. I didn't want him. But, for some strange reason, when you're casting a movie, you've got to go with the director's choices.

Richard Linklater: When Shawn first came in, he had a bullshitty attitude. I said, "Oh, I remember guys like that in high school." He seemed like he had a slightly shady side, but I liked that. I thought, that's what makes Pickford different from the jocks. He's not an athlete. He's the guy who drives the Trans Am. He's probably dealing drugs. Don correctly sensed that, "Oh, Shawn's not like these other guys." And I said, "Well, he's not, but that's good." I wanted the ensemble to be all different types.

Greg Sims: There was interest, and they went even further. Universal wanted Shawn to structure a three-picture deal—a guarantee that they could have three pictures at their election—before he even did a final test. So we made that three-picture deal, and then he got the role. That was crazy, because what are the odds? He'd never done anything like that before. He delivered. And they thought he could be *the guy*.

Richard Linklater: Oh, Universal made all the actors do that three-picture deal. It was like, "All these young actors! What if one of them becomes a huge star?" Even though they're paying them shit—everyone's getting scale—they hope you become huge. Like, "You owe us another film, and you're not getting a million dollars."

Jason Davids Scott: Before I'd even gotten to Texas, Shawn's manager called me and said, "This is the guy who's gonna be the *breakout star*!" No one else's manager called me.

John Cameron: His management published an ad, something about him being the next Brando.

Greg Sims: I don't believe I would ever actually include copy in a client's ad saying he was the next Brando, but I recall an ad that was definitely hyperbole, and I did believe in his talent.

John Cameron: His manager hung that millstone around Shawn's neck.

Greg Finton: Someone took out an ad in the trades that said, "Congratulations, Shawn Andrews, on getting the lead role in *Dazed and Confused*." Rick saw that and thought, "Wait a second! There *isn't* a lead role in this film."

Richard Linklater: Yeah, it seemed aggressive. And it further isolated him, that someone would invest those couple thousand dollars on a client who hasn't made them any money yet. Overly pushing someone just pisses off everybody else. At some point, you quit taking the manager's calls just because you're like, "Dude, leave me alone. I've got a whole cast. It's more than just *your guy*."

Bill Wise: The first time Shawn stepped off the plane, they had told him not to fucking cut his hair, and he had shorn the back of his head completely short. That was his entrance. Not only did he cut it, he cut it to a *skeetch*. As we say in the poker game, that's his tell. I remember Rick being fucking furious with him.

Ben Affleck: Shawn was always going around with his shirt open and flexing his abs, and he earned the loathing of everybody because: A) he was showing off his bod all the time and doing a hair flip, and B) he quickly took up with Milla, so naturally every guy was jealous of him. Somehow, the energy that was happening in the hallways of the Crest hotel was also bleeding into what was happening on camera.

Jason London: Because he was banging Milla, he thought he was the biggest stud in the world.

Rory Cochrane: He was too confident. To the point where he would tell the hotel staff, "Save my sheets, I'm gonna be famous."

Don Phillips: He cut the sheets into swatches to sell them to the maids, saying, "I'm gonna be the superstar of all time. Here, give me $25 and here's my autograph and you have a piece of the sheets!" Jerk-off.

Don Stroud: One time, I was just going to the restroom and Shawn stopped me. He said, "Hey, bro! Who's your favorite actor?"

I said, "I don't know, Robert De Niro?" And he said, "You'll say the same thing about me one day."

Nicky Katt: Shawn Andrews was just a piece of shit. When I got to the hotel lobby, he shook my hand, and he had something gross all over his hand. It was like, "What are you doing?" He was doing that Jared Leto bullshit. Like, you know, Jared Leto was sending people rats and used condoms for that *Suicide Squad* movie? It was like that.

Greg Sims: He'd put everybody off with his personality the minute he walked in a room. He would mindfuck people. It becomes really hard to work with someone like that.

J.R. Helton: I was two seconds away from kicking his ass. He was going to paint a Jimi Hendrix poster for Pickford's room. It was like, "Yeah, he wants to get into his character" but then it was like, "Oh, he's too busy." So I ended up painting it, and then he came in to "improve" upon it.

Shawn sat down and he'd say, "Okay, I see a train!" and Milla would paint a train. Like, a comically childish train. And then he'd say, "I see a flower!" and the other girl would say, "Groovy!" and paint a flower. It was really that stupid. I think my IQ dropped 50 points just having to listen to these three idiots.

He was looking in the mirror, looking at his hair, when I was trying to talk to him. And then, the next day, I heard somebody say, "Hey, did you see that Hendrix poster that Shawn did? He did that all by himself!" He was such a pretentious jerk.

Jason London: Shawn and Milla had decided that they were going to live as if they had been to Woodstock. In their hotel room, they took the bed apart, and they built like a fort out of it, and they stayed just to themselves and didn't interact with anybody else.

Richard Linklater: Poor Shawn. He was just kind of in his own movie, you know?

Sasha Jenson: He was playing a character that wasn't in the movie the rest of us were making.

Richard Linklater: Shawn wanted his character to die in

a car accident. I'm like, "I don't know what James Dean movie you were playing in your head."

Bill Wise: They needed to take all these yearbook pictures of the cast, for publicity. And Shawn had a cigarette, which you would have never done when you took your high school photo! But Shawn wouldn't be denied. It was one of those things where Shawn was so young and so gripped in his own self-excitement, he didn't listen.

Matthew McConaughey: That was a first major role for him. You come in, you're learnin' how to do it. One thing you can always do is just completely commit to the character, and I think he went very into . . . I'm not gonna use the word "Method," because it's overused.

Tracey Holman: He was constantly reciting *Cat in the Hat*. That was his acting exercise. *All the time.* People were like, "Can't he at least choose something else today?"

Joey Lauren Adams: Shawn would make us listen to *Green Eggs and Ham* in the van on the way to set. And we were like, "For real?"

Melanie Fletcher: You could hear him playing bongos in the trailer. The people on either side of him would go into their little honey wagon and try to collect themselves for the next scene, and they'd complain. He was constantly playing the bongos.

Chris Barton: I was writing for *the Daily Texan*, and when I was interviewing people from the movie, I asked him where he was from and he said, "Everywhere." I don't think I got a lot of straight answers from him. He called acting "painting." That seemed kind of pretentious.

Jason Davids Scott: He warmed up for scenes by listening to Jim Morrison and doing a weird dance.

Chris Barton: Oliver Stone's *Doors* movie was out around that time.

Jason London: Other people would be right in the middle of doing a scene, and he'd get up and get a big boom box, turn the music all the way up, and walk straight through our scene.

Kari Perkins: All the different departments were trying to mess with him. He'd set his jam box down and someone took his batteries out. And he came back and he was trying to play it and couldn't figure it out. We were all laughing.

Joey Lauren Adams: We were rehearsing and Rick was letting us improvise, and Shawn improvised, *I'm gonna go off by myself.* And Rick was like, "Uh, okay, but . . . you're not gonna be in the scene if you do that?"

Matthew McConaughey: We were all supposed to be sittin' around talking, and Shawn goes, "Well I wouldn't be right *here*, I'd be over *there*, under the tree with my girl, and I'd be reciting some poetry." And I remember Rick was like, "Cool, but you could do that here in the group." Rick's thinking, *I don't have time to go set up a whole new shot over there.* And Shawn's goin', "No, no, no, no, no! It's more true to me that I'm *over here* under the tree with my girl."

Greg Sims: Linklater gave the actors a lot of rope, and Shawn kind of hung himself with it.

Katy Jelski: He wasn't into being a workaday actor. He was going to be a *breakout actor.* Maybe he'd read something about Marlon Brando or something, but he had this idea that each take had to be unique and different and you just kept the surprises coming.

In the scene at Pickford's house, when he goes downstairs to sign for the keg, we were doing these wide shots, because there's a lot of people. Then we came in to do coverage. He could not do the same thing twice!

Wiley Wiggins: Shawn would improvise in the middle of *shooting* a scene as opposed to when stuff was being worked out beforehand.

John Swasey: So, Richard wants to rehearse the scene where I'm delivering the keg. We do the scene. Afterward, Shawn says, "So in *that* moment, I was trying to be stoned . . ." We do the scene again, and Shawn goes, "Okay, *that* time, I was trying to act hungover . . ." This wasn't some critical moment. It's like, you're saying goodbye to the *fucking beer guy.* Just do the scene!

Richard Linklater: He really wanted to be good. He cared *so much.* He'd call me at night, and we'd have these long talks. He was focusing too much on his relationship with me and not on his relationship with the ensemble. He just didn't fit in.

Jason London: I think the whole situation with Shawn came to a head when we got pretty close to getting in a fight. There's a scene in the high school where we're in the classroom, and Sasha is flirting with the teacher. Shawn is in the back of the classroom, and he's got a big red rubber ball, and while we're doing these scenes up at the front, he's in the back, throwing the ball across the room. It was like, whatever he could do to take attention away from other people and put it on himself!

Rory Cochrane: He did that to all of us. That's a shitty thing to do to other actors. If you're so fucking confident, then be *good* and shut the fuck up.

Jason London: Linklater was trying to diplomatically talk to Shawn about it. But I was like, "I'm gonna go punch this guy in the face." I was just fed up with his crap. I think Rick saw it about to happen, and he was just like, *Whoa!*

Richard Linklater: I think I prevented a fight. It was like, "Oh, we've got a problem. You have to be best friends, and you *hate* each other."

I mean, *everybody* wanted to kick Shawn's ass.

Rory Cochrane: If all the people in this book are all saying the same thing about him? That's fucking *karma.*

Anyone Who Had a Cell Phone
Was Instantly an Asshole

"What are you doing here? You're, like, 80, dude."

O ur ridiculous schedule means basically having to do a day and a half's work every day," Linklater wrote in his *"Dazed by Days"* diary. "I go in with my shot list and get to spend lunch hearing how we can't get all of it because we can't have any overtime or meal penalties, etc. This kind of shit is the most obvious difference between this production and the making of *Slacker*. On this, time is money, and there's not time to think or go very far with new inspirations—you better have it all going in. On *Slacker*, time was our least expensive commodity, and there was more room for variations on the original plan if it was an improvement."

Linklater ultimately finished *Dazed* on time and under budget, but only after brutal fights with his producer, Jim Jacks, over how every minute of both of their days was spent. Two weeks into production, Linklater sent a memo to Jacks with a list of complaints about the way he was working. He claimed that Jacks was drinking too much around set, socializing with the cast in inappropriate ways, and basically ruining his film by micromanaging the director. "Whether this is an okay movie or a great movie, your job is to enable me room to make a great movie," Linklater wrote in the memo. "Two weeks in, I'm making a compromised piece of shit."

Ethan Hawke: What motivates Rick most, in life and work, is a heightened awareness of time.

Jason Reitman: There has never been a more laid-back person who seems to be more concerned with the passing of time. He seems to understand the feeling of sand slipping through your fingers on a cellular level, and he's been able to approach that concept in multiple films. I think you really see that in *Dazed and Confused*.

Alison Macor: I think what *Dazed* does so well is capturing different approaches to time. There's the sense of urgency when you're a teenager, that things have to happen *right now*. But there's also a sense of, "Oh my god, this is going to last *forever*," that this time period will never end.

Richard Linklater: In school, you just stare at the clock all day long. That was the best thing about not being in school anymore. I never felt like I was run by a clock again. Until I started making movies.

Jim Jacks: Rick would fall behind on schedule, and he'd say, "The studio will give us six more days." And I'd say, "Rick, I don't think they will!" It took a lot of pounding before he finally understood that they weren't gonna give us more money.

Wiley Wiggins: I wasn't cognizant that there was any kind of tension between Rick and Jim until the baseball game scene, where we do the "good game, good game" hand slap.

Richard Linklater: Every day, during lunch, Jim took it upon himself to say, "We don't really need this scene. We're running

late anyway. We can cut this. We can cut that." He took it upon himself to be the arbiter of what we needed. And when I said, "No, that's important!" he didn't believe me. I don't know if he ever won those arguments, but it was like that *every day*, and it felt like a constant stream of negativity.

I wanted that "good game" scene because that's what you do after those Little League games! Everybody who played Little League in that era knows that.

Bill Wise: You know, when they do that little "good game, good game"? That's the small-town stuff that Rick definitely nailed. I remember touching gloves and doing a walk-down line after those Little Leagues games, saying, "Good game, good game, good game." And then you got a soda pop and you were on your merry way on your bicycle back to the house.

Ethan Hawke: When the game is over and Wiley's character goes through the obligatory "good game" line—that's where the movie stumbles on real grace, the stupidness and beauty of our ridiculous lives.

Wiley Wiggins: I guess they were behind schedule and Jim didn't want to shoot that "good game" scene. Rick had a cup of water, and he was so mad, he threw it on the pavement.

Katy Jelski: I said something to Jim about how we *had* to shoot the scene. I made up some reason why we wouldn't be able to cut from the game to the guys paddling in the parking lot unless we had this moment. Jim looked at me like, "This is bullshit. I know it's bullshit. *You* know it's bullshit." And then he just threw up his hands and we got the shot.

Richard Linklater: When I tell him, he thinks I'm lying, but when *she* tells him, he believes her.

Jonathan Burkhart: Jim was always just gently off to the side, pacing, looking at his watch.

Jim Jacks: Rick believes in improvisation and *rehearsing, rehearsing, rehearsing*. As a producer, that drives you somewhat insane, because you don't know if you're ever gonna get a shot.

One day, we literally got to the lunch break and we didn't have a shot.

Richard Linklater: The biggest self-serving lie Jim ever told in relation to me and the movie! Years after the fact, I noticed he was starting to tell these fictional, desperate-sounding scenarios to retrospectively justify his bully behavior. You don't finish a movie on schedule, especially *this* schedule, not shooting for half a day. Maybe the first hour, or hour and a half at most. I once challenged Jim to look through the production reports to prove there wasn't a day when I didn't shoot anything in the first half of the day. He wouldn't, of course.

Jim Jacks: Rick just kept rehearsing and rehearsing and rehearsing. I came out there and I said, "Where's Rick? I need to talk to him!" And they said, "Well, he's asleep in his trailer."

Richard Linklater: Another big lie he started telling years later! I basically never left the set. I spent about 30 minutes in my trailer the whole shoot, and that was only toward the end of the movie when I realized I even *had* a trailer. And I certainly never slept.

Jim Jack: I went and banged on the door, like, "Get on the set!"

Richard Linklater: Jim was disappointed with me because I didn't want to sit in a bar with him all night telling old war stories. He'd get pissed at me, like, "You know, some directors don't sleep!" And I'm like, "I like to get eight hours of sleep, because it's important that my brain works!"

Alison Macor: Jim had to leave town once, and as a joke, Rick put a picture on the camera of Jim looking at his watch. Jim was like, "It pissed me off, but I kind of *liked* it." That was his personality.

Richard Linklater: Jim would leave town to work on other films. He wasn't around the entire last week and it was such a relief. He and Sean [Daniel] had like four other films coming out that year—*Tombstone, Heart and Souls,* all these movies. He'd be all, "The script for *Tombstone* came in, and it's great!" I'd be all, "Wonderful, but I'm trying to make a movie here." Now, *Dazed* is a big film on their résumé, but at the time it was kind of this arty thing. Jim

was so busy working on other films that he would be on the phone talking while we were shooting.

Nina Jacobson: I can't tell you the number of times that Jim Jacks would call me on the phone and recite lengthy monologues from the *Tombstone* script. He'd say, "Like you know like you know like you know . . ." and then he'd read you Doc Holliday's *entire monologue.*

John Frick: We used to call him Phone Jack.

John Cameron: He never shut up. He was one of the most logorrheic people I've ever known. Once he started talking, you couldn't get a word in edgewise. It drove people insane. It drove *me* insane. If he buttonholed you and started talking to you, you were *doomed.*

Kim France: When I visited the set, the Hollywood producer kept fucking up the shots. He had a cell phone, and they had to cut a scene because they could hear him talking in the background. It was the scene where Michelle Burke kisses Jason London.

Richard Linklater: Jason London broke character, like, "Can you shut up over there? Jim, stop talking on the phone, we're rolling!"

I printed that tape, just so Jim would watch it in dailies: "Will you shut up?" Okay, cut. "Jim, we're trying to make a movie here!" A wonderfully awkward moment.

Kim France: This was before anybody really had cell phones. Anybody who had a cell phone was instantly an asshole.

Richard Linklater: Jim resented me because I wasn't being his best friend, so he had to find that elsewhere, by bothering the actors. He shouldn't have been staying in the hotel with the actors. I wasn't partying with the actors! I was their boss! But Jim just wanted attention. He's the nerdy kid who never had any friends.

Jim Jacks: One night, I almost threw Joey into the pool with Cole Hauser. She said, "Oh my god, the producer's about to throw me in the pool!" And I said, "What am I doing? I'm acting like I'm 18 years old again." So I put her down and said, "Well, never mind. I'm going to my room to try to remember that I'm 20 years older than you."

Joey Lauren Adams: When you're 23 or 24, anyone over 30 is ancient. So we were all just like, "What are you doing here? You're like, 80, dude."

Jim Jacks: I felt pretty old sometimes. I was supposed to play Renée Zellweger's father in one scene that got cut from the movie, and I said to her, "So I guess I'm gonna be your father?" And it was, "Ah, Mr. Jacks, you're not nearly old enough to be my father!" And I said, "You're gonna do very well in this business."

Richard Linklater: It was so unprofessional. It was just creepy. They all had to be nice to him. And he was promising the actors future roles, like, "Eh, you know this *Tombstone* script? There might be a role in it for you."

Ben Affleck: He told me he'd produced *Midnight Run*. At the time, I considered *Citizen Kane* and *Midnight Run* to be the two greatest films ever made. And then I became vaguely aware that he didn't really produce it. He was sort of an exhibition executive, or he had some peripheral role. He was prone to exaggerating his involvement in stuff. I think he liked having all these young people around who looked up to him.

Adam Goldberg: Jim was like, "Hey, there's a Coen brothers movie coming out, and there's a part for you: the elevator guy." I read the script for *The Hudsucker Proxy* on the train on the way home to L.A. from Austin. And by the time I got home, they had already cast Jim True in that role.

Joey Lauren Adams: When I think of Jim Jacks, I think of him sitting in a chair, watching us, amazed by us. He's such a geek, there's a sadness to it. Maybe he was wishing he had been like us when he was young. Or maybe it was just, like, *I have power over these kids.*

Richard Linklater: Jim was a frustrated screenwriter, and he was acting like *Dazed* was *his* film. I started to feel like, god, how do I get this guy out of here? I certainly learned not to allow someone like that around on future movies—just cut out that middleman, and life gets a lot easier.

Chapter 16

We Turned into Vampires

"They were like, 'We wanted to make sure you were still alive.'"

bout 30 minutes into *Dazed and Confused*, the film switches from daytime to nighttime. There's a marked difference between the breezy, "school's out for summer" tone of the beginning and the more manic tone of the rest of the movie. The daytime part mostly focuses on kids hanging out and chasing one another around, with some mild humiliations along the way. But once the sun goes down, the freshman boys get paddled, Mike (Adam Goldberg) gets into an ill-advised fistfight with Clint (Nicky Katt), and a total stranger points a gun at Pickford (Shawn Andrews). *Dazed* was mostly shot in sequential order, and when the cast started working at night, they felt the vibe changing, too.

Sasha Jenson: When we transitioned from day shoots into night shoots, that's when it shifted gears for us, too. We all got a little darker during that period, because we turned into vampires. We'd work all night and then hang out all day. We just wouldn't sleep.

Peter Millius: Our hotel was by the Congress Avenue Bridge, and that was the bridge where the bats would come out at dusk every night.

Jason London: Right when it's time for the bats to wake the fuck up and eat, they all fly out at the exact same time. It's kind of scary at first. As the sun is setting, a million bats fly out and people go down and lay on the banks of the river. The bats have sonar—they won't run into you. You'd lay down and have a million bats flying right over you, so many that it almost darkens the sky. And in the morning, you can watch them come back in.

Peter Millius: Our nights would end long after the bats were coming back under the bridge to sleep.

Marissa Ribisi: We'd come back from working, and then everyone would go to the bar at 7:00 a.m. and start drinking till noon.

Rory Cochrane: After the first night shoot, I wake up in my hotel room, middle of the day, and the maid's in the room. And I'm like, "Fuck, I'm sorry, let me put the Do Not Disturb sign out." The next day, the maid's in the room. I'm like, alright, I'll put the Do Not Disturb sign out *and* the dead bolt. And the next morning, I hear the door open and *boom!* It's the dead bolt. *Boom!* And I'm like, what the fuck is going on?

And then I hear voices, and I see a guy's arm reaching inside the door with a screwdriver, trying to take off the dead bolt. And I just *lost it*. I opened the door, and I was like, "What the fuck is wrong with you people?" And they were like, "We wanted to make sure you were still alive." You know: *Maybe you're a fucking heroin addict?*

Adam Goldberg: Everyone was just drinking and getting stoned the entire time.

Cole Hauser: As you get older, you can't get smashed on a Sunday from 1:00 a.m. to 8:00 a.m., fall asleep, and wake up at 6:30 p.m.

and feel good. But at 17 years old, you're like, "Give me a bottle of water! I'm ready to go."

Adam Goldberg: I got so high one time in Jason's room, I didn't recognize myself in the mirror. I think that was the last time I smoked pot while we were shooting. I went into the bathroom and looked in the mirror and thought, *I don't know who you are.*

Ben Affleck: I had a bad experience with marijuana at 15. I had a dissociative panic attack. So I only smoked weed if everyone else was smoking, and I had to sort of "Bill Clinton" it and fake it. I didn't really like marijuana. I also wasn't a very heavy drinker then. I became an alcoholic much, much later, and I'm in recovery now, so that was a whole different time. I was a little nervous, like, "Should we be drinking before we're working tomorrow?" Some people were actually drinking and getting stoned *at work.*

Jason London: The first time I smoked real pot and worked was the scene where the old man grabs my arm and says, "So you're gonna throw for so-and-so yards this year?" I went into the scene and met this lovely old couple and I was like, Holy crap, this is surreal! So that's when I discovered, like, wow, for certain scenes, having a little puff was not a terrible idea.

Sasha Jenson: I got high during the scene on the baseball field, with the paddles, and I *hated* it. I wasn't comfortable doing that.

Joey Lauren Adams: I was high for the scene on the football field. A lot of us were.

Rory Cochrane: We were shooting one scene where we're driving around in a Chevelle, and I took a hit off a real roach. That scene's not in the movie, but Matthew had to hit me on the back when they were rolling so I'd wake up.

Jason London: We basically smoked Austin out of all of its weed, and the person who was the worst was Milla. The rest of us were like, okay, we just have to wait till we can get more weed. She just went into full meltdown mode.

It might've been just her getting into character, but there was a certain point where people were like, "There's no more weed! I gave

you all we had! It's not like this shit is growing in the backyard. This shit comes from Mexico."

John Frick: There was a cast party in the Emporium and the cast pretty much trashed it. The owner of the place we used for the Emporium scenes, one of his big demands was no smoking, no drugs, no alcohol on his property. We had rented expensive pool tables. It must have been a long, wild, late-into-the-night party, because there were beer cans on the pool tables and cigarette butts everywhere.

Keith Fletcher: I was at the party, and Milla was standing next to me, and she literally just passed out.

Tracey Holman: At one point I looked up and I think Affleck was carrying Milla outside.

Keith Fletcher: She woke up a minute or two later. We were all standing over her, trying to help her, give her air, and she comes to, like, "Oh, that was weird!" Got up, and went on with the rest of the night.

The rest of us were like, "That was not healthy."

Melanie Fletcher: Everybody was getting high, and Milla wasn't eating. She *always* felt like she was just about to tip over.

Adam Goldberg: Back at the hotel, we were all getting into trouble.

Jason Davids Scott: Ben Affleck got a baby Siberian husky, but he had to keep it in the hotel room and not let them know, so he just didn't have them clean his hotel room, and it smelled.

Ben Affleck: Only when you're 20 do you think, "I'm broke, I have nothing, maybe I can be responsible for an animal?"

Anthony Rapp: I heard the cast got reprimanded because they went through the hotel, tipping over the tall ashtrays that were near the elevators. But I didn't do that.

Ben Affleck: We'd come back to the hotel from wherever we were, and everyone would break into the kitchen.

Marissa Ribisi: My brother came to visit. At one point, he and Jason [Lee] broke into the kitchen and stole cheese in the middle

of the night. I was like, "You fools! We're gonna get kicked out of here."

Adam Goldberg: It was Marissa's brother, Giovanni Ribisi, Jason, and me, chasing each other, running up and down stairs, and drinking. I was sent to my room the day before my fight scene with Nick, and when we shot it, I used the security guard who sent me to my room as my substitute for Nick, because he was just some fuckin' asshole security bully dick.

Cole Hauser: This was around the time Matthew [McConaughey] came into the fold.

Joey Lauren Adams: I didn't know what to think of Matthew. He wasn't staying at the hotel, so I didn't get to know him that well. The whole cast was there for two months and got really close, like family. And Matthew didn't feel like a part of that to me.

Adam Goldberg: I thought McConaughey was just a bartender who got a kitschy, nonsense role. He directed me in the last scene we shot together, like he was telling us what to do. I was just like, "Oh, I'll let this local have his little power trip." I mean, that's Matthew.

Cole Hauser: Matthew was like, "C'mon guys, get out of your hotel room, let me take you down to the river." You'd have these tubes, and you'd just throw a big cooler of beer in the middle, and you'd just float. It's muggy and nasty in Austin during the summer, so to have a cool spring with a beer in your hand and beautiful girls cruising by? It was heaven on earth.

Adam Goldberg: Floating down the river? I never did that shit.

Renée Zellweger: They were bonding as a cast, and I wasn't part of that. But the stuff they were doing? That was my life! We were always at the lake on the jet skis, or tubing, or whatever. That's just Austin.

Chrisse Harnos: We went river rafting. Oh god, you're in rapids, and I was scared shitless. It was like, *Ahhhhhhh! Should we really be doing this?*

Rory Cochrane: We went cliff jumping. There was a river, and you'd run and jump off the cliff, but you'd have to wear sneakers be-

Rory Cochrane *(left)* and Cole Hauser

cause you'd dive so far down, it would hurt the bottoms of your feet. I don't know why I thought that would be great to do.

Jason London: There was a swing hanging from a tree near the water. You could go up in the tree and swing out, but there were these spikes, like a death pit, that you had to clear to get to the water. You had to let go, and if you dropped at all, you were literally impaled. And apparently, that had happened a few times to people. That was terrifying. I refused to do that.

Sasha Jenson: Oh god, it was horrible. One of the local girls jumped in first, and she didn't come up. Yeah. *Didn't come up.* One of us said, "And that's the last we ever saw of her!" Like we had to throw in the comedy moment first. And then everybody jumped in looking for her.

We found her, and it wasn't good. She was under a log. And then I heard that, like, a week later, somebody *died* there.

Nicky Katt: Cole and Rory and Ben and me, we were all blowing our per diem at Red's Indoor Range. That was probably me

trying to show off, you know, "I'll show you what real men do" kind of thing.

Peter Millius: Ben liked to be the alpha male. He was definitely one of the guys who was like, "Yeah, let's go to the gun range!" Him and Cole.

Cole Hauser: We'd shoot all kinds of guns: .44s, 57s, shotguns. Man, they would give you *anything*. If they'd had a bazooka in there, we would've shot it.

Peter Millius: One time, we all went out drinking. At 9:30 in the morning, we get back to the hotel, and someone says, "Hey, let's go to a shooting range!" I thought, "Guys! We're all *hammered as hell*. There is *no way* anyone's gonna give us guns." We get to the gun range, and everyone's so excited, they all run in ahead of me. When I walk in, half the guys already have guns in their hands, shooting! And I can't believe they're giving all of us guns! It's a Texas thing. They're like, "You want a cup of water, or you want a gun?"

I think Ben and Cole actually *bought* guns.

Ben Affleck: Texas had extremely lax gun laws and most of us came from states where it was next to impossible to buy guns, so part of the newfound freedom of being down there was that a bunch of us bought guns and went shooting at ranges on weekends, which seemed fun and innocent at the time, but given the subsequent tragedies with young people and guns, it now makes me uncomfortable to remember.

Rory Cochrane: Cole might have bought a .357. I can't confirm whether or not he shot it out the window.

Cole Hauser: First of all, you can't buy a .357 in the state of Texas. And I definitely didn't shoot it out the window. That's just nuts.

Rory Cochrane: We went shooting on magic mushrooms. Which was not a great idea. Some of the girls were just waving the guns around, and we were supposed to be in *lanes*.

Cole Hauser: I wasn't on mushrooms. Rory might've been. He's pretty good about doing that stuff and you not knowing that

he's on it. He's not one of those guys dancing around in the tulips, speaking to the sky.

Nicky Katt: *He* was probably on mushrooms. I was not. But that probably explains why Rory discharged a firearm into the roof of the place. He was like, "Hey, how do I . . ." *Boom!* And it went off right over his head.

Rory Cochrane: Nobody got hurt, thankfully.

Nicky Katt: In hindsight, it's incredible that nobody drove off a cliff or anything. We were pretty off the leash.

Chapter 17

Go Ahead and Stab Me!

"Those guys were terrifying. They were like werewolf men."

Cole Hauser and Ben Affleck were already pretty good at playing asshole jocks. Both were bullies in *School Ties*, a 1992 film about a Jewish high school football star (Brendan Fraser) harassed by anti-Semitic teammates at an elite prep school.

"I don't think Ben had ever caught a ball in his life," says Hauser. "He was not a great athlete. But he was a big, strong kid. We'd pass the football around, and that was a wonderful experience, and maybe six months later, we were in Austin together. So there was a built-in relationship there."

They played raging meatheads again in *Dazed*, but both actors give their roles a surprising fragility. Affleck portrays O'Bannion, a perpetual senior who keeps failing school in order to beat up the next crop of incoming freshmen. He can be funny—he tells one potential victim's mother that he's actually *protecting* her son, because "there's some ruffians about"—but more often, he's the butt of the joke, willfully oblivious to the fact that his friends consider him a "dumb shit." His attempts to intimidate younger kids always seem kind of pathetic.

O'Bannion's second-in-command, Benny, desperately wants to be viewed as dangerous. It seems like he's actually *performing* for the freshmen. He's a wannabe thug whose baby face and loud, hammy, bad-guy voice are dead giveaways that he's still just a kid. But according to the actors who played the freshman boys, both Hauser and Affleck were genuinely scary.

Ben Affleck: I hate bullies. I'm not a bully. I didn't want to play bullies, but I kept getting bully parts. Maybe I looked like a frat dude or something? I can't explain it, because I had never even been inside a fraternity. I barely went to college. We certainly didn't have any hazing rituals, and hazing rituals would be an anathema to my personality anyway. But I seemed to fit the part, physically. I'm 6'4", so I'm taller than most actors. And I was probably around 225 pounds. I was fat, and I didn't care. I didn't work out. So if they were looking for a guy to chase somebody around, it was me.

Cole Hauser: Ben and I would do some intense scene where we're beating somebody up, and we'd come back kind of fired up.

Wiley Wiggins: Those guys were *terrifying*. They were like werewolf men. I still have nightmares about Ben Affleck running toward me in slow motion, like, drooling.

Ben Affleck: Cole was definitely more scary than I was. Cole was a scary guy! He has a certain menace that I'm not sure he's aware of, but he's got this laconic drawl, and he was quite big and strong and very "Method" at the time. And he took that to mean he should be terrorizing those kids.

Wiley Wiggins: It was this fucking Method actor bullshit that those L.A. guys were into. They all thought they were gonna be the next James Dean.

Cole Hauser: I never thought of myself as a Method actor, but who isn't into James Dean?

Jason Lee: Method acting was quite popular in the '90s. People were looking up to the Marlon Brandos and the Paul Newmans and the James Deans. There was more of that acting-class dedication to craft, and I think that comes about when you're new to acting. When you're older, it becomes more mechanical.

Adam Goldberg: Everybody was trying to be cool. It was like what I imagined was happening with the *Rebel Without a Cause* guys: Who can be the toughest? Who can smoke the most? Who can drink the most? Who can shoot the most guns? We were all obsessed with James Dean and Old Hollywood history. Everyone wanted to be the next *whatever*, and you can sort of see that in us.

Cole Hauser: The guys I liked were Brando, Christopher Walken, De Niro, Pacino, Duvall—you know, when American men were *men*. They've gone through stuff. There's life in their eyes.

Nicky Katt: You can spot everybody's influences pretty clearly if you watch *Dazed* with your eyes closed. Adam's doing Woody Allen. I'm doing Mickey Rourke. Cole's doing Christopher Walken. You *really* notice it with Cole. You're like, "Wait a minute, why would a football player talk like Christopher Walken?"

Jason London: He was just *fascinated* with Christopher Walken. He very much had that cadence, and that quasi-Elvis mumble thing, like, "Hey there, *guh-bah-guh-bah-guh*, Pinky boy."

Adam Goldberg: Cole was definitely a tough guy. Our joke about Cole was like, "Yo, how ya doin' kid, I'm from Santa *Bah-brah*."

He talked like he was from Boston, but he was from Santa Barbara. I mean, he's half-Jewish!

Rory Cochrane: Cole has been calling everybody "kid" since he was, like, 15. If you don't know how old he is, you're not gonna know how old he is, you know what I mean? There were guys 10 years older than him, and they were intimidated by him. And he's like a 17-year-old kid!

Jason Lee: Wait, Cole was 17? Shit!

Jason London: He had a gravitas to him even at that age. His dad is Wings Hauser, and he had that same attitude. Cole's dad was notorious for being a badass that you don't want to mess with. I think he dated the girl from *The Exorcist*, Linda Blair.

Peter Millius: Cole was a real "Who the fuck are you looking at?" kind of guy, almost to the point where if anybody looked at his crowd wrong, he would want to start a fight.

Jason Davids Scott: One night, we were at a blues bar, Antone's. It was Adam, Cole, and Ben, but I was the one who had the car, and they were already drinking. We knew very quickly we were not gonna get in. There's a giant bouncer at the door, and Cole's like, "C'mon let me in!" And the guy's like, "No, I can't let you in," in a totally nonconfrontational way. It was just sort of, *Scram, kid.* And Cole was like, "What, you want a piece of me? You wanna start going at me?"

Cole Hauser: Antone's was a predominantly black place, and we were often the only white guys in there, and we'd just dance our asses off and *sweat.* I did get in a fight there once, and they threw me out, but I think it was because I ran into somebody *inside* the club, or he ran into me, and we just got pissed off. It's one of those moments where they're like, "Fuck you!" and you're like, "Fuck *YOU*," and *boom!*

Jason Davids Scott: Instantly, Adam turned to me and he said, "Get the car," and they both pulled him away like, "We're *leaving.*" We're driving down the road, and then Cole looks at me and he's like, "Oh fuck. You're the *publicist.*" And I said, "You're fine. I'm not gonna tell anybody."

Sasha Jenson: Cole definitely stood out as the guy who was in the deepest state of a drunken stupor amongst all of us. A couple of times, I had to bail him out. He won't remember it, though. We were at a bar, and a guy wanted to stab him.

Cole Hauser: All I remember is Sasha screaming, "Guy's got a knife!"

Sasha Jenson: Cole pulled up his shirt and said, "Stab me! Go ahead and stab me!" And it was almost like he was *in character.* I was like, "This is real life, dude! You're not in Hollywood. You're gonna get *stabbed*!" And I literally pleaded with the guy. I was like, "He's a kid! He's a baby! Don't stab him."

Catherine Avril Morris: Cole Hauser seemed *angry as hell.* He seemed like a rodeo bull, right behind the gate, before they release it to go kill everybody—which worked. He and Ben used that vibe.

Mark Vandermeulen: We were the incoming freshman kids, and the actors playing the older kids were trying to intimidate us. They were like, "If you fuck this scene up, we're coming after you." It was like, "Okay. Shit!"

Esteban Powell: When we were at the baseball field, Wiley got his ass handed to him.

Wiley Wiggins: Rick had asked if I could play baseball and I lied. I think I said something like, "Yeah, but I'm not very good." And he said, "Oh, it's gonna be fine." I had never touched a baseball in my entire life! That is how much I lied. I wanted to be in a movie!

We went out and tossed a baseball back and forth, and I just couldn't catch it. Couldn't throw it. And he was like, "Oh. *Oh.*"

John Frick: Wiley couldn't get the ball to home plate.

Mark Vandermeulen: Wiley's throwing the ball, and it's going the wrong way, *every time.*

Jason Davids Scott: They got a stunt double to pitch in the movie, but it was a scrawny guy who was about a foot taller than Wiley. That's the best special effect in the movie: making Wiley Wiggins look like an athlete.

Wiley Wiggins: It was traumatic. I had to throw the ball for the cutaway to be done—and I *can't* throw a ball. So there was an

entire team of Little Leaguers who were the extras, and they were openly, loudly mocking me as I do this thing that I'm terrible at, *over and over and over again*. Yeah, it's *fine*. Builds character.

Mark Vandermeulen: After the baseball game, that's when the seniors paddle the freshmen.

Cole Hauser: I used to see jocks who were idiots that beat up on kids who were bad at sports. I was a jock myself, but I wanted to beat those guys up. So I made Benny that kind of guy.

Wiley Wiggins: He was scary. I've been getting my ass kicked by groups of testosteroned-out guys forever. I mean, I'm from *Texas*, man.

Cole Hauser: I know why Wiley and those guys were scared of Ben and me. The stunt guy put a piece of fiberglass on Wiley's ass with a pad, and he said, "You can hit him as hard as you want." And I was like, "Really?" I hit Wiley, and he turned around like he'd basically been shot up the ass with a shotgun. He started crying.

Richard Linklater: I'm pretty sure Cole is thinking of the first kid he paddled, right after school. You'd tell them, "Hey, back off a little bit!" But those guys don't know what it means to "back off

(left to right) Esteban Powell, Mark Vandermeulen, and Wiley Wiggins

a little bit." By the time Wiley was getting busted, we'd "perfected" the stunt. There was a metal bar in front of his butt—that's what they're hitting. It wasn't supposed to hurt.

Cole Hauser: I thought, Wow, what a pussy! You could've hit me over the head with a Louisville Slugger, and I wouldn't have cried. The whole crew were like, "That was so mean!" And I was like, "The stunt guy said I could!" And that kind of reverberated throughout the cast.

Mark Vandermeulen: Wiley got paddled for real.

Wiley Wiggins: Nope, I was safe. I barely felt a thing. For that scene, they blew menthol in my eyes to make me cry. But I was terrified by how animalistic their performances were getting.

Peter Millius: Cole said, "Oh my god, I really hit that kid *hard*." And then there was some sort of competition between Ben and Cole, like, "I want to make *my* kid more scared than you're making *your* kid."

Deenie Wallace: Just the way he held his chest, you could tell Ben Affleck was a silverback gorilla on set. He had this *charge*, that masculine authority.

Bill Wise: He was a *big dude*. Geez, once you put on those platform shoes, everyone was like a member of KISS. Everyone was, like, fucking 6'2" or 6'4" all of the sudden, so it was a lot of territorial pissing and pooping going on. And Ben Affleck had one of those "I am man, hear me roar!" vibes.

Jason London: When Cole and Ben are chasing the freshman guys, they jump out of the car and run. If you watch that scene again, Cole slips and falls. He busted his knee so hard. When he got up to throw the kid against the fence, he was in so much pain. He wasn't gonna yell "Cut!" and start crying like a baby. He was in agony. So he took it out on the kid.

Cole Hauser: I don't think I hurt myself. It just pissed me off. So I threw the kid against the chain-link fence.

Jason London: You heard about Cole getting in trouble by someone from the studio after that? Oh lawdy *lawdy*. The kid went and told his agent, and his agent threw a fit. It was a big deal. I don't

remember if they wanted to fire Cole, but I'm sure he got a finger-wagging, which Cole would've laughed at. He would've been like, "Ooh-kay, buddy, ooh-kay."

Jeremy Fox: My mother wanted to sue because I was totally covered in bruises. When Ben Affleck is paddling me in the movie, he's actually paddling the shit out of me.

Jonathan Burkhart: The way it was staged was that Ben would wind back, like you do with a baseball bat, and swing, but miss the kid. On the first take, he made contact with the kid. He physically hit him in the back and the ass, and the kid recoiled in absolute pain. If I'm not mistaken, the kid's mother was on set that day. It was like, "Holy shit, Ben! You weren't supposed to actually hit him!" And Ben was like, "I'm really sorry! Jesus Christ."

It was *bad*. We had to stop work for about a half hour so this kid could regain his composure. And then we had to do another take, and on the second take, we rolled again, and he hit this kid *the second time*. It was like, "Dude, this is *over*."

I was like, "What the fuck did you do? We just *told* you!" And Ben was like, "What the fuck you talking about? I barely hit the kid!" He was being very defensive. That pissed me off.

Deb Pastor: Ben was doing his Method madness, and you're watching this weirdness come out of him, and it got ugly. I'm standing there watching somebody get hurt because we're making a film. A fucking film! Who fucking cares about making a film when someone's getting hurt!

Richard Linklater: The goal, of course, wasn't to hurt anyone. We usually put a solid board there, so that the actors would be hitting a board, not a person. The only time we couldn't do it that way was when the camera was shooting from below, when they catch Jeremy as he's running away. So that one had to be done with some restraint. We padded Jeremy up, but Ben and Cole hit him harder than I asked. That was definitely a low point.

Ben Affleck: All I can say is, I am not the kind of person who would hit somebody with a paddle. I wouldn't think that was fun or funny or cool. If I hit him a little hard, it was an accident.

Richard Linklater: Ultimately, that would be my fault. If he got hurt, I feel horrible. But it was a failure of a stunt. It didn't feel like Ben or Cole ever did it intentionally. But the crew mostly sees them in character and judges them accordingly, not really acknowledging that they're acting. And young actors at that age, they're kind of wild and dangerous in general. They want to get real, and you really have to get them to back off. What we learned is that you can't let them make any contact whatsoever.

Catherine Avril Morris: After that, we shot the scene where Ben Affleck gets the paint spilled on his head.

Robert Janecka: Rick had wanted us to use real paint. I was like, "Are you crazy?" We ended up using flour and water. We were running out of time at the end of a 20-hour day, and everybody was tired, cranky, and the wardrobe only had one change of clothes left, so we had to nail it in one take. We did it one time, and we nailed it. It looks like we poured a gallon of paint on him, but it was *five gallons* of papier-mâché material. You pour five gallons of shit on somebody, they're gonna go, "What the hell?" I don't think he expected it to be that much. Ben was totally pissed off. That was real.

Ben Affleck: It wasn't one of those, like, stunty things where everyone prepares for it. It was a little loose, like, "They're just going to dump shit on you." And they did it—but it was fun! And I turned around, and I wanted to laugh, but I had to act like Biff in *Back to the Future* when he gets punched in the face, like, "Gosh darn it, heroes!"

Catherine Avril Morris: Rick was shooting these reaction shots of us being like, *"Whoa!"* while Ben spazzes out. I was genuinely scared of him.

Don Stroud: We thought he was going to kill everybody!

Deb Pastor: I was standing there during the scene when the kid got swatted, so when we dropped paint on Ben's head, it was really a highlight for everybody. If you watch Kahane's documentary, you hear everybody in the crew shrieking in happiness. Not because he just did a good job, which is what *he* probably thought.

Keith Fletcher: A large cheer went up from all the people hanging around the set that night. It was like, "Yes! You jerk!"

Ben Affleck: Oftentimes, people repeat stories about me—strange apocryphal stories that I know aren't true. But people come to believe them over time. Being any form of celebrity, you get talked about, so it's like, "Oh yeah, so-and-so was in that movie, and he paddled me!" But no. That's not true.

Everybody sort of inhabited their characters, and mine was just this incredibly douchey, fratty, redneck bully. People will send me replicas of the paddles we use in the movie, and they'll tell me they really loved my character. And I always think, "That's the way I know you and I are not going to get along. I think hazing sucks."

Chapter 18

The "Fuck" Police

"You want me to quit this movie right now?"

*W*hen it came to the final cut of a movie that was full of cursing, drinking, and smoking weed, there was one person who believed in propriety: producer Jim Jacks. He tormented Richard Linklater in pursuit of it, even though he

was known to drink and curse himself, and the two men fought hard over two scenes: when the freshman boys pour paint on O'Bannion (Ben Affleck), and when Mitch (Wiley Wiggins) makes out with Julie (Catherine Morris) in the grass while "Summer Breeze" plays in the background. The cast was caught in the middle between Linklater and Jacks, unsure whether they should listen to the cool, permissive director or the guy who was in greater danger of totally losing his mind.

Deena Martin-DeLucia: Universal wanted to keep the movie PG-13. It ended up being rated R because of the language. And Jim Jacks was so angry at us, and angry at Rick.

Jim Jacks: I wasn't trying to get a PG-13. I knew we weren't gonna get that. But there is a section of the audience that is turned off somewhat by heavy profanity. I was watching dailies, and I'd asked to cut down on the profanity, because I said, "Guys, each of you is saying *fuck* twice every scene. Now, if you guys each do that, and we shoot for 48 days, we're gonna end up cutting a movie that's gonna sound like *Mean Streets*. We're gonna have 700 versions of 'slut' and 'cunt' and 'cocksucker.' Use it sparingly!"

Mark Vandermeulen: I got a talking-to by Jim because I dropped 50 f-bombs in that movie. I was 14 years old. It was the best thing ever. It was like a cursing free-for-all!

Katy Jelski: We had to try to get a clean version of stuff without all the "fucks," and it was really hard to get those boys to stop cursing. Rick wasn't experienced working in a commercial system. He hadn't had to deal with rating boards and PG versions and PG-13 or whatever it was. He was pretty laissez-faire about that stuff.

Mark Vandermeulen: Later, I had to go back and dub over some f-words. I had to turn a "fuck" into a "shit" or a "damn."

Richard Linklater: Jim just assigned himself to be the "fuck" police. I said, "Jim, we've got kids drinking. We've got kids breaking bottles. We've got kids smoking pot. Everybody in this movie is underage. We have an R in the first eight seconds of this movie! We could change every 'fuck' to a 'fudge' and we'd still have an R. So let's at least be authentic."

Sasha Jenson: Jim would come up and go, "No more swearing!" And then Rick would come up and go, "Swear as much as you want!" And we didn't know who to listen to. Ben said, "You gotta listen to the producer." It was like having two sets of parents.

Ben Affleck: Well, I remember saying, "Jim, you're wrong!" *Dazed and Confused* was more interesting than most comedies for kids. This is a movie about what it's really like to be in high school, and they have to talk how people really talk.

Richard Linklater: Jim's from the South. He's kind of a military, conservative guy who's pretty straitlaced about sex and language. But Jim wasn't there when Ben got the paint dumped on him, and that's when Ben used the c-word. In the movie, he calls Carl's mother a "fucking bitch," but in one of the takes, Ben said "cunt." Jim saw the dailies about 24 hours later, the same scene over and over, and lost his shit.

Ben Affleck: Jim threw a fit. He threw something, and broke it, and we got into an argument. I said, "You don't get it, man! Of course we're going to swear!" There's nothing like the fucking arrogance of youth, where you think you have all the answers because you're 20 and you know everything. I was *so sure* that Jim was an idiot and I was right. Ironically, now, if some producer went crazy, I'd be much more inclined to be like, "Maybe we shouldn't be swearing in this movie?" But at the time, I wanted to stand up for Rick. I wanted to be on his side.

Jim Jacks: After that, I stormed out and found Rick in his trailer.

Richard Linklater: I think Jim had been drinking. He'd have friends in town, they'd go to strip clubs and then come back to set, and you'd have to deal with that. And I heard this slam on my door. *Pow!* He was just *crazy.* He was like, "How *dare* you!"

I was like, "Jim! He didn't say '*fuck.*'"

"'Cunt's' a million times worse!"

I'm like, "I didn't get the memo, what's the order of the bad words?"

Jim was just going *nuts*. So I was like, "Is this it? Are we actually gonna fight?"

He was triggering in me—and maybe this was appropriate for the movie—that state of self-protectiveness I remember from grades 1 through 12, where you just might have to fight at any minute and the worst thing you could do was back down. You'd always be at the ready, like, "If that guy makes a move, I'm going to aim for the side of his head."

I thought, Jim's a wrestler, so he's gonna come in for a bear hug. And he outweighs me by double, so I'll have to float like a butterfly and use my quickness and start pounding his face like, *Pow! Pow! Pow!*

That was my strategy if he came at me. But he never threw the first punch.

Jim Jacks: I punctuated that fight by smashing my hand on a telephone pole. I hit it so hard, I blew open a knuckle. There was blood dripping from my hand the rest of the day, and some poor little PA said, "Can I clean your hand, Mr. Jacks?" And I said, "No, I just want to stand here just like this."

Richard Linklater: Jim also wanted to cut the scene where Wiley is making out with Catherine at the end of the movie, because he thought Mitch was having sex! I said, "They're just making out!"

At one point, I heard that scene was off the schedule, and I looked over at Jim and I went, "Can I have a word with you?" We walked one yard over. And I walked ahead of him. Then I spun around and got right in his face.

I said, "You want me to quit the movie right now? It's me or you. I'm leaving this fucking movie." And then we just started at it, for like five straight minutes. It was *intense*. I had a good knock-down drag-out with Jim.

Then I called Sean. And Sean didn't call me back for like *a week*. I was gonna tell him, "It's me or Jim. Get this guy out of here."

Sean Daniel: I have some memory of wanting there to be a slight cooling-off period between Jim and Rick, and urging Jim to

just chill. The financial pressures were really intense on us. We had a deal where we had to deliver this movie for this price. I think it was, "Hey, these guys gotta calm down and get through the next number of days they have left."

Jim Jacks: Don't get me wrong, I really like Rick. At one point, he was like, "You and I are gonna make movies together again!" and I was like, well, maybe not. I didn't mean that I didn't want to. It was just like, maybe we will and maybe we won't, but first we gotta get through this one.

Chapter 19

Dumb and Horny and Mean and Drunk

"You've gotta get me some tits in this movie!"

If the high school movies of the '80s have taught us anything, it's that movies about teens are actually movies about sex. No matter what the film is about, someone's probably going to

lose their virginity. It happens in *Say Anything*, and *Heathers*, and *Fast Times at Ridgemont High*, and it happens most notably in *Porky's*, an exploitation flick for the young, dumb, and smutty that was released in 1981 and set the precedent for the whole decade.

Compared to the films that immediately preceded it, *Dazed and Confused* is notable for how innocent it looks. Pink (Jason London) didn't even have a girlfriend in some early versions of the script. Someone at Universal suggested that Linklater give him a love interest or two so that he didn't come off as sexless. There's no nudity in the movie, and no actual sex that's not just implied in conversation, though there are a few memorable make-out scenes. Mitch (Wiley Wiggins) and Julie (Catherine Morris) mess around in the grass while "Summer Breeze" plays in the background. Hirshfelder (Jeremy Fox) sloppily kisses a girl (Deenie Ellis, now known as Deenie Wallace) before his friends drag him away from the junior high dance. But it always looks more clumsy than sexy. And that's exactly how it felt to the actors in real life.

Before they shot the "Summer Breeze" scene, 16-year-old Morris and 14-year-old Wiggins talked to Kahane Corn about how to capture that tense moment right before two teenagers kiss. "You know what's really terrible?" Morris told Corn at the time. "Forgive me, Wiley, but I keep wondering what type of kisser he is. You know how some people kiss and put their spittle all over your face and it's kind of nasty?" Wiggins, who's clearly nervous, looks like he wants to die right there. Making the scene look awkward didn't require much acting.

Richard Linklater: As a horny teenage guy, you think there's never enough sex. You have to be home at the end of the night. You can't sleep over. There's not even a place to have sex, unless you're in a car. That was the vibe I was trying to re-create with *Dazed*. That's why there's not a lot of sex in it.

Jim Jacks: Universal really wanted more sex. Their point was, if we were gonna get an R rating, why not get it for sex? They weren't saying *don't* have language and drugs, but it was like, we might as well have sex, too.

Don Phillips: Rick needed another million dollars for the

budget, so I called Tom, and Tom said, "If you get Rick to do a nude scene, he's got the million."

Tom Pollock: I don't recall saying that. But I probably said something like, "If you're going to go R, go R."

Richard Linklater: I think it was only half a million. Tom's like, "Don! You've gotta get me some tits in this movie!" It was just a crude man-to-man joke. So I actually, in an almost jokey way, wrote a scene.

Excerpt from *Dazed and Confused* Shooting Script, June 25, 1992

Mike stares out the window at the cars going by on the main drag. Suddenly he perks up.

MIKE

Whooah! You guys see that?

TONY AND CYNTHIA

Where? What?

MIKE

A woman in that car that just drove by pulled up her shirt and flashed her tits in this direction
. . .

CYNTHIA

I wish I was one of those people who could do something like that. You know, that spontaneous.

TONY

Don't let us discourage you.

Richard Linklater: At my very first concert in fall of '75, ZZ Top, a lot of women were pulling up their shirts and flashing. So I wrote in a little tit flash. And they didn't up our budget. So I took it out.

Deena Martin-DeLucia: Early in the first audition, I told them I would absolutely not do any nude scenes, because I'm Christian.

Michelle Burke Thomas: You know the story about them asking me to show my boobs? Richard pulled me aside that night when we were filming the scene where I'm making out with Jason and he said, "Okay, I have to ask you, because I told them I would: Will you show your boobs?" And I said, "Nope." And he said, "Okay, let's film."

He didn't pressure me. There was no, "But the studio really wants it!" That was it! He felt like he had to ask, and he did, but he didn't ever mention it again. Wouldn't it be a different movie if I had shown my boobs? It's just so sweet and innocent the way it is!

Richard Linklater: I decided to have Pink cheat on his girl-friend with Jodi because I needed some tension for his character. I was getting notes like, "Pink just sails through life and everyone likes him." So I thought, I'll add this conundrum. It felt real. When I was in Huntsville, I remember being at the beer bust and being with, like, three or four different girls in one night. I wasn't much of a loyal boyfriend. I was prone to dating one person, and then getting caught making out with someone else, or getting caught with a hickey on my neck. That was my weak area, from high school into adulthood. But in high school, it wasn't that much about sex. It was about making out.

Tom Pollock: There was a lot of talking about sex in *Dazed*, but not much actually seeing it.

Autumn Barr: This scene got cut from the movie, but my char-acter, Stacy, was supposed to make out with a guy in the car, get out, tuck her shirt in, and then go talk to the girls about losing her virginity, and how it kind of hurt, and the girls ask how big "it" is, and she says "kinda big."

Rick asked me if I was comfortable talking about that, and I was like, "Yeah, absolutely!" Of course, at the time, I totally had *not* lost my virginity, so I was really nervous about having to talk about that

on set—in front of my mom! And the person I was supposed to make out with was Rick, and I was *terrified* about that. And then, all of a sudden, Rick was not going to do it.

Richard Linklater: God, I'm so glad that didn't happen. It was a joke that came up in rehearsals, like, "Rick! You have to make your cameo!" But then the cast was pressuring me, and I felt weird about it. I was so busy that night, I didn't have time to go through hair and makeup. So I had Pete do it.

Autumn Barr: I made out with Deena's older boyfriend, which is equally intimidating for a little 16-year-old.

Wiley Wiggins: It's a weird thing to tell 15- or 16-year-olds to go make out while a bunch of people look.

Christin Hinojosa-Kirschenbaum: When Anthony Rapp and I were supposed to shoot our kissing scene, I remember him putting breath spray in his mouth. And I thought, oh my god, am I supposed to do that too? I was so stressed!

Sasha Jenson: Certain scenes in the movie are horrific when you look at them now. It hit me the other day that one of my lines is like, I'm talking to a 14-year-old girl and I'm asking her if she spits or swallows. And I'm *laughing*.

Erika Geminder Drake: When I saw that "spit or swallow" scene, I'm not even sure I knew what that meant.

Catherine Avril Morris: That scene just hit way too close to home. I was one of those teenagers who was like, "I'm sexually active and proud of it," and that was because I was protecting myself from being taken advantage of—by becoming the wise, experienced one.

So seeing that young woman on camera who's like, "Whatever you want"? That is very vulnerable for me, emotionally. I feel like that's the little girl in my heart. You want her to be like, "Fuck you!" But she doesn't even know enough to do that.

Wiley Wiggins: That scene has a much darker tone to it when you watch it now. And I'm glad it's there. There's a dark undercurrent when you're a teenager. Teenagers are dumb and horny and mean and drunk.

Richard Linklater: Oh, yeah, that scene is crude and abusive. Don is a total asshole for saying that. But that's a guy under peer pressure. You get a group of people together, and there's a group asshole thing going on. It's like pack animal instinct. You do things in a group that you would never do alone.

Steven Hyden: One of the things Linklater does really well in *Dazed* is depicting how awful kids are at that age, but he's also very warm in his depiction, because there are certain things that don't even occur to you to call out when you're that age, things you know are wrong, but that's just the way life is. It's only when you're older that you can look back at it and see how awful it is. And I think Linklater has enough generosity to show how the kids actually experience it as it's happening.

Jeremy Fox: You know that scene at the dance where I'm making out with a girl, and Wiley and Esteban interrupt me, and I'm like, "I was gettin' there! I had my hand up her shirt!" Well, when the time came for that scene, Rick allowed me to pick a girl to kiss. I knew that girl in real life. Her name was Sara DeNean.

Deenie Wallace: Kids called me Deenie.

Jeremy Fox: I had a crush on her for a long time. We had been going to the same school together for a while. I had never kissed her before, so for me, that scene was fantastic. Unfortunately, I got a little too excited. I'd had a huge crush on this girl for so long! I was having a bit of an erection in my bell-bottoms. I had to take a break, because it's not that kind of movie.

Deenie Wallace: Jeremy would start coming in for the kiss, and I'm like, "He didn't even say *action* yet!" And it was weird kissing a friend! It seemed like we took an exorbitant amount of takes. I was probably really insensitive to Jeremy's feelings because that totally blurs the friendship lines when you have to French kiss someone 25 times.

So I had an emotional cocktail of excited and also embarrassed and awkward and worried. It probably changed our friendship. I said something really, really cruel like, "I've never kissed someone and felt *nothing* before!"

Wiley Wiggins: The main thing I remember about my kissing scene was trying to get things with Catherine Morris to work. Because we actually didn't get along that well. My mother was briefly married to a guy who kind of lived above his means, so I got to go to private school for a year. Catherine was friends with my older stepsister, so there was like a smelly kid brother kind of vibe going, which is really difficult to get over if you're supposed to pretend to be romantically interested in someone.

Catherine Avril Morris: I was not attracted to Wiley at all. No offense to him. He was not my type. So I was not looking forward to it.

Wiley Wiggins

Wiley Wiggins: I was excited. I don't think I'd really kissed anybody before that.

Catherine Avril Morris: They did basically twelve takes: six of them panning in, and six of them panning back out. And each take, Wiley got progressively more comfortable, and therefore more aggressive in his kissing, which I did not like.

Wiley Wiggins: I hadn't really kissed that many girls before, so I went overboard. She was like, "You're kissing me too hard! This is gross! You're actually really kissing me!" But I had been told to actually kiss!

Catherine Avril Morris: We finally finished, and craft services had made blueberry pancakes for breakfast, and I'd been so excited about it, and I just couldn't eat. I was too nauseated. The whole thing had just been too much.

Wiley Wiggins: I felt terrible that I'd made her feel bad. It wasn't at all like I'd imagined it. Traditionally, teen movies are exploitation movies, right? People watch them because they have this fantasy of teenage sexuality. But actual teenage sexuality is an unglamorous thing, and it mostly just happens in your mind.

Chapter 20

Alright, Alright, Alright

*"That's **the character we want to see**—*
the creepy old guy!"

Even people who've never seen *Dazed* probably know its most famous line: "Alright, alright, alright." You might assume it's famous because it's the first thing Matthew

McConaughey (Wooderson) ever said in a movie. That's the explanation McConaughey himself tends to give. He just happens to be wrong.

Technically, McConaughey's first line in *Dazed* is "Alright, let's rock 'n' roll." He does say "Alright, alright, alright" later in the movie—twice—but both times, he's off-camera. The first time, you hear Wooderson's voice as his car pulls into a parking lot. Later, he repeats it when he pulls into the Top Notch drive-in, right before he invites Cynthia to the moon tower party.

The real reason the phrase caught on is that McConaughey became a one-man marketing team for it. He never misses an opportunity to explain its origin, or say it in front of a crowd. When he won the Oscar for his performance in *Dallas Buyers Club* in 2014, he ended his speech with, "Alright, alright, alright." He has repeated the phrase in 1995's *Texas Chainsaw Massacre: The Next Generation* and 2012's *Magic Mike*. According to an amusing YouTube supercut titled "Every Matthew McConaughey 'Alright' in Chronological Order," McConaughey has used the word "alright" nearly 300 times on-screen between 1993 and 2017.

At this point, you'd be forgiven for wondering if it's just a verbal tic. "I have to believe that's one of those things you tend to say in real life, and then it ends up in a movie," says Adam Goldberg. "It's like how I say 'pal' in everything I'm in, or how Martin Sheen says 'good deal' in every movie."

But McConaughey believes it was intentional. In his mind, it will always mark the first time he ever improvised a line as an actor, and his last carefree moment on set before his whole life changed.

Matthew McConaughey: Anytime I say, "Alright, alright, alright," I'm going to call back to a moment from this great little summer I had. We were over by the Top Notch drive-in, and Rick goes, "Hey, man, I got this idea."

Marissa Ribisi: Rick was like, "We don't have anywhere in the script where you guys find out where the party is. Someone needs to tell you. It's going to be Wooderson."

Richard Linklater: I remember my sister saying, "Marissa's so cute with her red hair. Wouldn't it be great if she was someone's love interest?" So I had Matthew flirt with her.

Matthew McConaughey: Rick goes, "Wooderson's been with the typical chicks, right? The cheerleaders. What people call the 'typical hotties.' Do you think you'd be interested in the redheaded intellectual?" I go, *"Yeah."*

Marissa Ribisi: In the original script, my character was supposed to flirt with Anthony's character, but Rick changed it to Matthew. And I was like, "Oh, I can see that, because Cynthia's an intellectual, so she might be attracted to older men." It's so wrong that it's kind of right!

Matthew McConaughey: I remember sayin', "Give me 30 minutes, 'cause I need to take a walk and go through 'Who am I?' And I walked off, and next thing I know, I'm in the car. We're gonna shoot this first scene with me in the movie. And I'm thinking about this Jim Morrison live record where he barked, "Alright, alright, alright, alright." He said four of them, but very aggressively.

I grabbed that line and threw it into three affirmations via the Wooderson way. I'm saying to myself, "What's Wooderson about?" Well, he's about his car, his '70 Chevelle, that's one. And Wooderson's about gettin' high: Slater's ridin' shotgun, and Wooderson's always got a doobie rolled up. He's about rock 'n' roll: he's got Ted Nugent *"Stranglehold"* playin' in the 8-track. And he's about chicks.

Right about this time, I hear, "Action!" In my mind, I go, "Well, he's got three out of four of those things, and there's the fourth one that I'm pullin' up to go get right now. *Alright, alright, alright!"* There's my three affirmations for the three things that I do have, as I'm goin' to get the fourth.

Marissa Ribisi: Rick said, "You and Matthew go figure out what you're gonna say, and then we'll shoot it." So I go, "Okay, we have to figure this out. Why do you like me? Oh, I know, red hair!" When I'm walking down the street, there are men who have a penchant for redheads, and they say crazy shit like, "Is there fire in the pants?"

I'd get those comments, and I'm not even a real redhead!

And Matthew goes, "Oh my god, that's good!" So that's why he said, "I love those redheads." And I said, "You should give yourself away by saying, 'Do you need a ride?'" Because I'm driving my own car. And it gives him away a little bit, that you'd make a stupid remark like that if you kinda liked somebody.

Tricia Linklater: That's how boys are! They just say stupid stuff. It's like, "I like your backpack." They don't know what's coming out of their mouth half the time.

Marissa Ribisi: In the moment, I felt kind of tingly, like, "Oh my god, this guy *likes* me! And now these two guys in the car are giving me shit about it. And, oh my god, he's kind of cute!"

Deb Pastor: The minute he said that "alright, alright, alright" thing, I just went, "Oh my god, for the rest of time, people are going to be saying everything this motherfucker says." How many movies have we worked on where, the minute it comes out of their mouth, you know that you're going to quote it the rest of your life? My god! That was not even written in the script!

Wiley Wiggins: That could've been *bad*, right? That could turn into this catchphrasey kind of thing, which it was on the edge of. But he personally saved it, because he's interesting to see on-screen. He seems like an actual person, not just a caricature.

Greg Finton: The day Matthew said, "Alright, alright, alright"— that was the first day it clicked with the crew. Like, "Oh, *this* is what this film is going to be. *This* is the vibe it's going to have."

Robert Brakey: The original scripts are a lot different than the movie that came out. I mean, it's funny, but I wouldn't call it a *comedy*. It had some poignant scenes about growing up and "We're done with high school, now what do we do?" It was existential that way.

Wooderson was a guy who's stuck in a loop. He was a loser who refused to grow up. He was in an arrested state of picking up high school chicks and cruising the Emporium. He wasn't anybody that you would want to *hang out* with.

But the first time I saw McConaughey as Wooderson, I remember

everybody stopping what they were doing and going, "Oh, this is totally different than what we thought." I don't think we were expecting humor in that character. That weird cross-eye thing that he does? It was *wacky*. Credit goes to Rick for going with it, because I don't know if that's what Rick expected, but it worked. The movie became a lot more fun with more Wooderson.

Jason Davids Scott: Every time Matthew showed up, people were like, "*That's* the character we want to see—the creepy old guy!"

Matthew McConaughey: People are like, "Don't you get tired of *alright, alright, alright*?" I'm not arrogant enough to be tired of that. Those are the first words I said in a job. I didn't know if that was going to be my last night's work. So, here I sit, what, 27 years later? I've made a career out of this thing that could've been a whim. It's the original lineage of the journey that has been my career to this day.

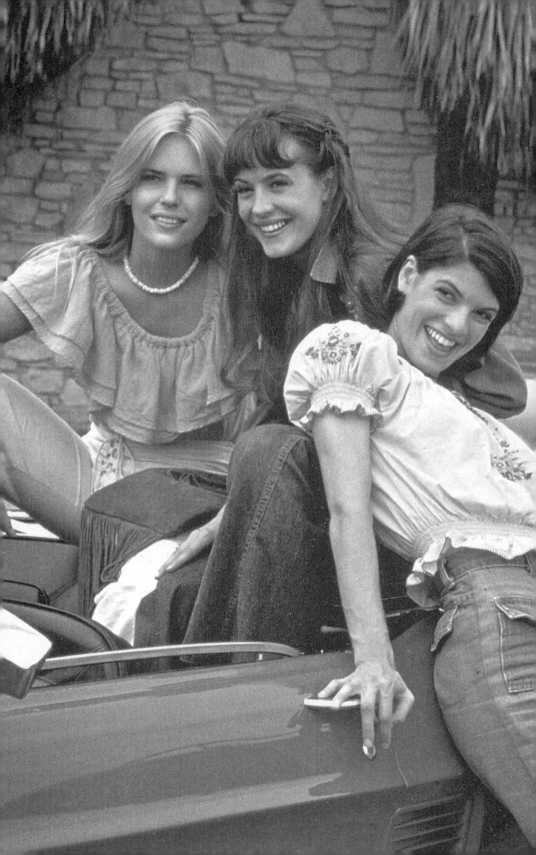

She Called You a Bitch and You a Slut

*"Oh, I guess there's no female lead
in the movie anymore?"*

Hollywood loves movies about high school, probably because Hollywood *is* high school. There's just as much pettiness and self-consciousness and concern over who is friends with whom, and it's rough on nearly everyone involved. The outcasts think the popular kids are fake. The popular kids truly believe they're outcasts. And there's always someone who seems to join the cool crowd overnight, only to discover that everyone else resents them for it.

According to many of the guys in *Dazed and Confused*, the relationships between the women felt "like high school." From the outside, that might seem like an unfair interpretation, since the guys had cliques of their own, but the women don't really dispute it. Joey Lauren Adams says that's the way the dynamic between them was designed. "They pitted us against one another from the very beginning," she says. "Instead of auditioning for the role we wanted, all of the women had to audition for the same role—the one Michelle got. There was a feeling that we were working against one another, and that feeling continued on set once we got to Austin."

Adams also points out that the stakes were higher for the women. With the exception of Chrisse Harnos and Milla Jovovich, none of them had really had a major role in a film before. That wasn't true for most of the men. And the women had fewer scenes that allowed them to explore their characters in depth. While shooting *Dazed*, Adams told Kahane Corn that *Dazed* felt like the guys' movie. When the male characters were in a scene together, they were discussing all kinds of things: cars, football, drugs, politics. "And then the scene with the girls, they're in the bathroom and they're talking about *boys*," Adams said. "And that's such a man's idea of what we'd be talking about!"

Adams and Parker Posey were smart: since their roles were limited, they banded together and wrote their own scenes. Other women's roles were whittled down, which added to their sense of marginalization. Most of the actresses were in their mid-20s by the time *Dazed* came along. They probably knew they had less time to prove themselves than the guys had, since opportunities for actresses drop off steeply once they reach their 30s. Knowing *Dazed* was their first big chance for a breakout role forced them to fight harder to distinguish themselves in an ensemble story that was already dominated by the men. Instead of viewing one another as allies, some ended up treating one another as competition.

Richard Linklater: High schools are testosterone fests. The young men just overpower everything. And they did that in the film, too.

Adam Goldberg: The girls really got the short shrift in *Dazed*. They had much larger roles in the script. When I watched the movie, I was like, "Oh, I guess there's no female lead in the movie anymore?"

Richard Linklater: I really wanted a young woman's perspective in the movie, and it's just barely there now. I feel like I failed with the women. Chrisse Harnos, for instance. There was a lot more there with her in the beginning.

Jason Davids Scott: The screenplay version of the *Gilligan's Island* conversation in the bathroom was much longer.

Excerpt from Dazed and Confused
Shooting Script, June 25, 1992

 KAYE

You know, this is really pathetic. All you ever
talk about is guys. Everything is always guys—
going to watch guys do whatever it is they're do-
ing at the time, getting all dressed up so maybe
some guy will notice you . . . Do you think guys
spend one-tenth the time we do thinking and ca-
tering to us? Hell no . . . They're too busy DOING
things. What do we do besides sit around talking
and plotting about them?

 SHAVONNE

Yeah, but look at the shit they do: playing sports,
fixing up their cars . . . it's all bullshit any-
way, who can take that serious?

 JODI

We don't have any choice BUT to take whatever they
do serious. Look at what it's like around here
during football season—everything shuts down and
takes a back seat to the fact that our guys are
going to try to beat the crap out of some other
guys.

 KAYE

Exactly.
(to Shavonne)
And then you were in class with them trying to
list all *the Gilligan's Island* episodes without
even a HINT of irony.

 SHAVONNE
What the hell are you talking about, girl?

 KAYE
You never thought about that show? It's what's
called a male pornographic fantasy. Think about
it: you're basically alone on an island with two
readily available women, one seductive, sex-
goddess type, the other a healthy, girl-next-door
type with a nice butt. So, guys have it all, the
Madonna and the whore. And what do women get? Noth-
ing. A geek, an overweight middle-age guy, a nerdy
scientific type. Those are all the types that
your typical male feels least threatened by. So
in the male viewer's mind, he puts himself on the
island and he can have it all. A woman puts her-
self on the island and she's bored shitless . . .
Women are taught to not mind being bored as long
as they are occasionally acknowledged.

Chrisse Harnos: I took it personally when my scenes were
cut. I blamed myself. I thought I wasn't good enough. You're all per-
forming together and there's always that thing of, wait, how am I
gonna come off, versus him or her? Am I gonna get left behind?

Joey Lauren Adams: Well, *my* part got bigger, so I can't com-
plain. Parker and I would write a scene and Rick would say, "Okay,
I'll give you one take."

Parker Posey: Joey and I wrote a scene where we were going to
the bathroom in the woods.

Joey Lauren Adams: We were like, "You're gonna start with
the camera on our faces, and it's gonna seem like we're having a
contemplative moment, but then you're gonna pull back and see that
we're both just wasted and pissing." We shot that!

Parker Posey: I'd never seen women in a movie going to the bathroom in the woods before! But we ended up shooting it wrong. You could see that we had our pants on.

Joey Lauren Adams: The scene where I trip and fall in the woods came from us walking around in those platform shoes and always busting our asses.

Jason London: Joey was not supposed to fall there!

Joey Lauren Adams: No, that's not true.

Richard Linklater: Her fall was 100 percent planned, framed and executed.

Jason London: I love the laugh that comes out of Parker, because it was absolutely real. It wasn't Darla laughing at Simone. It was Parker laughing at Joey.

Parker Posey: I think I pushed Joey back down after she fell! There's nothing funnier than people falling, and you're like, "I'm gonna help you out!" and then you push them back down.

Deena Martin-DeLucia: Joey tripped and fell right on her face. I guess she kind of deserved it after what they did to me.

Joey and Parker and I were supposed to all hang out as girls on the town, and they led me to a bar to meet them there, and they went to a totally different place to play a joke on me. I got to the bar, and I'm like, "I'm meeting two girls here!" And the bouncer's like, "Yeah, we know that." Like, of course you are! And I'm like, "Really? You knew that I was gonna meet two girls here?" And they were like, "Well, yeah."

And then I find out that it's a lesbian bar.

Parker Posey: I don't remember this! I have no idea where the idea came from. Jim Jacks may have suggested it. Deena's character rode the edge between the good girls and the bad girls, so she could hang out with us. The dissension between the popular girls and the bad girls was dictated early, and we played it out. For the record, I love lesbians.

Sasha Jenson: It was kind of catty between the girls. I think that's the difference between guys and girls. With guys, it's like,

"Who's got the ball? You got the ball? I'll be your buddy!" It's all activity-driven. And it's not that simple with girls.

Michelle Burke Thomas: When we'd get up in the morning and go to the makeup trailer, Parker and Joey would be talking about how fun it was last night and laughing and giggling and, you know, "What are we doing tonight?"

And I'd go, "Yeah! What's happening tonight?" And they'd just kind of look at me like, *Ha ha ha . . .* It was just *nasty*.

I would leave the makeup trailer every morning as fast as I could so no one would see my hurt feelings after hearing about everybody's awesome night. Holding back my tears while they all laughed hysterically about the amazing time they had together. I can't tell you how many times I cried.

Parker Posey: I had no idea. She was always smiling and seemed so happy.

Joey Lauren Adams: I can't imagine us being that cruel, but I respect her memory about it.

Richard Linklater: Everybody wanted to be Jodi. So if you're not Jodi, you're gunning for the person who's playing Jodi. You've got 23-year-olds in the group, and they should be beyond this petty, back-biting, bitchy high school stuff. But they weren't.

Parker Posey: Well, we were the bad girls in the movie! That's the thing. It's like, it's too bad we had to be enemies! Michelle was playing the most popular girl on *Dazed and Confused*, and the jealousy and envy toward that is in the mind of those girls. And Michelle was so likable! And she was so pretty and so popular! And we were the outsiders.

Michelle Burke Thomas: I think they were jealous of my career. I was the girl who came from fucking nowhere, who didn't know anybody, who didn't have Hollywood royalty on her side, didn't come from money, didn't fuck anybody to get where I wanted to be. I just worked really fucking hard and got the role, and they didn't like it.

Joey Lauren Adams: I'm sure there was some really immature jealousy that she was the lead, because I had read for that role, too,

and I probably thought she knew she was *all that*, you know? And we probably did think she was a girlie-girl, with her hair extensions. That was an extra little nod against Michelle: they gave her hair extensions, but I wasn't important enough to get them.

Jason Davids Scott: The scene in the truck where Shavonne says, "She called you a bitch and she called you a slut"—Joey and Parker wrote that scene on their own.

Transcript from Dazed and Confused
Final Film, 1993

DARLA

What did she call *me*?

SIMONE

You hang out with her. You know it. I mean, we know they talk about us. Just tell us!

SHAVONNE

Nothing!

SIMONE

We don't care!

DARLA

Oh, come on, "Nothing," that's a lie. When you do that, I know you're lying, you bitch! I know you're lying.

SHAVONNE

Well, you're not gonna get mad?

SIMONE

No. Like we care what they think!

 DARLA

We're not gonna get mad! I think it's a riot. I
don't care what she thinks.

 SHAVONNE

Alright, alright. She called you a bitch and you
a slut.

 SIMONE

A slut? She called me a *slut*? That bitch!

 SHAVONNE

Everybody calls you a slut!

 DARLA

Oh shit!

 SIMONE

Oh, that bitch. I'm gonna kick her ass! I can't
believe that! What a bitch!

 SHAVONNE

I thought you said you weren't gonna get mad, man?

 SIMONE

I'm not mad.

Deena Martin-DeLucia: Parker and Joey kind of sprung that
scene on me late. And we rehearsed it, and we shot it in one take, two
takes at the most. But I didn't know the background of it.

Jason London: That was from real life. They're bitching about
Michelle.

Michelle Burke Thomas: I didn't know that. That makes my

heart break to think that that was their little inside joke. How fuck-ing mean!

Joey Lauren Adams: That scene wasn't particularly about Michelle. It's just like, that's what high school girls did, ride around and talk shit about other girls! But I can see someone asking Parker, and Parker just saying, "Yeah!" because she's Parker, you know? "Yeah, it was about that bitch!" Even if it hadn't been.

Parker Posey: I don't remember it being about Michelle, but I'm sure I was acting out in some way. I'm just sorry I didn't go, "Hey! It's all tongue in cheek!"

Jason London: Michelle was so *va-va-voom*. She was built like a brick shithouse and she had that ass on her, and all the guys were like, *Uhhh uhhhh uhhhh*. I think that's another reason why the other girls were like, *Bitch*.

Peter Millius: Chrisse thought Michelle was flirting with Jason, because Michelle and Jason kiss in the movie, and I think Chrisse felt Michelle was crossing lines.

Chrisse Harnos: Definitely there was a part of me that didn't trust Michelle. Now, whether she was trustworthy or not, I have no idea.

Michelle Burke Thomas: No, I've never kissed Jason outside of those scenes. You know, Chrisse was the epitome of everything I wanted to be. She was cool. She was smart. She was savvy. She was an amazing actress. She was that quintessential, everything-you-want-in-a-woman, but she couldn't see that. She was very self-conscious about who she was. I think that's what prevented us from being close.

Jason London: I would've had to have been the most stealth guy on the planet! Chrisse and I were together all day, every day, and all night, every night. It didn't happen!

Chrisse Harnos: Poor Jason! I was probably like, *Rrrrroar!* Joey also had to kiss him, and it was like, "Oh, so you did a scene with Joey today?" Jason was getting grilled at every turn. I was jealous of both Michelle and Joey. I was even jealous of Milla!

Jason London: I think maybe there was also some judgment from the girls' side because Michelle had a child.

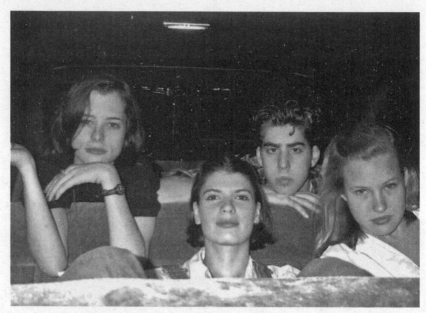

(left to right) Parker Posey, Chrisse Harnos, Adam Goldberg, and Joey Lauren Adams

Michelle Burke Thomas: I got pregnant in high school and had a baby. You know, *Dazed* really was my high school experience, because I didn't get to graduate and I didn't get to go to prom and I didn't get to do all those things, because I had a baby. Which was a whole other reason that I felt like nobody liked me.

My manager didn't want anybody to know I had a child because she felt it would typecast me into certain roles and people wouldn't want to deal with, like, the extra expense of having a tutor on set if I wanted to bring the kid, and blah blah blah. So not telling most people was a choice I made solely based on the advice of people that I trusted, and now I wish I hadn't done that. But some people knew.

Marissa Ribisi: Not many people knew about her daughter. She was four. Michelle told me, and I kept it a secret. Back then, it was so inappropriate: if you were a certain age, they would use it against you, and Michelle was afraid, because she was the lead girl, so she had a lot of pressure to hide it.

Christin Hinojosa-Kirschenbaum: Michelle always thought that people were against her. I think that's why she latched on to me. She kind of played up that "big sister" role that she had in the movie in real life.

Richard Linklater: Michelle took Christin under her wing. I think that didn't help Christin's relationship with the other girls.

Christin Hinojosa

Christin Hinojosa-Kirschenbaum: Most of the girls didn't like me very much. I found out later from Joey. She said, "Well, we all thought you were sleeping with Rick." I never slept with Rick in my life! We were friends. Nothing even remotely romantic ever happened. People can't believe, like, why would *she* get this part? I think that's part of it.

Michelle Burke Thomas: Well, she was playing the role of the girl who Rick loved when he was a kid.

Sasha Jenson: Rick had a crush on Christin. Everybody knew that. Christin was the beautiful Bambi of the cast who everybody wanted to take care of. Here comes the boisterous Hollywood crew

rolling in, and she's beautiful and sweet. That's going to get some attention.

Richard Linklater: No. That's crazy. I probably did treat her a little special because she was younger and I knew her parents and I was trying to protect her from others. But I was doing a similar version of that with Wiley, too.

Joey Lauren Adams: We all had crushes on Rick. I wanted to sleep with Rick. I ran into him in a bar in L.A. after the movie. I tried to kiss him, and he didn't cross the line, which made you want him to cross the line even more.

Richard Linklater: I was like, I'm not going to be that guy. I'm not going to date someone I'm working with, because word gets out and it throws off the ensemble. Like, "Oh, there's an extra scene for Joey now?" No.

Joey Lauren Adams: Rick always treated you in a nonsexual way, and for all of us women who had been treated in sexual ways for so long, to have a man who's not like that? It's weird. It's like, how come you don't like me?

Anthony Rapp: Being a woman in Hollywood is hard anyway, and being a woman in that very high-testosterone environment of *Dazed and Confused* was probably extra hard. The guys already got so much attention, and the women had to fight for what was left.

Michelle Burke Thomas: My experience with the girls on that movie *sucked*, but it didn't feel like high school. My freshman year, I was head cheerleader for varsity football and basketball. I had a lot of friends. However, 30 years later, hearing what other people were saying about me back when we were making the movie? *That* feels like high school.

Parker Posey: Rick wanted to create an authentic high school experience in 1976, and we were fully committed. High school can be catty. Does that sound sexist? Weren't the '70s sexist? Aren't we still in this patriarchal thinking? Obviously. This pitting [women] against [one another]. It's constant and it's catty. Do I think men like to see that? Yes. Do I think women play into that? Yes. When will

this dialogue get so boring to the point of getting back to [something more] interesting and human?

I think of Bette Davis and how much fun she had playing bitches. That quote of hers, "When a man gives his opinion, he's a man. When a woman gives her opinion, she's a bitch."

And the other one [about Davis's longtime rival, Joan Crawford]: "Why am I so good at playing bitches? I think it's because I'm not a bitch. Maybe that's why [Joan Crawford] always plays ladies."

Chapter 22

They Stay the Same Age

"It's like Babe Ruth pointing the bat and telling people where he's gonna hit the home run, and then hitting it."

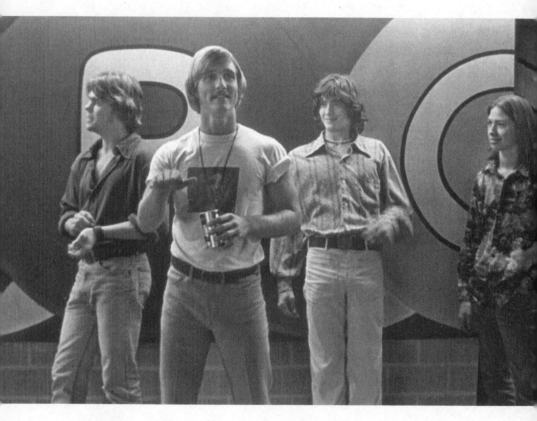

ne of the reasons people still love to watch *Dazed and Confused* is that it transports you back in time—not just to 1976, but also to 1992. You can return to the days when Ben

Affleck still had baby fat and Parker Posey still smacked her gum. We get older. They stay the same age. The cast is forever preserved on-screen at a moment of infinite potential, one of the last moments before they'd have to start acting less like regular goofballs and more like movie stars. "We went into the movie a bunch of kids, and we came out a lot more mature," says Jason London. "It was the beginning of us becoming adults."

No one felt that change more acutely than Matthew McConaughey. He was 23 years old when he filmed *Dazed*, and like his character, Wooderson, he was still mostly hanging out with younger people. He hadn't yet finished his undergraduate studies at the University of Texas, and he was still partying with his fraternity brothers. But he was only on set a few days when two things happened that forced him to grow up fast. First, his father died. Then he delivered the line that transformed him from a bit player into a leading man.

Matthew McConaughey: I was about four or five days into shooting and I got the call.

Monnie Wills: Matthew was shooting nights, sleeping during the day. His mom tried to call us and we didn't answer the phone because it was early. We might even have turned the ringers off. His girlfriend Toni came to the house and came to my room because she couldn't bring herself to tell Matthew what had happened. She was in tears. I could barely get it out of her. She said, "I can't be the one to tell him."

So I went down and said, "Matthew, something's happened. You need to call your mom."

Matthew McConaughey: My dad died making love to my mother. Six thirty on a Monday morning. My dad had always told me and my two brothers, "Boy, when I go, I'm going to be making love to your mother," and he did. Talk about a badass! The guy called his shot about how he was leaving this Earth and did it.

S.R. Bindler: That's perfect, right? It's like Babe Ruth pointing the bat and telling people where he's gonna hit the home run, and then hitting it.

Sam Lawrence: Matthew called me the day his dad died. "Dude, I need someone to hang out with." And we ended up at a strip club. By the way, if you ever want to feel completely invisible, go to a strip club with Matthew McConaughey.

It was *weird*. He was talking about his dad, really emotional stuff; we're talking across the table, just looking at each other, and in the meantime, strippers are walking across the table.

Monnie Wills: Maybe the next day, he called me and said, "We're having a little thing. Do you wanna come up to Houston?" I said, "Of course." So I drove to Houston. It was a small, intimate gathering.

Jason London: He had one of those incredibly close families. I met his dad once, and Jim was like your typical John Wayne Texas cowboy, and his mother was lovely. You could tell that they were all madly in love with each other, and if the world ended, they would be out there on their compound and they would be the last to survive. I mean, they had fucking *tanks* and shit! They had rocket launchers! I don't know why. For fun?

Monnie Wills: Everyone was telling stories about Jim. We were drinking a lot of Miller Lite and trying to be upbeat.

Matthew McConaughey: We had an Irish wake. It was full-on roasting the snot out of him.

Jason Davids Scott: Later, someone said, "What was the service like?" And Matthew said, "Well, my mom told the story about how my dad died. They were in the act of lovemaking." And apparently his mom said—at the funeral!—"By the way, he did get to finish."

Monnie Wills: The telephone book story made the rounds at the funeral.

Matthew McConaughey: Dad was in the oil business, and he had a lot of people that owed him money. He had hired two guys to go collect for him. Well, one of them was like 6'4", his name was Big Ray, and he had dark shades, dark suit. And the other one was this little Asian guy, about 5'2". And what they evidently did was, Ray

went over behind the desk of the person who owes Dad. "Hey, I hear you owe Mr. McConaughey. We've been trying to collect this in a congenial manner. We've given you a few chances. Time's up." And he's like, "Yeah, it's comin'! I'm gettin' it right now!"

"See, we've been really patient with you, sir . . ." And as they're having this creepy, quiet conversation with this man, Big Ray moves behind the desk, and the Asian guy's putting on a pair of black gloves. Big Ray grabs the Houston phone book, lifts the guy up, holds the guy's arms back, and holds the Houston phone book against his chest. Now, the Asian guy lifts up a pistol. Well, the guy just fell to the ground, shit himself, crying, "I'm payin'! I'm payin'!" Goes to the safe, gives him the money, blah, blah, blah.

Big Ray says, "Don't let it happen again, or next time my man here won't just use a .22." Because a .22 will only make it to "M" in the Houston phone book.

Isn't that great? Dad loved shady deals, man. He collected on that, but what was better than collecting the money was having that story.

S.R. Bindler: Jim was a great storyteller, charming as hell. He had a twinkle in his eye, man. Matthew is a movie star, and charms everybody he meets, but you put him next to Jim McConaughey, you're gonna watch Jim McConaughey, you know? And Matthew would love to hear that.

Matthew wasn't dwelling on the fact that he lost his father. It was, how can I honor my father? What are great stories I have from my father? What did my father teach me?

Matthew McConaughey: I was trying to figure out what that means, when you lose a father.

Monnie Wills: I know Matthew was probably processing all that was happening, but there's no universe where K-Mac, his mom, is gonna let those boys wallow in any kind of self-pity.

S.R. Bindler: At Matthew's house, if we went out and spent the night there, it's 7:00 a.m., K-Mac storms into Matthew's bedroom, flings open the blinds and the drapes. Texas summer sun is ripping in. And she gets a big gallon pot of water with ice in it, and

would dump it on us. "It's 7:00 a.m.! You guys can't sleep all day! Get out of the bed!"

Monnie Wills: Matthew told me if he got up in the morning and came down with a bad attitude, she'd send him back to his room and would literally say, "Get back in bed. Get out of bed. Try again."

She did not let Matthew have any sense of, "Oh, you're a victim, you poor thing." It's like, something's not going right? Go look in the mirror. That's the guy right there that can handle that for you.

Matthew McConaughey: We had very simple rules in my house. You weren't allowed to say "*can't.*" You can say, "I'm having *trouble.*"

I remember that lesson very clearly. It was a Saturday morning, I was supposed to mow the lawn; I was having trouble getting the lawnmower started. I went in and told my dad, "I can't get the lawnmower started." And he'd hear *that word*, and you'd see his ears perk up, and you saw his jaw start to kinda grindin' his molars, and he slowly got up, walked outta the house, tried to start the lawnmower, didn't start. He took the thing apart, put some new gas, put a new spark plug, whatever, and about 45 minutes later, it started.

He hadn't said a word this whole time, and then he looked at me, he goes, "See? You were just having *trouble.*"

Monnie Wills: I think Matthew would tell you the way his dad died is about as good as you could ask for. The logic of that made sense to Matthew, that his dad was a happy man and had no real regrets and it wasn't tragic. And I think that nexus between being right in the middle of production and his father passing created some kind of energy in him.

Matthew McConaughey: My family was like, "You've got to go back." It was obvious to go back. What my dad taught us was resilience. No way was I going to be moping around and miss what I was in the middle of doing.

Jason Davids Scott: Don Phillips had flown in for the funeral, and everybody was like, okay, he'll be gone for a couple of days. This was the beginning of the Emporium week, so it was like, we'll shoot around Matthew, he's not a major character, he doesn't have to be in every scene.

Jason London: Matthew wasn't on set. So it was like, "Where's Matthew?" And Rick takes me aside, like, "We're flipping the schedule around right now, we're trying to figure out what we're gonna do. Matthew's father died." And we're like, "Oh my god oh my god oh my god."

We look up, and Matthew's *right there*. And I'm like, "Are you *sure* his dad died?"

Jason Davids Scott: He was back *the next day*. I remember seeing a couple of people *crying*. Everyone's coming out, saying, "Oh Matthew, I'm so *sorry*."

Richard Linklater: I saw him walking up. I just ran over to him and we talked for a while. I was just trying to gauge where he was at. But he was like, "No, man, I'm good."

Jason Davids Scott: That was the day he does, "That's what I love about these high school girls, man. I get older, they stay the same age."

Anthony Rapp: "I get older, they stay the same age"? That's funny, but it's really fucked up.

Richard Linklater: It's meant to be harsh. Sasha's character, Don, says Wooderson should go to jail for saying that.

Ben Affleck: In light of the Me Too era, it's not an entirely appropriate thing to be quoting. It probably never was. "I keep getting older and they stay the same age"? That's R. Kelly's anthem.

But to this day, people still quote that line to me, and I'm not even in the scene. That's a testament to Matthew's enormous charm.

Matthew McConaughey: I mean, if we're gonna sit here and do any kind of psychoanalysis or objective judgment, if you're gonna try to break Wooderson down, you're already in a different narrative than he is. The everyday world, the manners and social graces, and the way life is supposed to go on and men are supposed to evolve— yeah, he doesn't fit in that. He's on his own frequency. He is living in ignorance.

Wooderson is not the kind of guy who's gonna get conscious of, like, "Oh, this is creepy." He's just the kind of guy that goes, "I'm sorry you see it that way. Whatever's going on in your life, I hope you

get through it." I love characters and people in life with great convictions that are outside of the mainstream. At least you see where they stand. At least they're not trying to placate and pander. You can trust Wooderson, man. He's right there in the open with you. There's nothing about him that I ever saw as creepy—which might be exactly why that's even creepier. But *you* can say that, not me, you know what I mean?

In every script, you hopefully get at least one what I call a "launch-pad line." You go, okay, if I deconstruct the meaning of this, there's a *book* on this character.

That line Rick wrote, you unpack that line. Who not only *thinks* that, but *believes* that? That's this guy's DNA. He has gotten to a place where he's like, "I've out–Peter Panned Peter Pan! I have got this figured out!" I mean, he's not thinking ahead: "Oh, this will be tougher in 10 years." No, no, no, no. Wooderson steps forward to the curb and says that, like, to the *world*. To the *ether*.

It's a *mantra*. It's a *philosophy*. He's pleased with his place and his coordinates in the universe. You could say he's delusionally optimistic.

Valerie DeKeyser: The minute those words came out of his mouth, I swear to God, he immediately took us all: the cast, the crew. It was like, "Holy shit. Who is that guy?"

Jason Davids Scott: Don turned to Jim Jacks and said, "This is a movie star." It was weird because he wasn't a big character. He wasn't even on my radar.

John Cameron: He was just a *guy*, right? Just another one of the cast, and one of the lesser-known people. We had people who had already established a reputation, even in their youth, and Matthew just came in and blew everybody away. And it really elevated the film. It made it something, to me, beyond just funny. He brought a sense of sadness.

Deb Pastor: He was processing this deep, deep loss as he was doing his job. How could all of us not love this guy after experiencing that? And this was going to stay with him, through all the successes he experienced.

Matthew McConaughey: It was very cool that I had already started the film when my dad passed away. He got to be alive for what ended up being what I do with my career. There's grace in that for me.

Monnie Wills: After his dad died, a switch flipped for sure. You know, you hear these stories of, like, Bill Clinton meets John F. Kennedy when he's 16 years old and he decides, "I'm gonna be president one day," or the moment that makes Tiger Woods decide, "I'm gonna be the best golfer." After his father passed, I think some sort of ambition clicked into Matthew. Like, life is short and I'm gonna do the things I'm good at. And I don't give a fuck what anybody else thinks.

Chapter 23

Party at the Moon Tower

"It's kind of a recipe for chaos."

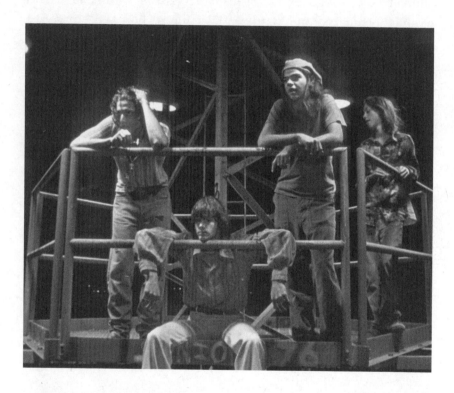

ometimes, it's pretty obvious that a screenwriter has forgotten what high school parties are actually like. Too often, the party takes place in some rich kid's mansion, where literally everyone is dancing, and someone is always about to fall, fully clothed, into a swimming pool.

By comparison, the moon tower party in *Dazed* almost looks like

a documentary. It's dingy and unglamorous and takes place in the woods. The beer is foamy. The faces look greasy. No one's doing much beyond standing around, talking. And yet, the excitement is still palpable. From the moment Mitch arrives, it's clear that he's so eager to party with the upperclassmen that he has to focus *really hard* on wandering around aimlessly, finding kids he knows, pretending that drinking beer is something he totally does all the time.

The whole scene looks so natural that shooting it should've been easy. There were real moon towers in Austin, and the actors were already partying together at local bars, rock clubs, and in their rooms. In theory, all Linklater had to do was gather the cast at Walter E. Long Park and film them doing exactly what they'd been doing ever since they got to Austin.

As it turns out, that's exactly why it was hard.

Jeffrey Kerr: Austin put their moonlight towers up in 1895. In the late 19th century, every city with aspirations to be a big city was trying to figure out how to light up the streets, and one of the methods proposed was putting up these big towers throughout town, rather than trying to string streetlights with miles and miles of electric cord throughout the city.

About 10 years before the towers went up, there had been a series of grisly murders in Austin by a serial killer known as the Servant Girl Annihilator. The first few murders were all black servant girls. The murders were never solved, and people still had this on their minds as these towers went up. All of a sudden, it was light and people felt much safer walking around the streets. Over the years, the moonlight towers became obsolete in other cities. As they started putting up taller buildings, they would take them down. Austin became the only city in the United States that still has functioning moonlight towers.

Richard Linklater: When I wrote the scenes at the moon tower, I wasn't thinking about Austin—the towers were just functioning as a believable light source for the scene. I was really thinking about the fire tower in Huntsville. Everybody would go out there

with a bunch of six-packs and the occasional keg, and park their cars, and party at the fire tower, just like in the movie.

The fire tower was just one of several locations in Huntsville where we'd have parties. You always tried to be a little unpredictable and stay ahead of the law. If the word got out too far in advance, the word would spread and the police would know where the party was on Saturday night. So it behooved everyone to be spontaneous and say, "Hey, there's going to be a thing later tonight." So that's why it happened like that in the movie.

You'd have a few beers, climb up to the top, maybe if you're with some girl you've been hanging out with, you'd make out and look out over the town. It was typical teenage shit. But the purpose of being there wasn't to climb the thing. The party was happening on the ground. I would think, on any given night, probably 25 percent of the people at the party actually climbed up to the top.

Jeffrey Kerr: The story in the movie about the kid who falls off the moon tower? I've always wondered if that was based on a true story.

In 1930, an 11-year-old boy named Jamie Fowler was out late at night playing with his friends downtown, and one of them issued a challenge: *You're a chicken if you haven't climbed up one of those towers by the time you're 12 years old.* So up they went. They made it all the way to the top, and then they started down, and Jamie slipped and fell and literally did bang off the bars all the way down until he landed on the catwalk that's about 15 feet above the street level. But he *survived.*

Richard Linklater: That story is not ringing a bell with me. I just thought it would be funny for Slater to exaggerate a story like that. I don't know how you would even climb a moon tower. I'm not saying people haven't done it, but moon towers are mostly in urban neighborhoods, and there's not really a ground area below them where people would party, and it's really hard to get up those things. They're really tall. The real ones are like 165 feet off the ground—that's like a 16-story building. The ones we used in the movie were not that tall.

John Frick: You could never get the cast to climb that high. The producers and the insurance people, no way would they allow it. So we actually had the real tower company come and build a fake moon tower for us, with real moon tower parts.

Richard Linklater: I wanted the actual cage part, where they climb up, to be real, and then they could make the actual tower as tall as they wanted. But when it finally showed up, it was truly the Stonehenge moment from *Spinal Tap*. It was just a little bitty column! I was like, "Oh my god, you've gotta be kidding me!" I think it was technically about 25 or 30 feet off the ground, but it looked embarrassingly short. I used a really wide lens and put the camera as low as possible, so when they're climbing up, you can't tell how tall it is. You never see it head to toe.

Wiley Wiggins: I was really scared of heights, so even with those short, fake moon towers, climbing up and down them bugged me out. I was already a little on edge with that, and then we were climbing down and Shawn Andrews had these fucking boots with these big heels on them and he planted one right on my hand. I probably overreacted because I was so scared of falling.

Jason London: When we were shooting the stuff at the moon tower, it felt like a real party. There were all these people out in the park with a tower and some kegs, but they could only film us in groups. So, if they're filming Adam and Nicky fighting, I've got two hours where I'm not doing anything, and I'm out there with all these people, and we're supposed to be drunk and stoned off our heads. What do you think we were gonna be doing?

Richard Linklater: When you've got a ton of young people in a party scene, out in the woods, it's kind of a recipe for chaos. You do the math and you go, "Oh shit. This is going to be a challenge."

Jonathan Burkhart: All those night scenes at the moon tower, there was always the smell of pot in the air.

Robert Janecka: They had this smokable herb, which actually smelled like weed. So we would put that in all the bongs. And they're

smoking so many joints in the movie, every scene, I was rolling two joints at a time, one-handed each.

Jason London: We were supposed to be smoking this passion-flower herbal tea stuff, but it was disgusting, and I got so sick on that damn near beer! So we decided to get something real.

Robert Janecka: Back then, the normal keg of beer was 50 bucks, and for a nonalcoholic, I think it was 80. So Matthew and all those guys were like, "We'll get real beer." I was like, "I can't get real beer! You guys are all underage and shit!"

Christopher Morris: There was a rumor going around that the beer in the kegs was alcoholic, so a bunch of us tried to chug as much beer as possible. Then the second AD told us, "Hey, there's no alcohol in the beer, stop drinking it." A bunch of us got stomach-aches, because those were long, 12- to 14-hour nights, a lot of standing around, pumping the keg.

Jason London: We were supposed to be more and more wasted as the night went on. So Deena's boyfriend, Peter, had a cooler in the trunk of his car with beers and weed.

Peter Millius: I wasn't supposed to do that, but, I mean, we're at a keg party! I always joked that I was the craft services for beer and weed.

Jason London: It didn't even occur to me that when I walked back to the set, they could smell me.

Matthew McConaughey: Peter Millius! He turned me on to the greatest Lynyrd Skynyrd song ever, "The Ballad of Curtis Loew." He had good music, and in between scenes, we'd go sit in his car and *get right*. It was a gray Ford Explorer. And he always had cold beer and one to burn.

Wooderson's always pulling on a doobie, right? Or a pipe. And there was always the oregano version, but you know the scene where Cochrane jumps in the back of the car? We'd done like two or three takes, and then the fourth one, Cochrane passes the real deal to me. As soon as I hit it, I can tell. And that's the part where I go, "Whoa, watch the leather, man!" And that stuck. And I was like, "Thank you, Cochrane. That was a good choice."

Deenie Wallace: There was a shift in McConaughey's character that you could sense after that. His eyes were kind of drooping.

Don Stroud: Some of the extras there that night, the AD staff was having a tough time keeping track of them. They were running off into the woods and hooking up with each other.

Tracey Holman: We were literally beating the bushes going, "Hands off!"

Cole Hauser: I wasn't smoking a lot of grass, but I liked to drink. I would drink on set, but I was never shitfaced or out of control.

Bill Wise: I remember the drunken shenanigans of Cole Hauser! During the beer bust scene, Rick came all the way from his monitor at a full sprint to one of the trucks, which was fucking 40, 50 yards away, and yelled at Cole, "You need to fucking take it down, man! You are being way too loud back here!"

The way he had said it was like, "You fuckers are too drunk!"

Richard Linklater: I think I just meant they were *acting* too drunk. Were they drunk in real life?

Cole Hauser: No, that's bullshit. Rick came over during the party scene and said, "What do you want to do?" And I said, "One night here in Austin, I was so drunk that I started to stand up, and then I realized I was too drunk to stand, so I sat back down." And he said, "Great! Let's film that." I think that's an iconic moment. Thousands of people have brought it up in the past 25 years, like, "Man, I love that moment!"

Robert Brakey: It was like an all-night party that went on for hours and hours and hours. They were shooting in the middle of the night. You can see it in the film: the traffic lights are blinking red, which they don't do until 2:00 or 3:00 in the morning.

Ben Affleck: I don't remember any opiates or cocaine or speed or anything like that around. It was all very innocent. Everything that was happening then is legal in the state of California now.

Don Stroud: Toward the end of the shoot, everyone was falling asleep—the DP, the extras, just *everyone*, nodding off. There's some bootleg behind-the-scenes footage with a silhouetted, 4:00 in the

morning image of John Cameron with the bullhorn. Nothing short of, "Alright, you motherfuckers! Here's what needs to happen!" Everyone's patience is very slim, and you can hear the tone in his voice. He has just about had it.

John Cameron: These were young kids! This represented the hardest work they'd ever done. Making movies, when you're 15, it sounds glamorous and fun, but it's 12 to 14 hours of grueling, repetitive work, and for teenagers, it's hard to sustain that creative energy over the course of a night. It could be as simple as messing up their blocking, like, "What are you doing? We rehearsed this!" And at the end of a shoot, everybody's tired.

Jason London: We worked all night until the sun came up. When you see the sun coming up in the movie, that's really the sun coming up. That was one of the greatest filming nights of my life.

Chapter 24

Shawn and Milla Self-Destruct

"Well, I quit the film!"

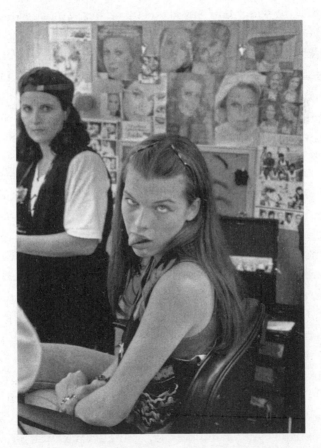

I t's hard to remember that Matthew McConaughey, Ben Affleck, and Renée Zellweger weren't always, well, Matthew McConaughey, Ben Affleck, and Renée Zellweger. But back in 1992, Milla Jovovich was the biggest star in *Dazed*.

Born in Kiev with striking, cobalt-blue eyes, Jovovich emigrated with her family to London when she was five, and eventually settled in Los Angeles. By 11, she was modeling for the legendary photographer Richard Avedon, who would feature her in Revlon's "Most Unforgettable Women in the World" campaign. By 16, she had starred in the desert-island film *Return to the Blue Lagoon*, danced in her underwear with Christian Slater in *Kuffs*, and played the child bride of Robert Downey Jr.'s Charlie Chaplin in *Chaplin*. She was also starting to write the songs that would end up on her 1994 pop album, *The Divine Comedy*, which earned praise from *Rolling Stone* and fandom from Mick Jagger. "Milla was a superstar," Jason London recalls.

She was 16 when she got cast in *Dazed and Confused*. Her part, the stoner girl Michelle, was described in the script as "Pickford's girlfriend, doesn't talk much but is perhaps the coolest girl around." You might think that role sounds too small for the biggest star in the film. You wouldn't necessarily be wrong.

Jovovich told Linklater she wasn't interested in doing *Dazed* unless she got a bigger part, and she has said Linklater agreed that she could make the part bigger. She believed she only needed one scene to make her character memorable. She never got that chance. Her volatile boyfriend, Shawn Andrews (Pickford), was already creating drama with the cast, and she was pulled into it.

By the end, you saw more of her on the poster than you did in the movie. "It sucks—they're totally exploiting my image," she said in 1994. "They screwed me." Maybe. Or maybe Jovovich and Andrews screwed themselves.

Richard Linklater: Milla came in wanting to play Jodi. She didn't get that part. She reluctantly agreed to play a much smaller part. I talked to her in preproduction about how I wanted her character to expand. But having her play a smaller part was ultimately a mistake, because she wasn't happy.

Jason London: Before *Dazed*, I'd done a movie called *December* with Brian Krause, who did *Return to the Blue Lagoon* with Milla. We lived in a crappy apartment in North Hollywood, and a limo pulled

up to pick up Brian for the publicity tour. Milla came in to get him, and she was like, "Wow. How do you live in this shithole?"

She was used to a very different life.

Justin O'Baugh: The pomp and circumstance surrounding Milla was the only black spot on the entire experience, all the baggage that came along with her. People were like, "Oh, fucking *Milla!*"

Kim France: She was also trying to have a music career. I remember, because I was writing about *Dazed and Confused* for *Sussy*, and Christina Kelly had written something mean about her incipient music career in *Sassy*, and when I came to the set, they were like, "Yeah, Milla doesn't want to talk to you."

Jason Davids Scott: I played guitar, and Milla said, "I play guitar, too! Come to my room and I'll play you this demo tape that I made." And I was like, Oh, *great*, because she was a model, not a musician, and I didn't think she'd be any good. So I went up to her room, and she played me the demo tape for what eventually became her first album. And it was like, *Oh my god, this is really good!*

I always feel bad that Milla got stuck with Shawn, because if anyone was the big star, *she* was.

Richard Linklater: Milla gave over her power to Shawn. I would talk to her about her character, but she would just look over at Shawn: "What do *you* say?" She was 16. He was 21 or something. I'm like, "Milla, don't! Forget him! This is *your* character."

Rory Cochrane: It was almost cultish. Shawn was like, "It's just you and me, and that's it." I don't remember her having her own free will.

Jason Davids Scott: In the script, they were supposed to play "After the Gold Rush" in the scene where they're in the woods, talking about aliens. But "After the Gold Rush" was apparently the most expensive line item on the soundtrack. At the very last minute, Milla said, "I'll play this song I wrote!" It sounds like it's about aliens. She's singing "Watch them fly." Nobody realized that it was a real song on her album ["The Alien Song"]. We all thought it was just Milla improvising.

Richard Linklater: Milla did finally write a little monologue where she was playing pinball and talking to someone. I thought, "I don't know if it'll make the final movie, but I want her to do the scene." But we were behind schedule. Anne [Walker-McBay] said, "Rick, we don't have time." And I was like, "Aw shit, Milla's going to be pissed."

Chrisse Harnos: I was supposed to be in that scene with Milla, at the pinball machine. And I remember her being like, "Nobody's valuing what I have to offer!"

Jonathan Burkhart: We had broken for lunch, and Shawn had gone to Rick, like, "Milla and I have rewritten a scene that we want to shoot in a particular way." I was sitting with Rick and Lee [Daniel] at lunch, and we say, "Okay, cool, we'll check it out!" And they're like, "No, we *really* want you to read these pages. We spent a long time doing this."

That's inappropriate. You, the cast, don't rewrite your lines on the spot and say, "I want to shoot it this way!" We got back from lunch and found out Milla and Shawn had locked themselves in somewhere, in protest, saying that unless Rick read their new version of the script, they weren't going to come out.

The ADs were like, "Fine! You don't want to come out? We're not going to shoot with you." I remember it being like, who the fuck do you think you are?

Richard Linklater: Milla wouldn't come out. And then she said, "Well, I quit the film."

Jason Davids Scott: Rick ended up basically cutting both Milla and Shawn almost entirely out of the movie.

Adam Goldberg: Shawn left before we wrapped. It was my understanding that he got fired before they shot the scene on the football field.

Richard Linklater: No, I didn't fire him. You don't fire actors late in the game like that. I just waited until all his stuff was done, and then called him up and we talked for a while. I told him that his character wasn't going to be driving to get the Aerosmith

tickets—Wooderson was. He wasn't pissed off or anything, and he actually agreed that his character probably wouldn't be doing that.

Bill Wise: Shawn Andrews didn't even get a work finish. Do you know what it means? It's kind of ritual that's gone down from back in the day, and every one of the leads at some point gets a work finish: "That's a wrap for Bill Wise," and everyone applauds. Shawn never got one. In fact, the last week, he was still in his honey wagon and no one had even taken the time to say, "Man, if you want to go, that's cool. We're done here."

Matthew McConaughey: Without even knowing it, Shawn was writing himself out of the film. I started getting invited in places that maybe Shawn was going to be in. Other actors started lobbing me lines. And all of a sudden, I'm gettin' written into the movie.

Richard Linklater: Note to actors: Get along with people you're in an ensemble with. Especially with the director. Don't forget who edits and controls all this.

Chapter 25

Just Keep Livin'

"I was like, This is the climax? Really?"

*O*n the final night of shooting, Linklater still wasn't totally sure how to end the movie. He knew he had to wrap up the film's central problem—whether or not Pink (Jason London) would sign a clean-living pledge given to him by his coach—but beyond that, he was open to suggestions from the cast about what, exactly, Pink and his friends would say to one another when they gathered on the football field after the party.

The cast understood one thing about the scene they were about to shoot: It had to matter. It had to reflect who their characters were

and what this film was supposed to say. But in a plotless movie like *Dazed*, such conclusions were difficult to reach. Should they talk about everything or should they talk about nothing? Should the conversation be funny or poignant? Should they be smoking joints or should they be rolling joints? How do you find meaning within a story that habitually rejects the obvious?

Like so many things in *Dazed*, the problem was solved by Matthew McConaughey. Linklater included him, so that he could deliver a little speech. When other cast members improvised, they usually brought comedy to the movie, but McConaughey was a cosmic cowboy, prone to stoner-friendly discussions about the nature of *life*, man. He brought a bit of poetry to the scene.

Richard Linklater: I wanted to have a scene where they hang out on the football field. That's what teenagers do! On a Saturday night, they go hang out in the school parking lot, but they're drinking beer and fucking around. They're doing something they can't do during school. There's a certain rebellion in that. It seems conformist to go back to that location—like, we hate school, why would we go back there? Well, because it's different now. We own that football field. No one's telling us what to do.

John Cameron: An empty stadium late at night was kind of a special, secret place to be. It's one of those film things where you have access to places that, normally, you wouldn't. I remember that scene as a bittersweet thing in the film. Filming it felt bittersweet as well. It was the last night of shooting.

Nicky Katt: I was already wrapped, but I stayed just to watch them shoot that scene. It was like I couldn't let go.

Jason Davids Scott: There was only a skeleton crew of people left.

Peter Millius: It was intense, because everyone knew, *this is it*. This was the last night of shooting, the grand finale. It was a really big deal. Everybody cared about it. They were all so excited and so nervous. Sasha was betting guys on the crew about how fast he could run around the track, and they were timing him. The other

kids were on the field, talking about their lives, and talking about how they wanted to do that scene.

Jason Davids Scott: That was the one time I got to see them work really closely with Rick.

Peter Millius: They would present an idea to Rick, and Rick would say, "Yeah, use part of that" or "Use all of it." They all wanted to make a statement about their character, and sign off in the right way.

Jason London: Sasha and I were supposed to pretend to be the coaches, like, "Break down, boy!" Well, my real high school football coach was a cool Vietnam vet who would tell us stories about Vietnam that always ended with "OTSS! Only the strong survive!" So I asked Rick, "Can I say that here?" And he was like, "You just gave me gold. Yes, please."

Deena Martin-DeLucia: Sasha had been coming on to me so strong throughout the whole movie. So after his character says that he "dogged as many chicks as he could while he was stuck in this place," my boyfriend Peter suggested that I say, "Yeah right, Mr. Premature Ejaculation." Peter had run the line through Rick, and he said, "You're gonna get it on the master shot, and we're not gonna tell Sasha." So Sasha wasn't expecting it at all.

Sasha Jenson: That was Peter's idea? Well, he got such a great reaction out of me, I should thank him!

I don't think we'd ever rehearsed that football field scene during the rehearsal process. We came up with most of it on the spot. I think Rick was like, okay, I gotta bring this movie home, because the whole movie's about Pink and this football letter, and we don't really know what happens with that, but that was really just an excuse to let McConaughey do that little speech.

Nicky Katt: Early on, it was Pickford who was supposed to be there with Pink. But they all wanted McConaughey there instead.

Excerpt from *Dazed and Confused*
Shooting Script, June 25, 1992

PICKFORD
I like the "I voluntarily sign this" part.

PINK
Yeah the best kind of extortion and behavior con-
trol is the kind you volunteer for.

> *He wads [the agreement] up again and*
> *tosses it out in front of them.*

PICKFORD
That means a no signature from you?

PINK
I dunno. I'll probably eventually sign it and end
up playing—I just want to do it on my terms some-
how.

PICKFORD
When you do, just sign that wadded up piece of
paper—that'll tell them something.

Richard Linklater: We were working on the final scene,
just trying to get what Wooderson would say to Pink at that point.
And I'll never forget Matthew looking over at me and saying, "It's
about livin', ain't it?" It was just obvious that it was about his dad.

Matthew McConaughey: Rick and I probably started our bond
when my father passed on. I remember when I first got back after
the funeral, I took a good long walk with Rick, who's a wonderful
listener. We were talking about what's the best way to get through
it, still appreciating a mourning process but not being subdued by

a mourning process, and how you keep someone's spirit alive even though, physically, they're no longer here. That was the night that "Just keep livin'" came out of my mouth. A light went off for me about how to navigate losing my father, just keeping his spirit alive.

Don Howard: Rick said, let's just get Matthew McConaughey in here and let him carry that last scene.

Sasha Jenson: We were shooting, and I was like, *This* is the climax? Really? Pink throws the letter on the ground, and that's the end of the movie? And McConaughey's going, "J.K. Livin'"? Honestly, at that point, it didn't make any sense!

Don Howard: Yeah, it doesn't make any sense that Wooderson would be there with them. He's an older guy! What's he doing on a high school football field? But it doesn't matter. McConaughey's so good, you don't even think about, "What is that older dude doing here?"

Jason Davids Scott: McConaughey so understood the value of that moment. He'd been the creepy older guy, but then he gets some wisdom. That would've been harder to pull off with Pickford. Pickford was just the rich kid. There was no way that character could've come up with that.

Bill Wise: When you're at the end of the party, and the sun's rays are coming up, that's when you don't overthink. You're stoned and tired. You just say, "Oh, man, you just got to keep living is what you do! You got one day, and then you got tomorrow! You've got to keep moving forward!" You know Wooderson is going to espouse some kind of empty sloganeering, and that's the beauty of it. When you're young and stoned, somebody will say something like that, and it's like, "Man, that guy is deep!"

Jason London: You know when McConaughey goes into these inspirational speeches? He's always been that way. Even before he was famous.

Matthew McConaughey: Look, "just keep living," the origin is my father moving on, but I love a good truism that you can apply to an infinite amount of situations, as a decision-making paradigm.

There's a "just keep living" decision with every single thing that I do. I could also argue that every character I play is a "just keep living" character. It's a life affirmant. I've not found any place where it's not applicable.

Sasha Jenson: The J.K. Livin' thing? McConaughey carved it into his car with a knife! That was his *thing*.

Jason Davids Scott: He had "J.K. Livin'" on his answering machine message after that. It was like, "Alright, this is Matthew and I can't get to the phone, but leave a message and I'll get back to you. J.K. Livin'." And this was before the film had come out! But I think he brought that attitude with him back to L.A.

Richard Linklater: The last week of production on *Dazed*, we were sitting at dinner, and Matthew was like, "You know, I think I'm going to move to L.A." And I was just like, *"Really?"* I was kinda surprised! I mean, he was great, but I've always been like, don't act unless you can't live your life *not* doing it, because it's a shitty business. It's a great calling, but it can be a tough life.

Justin O'Baugh: He wasn't "Matthew McConaughey" until then. He could've just been an extra. It was like, "Oh. You got a part, dude? Good for you, man. Congratulations." And then you see him in the movie, going "Just keep livin'" and you're like, "Oh! That was that dude, man! He had the best part of the whole movie! Aw, man!" And then you know what happens from there.

Nicky Katt: Matthew became a pit bull for success.

Chapter 26

You Can't Go Home Again

"I don't think any of us wanted it to end."

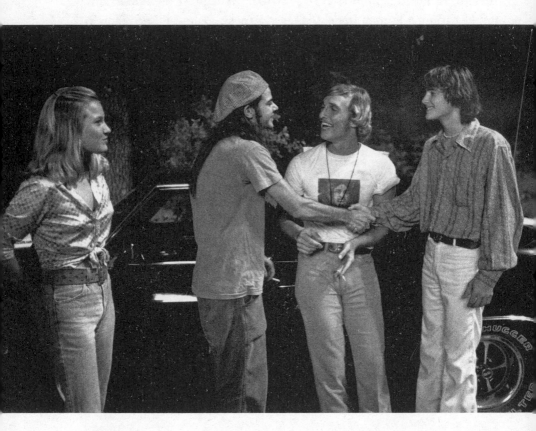

Unlike most high school movies, no lessons are learned in
Dazed, and no lives are changed. For most of the movie,
the characters aren't thinking about much beyond what-
ever's going to happen that night. The idea that this moment is
somehow meaningful is never considered. But when they drive off

to get Aerosmith tickets in the final scene, it still feels poignant—maybe not to Pink (Jason London) and his friends, but to the viewers, because we know what the characters don't: These kids can never go back. A party that seems forgettable when you're 17 eventually becomes a night you can only hope to remember.

"Linklater perfectly walks this tightrope between a very avant-garde movie in which nothing really happens and an extraordinarily entertaining movie where the stakes couldn't be higher," says film-maker Jason Reitman, a fan of the film who staged a live reading of *Dazed* in 2015. "Obviously, for those characters at the time, the stakes are: *Will I ever fit in? Will I get the guy? Will I get the girl? Will I get the beer?* But then you watch it as you get older, and you realize the stakes are so much grander. It's like: *Will life ever get as good as this? Will I ever know people as well as I knew the people I knew in high school? Will I ever think about the coming summer with a sense of hope again?*"

Even as they shot the scene, the actors were asking themselves those very same questions.

Joey Lauren Adams: There was a sadness to shooting that last scene in the car, where we're driving off to get Aerosmith tickets. It was like, *This is it.* Because that was the last scene we shot, and then we were all going to go our separate ways. And we shared this moment, and it kind of felt like everyone was going to be moving on. Our characters, and us. We were going to be leaving Austin.

Rory Cochrane: Matthew wasn't supposed to be in that scene. Pickford was supposed to be driving the car. But we all rallied around Matthew, and Rick agreed, because we knew that was the end of our summer. It was bittersweet for sure.

Jason London: The last shot of the movie is us smoking a joint in the car. So Rory pulled out a real joint.

Rory Cochrane: We had a prop joint, and those things didn't taste very good. They kind of burned your throat, and they weren't really rolled properly. In that scene, I take a huge hit and I'm cough-ing, and that leads me to believe that that was the fake stuff, but we

probably had multiple takes on that shot, and I might've switched to something real.

Anthony Rapp: That last sequence? There was a cut I saw where they're all just staring out the window. And I liked that cut, because it was real. They've had this all-nighter, and they're just wrecked, and the horizon didn't end. It was like the ending of *The Graduate*. That close-up of them, like, "Now what?"

Jason London: Shooting that last scene was insanely emotional. I'd just gotten to experience something that, in my wildest dreams, I would have never thought I would have experienced, and now it was over. And I had to hang up Randall "Pink" Floyd. After that, I'd have to go back to being the guy that wasn't the cool dude.

Rory Cochrane: I don't think any of us wanted it to end.

Peter Millius: We had a wrap party on Lake Travis. We were all told it was gonna be a day party, and the park closes at sundown. Either you get out of the park by 8:00 or you spend the night in the park. I turned to Matthew and I said, "Let's fuck with everybody. Let's let everyone think they're locked in for the night." Matthew was like, "Fuck yeah!"

So I jumped out, closed the gate. I took the chain, wrapped it around the gate so it looked like it was locked. It was one of those big gates that you go through at a tollhouse, and it blocked the road. We pulled the car around behind the trees so they couldn't see our car. And we hid in the bushes and waited for everybody to come up.

Matthew McConaughey: I had a speaker in the grille of my truck; on the inside on my CB I could turn it into a PA. So everyone's there in the park, hanging out, and things are getting loose, and I come back like I'm highway patrol.

Deena Martin-DeLucia: Matthew was yelling, "You are locked in for the evening! It's not my rules, it's the state rules! You guys sleep in the park." Everybody was getting out of their cars: Jim Jacks, Donnie Phillips, Lee Daniel, all walking up to this big chain fence.

Peter Millius: Everyone was like, "You gotta let us out of here!" And we were laughing our asses off behind the bushes. Lee

Daniel walked up to the gate. He was *pissed off*, like, "Come out and talk to us! Where are you?" And Matthew wouldn't answer.

Lee kicked the gate really hard, and the chain unraveled. We pulled out from behind the bushes and Matthew said in his trooper voice, "Get in your cars and continue to Sixth Street! We're gonna continue this party!" We were waving and honking our horn.

Matthew McConaughey: Everyone got a new bolt of energy to continue partying harder.

Deena Martin-DeLucia: We were such a tight-knit group that a lot of us were scheduled to fly out that day, but we canceled our flights and stayed one more night at Matthew's. We all crashed on the floor, 'cause we just couldn't leave yet.

Marissa Ribisi: We didn't have smartphones. We didn't have cars. We just had these crazy conversations. And that's why I think it got so crazy deep in the end. Everyone was sobbing. It was hard to leave.

Joey Lauren Adams: It was one of those "art imitating life" things. I felt like I'd graduated from something.

Katherine Dover: After the movie, Milla ran off with Shawn. They got married in Vegas. Milla's mother had just left the week before. She'd gone back to L.A. Milla's mother started procedures to annul right away.

John Frick: Milla was 16 when they got married.

Katy Jelski: Milla's mother, who was a real formidable Eastern European stage mother, wanted big things for her girl. She had been an actress herself, and she was not going to let her daughter get stuck with this loser.

Kahane Cooperman: I was really invested in what would happen to the younger kids from Austin. Because they weren't really people who were really seeking out an acting career, I had more access with them, and I really connected with them. When we finished filming, I drove Wiley back to his first day of high school.

Wiley Wiggins: That was weird. In Kahane's documentary, you can see me standing outside my high school, telling her camera

crew to leave. I was wearing a *Dazed and Confused* T-shirt, which didn't mean anything to anyone except for the extras. That was a pretty uncool thing to do, wearing a T-shirt from your own movie.

Catherine Avril Morris: My last night of filming ended the morning before the first day of school. I got to school at 11:00 a.m. and it started at 9:00 a.m. My schedule all summer had been to go to bed during the daytime. I was sobbing. My mom had to leave work and come get me.

Dazed taught me to look at my own high school experience from the outside. You know how Rick and Lee do those shots, like the one with Jason London on the football field, where it centers on somebody's face, and the sky is behind them, and you know exactly what that moment is like for them, that moment of removal from their own present reality? It's like they're already their older selves, looking back, from a later time?

I already had that feeling. Rick just gave me the real framework for it. Making a film with somebody who was already in his 30s and was making a film about what he remembers about high school showed me that this is all gonna be *done*, and we'll be moving on and looking back on this.

Christin Hinojosa-Kirschenbaum: There is a kind of magic to making a movie. Doing an artistic endeavor in such close collaboration with each other forms this very special thing. And everyone else was going back to L.A. to do that, and I think I was like, "Oh, I don't get to do that anymore? I have to go to, like, chemistry class?"

I felt left behind. Everyone was going back to do other movies, and I was going back to high school. So after I was done, I couldn't really go back to high school life. It kind of did form a rift between me and the other kids. Maybe it was me? I felt like it was them. But maybe it was me not feeling like I belonged anymore.

Wiley Wiggins: I didn't stay in school much longer. I didn't get my GED until 2017.

Jeremy Fox: Six months after the film was released, I dropped out.

Christin Hinojosa-Kirschenbaum: The last day of shoot-ing, I had talked to Parker about going back, and Parker told me what she had done, which was march into her guidance counselor and say, "I'm dropping out if you don't let me graduate a year early." So that's what I did. I wanted to be in the new reality. I was just kind of done. I graduated at 17 and moved out to L.A.

Adam Goldberg: My plan was to take the train back to L.A. It created a transitional period for me where I could ease my way back to society. I think it seemed too crazy to me, the idea of being there in Austin and then being in L.A., back home. It was just too heavy of an experience.

Jason London: Chrisse and I went straight from Austin up to see my mom, my stepdad, my sister, and her baby in Tulsa. And then I went to Atlanta where my brother Jeremy was doing his TV series, *I'll Fly Away.*

So I meet with my brother, we go out and have a few beers, and something felt weird. So we were like, let's go back to the apartment. We go in, and the voice mail is blinking. He pushes the button, and it's my stepdad. And he says, "Boys, you need to call home right now, it's an emergency."

My sister's son was seven months old at the time. He had been born with so many diseases and health issues that we immediately thought, "Shit, the baby died." We're in my brother's apartment and we're like, *Oh my god oh my god oh my god please please please please.* I remember staring out the window on the seventeenth floor of his building and hearing Jeremy get on the phone. He's calling and call-ing and can't get ahold of my mom or my stepdad, and then all of a sudden the phone rings. And I'm sitting there, going, *Everything's fine everything's fine everything's fine.*

Then I hear Jeremy go, "Dedra's dead."

Chrisse Harnos: He lost his sister, which was devastating. She died in a car accident. And she was only 16. There was a loss of inno-cence to him after that. The pain of that was really dark and heavy. Jason really loved her.

Jason London: Full blackout mode from then on. I remember just losing my mind.

Nicky Katt: When everybody had to go back to their lives after *Dazed,* it was a fucking *hard* comedown. For all of us.

Kahane Cooperman: It was poignant. They'd all had this amazing experience together, with a lot of extreme emotions, and a lot of fun, and when that was over, it really made you think about the fleeting nature of things. It was the end of a life experience, and they all felt it. Palpably. I felt it myself.

Kahane Corn (now known as Kahane Cooperman)
in her pregnancy costume

Richard Linklater: A ways into post-production that fall, I found out that Tina and I were going to have a kid.

Shana Scott: To find out that he got a girl pregnant and was having a child? Kahane blew up. She was like, "I came down to Austin, I'm spending all this money making this documentary, and apparently you've got a girl in every port!"

Kahane Cooperman: Admittedly, I thought I was in a monogamous relationship. When I found out otherwise, I ended it. But that didn't have an impact on making the doc.

Richard Linklater: There was definitely a little overlap there with Kahane and Tina. We were friends again not that long afterward, but I think she thought I was Mr. Evil for a while.

Kahane Cooperman: I will say that the irony wasn't lost on me that, in my *Dazed* cameo, I'm wearing a fake latex pregnancy belly and maternity bell-bottoms. But I'm glad Rick found his life partner.

Richard Linklater: It's not like Tina and I were some long-term couple at the time. When I told my family that Tina was pregnant, they were like, "Huh? Who is this person?" We were still getting to know each other, even when we were becoming parents.

When I was growing up, I saw domesticity as the big trap. Had I become a father at 21 and had to work eight hours a day to support that kid, I would have never become a filmmaker. You can't really do that part-time, at night, at home. Film is so all-encompassing. I never would have pulled it together had I been a young parent.

My mom and dad's generation, all of them had kids young. That's what you did. You go to work and you support that family and you do that. Growing up, I saw my mom struggle, and I was like, *Don't have a kid when you're young!* My generation was the first to say, "You know, we're going to delay that a bit." But by the time I was 32, I was like, okay, I can incorporate a kid into this. I was as ready as I was ever going to be.

I'd always thought having a long-term relationship would come down to finding that perfect partner, which I couldn't imagine, because I knew I was an imperfect partner. So it's probably good, the way it all happened, just getting thrown in together by fate. It confirms my worldview: Life isn't perfectly planned. It's all just randomness.

And that's kind of how I felt about *Dazed*, too. I never could have predicted how everything turned out. When you're young and full of yourself, you think, "Oh, the universe will reward my desires!" And it turned out I was wrong.

Part III

The Comedown

Chapter 27

Faster, Funnier, Stupider

"Everybody had a problem with the ending.
It was like, 'What ending?'"

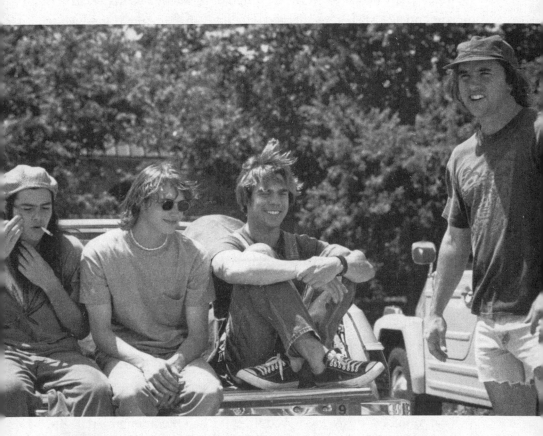

*D*azed and Confused is largely remembered as a party movie, but it started out with a darker worldview than you might expect. In early drafts, Cynthia (Marissa Ribisi) considers the possibility of a global thermonuclear war. Kaye (Chrisse Harnos)

wonders whether she was born simply because her mother couldn't legally abort her. There's a horrific encounter between Mike (Adam Goldberg) and a very drunk girl in the woods that reads like a rape scene.

By the time the movie reached final cut, though, it had become a much more lighthearted film, one that stayed true to Linklater's vision—and yet, it wasn't quite what Universal wanted. The studio had signed up for the next *American Graffiti*. They'd ordered that *Dazed* should be cut in the style of a broader comedy, and still weren't satisfied at the end. The director acceded to as many of their demands as his personality would allow: virtually none. And some people believe Universal punished him for it.

Robert Brakey: For the last 25 years, whenever people talk about *Dazed and Confused*, they say, "Oh, that movie's so funny!" And I'm always thinking, there's a whole other movie that was part of *Dazed* that you'll never see. The first cut of the movie was over three and a half hours long. I was like, how are you gonna get this down to 90 minutes? At that point, the whole push from the studio and the producers was to go for the comedy part of the movie, and Rick and Sandra resented that.

Sandra Adair: From the very beginning, Jim Jacks and Sean Daniel were calling me in the cutting room and saying, "Are you getting enough coverage? Do you have enough shots to really cut this in a comedic style?" Rick is a very stylistic director. You can't always do fast cutting with him. But they were always asking for faster, funnier, stupider.

Richard Linklater: Kate Jelski, my script supervisor, accused Jim of thinking that way, and she threw in that line: "faster, funnier, stupider."

You couldn't make *Dazed* any more stupid than it was already. That kind of comedy was baked in. But I had these long monologue scenes that were probably more soul-searching, more thoughtful. I didn't really pull them off. And I admitted it to myself. The teenager in me was beating out his more reflective adult collaborator, who was trying to say too much. So we cut a few scenes.

Robert Brakey: We cut a lot of the poignant, thoughtful, angsty stuff and went for the jokes. And so the paddling became more of a big deal. Wooderson became more of a big deal. The party at the moon tower became more of a big deal. And all this other stuff just got lost. Like this scene about Vietnam.

Richard Linklater: In 1975, after the war was over, three Vietnamese girls moved to our town in Huntsville. I felt sorry for them, like, "Wow, what have they been through?" I probably wasn't that conscious of North Vietnam, South Vietnam, what side we were on, but I just knew the war was fucked up. There were all these slogans out there, like, "Return home with honor." We didn't want to admit that we'd lost the war. But then we all saw the last chopper out, and it was pretty horrific images. You see it on TV at 14, 15 years old, and you realize, "Oh, those people left behind are going to die. That's not a victorious send-off from a war." So I conjured up this scene where Benny would be the nationalist guy, like, "Hey, we never lost no war." We shot that.

Excerpt from *Dazed and Confused* Shooting Script, June 25, 1992

Three Vietnamese girls walk down the street.

BENNY

That's the second group of them slant-eyed Viet-cong I've seen today. What the hell's going on? Why didn't they stay where they came from?

PINK

Well, maybe because our country had something to do with fucking up where they lived and the least we could do was help out the ones that got away.

<div style="text-align:center">DON</div>

The side we were fighting for finally lost, right?

<div style="text-align:center">BENNY</div>

But not while we were fighting with them . . .

<div style="text-align:center">PINK</div>

Everyone was bailing out, but hey, when they lost, we lost.

<div style="text-align:center">BENNY</div>

We never lost no war, man.

<div style="text-align:center">PINK</div>

When the Communist troops swarmed into Saigon and everybody was running for their lives, holding onto the outside of planes that were leaving, it was all over.

<div style="text-align:center">BENNY</div>

It might not have worked out perfectly, but I bet we killed a lot more of them than they killed us, right?

Jason Reitman: In the original script, there's an amazing scene where the girls go up to the top of the moon tower. They've just walked through this graveyard, and the sun is rising and they're looking out over the city.

Excerpt from Dazed and Confused
Seventh Draft, April 16, 1992

KAYE
I can't stop thinking about this tombstone I saw back there. This girl was only 19 when she died. 1948 to 1967.

JODI
Sucks, but you can't let stuff like that bother you.

KAYE
It's just sad. Like, who's even thinking about her right now?

JODI
I don't know. People that knew her. You're thinking of her.

KAYE
Because there's a rock in the ground with her name on it.
They both stare out at the horizon.

JODI
I don't think anyone can ever really know anyone else.
She looks back down where all the people were gathered earlier.

KAYE
What's going to happen to all of us? I mean, everyone that was here tonight, within a year or so,

we'll all be scattered and most of us will never
see each other again.

 JODI
Yeah. It's like you're all alone but the people
around you will keep changing.

Jason Davids Scott: Rick shot some of that scene, focusing on their eyes, just panning back and forth between them.

Jason Reitman: Here's a movie where, up until this moment, to think about your future is to think about, are you going to be able to get booze tonight? Your future is basically 10 minutes ahead of you. And all of a sudden, these young women are pondering their existence and wondering who they will become. I love that scene. I always wonder why he cut it.

Richard Linklater: It was at the end of the movie, after that big party, and we're coming down from that to hang out with two of them in a graveyard? It just sent the movie in a sideways direction. But I loved that scene so much, I put it in my next movie. In *Before Sunrise*, they're walking through the cemetery. I totally recycled that scene.

Don Howard: *Dazed* was more of an art movie at one point. I probably argued with Rick and Sandra too much, because I wanted more of the class stuff in the movie to be visible. One of my favorite scenes got cut. Early in the movie, when you first meet Sabrina, the older girls pull up to a house and they let her off. She gets out of the truck, and she's clearly waiting for the truck to leave, then she walks down to this other little house in the back, and her mom is there. It's not like her mom says anything mean to her, but you get this feeling that they live a hard life. Later, Sabrina has her first kiss outside the house where the older girls dropped her off. She lets Tony kiss her in front of her neighbor's house because she doesn't want him to see where she lives.

Richard Linklater: That was personal to me. She's kind of ashamed of the house she lives in. She doesn't want the other girls to know where she lives. So she gets dropped off next door and she walks home. I remember doing that, because my mom bought a really crummy little house in Huntsville. I mean, single mom, inflation in the '70s—we were poor. I just didn't wanna look like white trash.

The day we shot that was the one day my mom visited the set. She was like, "What's going on in this scene?" I couldn't tell her straight up. I was like, "Oh, she's getting dropped off after school. Have you visited the craft service table?"

Don Howard: I was always pushing for some aspects of the movie that were more harsh in terms of those kids' view of the world. There was a scene where the guys are at the moon tower, looking down on the town, and they're talking about the people in the town and how they all go to work and live these dead-end lives. It's always been a good scene, but it was fatter in the beginning. When they brought that scene back, it had devolved to just, "Imagine how many people are out there fucking right now." And to me, that's emblematic of the direction the film went.

Richard Linklater: It was just part of this ongoing process of having screenings, and trimming the movie. You squirm in your seat when something's clearly not working. And the film did get better. Somewhere along the way, you go, why go dark? There's enough little dark rings around things. You're in the editing room with your 2 hour 45 minute movie and you're like, "Well, it's not consistently funny." You have to let a film be what it's meant to be, and ultimately *Dazed* wanted to be more of a party movie. I think that's why we're here talking about it almost 30 years later.

Robert Brakey: For the first preview, which was in Dallas, we had to drastically cut the film from the original runtime. Sandra said, "Have you been through this before?" I said, "No. What can I expect?" She dragged her finger across her throat, like, *this is death.*

Excerpt from Richard Linklater's
"Dazed by Days" Diary
Dallas, November 1992

We have our first obligatory preview to a half-full theater in some Dallas shopping center. The audience seems to really like it, but, of course, the critics emerge when it's time to fill out those stupid cards. Everyone's a Siskel or Ebert.

Later, the company conducting the preview writes a letter to Universal trying to cover their ass for not filling up the theater. Instead of rightly saying there was a Cowboy game going on at the same time and maybe they shouldn't have scheduled a suburban Dallas preview right then, they blame it on the film: no one thought it even sounded interesting enough to want to attend for free—there was nothing appealing about the seventies, and no stars in the movie, so they were unable to even give the tickets away. Furthermore, when trying to explain why they didn't get a response card from almost everyone in the audience, they, of course, don't admit they forgot to tell everyone to wait after the show to fill out a card. Instead the audience "bolted" from their seats after the screening, apparently completely disappointed with the film.

Welcome to an industry that's all about not looking bad no matter who you have to fuck over in the process.

And for this kind of bullshit Universal throws away about twenty grand per preview. It's completely ludicrous—a total waste of cash.

I don't even bother to look at the cards—I don't want to give them that power. I'm only concerned with how I feel watching with an audience and in that way it is helpful. You're forced to confront your material in a big way when you know others are watching. You can no longer tell yourself something is working when it isn't or that the film can't be any shorter when you feel it dragging in spots.

*The worst thing now is, they want us to come to L.A. to keep ed-
iting and to prepare for the next preview. "It's in the best interests of
the picture." Hmmm.*

Russell Schwartz: You're familiar with research screenings,
right? When a movie is tested, there is a recruited audience that
comes, and you try to make sure that's the audience that will re-
spond most to the movie. Then 20 or 25 people are asked if they
want to be in a focus group, which will happen after the screening.
So there's a public reaction, then there's a smaller focus group where
we ask things like "Would you definitely recommend it?" And then,
based on that, you look to see whether the film is clicking with the
audience or not.

The norm for screenings was probably that 35 percent would say
the film was excellent, and maybe 30 percent would say the film
was very good, so you've got 65 percent in the top two boxes. Every-
body thinks if they hit that norm, they're really doing well, but in
fact they're not, because that's equivalent to a C. It just means you
passed.

Robert Brakey: The Dallas preview did not go well and word
came down that we were packing up and moving to the Univer-
sal Studios lot. They wanted us under their thumb. Sandra asked
me if I could drive all the dailies from Austin to California—in a
U-Haul. I didn't know what it would be like to work in a cutting
room, so it definitely showed me what that was like, and not in a
glamorous way.

Greg Finton: We were treated like the bastard stepchildren
once everyone got to L.A. Rick was an out-of-towner, so the studio
needed to rent him a car. Normally, a director working from out of
town is gonna get a BMW or a Mercedes. They rented him a Geo
Metro.

Richard Linklater: Part of the psych ops they did on me was, I was staying at the Oakwood Apartments, right by Universal, which was really horrible. I found out later, Nirvana was there at the same time doing *In Utero*, and Cobain writes about it, like, "It's a sad place. All *Star Search* moms."

Greg Finton: Most films are brought to L.A. to finish if it's a studio film, and this was technically a studio film, but we certainly did not get the respect a studio film would get. They put us in a completely dilapidated building at Universal.

Robert Brakey: It was the costume warehouse. Greg and I would go exploring and find an office with a box of old scripts and costumes from some '70s TV show.

Greg Finton: They were just waiting for us to finish editing so they could tear the entire building down. We were on the second floor, and it rained a lot that winter. We constantly had leaks that were dripping onto our work print, and I had to move the film from one room to another to get away from the leaks. We had our sound editors down the hall, and when you walked down the hallway, the floor would flex under your legs.

Sandra Adair: We had a small earthquake while we were editing. All the film reels on the rack were shaking and I thought the whole building was going to crumble. It probably wasn't safe for us to be in there.

Greg Finton: Universal wanted to have control over the film. They didn't trust Rick. It was odd that they're hired him to make this cutting-edge indie film for them but they didn't trust in that process at all.

Russell Schwartz: After the first research screening in Woodland Hills, Tom Pollock said, "My wife doesn't like the movie." I said, "Oh shit."

Richard Linklater: Tom only came to one screening. And it's like, if you only came to one screening, why'd you drag your wife to a teenage movie in fucking Woodland Hills to do *your* job?

Tom Pollock: She's now my ex-wife, so please don't get me in trouble. I vaguely remember that she didn't like it. I don't remember why.

Nicky Katt: I heard she thought it was some booby, druggie movie, like *Porky's* or something, so he was like, "I'm gonna bury this film."

Richard Linklater: That definitely had a chilling effect.

At some point, Universal decided to release *Dazed* as a much smaller thing. They had formed a company called Gramercy Pictures to do specialty films. So I went through the whole studio experience, and then I got the specialty film release. Which *sucked,* because it's the worst of both worlds.

Russell Schwartz: Gramercy was a co-venture between Poly-Gram Films and Universal. The idea was that both companies were feeding into this centralized marketing system.

Samantha Hart: Gramercy was created as a dumping ground for movies the studios didn't know what to do with.

John Pierson: Gramercy was supposed to be the artsier direction. "Oh, we're not really a *Universal* film, we're a *Gramercy* film." So *Dazed* was caught in betwixt and between. "Are we commercial? Are we art? Are we Universal? Are we Gramercy? We're neither fish nor fowl."

Greg Finton: We kept *endlessly* previewing the film in L.A. Normally when you preview a film, you do it far enough outside the city where you don't have people within the industry showing up to your screenings, and you never do it in the same place. But I remember us going out to the same theater in the Valley and seeing half the audience look like the same kids who were there two weeks earlier.

Richard Linklater: It was so weird. You'd sit through test screenings and it would be through the roof. People would applaud at the end. They'd laugh through the whole film. They'd have a great time. And then the scores would come in and they weren't that good.

The first screening in Dallas was a 38 or so. We progressed up as we trimmed and polished, ending up in the high 70s, or low 80s. Better, but not "enough."

Russell Schwartz: Most independent movies don't test well. *Fargo* tested at about 26 percent in the top two boxes. *About Schmidt* tested at about 30 percent. If you went by traditional research methodologies with these movies, they would never get released.

Richard Linklater: When we did these screenings, they'd press the audience about the ending, and lo and behold, everybody had a problem with the ending. It was like, "*What* ending?"

Greg Finton: Yeah, it was, "What ending? What beginning? What middle?" The beauty of the film was completely lost on them.

Richard Linklater: They'd ask the audience, "Who are your least favorite characters?" Well, what do you know, Darla and O'Bannion are their least favorites. And we'd hear from the studio, "People don't like them."

And I'm like, "*They're the bad guys!* Are you telling me to cut them out of the movie?"

Adam Goldberg: I remember Rick telling me that it was like, "What's your favorite part of the movie?" And someone had written, "The part where the Jew gets his ass kicked."

Richard Linklater: That's the kind of stuff you have to go through. Constant stupidity.

Greg Finton: It felt like we were doing preview screenings *every week*. I'd worked on Robert Redford's film *A River Runs Through It,* and the experience of working with Redford as a director versus Linklater couldn't have been any more different. Redford said to the studio, "You can preview my film, but you can't take any numbers. You can't do any Scantron sheets. You have to sit in the audience and watch them and read them yourselves." He had the power where he could do that.

Rick didn't have any power. But the beauty of what Rick did with *Dazed* is that no matter how many times it got cut down, no matter how many notes he got, the film stuck to his vision. It probably sur-

vived more than any other film I've ever worked on. The guy with the least amount of power maintained the most amount of power in the end.

Jim Jacks: Toward the end, Universal had a real lack of confidence in the movie. They were spending enough money that they couldn't just throw it away—but ultimately, they did, because of the whole thing about the soundtrack.

Richard Linklater: I'd already made up my mind: If the ship was gonna sink, I was gonna go down with it.

Tracklist from Richard Linklater's Original
Dazed and Confused Mixtapes

Songs that ended up in the movie appear in bold.

SIDE A
Aerosmith, "Sweet Emotion"
Foghat, "Slow Ride"
ZZ Top, "Thunderbird"
KISS, "Rock and Roll All Nite"
Led Zeppelin, "D'yer Mak'er"
Bob Dylan, "Hurricane"
Isley Brothers, "Fight the Power"
The Edgar Winter Group, "Free Ride"
Ted Nugent, "Stranglehold"
Sweet, "Fox on the Run"
Rick Derringer, "Rock and Roll, Hoochie Koo"

SIDE B
Aerosmith, "Dream On"
Ohio Players, "Love Rollercoaster"
Golden Earring, "Radar Love"
Led Zeppelin, "Rock and Roll"
ZZ Top, "Balinese"
Electric Light Orchestra, "Strange Magic"
Nazareth, "Love Hurts"
Bruce Springsteen, "Tenth Avenue Freeze-Out"
War, "Low Rider"
Peter Frampton, "Show Me the Way"
Jethro Tull, "Locomotive Breath"
Black Sabbath, "Paranoid"
Grand Funk Railroad, "Some Kind of Wonderful"
Bee Gees, "Jive Talkin'"

SIDE C

Roxy Music, "Love Is the Drug"
David Bowie, "Golden Years"
Head East, "Never Been Any Reason"
Foghat, "I Just Want to Make Love to You"
Jigsaw, "Sky High"
Ted Nugent, "Hey Baby"
Lynyrd Skynyrd, "Sweet Home Alabama"
Deep Purple, "Woman from Tokyo"
Steve Miller Band, "Living in the U.S.A."
KC & the Sunshine Band, "That's the Way (I Like It)"
Orleans, "Dance with Me"
Seals & Crofts, "Summer Breeze"
Hamilton, Joe Frank & Reynolds, "Fallin' in Love"
The Stylistics, "Break Up to Make Up"

SIDE D

Led Zeppelin, "Communication Breakdown"
Aerosmith, "You See Me Crying"
Electric Light Orchestra, "Evil Woman"
Led Zeppelin, "Dazed and Confused"
ZZ Top, "Backdoor Medley"

Chapter 28

Instead of Led Zeppelin, How About . . . Jackyl?

"I was going to go into Tom Pollock's office with a razor."

he soundtrack to *Dazed and Confused* has become just as iconic as the movie itself. It now seems like a brilliant encapsulation of what many kids would have actually listened to in 1976. But at the time of its release, it was hard to tell if the songs were supposed to reflect the era of music or if they were commenting on the characters' pedestrian taste.

In June 1992, before production began, Richard Linklater sent a mixtape to the cast with all the songs he wanted to use in the movie.

"A few of the songs are a little cheesy (there are a few places for ironic usage, etc.) but for the most part I believe this music I want is like the movie itself: straightforward, honest and fun," he wrote in the accompanying letter.

Linklater's song choices were risky at the time. Throughout most of the 1980s, '70s arena rock was viewed as totally irrelevant. Somehow, Linklater was prescient enough to pick songs that were not only true to the era but also memorable and durable, to the point where they'd soon be collectively regarded as timeless.

Nearly 10 percent of the film's budget was originally set aside for securing the music rights—about the same percentage George Lucas spent securing the music rights for *American Graffiti*. The movie's title came from a Led Zeppelin song. (Legally, they were able to use the song title without clearing it with the band.) Linklater believed the music could end up defining the film, and he was right. The soundtrack sold more than two million copies and yielded a sequel, *Even More Dazed and Confused*. *Dazed* is now remembered as one of the greatest rock 'n' roll movies of all time.

Yet when Linklater talks about the soundtrack now, he mostly remembers it as the singular detail that nearly made him lose his mind. To the average person, Universal's suggestions about the soundtrack might seem unsurprising: the studio wanted to cut the music budget, and they wanted the album to be released by Geffen Records, a subsidiary of MCA Records, which had corporate ties to Universal. But to Linklater, Universal was calling for major, film-destroying sacrifices, especially once the executives started making demands about which bands to include on the soundtrack. Linklater had a choice: concede to the music titans or go to battle over a cloddish hard rock band known for using a chainsaw in concert.

Richard Linklater: Teenagers can't express themselves very well, so music is their voice. Music expresses their emotions. That's why it means so much to them. I wanted to transfer that to the screen somehow.

The core of *Dazed and Confused* was this one night I spent driving around in my friend's LeMans all night. I was in La Porte, Texas,

down in South Houston. My dad lived near there, so I'd go down there on weekends. This was maybe my freshman year of high school. We were listening to *Fandango!* by ZZ Top, and just riding around all night. And I remember at the end of the night, we'd gone like 130 miles and we hadn't even left the city.

So that was my original idea for *Dazed and Confused*: *Fandango!* would be playing and you'd hear the click of the 8-track, and we'd just play the album in real time. We'll never leave the car. But all this weird shit would be happening in and around the car. And the 8-track would go around a couple of times, so you would hear every song at least twice. That was the movie.

Don Howard: You still hear a few ZZ Top songs in the movie, and there is still a shot of an 8-track tape of *Fandango!* going into a tape deck in the car. In my mind, they shot that as a specific homage to that the original idea.

Richard Linklater: Once I opened that gate, I had too much else to cover. Last day of school, the hazing. It just opened up.

Don Howard: When we were first starting to work on the movie, Rick gave us three cassette tapes that had all the '70s songs he was thinking about using. So I'm driving around, listening to these things constantly and trying to figure out, "Okay, yeah, that's a dumb song, but that would be great in this movie." Or: "This one is a *great* song." But some of those songs, it was hard to tell if Rick thought they were cool or not. He's very canny that way. He's able to play it both ways.

Marissa Ribisi: When we got the part, Rick sent each of us a mixtape, and I thought it was the coolest thing in the world! At the time, you couldn't really look up, like, Captain & Tennille on the internet. I was really into Sinéad O' Connor and Kate Bush. I didn't know about that other stuff.

Richard Linklater: There were slight variations between the characters' mixtapes. I would say, "*You* would like Joni Mitchell, and *you* would like Jethro Tull."

Steven Hyden: I heard that Adam Goldberg didn't love his tape because he was a huge Neil Young fan and there were all these

Foghat songs on there, and he was wishing that his character had cooler taste. But I think that really speaks to how Linklater felt that music was a big part of these characters' identities, as it is for a lot of teenagers. The kind of music you like as a teenager is a big part of your personality. If you fancy yourself an intellectual, you like smarter bands. If you picture yourself as more of a blue-collar athlete, you're going to like more aggressive, visceral bands. Music is an instant personality kit to put on while you try to figure out who you are.

Jason Reitman: You see a lot of movies where people are just generic, like they've been cut out of a bologna package, but *Dazed* has none of that. The characters are specifically identified from the very first moment by the music they like.

Steven Hyden: Benny is one of the ringleaders of the bullying, and whenever you see him in his truck chasing these kids, there's always hard rock and Southern rock playing. Like, you hear Deep Purple's "Highway Star" and you hear "Jim Dandy" by Black Oak Arkansas. And I love that, because it seems very authentic to who that character is. That's what jocks in Texas probably listened to! And McConaughey has said he listened to Ted Nugent's "Stranglehold" when he was getting ready for his scenes, and Nugent influenced the way his character walked: crotch forward. Wooderson kind of has that arena-rock swagger.

Richard Linklater: The movie is bigger than any one person's tastes, though. I wanted to go for a kind of monoculture of what kids might be listening to in 1976, and I didn't want to make the music retrospectively cooler, based on my adult taste. Like, I wasn't gonna put Big Star on there, because I didn't know who Big Star was when I was in high school. None of my friends did. This was 16- or 17-year-olds picking the music—that's how I had to look at it.

Steven Hyden: He's smart because he knows these kids aren't gonna be listening to deep cuts. Like, Black Sabbath's "Paranoid" is in the movie, and that came out a few years before 1976, but they wouldn't necessarily be listening to *Sabotage,* just because that was the newer Sabbath album at the time. They're in high school. They'd

probably be listening to some "greatest hits" album that had "Paranoid" on it. Kids don't always listen to new songs. In fact, if Linklater made a movie about the mid-'90s, he could still probably use some of the same songs from *Dazed and Confused*.

Sasha Jenson: When Rick gave us tapes of all of the music that was going to be in the movie, it was like, oh yeah, we listen to this kind of music all the time anyway. Because in the '90s, it was Pearl Jam, it was Smashing Pumpkins. Our music still kind of tasted the same as '70s rock.

Ben Affleck: When I did *Dazed*, I was listening to Bob Marley, the Rolling Stones, Led Zeppelin, all these '70s bands. That was what seemed authentic. It was kind of odd to revere your parents' cultural choices, because usually you rebel, but where I grew up, we had the Grateful Dead, and we thought, like, "They don't make good music like this anymore!"

Richard Linklater: When I was young, we were tossing out previous generations. That's what punk rock was about. "Get rid of that! That's old!" I wasn't, like, going to a Benny Goodman show with my parents and grandparents. But half the acts on the *Dazed* soundtrack were still on tour in '92 and '93. I wanted to show that this boomer culture was never going away.

Brian Raftery: Aerosmith was still a big band in the '90s. I think that's why that opening scene in *Dazed* worked. "Sweet Emotion" was still a big song, and you'd drive around in the parking lot in a car playing it. That's one of the greatest needle-drop opening-credits music cues of all time, because you are immediately sucked into the '70s, but you were also like, this could be the present.

Richard Linklater: From the very first day, I was like, "The music budget on this movie's going to be big. I might need a million dollars." "Sweet Emotion" cost $100,000. "Hurricane" cost $80,000. I mean, it's expensive! But they kept cutting the music budget. When I'd object, they said they'd add it back in post. Yeah, right.

Steven Hyden: My favorite musical sequence in the movie is when Wooderson, Pink, and Mitch walk into the Emporium and you

hear Bob Dylan's "Hurricane" in the background. I always think of that song as being a comment on Wooderson. Most of the songs in the movie are sort of party music, kid music, but Bob Dylan is a very "adult" artist, and Wooderson is the one real adult in the room. When he walks in to that song, it's so triumphant, but Linklater's also sort of undercutting the triumph of that a little bit, because Dylan's singing about this guy who "could have been the champion of the world." It's like he's saying Wooderson could've been great, but now he's kind of a loser. The music is kind of the Greek chorus in the movie, commenting on the characters and the action.

Richard Linklater: I battled with the literalness of the songs sometimes. For instance, using Alice Cooper's "School's Out" when school's getting out—that's so obvious. And then there's the other Alice Cooper song, "No More Mister Nice Guy," playing when Wiley's getting pounced. And Nazareth's "Love Hurts" during the junior high dance. Even in the editing room, we were like, "Are those too literal?" But when you're in a genre, you've got to embrace the literal, and when you're a teenager, you *want* music to be literal sometimes.

Peter Millius: Led Zeppelin's "Rock and Roll" was supposed to be playing during the last scene where they're driving off to get Aerosmith tickets.

Nicky Katt: We saw an advance screening of *Dazed*, and it had "Rock and Roll" at the end. Everyone was in tears, like, "Oh my god!" Because no one had seen a Zeppelin song in a movie besides *Fast Times at Ridgemont High*.

Peter Millius: They even make a joke about it in *Wayne's World*. They're in the guitar shop where people are playing different songs, and one of the guys is about to play a "Stairway to Heaven" lick and someone stops them and points to a sign that says "No Stairway to Heaven."

Richard Linklater: We kind of bribed Jimmy Page. My music supervisor, Harry Garfield, heard through the grapevine that Page had a big laser disc collection, so we sent him 10 laser discs,

stuff like *The Godfather* and whatever. Big films. I also recorded a personal plea, like, "Hi! I know you guys don't ever give your songs to movies, but this song is integral to this movie." I was so thrilled and honored when he said yes.

But Jimmy and Rob weren't getting along at that moment, so I was a little afraid. It was like, "Have we heard from Plant?" "No, nothing. Nothing. Nothing."

Kathy Nelson was the head of the soundtrack division at MCA, and she had been involved in the *Reservoir Dogs* soundtrack, which had a bunch of '70s songs, and she said it didn't sell well, so she was convinced no one would buy our album unless we had a modern band on it. She was like, "If we get a new band to cover a '70s song, then MTV will get behind the movie!" Then this A&R guy comes in and wants to use the movie to promote one of his new bands. Not even a phone call to me. Just this unilateral move.

Jesse James Dupree: My band, Jackyl, was on Geffen, and someone told us they might want to use one of our songs in the movie. So we went into the studio and recorded a cover of "We're an American Band."

Richard Linklater: This was a band no one had ever heard of. They had chainsaws on stage, and the singer ran around half-naked. I was like, *no way.* I wrote about it in my diary.

Excerpt from Richard Linklater's "Dazed by Days" Diary Austin, June 1993

They send me this band's CD somewhere along the way, and it's like they just stepped out of Spinal Tap. *There's actually a song on it called "She Loves My Cock" without a hint of irony. Ohmigod, this isn't happening. I'm sending daily faxes explaining in a nice way just how bad a thing this would be for the film.*

Jim Jacks: The song was gonna run over the last half of the credits. I had a long conversation with Rick, where he said, "I don't want to have this!" And I go, "But Rick, they're gonna give you *a lot of money* for the record album, and this song is gonna run over the *second half* of the closing credits! It's not like anybody's gonna be waiting to make up their mind about the movie at this point—if they're even in the theater." Like, who cares? *Who cares?!*

Excerpt from Richard Linklater's "Dazed by Days" Diary Los Angeles, June 1993

When I come out to California these days, I fly coach, have to rent my own car and beg for reimbursement for the next six weeks, and when I get to my hotel, I usually have a reservation but no method of payment. It's a long way from my limo and Chateau Marmont days. I find out in a meeting that not only have [Jackyl] already gone into the recording studio and cut this song, but it's a done deal, always has been. It was the terms of the album deal all along and our needed record advance is predicated on it.

As Henry Hill narrates in Goodfellas, *"This is the bad time."*

So I'm trying to put this all together in my head. The people closest to me in this deal, acting in what they probably sincerely think is in their definition of the film's best interests, have sold me down the river, big time, in the only way they could have. I'm numb, I have a meeting with Kathy Nelson. She feels she's paid too high an advance for the soundtrack and wants this additional hook. It's hopeless—the impenetrable corporation always wins out in the end. I used to think it was a photo finish, but now I'd have to say the music industry is at least 30% more slimy than the film industry. At least most film people at some point early on actually loved the film and wanted to do something good. This impulse is lost rather quickly, of course, as they

soon give in to the ways of the corporate ogre they work for. I leave town with what I know are percolating stomach ulcers.

Richard Linklater: Steven Soderbergh was directing *King of the Hill*, his third movie, at Universal at that time. It's a beautiful art film, but it had a slightly bigger budget than me. And he had already seen *Dazed*, and he was on my side, telling them, "Have you seen this movie? There's no place for a rerecorded modern song!"

Steven Soderbergh: *Of course* there shouldn't have been rerecorded songs in that movie.

Excerpt from Richard Linklater's Memo to Jim Jacks and Sean Daniel June 1993

RE: Public embarrassment & professional stupidity
DATE: Not too late

Dear Jim and Sean,
Lead singer (high-pitched, screechy): "She loves my cock"
Rest of group (lower, but in agreement): "She loves my cock"
Repeat over and over
This is Jackyl.
Being aligned with these guys is a huge mistake on multiple levels . . .
 DAZED AND CONFUSED will stand the test of time and can only be associated with like material. Jackyl will probably get dropped by Geffen within two years and disappear for all time. Twenty years from now, I will still cringe when the closing credits roll. In short, Jackyl doesn't qualify, they're not in the same ballpark, or anywhere

near. They can still be "launched" by any number of the dumb mov-
ies Universal puts out. Not this one. How about Nirvana? Pearl
Jam? Anyone who might have some actual sincere '70s roots and not
be embarrassing to be artistically aligned with. Jackyl has its roots in
'80s heavy metal—a horrible genre nowhere near DAZED . . .

If others still insist upon this new band thing, find me a new band
I can live with. Please get back with me.

"She loves my cock"
"She loves my cock"
Repeat over and over

<div align="right">

Best,
Richard Linklater

</div>

Jim Jacks: Unbeknownst to me, Rick contacted the band.

Richard Linklater: I sent a personal letter to Jackyl just say-ing, "Nothing personal, but the studio was doing all this against my wishes; it's a period film, all period music, etc."

Jesse James Dupree: We understood where he was coming from. We didn't want to force someone to use our music in the movie.

Richard Linklater: They dropped out immediately, and I'll always respect them and be very thankful to them for that. That's why I've never bad-mouthed them. Well, I guess I have personally, but not professionally. Actually, their version of "American Band" was pretty good. It was just the principle of it.

Jim Jacks: Tom Pollock called me, *furious.*

Richard Linklater: We were having a meeting, and Nina said, "We've treated you better than anyone we're working with!"

I was like, "I was just hanging out with Steven Soderbergh. That's not what I hear!"

And she just got up and left the room.

Nina Jacobson: I honestly don't remember that. But I'm sure the studio was pissed that he contacted Jackyl and told them not to be

on the soundtrack. That would've been pretty unusual. The studio's expectation is that you'll play ball. Lots of filmmakers don't play ball, it's just that they're usually more established when they don't.

Jim Jacks: Rick's screwup with Jackyl blew up the soundtrack deal with Geffen.

Richard Linklater: Kathy Nelson dumped the album, convinced it wouldn't sell. We had a $300,000 advance—significant money for a record! We needed the money to pay for all our music in the movie. So when the album goes away, we don't get that $300,000. I go down in the books as the bad guy, but she's the one who gave away a corporate asset that ended up making millions elsewhere.

Excerpt from Richard Linklater's
"Dazed by Days" Diary
Los Angeles, July 1993

They give me a list of songs they think I should cut—they're either too expensive (Dylan's "Hurricane") or are "background songs" (Frampton's "Do You Feel Like We Do").

My lawyer and I sit there for two days trying to get the studio to discuss alternatives to this proposed hatchet job on the film. No response other than either "pay for them yourself" or "cut them." It's obvious this is simply my punishment for the album deal . . . It's a blinking contest and soon there is talk of my back-end participation ultimately covering these costs.

I think they think if the film ever makes money, I'll be paying for these music costs out of my share. I guess it's enough for them to feel I'm going to receive some "deferred punishment." The gist of my thinking is now maybe what they wanted all along: I'm saying fuck the money, I don't care if I ever make a fucking dime off this movie, just don't mess it up for all time. It's like being robbed—take anything you want, just don't hurt my family.

Sandra Adair: In the cutting room, Rick was reading stuff about serial killers. I remember thinking, *God, that's weird.*

Richard Linklater: While I was staying at the Oakwood Apartments, there had been a shooting in L.A., and the guy who did it was also living at the Oakwood Apartments. I cut out the article with a picture of his face and gave it to a friend who put it up at Universal. The article had a line that said, "The universal question is: Why?" I highlighted "universal" and "Oakwood Apartments." Like, *See? All roads are leading here! I'm the next guy to walk in there and shoot!*

I actually did have a strategy. I was going to go into Tom Pollock's office with a razor, and I was going to start cutting myself. I was going to start bleeding on his carpet until he gave me the music for my movie. And just as I was about to do that, Jim and Sean came back with this offer, like, "Okay! You can have the music."

You get desperate!

Jim Jacks: Our production company had to give up their back end to cover the music. So the little bit of compensation we were getting for this movie, we lost because of Rick's bonehead play. We could've just gone with half the songs, but the movie was so dependent on the songs, we finally said, "Alright, fuck it, we'll do it." Sean and I weren't happy about it.

Richard Linklater: All the money's gone. In the place of some of the songs, they wanted to record '70s-style guitar licks. I'm like, "What the fuck?" Harry had to oversee that.

Harry Garfield: I played guitar, and I hired [keyboardist] Nicky Hopkins. He's the one playing on the Kinks' "Sunny Afternoon" and John Lennon's *Imagine* and the Rolling Stones' "She's a Rainbow." He was our studio guy. And I had Rick Marotta on drums and Leland Sklar on bass, and I had them record some stuff that was the same groove as the songs that Richard wanted. We didn't even put it up to picture. It didn't work.

Richard Linklater: And then I got a call from Harry, and he was like, "Plant says no." I was like, "What? Come on!" I just let loose in my little diary.

Excerpt from Richard Linklater's
"Dazed by Days" Diary
Los Angeles, July 1993

Robert Plant says no . . .

The official reason is that "it is in direct competition with his solo career." Plant doing lame covers of old songs and uninspired new garbage is not much of a solo career. But, hey, by not having a Zeppelin tune in this movie, everyone will naturally forget that Zeppelin and Mr. Plant's only viable blip on the music history's scene ever existed. Then they will all run out and purchase this pathetically aging rock star's (who still wants to look and act like he did 20 years ago) illustrious solo album. Yeah, right.

It's always the lesser talents who have the major attitudes. Everyone knows who the major architect behind Zeppelin was. One's a musical genius, one's a construction worker with a good voice. Lifetime boycott.

Richard Linklater: Once Zeppelin said no, I played with other alternatives, like Thin Lizzy's "Cowboy Song." But the Thin Lizzy song had technically come out two and a half weeks after the day *Dazed* was set. Plus, it was cheaper to use Foghat's "Slow Ride" again. It was a financial thing.

Steven Hyden: You hear the same songs and the same bands more than once in the movie. You hear Peter Frampton in the background of several scenes. You hear the same Ted Nugent song in a couple of different scenes. And obviously the same Foghat song. I think that's very true to being a teenager growing up in the '70s—or in the '90s. Now, kids can listen to whatever's on Spotify, but back then, you heard the same songs on the radio all the time, and they implanted into your brain. Even if you didn't like the song, you ended up loving it because you heard it so many times in someone else's car.

Roger Earl: Foghat had just reunited for the first time since 1984 when they put two of our songs in *Dazed and Confused*: "Slow Ride" and "I Just Want to Make Love to You." "Slow Ride" opened us up to a much younger audience. Many of our younger fans tell us that the movie was the first time they heard our music. The interesting thing is, they don't get what the song is about. They hear it in the movie, and they think it's about riding slowly in your car. They don't understand that it's about sex.

Richard Linklater: When the album got dropped, we couldn't get anyone else to take it. So there was a lot of the pressure to have something promotional. In '92, '93, MTV was showing music videos with movie footage in them. Like there was *Wayne's World* footage in the video for "Bohemian Rhapsody." So I thought, we have a good KISS sequence in the movie. What if we got them to cross-promote?

Jason Davids Scott: The plot about the KISS statues used to be a bigger part of the movie.

Richard Linklater: Yeah, the story came from Bill.

Bill Daniel: When I was in high school, my friend Grant and I stole a huge fiberglass Ronald McDonald statue that had a little speaker in the stomach, like, "You order here" in the drive-through, you know? We're in my mom's station wagon, and we stuff him into the back and hide him in my garage. And we'd take him to keg parties as our mascot.

There was a party where Ronald was dressed up as Gene Simmons. And the cops bust up the party and see there's Ronald McDonald looking like KISS, and it's obviously stolen, so the cops carry it out. We're dying laughing at the cops trying to wrestle this huge statue out of the party. They called a paddy wagon because it won't fit in a cruiser.

The next Monday at school, the announcement voice goes on: "Will Bill and Grant please come to the principal's office?" And we go, "Holy shit." So somehow we met and said, "Okay, we'll say we found it in the creek where it goes under LBJ Freeway, on the north side, in the grass next to the water." Airtight story!

We walk into the principal's office and there's a Dallas police officer

waiting for us. He takes us down in the back of the cruiser, and they put me in a room and Grant disappears with a cop. They were gone for five hours, and I am terrified. Then the cop comes back for me and we get in the car and he says, "Alright, tell me where you found him." And I say, "There's a little trail over here, and we found him right there." And the cop says, "Was he faceup or facedown?" And I'm like, "Holy shit! We didn't figure that out!"

I thought, what would Grant say? Grant's really smart, so he would say faceup, because something faceup is much easier to see. So I say, "Faceup!" And the cop doesn't say anything. He starts walking back to the car. And we get in the car and I'm like, "What is happening?" And then the cop starts telling me all the hell-raising stories that he did when he was in high school! Like, shit he stole! Like *commercial statues* that he stole! He's killing me with hell-raising stories. So we get back, and he's like, "You can go."

Greg Finton: That's why, in the film that exists today, the cops show up on the football field. They were originally there to bust them for the theft of the statue. We changed it in post to make it look like they were busting them for just being on the field.

Richard Linklater: That subplot was jinxed from the beginning. Someone at Universal called McDonald's and asked them if we could use Ronald McDonald before we could even talk about fair use! And, of course, they said no. I was really mad. Don't collect a legal "no" for something that important when we didn't even discuss a strategy!

That story gets cut down in the movie, but the statues are still there, and I wanted to do something with KISS. I thought, "This will help us get a label, and this will make the studio feel happy." And then Gene Simmons and Paul Stanley came to a screening in New York.

Peter Millius: I worked with KISS on two records, so I was helping Rick make this happen.

Jason Davids Scott: We'd planned to record a syndicated half-hour radio feature that was going to be KISS and Rick talking about rock music in the '70s and playing some songs from the movie. We had rented a recording studio, and Gene Simmons was going to see

a cut of the film where there was more of the KISS plotline. I think it opened with the scene of them stealing the statues. And the screening was gonna be at 7:00 p.m., so it's 9:10, and then it's 9:30, and nobody's showing up.

Richard Linklater: Peter came up to me, and he was like, "They're not coming. They saw the movie, and they don't want to be associated with drugs and alcohol." I was like, *Are you kidding me?* The band that sang fucking "rock and roll all night and party every day"?

Jason Davids Scott: Rick was just hanging his head, but I was furious. Nobody freaking cared about KISS in 1992, 1993! The only people who cared were the people who were drunk and stoned in 1976. For them to say that's not their image? It's like, *Come on!* This film would do you a favor.

Richard Linklater: Later, KISS changed their mind because they heard the film was good, so they threw together a music video for "Rock and Roll All Nite" with *Dazed* footage in it. But that had nothing to do with me. I don't know if they even remembered me. Gene Simmons kept calling me Art Linkletter.

Burt Berman: Someone still needed to pick up the soundtrack. But when one place passes on the album, people are wondering, *Where are the cooties? What smells about this?*

Now, Irving Azoff had just left Universal. He was trying to spread his wings in a whole new corporate orbit of Warner Bros. He had started a new label, Giant. Lo and behold, I'm on a flight with Nina Jacobson, and she's telling me that her brother works for Irving. He was kind of a hustler, in the positive sense of the word, and he brought the album in to Irving.

Richard Linklater: Irving picked up the soundtrack.

Burt Berman: It's kind of ironic that, ultimately, he ended up with the soundtrack. There was a twisted poetic justice that Irving might have a hit album that he got from a place where he used to work. I always had this feeling that he was rubbing it in Universal's face.

Richard Linklater: We were supposed to get an advance, but Kathy Nelson called up Irving and told him there were no other bidders, so they lowered their advance to almost nothing, for no reason except that they could.

Burt Berman: I think Irving paid $35,000 for it. That was purely covering the legal costs. That added insult to injury.

Richard Linklater: At that point, I said, "Okay, fuck you guys!" That's so mean. Unnecessarily. I said then that I'd never have anything to do with anybody involved in the album. Every time the album went gold, platinum, or double platinum, they always wanted a picture with somebody, so they'd ask me. I always refused. For years, I had the gold record hung up right by the toilet in my office bathroom.

I think the soundtrack was the final linchpin. I could tell they were dumping the movie.

Sean Daniel: Losing the album put the filmmakers at a political disadvantage in winning the marketing battle. Everything's a war in making a movie, and it's always, what are your weapons? We didn't have any weapons anymore.

Chapter 29

Seduced and Abandoned

"There's 30 million people who smoke marijuana regularly!
If they all go to the movie, we've got a big hit."

Stoner comedies didn't really have a place in the "Just Say No" society of the '80s. The genre hadn't really changed much since Cheech and Chong's 1978 classic *Up in Smoke*. Most

movies involving weed featured a pair of slow-witted, longhaired burnouts who dodged authority figures in pursuit of some cute girls and the perfect strain. In teen movies, weed smokers were generally depicted as cartoonish figures. When Emilio Estevez's character gets high in *The Breakfast Club*, he goes cartwheeling down the hall.

Those movies were particularly out of touch by the early '90s. When Linklater asked people at Universal whether the drug use in *Dazed* would be a problem, they told him no one in Hollywood considered marijuana much of a drug. It was a time when Dr. Dre named an album *The Chronic* and still sold three million copies. Bill Clinton smoked weed and still became president. There was room for a new kind of stoner comedy that reflected a more laid-back attitude toward drugs.

Gramercy Pictures president Russell Schwartz had a hunch that he should market *Dazed* as a stoner comedy. It was as good a hunch as any. As screenwriter William Goldman wrote in his 1983 book *Adventures in the Screen Trade*, "Not one person in the entire motion picture field knows for a certainty what's going to work. Every time out it's a guess—and, if you're lucky, an educated one."

Clever, mischievous, and highly regarded in the industry, Schwartz had come to Gramercy from Miramax Films. As executive vice president, he'd overseen the marketing of movies like *Madonna: Truth or Dare*. In the trailers for that 1991 documentary, a black box appeared over Madonna's mouth whenever she said something even slightly dirty, making the film seem more salacious than it was. The trailers ended up earning an infamous "red band," meaning the previews themselves were R-rated. While working on the 1991 British satire *The Pope Must Die*, Schwartz also oversaw TV ads that showed the pope character advocating for safe sex, which shocked Catholics and successfully got the ads banned. Both controversies drummed up more publicity for the movies.

Schwartz had taken the political movement toward chasteness—the Parents Music Resource Center, the culture wars—and turned it to his advantage, pushing scandal as a marketing tool. Gramercy's press kit comprised articles on the "resurgence of marijuana use,"

promotional pot-leaf earrings, and rolling papers. Linklater didn't love Schwartz's marketing strategy. The soundtrack battle had left him exhausted, but he could always muster energy to fight with a movie executive.

Jason London: One of the things that's always pissed me off is that people made *Dazed* a drug movie. It's not.

Richard Linklater: Look, there's a history of stoner comedies out there. I definitely came of age with Cheech and Chong albums, and I was there opening weekend, summer of '78, for *Up in Smoke*. They occupy a really special place for me, and their movies were just increasingly crazy. You know, like, joints the size of a log, and just funny, funny, funny. I guess *Dazed* was in the stoner humor vein, but I didn't want weed to be the big joke. I just wanted it to be a natural part of their lives.

Brian Raftery: I don't even think it's fun to watch *Dazed* if you're super high. It doesn't have big laugh lines. It's not like someone opens the door of the van and tons of smoke comes out and someone falls out the back. I don't think there's even that much weed in *Dazed and Confused*. And that's probably a lot more true to what being a stoner is like when you're a teenager. You fight hard to get a little bit of pot, and you get a *little* stoned, but you're just kind of buzzed.

Tom Junod: The other thing that makes *Dazed and Confused* different from other stoner comedies is that almost everyone in that movie smokes pot.

Russell Schwartz: In other high school movies, there was always one character sitting in a corner getting high. There was never a *whole group* of people getting high.

Tom Junod: Weed is presented as the solvent that breaks up social stratifications between the different groups in high school, and that feels true to life, too. When you're passing a pipe around in a car, it's a communal experience. Weed starts these comic conversations in the movie and enables comic things to happen, but weed itself is not a comic device.

Jason London: If people think *Dazed* is a new kind of stoner comedy, it's because of how brilliant Rory Cochrane is. He went to

one of those *Fame* high schools in New York, and he's one of those artists who approaches things in ways you might not expect.

Rory Cochrane: I just tried to make Slater a real person. There's plenty of movies where stoners are just, like, eating Cheetos, and they're only there so you can laugh at them. But I think the real laughs come when you can *relate* to a person who's stoned.

Tom Junod: It's interesting that Slater is one of the more popular characters in that movie, because he is not a cool guy. He's such an innocent. He has no success at all talking to girls in the movie. When he says, "Check you later!" Don's like, "I hate it when you do that." Slater is a dweeb in a lot of ways.

Jason Davids Scott: Slater's a smart stoner. That had not quite been seen in a movie yet. The stoner is usually Spicoli—the generic surfer, stupid, no short-term memory. Slater's brain is really active.

Jason London: The George Washington stuff shows that he's actually insanely intelligent.

Transcript from Dazed and Confused
Final Film, 1993

SLATER
George Washington, man. He was in a cult, and the cult was into aliens, man. You didn't know that? Oh, man, they were way into that type of stuff, man . . .

STONER
George toked weed, man?

SLATER
Absolutely George toked weed. Are you kidding me, man? He grew fields of that stuff, man. That's what I'm talking about. Fields.

STONER

He grew that shit up Mount Vernon, man?

SLATER

Mount Vernon, man. He grew it all over the coun-
try, man. He had people growing it all over the
country, you know. The whole country back then
was getting high. Let me tell you, man, 'cause,
'cause, 'cause he *knew*. He was on to something,
man. He knew that it would be a good cash crop
for the Southern states, man. So he grew fields
of it, man. But you know what? Behind every good
man there's a woman. And that woman was Martha
Washington, man. And every day George would come
home, she'd have a big fat bowl waiting for him,
man, when he'd come in the door, man. She was hip,
hip, hip lady, man.

Richard Linklater: The thing about George Washington
and hemp was just always around in the culture in general. I remem-
ber working on a scene for *Slacker* with King Coffey, the Butthole
Surfers' drummer, about that whole George Washington and hemp
thing. He ended up on tour with *Butthole Surfers,* and we couldn't
shoot the scene, but that was a monologue we were working on, and
that kicked it into my more immediate consciousness in that era.
And I think it's still around. Spike Jonze just made a commercial
about the history of hemp, and it starts with George Washington.

Tom Junod: When I was a senior in high school, I wrote a paper
advocating for the legalization of marijuana, and one of the things
that I talked about was the fact that George Washington grew hemp
on his Mount Vernon farm. I had a friend of mine draw pictures of
George Washington smoking a big fat bowl. And this was in 1976!
So of course when I see that scene, that was me, literally.

What's wonderful about that scene is that marijuana is presented

as a force of revelation. That's a genuine way of showing the type of conversations you have when you're high. I think that's the weediest conversation that's ever been recorded on celluloid.

It's also very true to 17-year-old kids talking about things that they really have no understanding of, and have no business talking about. It's like, you've smoked a bowl and you think that things makes sense for that moment. The movie captures that really beautifully.

Russell Schwartz: *Dazed and Confused* was such a druggie movie, you didn't know who the audience was, other than druggies. What else are you gonna lay it on? There was no real story. It was difficult to market, because we had no stars. It wasn't really a genre film. It was art-house leaning, but the subject matter was very non-art-house. So finally we just said, "Screw it, we're going the pot route."

Richard Linklater: Today, films are green-lit by the marketing departments. Studios are like, "Can you sell this worldwide? Because we ran the numbers, and for that actor, the budget can't be more than this exact figure." There's formulas. The industry's trying to be data-driven, and they've never quite cracked it. But back then, they weren't even trying.

I knew high school kids would like *Dazed* the way we liked *American Graffiti*. And I thought the stoner angle made it look a little dumber than it was.

Russell got it into his head, like, "There's 30 million people who smoke marijuana regularly! If they all go to the movie, we've got a big hit."

I'm like, "Stoners don't go to movies. They stay home on their couch and get high. I don't know if they're a first-weekend crowd."

Samantha Hart: Rick didn't like the stoner movie idea, but Russell taught me to take risks. Here's a perfect example of Russell: The O.J. Simpson trial was going when we were working on the second *Candyman* movie. The poster was a black man coming up behind this white girl with the knife. So what does Russell do? He buys a billboard right in front of the courthouse where the O.J. trial was happening. That is Russell Schwartz.

Russell Schwartz: When I worked at Miramax, we sued the MPAA over the X rating for *Tie Me Up! Tie Me Down!* the [Pedro] Almodóvar movie, and we sued them on the X rating for *The Cook, the Thief, His Wife & Her Lover*, the Peter Greenaway movie with Helen Mirren. [O.J. Simpson's defense attorney] Alan Dershowitz was the lawyer, and a lot of hoopla came out of those lawsuits, so we knew that when the marketing or advertising is banned for a movie, it sometimes helps.

That idea was also in the rebel spirit of *Dazed and Confused*, and the rebel spirit of Richard himself. When we were at the screening in the Marina del Ray, Tom told me, "This is the most socially irresponsible film that Universal has ever produced." And I said, "Congratulations!"

Richard Linklater: Tom Pollock's not a total square. I think he said that with a slight grin. Afterward, I think Russell might have told the *Austin American-Statesman* that Tom said that—or maybe I was the one who told them. It was part of the plan to play that up for marketing.

EXCERPT FROM "LINKLATER FILM RUFFLING HOLLYWOOD
FEATHERS," BY MICHAEL MACCAMBRIDGE

Austin American-Statesman, May 7, 1993

Last month in Marina Del Rey, Calif., the executives for Universal Pictures took a couple hours out of their all-consuming promotional preparation for this summer's mammoth better-be-blockbuster *Jurassic Park* to visit a test screening of another film they'd underwritten, Richard Linklater's *Dazed and Confused* . . .

The screening went extremely well. An auditorium full of teen-agers laughed throughout and cheered afterward. And it was at that time that the Universal executives finally realized exactly what they were getting into. Tom Pollock, the chairman at Universal and one of the four or five most powerful men in the

film business, walked over to Russell Schwartz, head of Gramercy Pictures, Universal's new prestige subsidiary, and told him, "This is the most socially irresponsible film that Universal has ever produced."

And the buzz has started.

<div style="text-align:center">

**EXCERPT FROM *DAZED AND CONFUSED*
REVIEW BY PETER TRAVERS**

Rolling Stone, September 24, 1993

</div>

[Linklater's] shitfaced *American Graffiti* is the ultimate party movie—loud, crude, socially irresponsible and totally irresistible.

Samantha Hart: Wait, Peter Travers called it "socially irresponsible," after Tom said it was the most socially irresponsible movie that Universal had ever made? Well, when marketing is working, you are almost brainwashing critics. They fall in love with the marketing.

Richard Linklater: The same thing happened when we finally got our rating. We got an R rating for "pervasive and continuous alcohol or drug use." And it sounded like an endorsement. Gramercy used it in an ad, but they just used the "pervasive and continuous alcohol or drug use" part. They didn't say the MPAA said it. I said, "You idiots! It's only funny because the MPAA said it!"

Samantha Hart: I'd joined Gramercy out of the record business. When I was at Geffen, Nirvana's *Nevermind* came out. It was Kurt Cobain's idea to do the naked baby reaching for the dollar bill, so I had a photo shoot and we threw a bunch of babies in the water, and the art director picked one of a baby boy. I took it up to the president of the company, and he's like, "You gotta take the penis off the album. Walmart won't carry that." I said, "Well, that's probably a good thing for this band. You'll create more publicity from that than

anything." I finally took it to David Geffen, and he said, "The penis stays." Walmart wouldn't carry it, and the rest is history. To me, the strategy behind *Dazed* was similar.

Russell Schwartz: The most fun we had was sitting with Samantha and the marketing team and coming up with shit that would make people say, "This movie should be thrown off the screen!" We tried to stir things up.

Samantha Hart: Russell really wanted an icon for the movie so that, when you see that icon, you know it's *Dazed and Confused*. In high school, I did a lot of drugs, and the first thing that came to my mind was the sad happy face I used to draw that looks stoned. Then I wove it into the '70s iconography of the smiley face.

If you had a newspaper ad and couldn't buy a lot of ad space? *Boom!* You'd just put that in the corner. Everybody would know it's *Dazed*.

Adam Goldberg: From the second I saw that smiley face poster, I thought the whole thing was fucked. Because I was like, *that's* not the movie we did!

Samantha Hart: Rick *hated* the happy face.

Richard Linklater: The smiley face was out of the culture by late '74. It's a '72 to '74 thing. I was like, "No, no, no!" It was just one more indicator that Gramercy didn't care about authenticity. To this day, when someone gives me a smiley face poster to sign, I always do the same thing: I put a little mustache on him. I do little stoned eyes. I put little horns on him. I deface him.

Nicky Katt: Rick got this rock 'n' roll poster guy, Frank Kozik, to design a different poster. Rick used to plaster Austin with flyers for *Slacker*, and people thought the flyers were for a punk band. The Kozik poster for *Dazed* was a reflection of that ethos. What better way to attract folks to a rock and roll movie.

Cole Hauser: Kozik's poster was *iconic*. There were yearbook pictures of the cast and a badass Duster driving down the middle. It just screams '70s.

Nicky Katt: The idea was of course swatted away by Gramercy. Fucking morons.

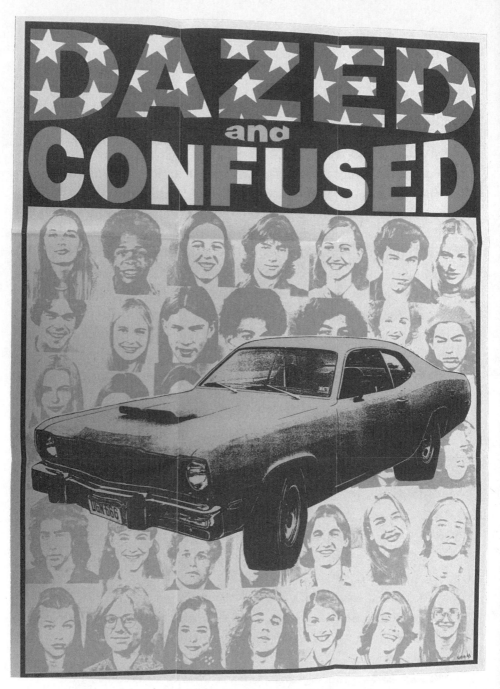

Frank Kozik's *Dazed and Confused* poster

EXCERPT FROM RICHARD LINKLATER'S
LETTER TO THE CAST

Fall 1993

Me: yearbook photos just scream high school, and in our case, '70s fashion. There's an immediate connection.

Gramercy: They're a bunch of people nobody knows, we don't have any stars, we need a hook. ("A pro-reefer movie.")

Me: Everyone in our society has been through high school. They know what yearbook photos are. I think the public would have a more natural connection to real people, especially people who seem pretty familiar to them, than to a stoned happy face.

Gramercy: You're just going to have to trust us. (Hollywood translation: fuck you.)

Richard Linklater: The smiley face kept coming back.

Samantha Hart: At the bottom of the smiley face poster, I wrote: "The Film Everyone Will Be Toking About." At the time, *The Crying Game* was very popular, and that was their logline: "The Film Everyone Will Be Talking About," so I thought to myself, maybe this will slip through the MPAA.

The MPAA was a huge obstacle back then. Jack Valenti was in charge, and he was very uptight. It was like Sunday school teachers approving ads. But the MPAA approved it! I don't think they got what "toking" was. So Russell's like, "No way! MPAA approved this? It's going up!"

Then we needed another poster. It was an ensemble cast, and there was no star, but Milla was kind of known, so we put her on the poster and gave it a smoky background.

Jason Davids Scott: It was like, "Oh look, here's Milla, and she has a funny expression on her face!" And it's like, she's barely even in the movie!

Samantha Hart: I had the story line for that poster: "It was the last day of school in 1976. A time they will never forget. (If only they could remember.)" Why can't they remember? Because they're old? No, because they were on pot!

"See it with a bud" was the button. We didn't think it would get approved.

And—what gold is this!—all of this happens after Bill Clinton says, "I did smoke a marijuana cigarette, but I didn't inhale." So we did a television spot that started out: "Finally, a movie for anyone who *did* inhale."

That's when the MPAA went batshit crazy.

It was like that moment [in *The Usual Suspects*] when the cop realizes Keyser Söze is the guy sitting in front of him the whole time. Like, "Ahhh, the whole thing is a pot show!" They banned most of it.

Russell Schwartz: We tried to set up screenings for Christian groups, or antidrug groups, or conservative groups, so that they would protest. No one ever did, though. We should've created our own group and had them protest! In this fake news era, that's where my mind goes.

Richard Linklater: To be protested against, you have to be a more mainstream, commercial thing. The national conversation usually doesn't swarm around an indie film. It might've worked if it was a bigger release.

Russell Schwartz: One of the first areas we tried to book was Utah. In Provo, they have their own censorship organization because of the Mormon thing. The movie was banned by the exhibitor in Provo, Utah. They would never tell you why it's banned, but of course, we knew immediately. It was a field day for us! There hadn't really been a movie in decades that was banned because of the subject matter.

Jason Davids Scott: Nobody had thought to pitch *High Times* about the movie, so I called up the editor, like, "Look, this is like the stoniest stoner movie ever made." And he saw the movie and we got

the cover of *High Times*. Initially, it was going to be Rick on the cover, but he was uncomfortable with it, so it ended up being Rory.

Rory Cochrane: I got extremely high for that shoot, and I didn't necessarily want to. They flew me out to New York. Everybody was just packing the bong like, "Rip it up!" And Sebastian Bach from the band Skid Row was also doing a photo shoot for them, so he sort of kidnapped me afterward and took me to his recording studio in his convertible IROC with Radiohead blasting out of it. He was like, "You want to drive the car?" And I was like, "No! I don't!"

Marjorie Baumgarten: The way Gramercy promoted the movie really upset Rick.

Richard Linklater: They didn't really have a distribution plan for the movie. I wrote about that.

Excerpt from Richard Linklater's
"Dazed by Days" Diary
Los Angeles, February 1993

After our latest Canoga Park preview, we have our first marketing meeting. Somewhere early on, somebody looks up and asks, so when should this film come out? I can't believe these people about the obvious time this film should be in theaters. Since the film takes place on the last day of school and has that end of school energy, maybe it should come out a little before school's out? Russell Schwartz (Gramercy) says that's not enough time, and the others seem to agree with him. He's absolutely right—it isn't enough time, if the first fucking time you're thinking about it is here at breakfast in February.

Russell Schwartz: You can't forget that the movie was in limbo while Universal was deciding what they wanted to do with it.

There was certainly no reason for Gramercy to think about the movie before February of 1993. I don't think we had gotten a confirmation that we were even *getting* the movie until right before that.

Richard Linklater: I was like, "Well, I had my first big *Slacker* success at the Seattle International Film Festival in '90, before I even had national distribution. Could we show it there?" So that was our premiere.

Russell Schwartz: The Seattle International Film Festival was in June, but we already had a September release date in our minds. If Richard wanted to do that, I'm sure we said, "Okay," but you don't necessarily want to go with the world premiere of the movie three months before the film goes into the theaters, because that can only hurt you if it doesn't get good reviews.

Sean Daniel: By the time the year was over, *Dazed and Confused* had the second-best set of reviews at Universal, after *Schindler's List*. Richard likes to point that out.

EXCERPT FROM *DAZED AND CONFUSED* REVIEW BY OWEN GLEIBERMAN

Entertainment Weekly, September 24, 1993

Once every decade or so, a movie captures the hormone-drenched, fashion-crazed, pop-song-driven rituals of American youth culture with such loving authenticity that it comes to seem a kind of anthem, as innocently giddy and spirited as the teenagers it's about. George Lucas' *American Graffiti* (1972) had this open-eyed exuberance. So, to a lesser degree, did *Fast Times at Ridgemont High* (1982). Now, in the exhilarating *Dazed and Confused*, 31-year-old director Richard Linklater delivers what may be the most slyly funny and dead-on portrait of American teenage life ever made.

Richard Linklater: We could've had a bigger premiere than Seattle if they'd cared enough to plan further ahead. This shows how little Universal thought of the movie. We were coming out in September. We could have premiered at the Toronto [International] Film Festival in September. They didn't care. So we just premiered it in Seattle. There was no L.A. premiere.

Adam Goldberg: The L.A. premiere was this KROQ radio screening that wasn't really a premiere. No one even reserved a seat for me. I was standing as the film started.

Richard Linklater: If you don't get an L.A. premiere, they're kinda saying, "Fuck you."

Russell Schwartz: The question was whether *Dazed* was a wide commercial release or whether it was going to be a smaller-platform release. The cast wasn't well known, but because it had a topicality, it felt like it could've been more commercial.

Adam Goldberg: It seemed unknown whether it was going to be a *Fast Times*–type mainstream success. But from the moment I saw the trailer, which looked like it was actually made in 1976, I was like, Oh, this is an independent movie.

Richard Linklater: Other films got 800 screens and billboards and buses—they *really* got a studio release. We didn't get that because we didn't have stars.

Russell Schwartz: I wanted to go wider, but I think our release was about 183 theaters. That was death. Too big to be platform and too small to be commercial.

Adam Goldberg: McConaughey, Cole, Rory, and I went to see *Dazed* at the Beverly Center in L.A., and we were the only people in the theater. I think that was the first time we realized, oh, this isn't going to be a success.

Ben Affleck: I came back to L.A. after doing the movie and I was walking down Fair Oaks Avenue in Pasadena, and I got hit up by somebody trying to give away tickets to a movie preview. He said, "Hey, do you want to come see a free movie?"

And I said, "What's it about?"

And he said, "Well, it's like a high school party movie. Honestly, it's a shitty movie. You don't want to see it."

I realized that was *Dazed and Confused*. I was so bummed out, because I'd had such a good time making it, and I believed in Rick. And then the movie came out and it bombed.

Russell Schwartz: The movie opened to a little under $1 million. By today's standards, that's not bad. *Dazed* went on to gross $8 million, and we didn't expand to more than 300 screens, so the fact that it grows to eight times the opening weekend number was pretty good. But, of course, nobody was happy with that number at all, particularly at Universal. They were dealing with multimillion-dollar movies. To them, $8 million was a failure.

Richard Linklater: Before *Dazed* came out, I thought, maybe I'm one of those directors whose personal films are actually commercial, too. I think that's what the disappointment was. I thought my little whimsical, quirky ideas were totally in sync with the broader public, and then *Dazed* kind of proved they weren't. This set a template that I've gotten so used to, it hardly bothers me anymore. I learned right then and there not to consider how a film did financially as the barometer of much of anything. It's really not something you can control—it's out of your hands. The deal I made with the film gods was simply to be able to make films. The definition of success wasn't spelled out.

Nicky Katt: It was a big bummer for everyone. Rick wrote us this beautiful letter, like, "I did everything I could. We just didn't get the studio love."

Ben Affleck: When I had to move houses, after I got divorced, I got everything out of storage, and I found all these old letters from the early and mid-'90s, and two of them were Rick's letters that I had saved. And there was one from before the movie. That one was full of hope. And then the second was deeply bitter and profoundly disillusioned. And I thought, "Well, that's the story of this movie."

EXCERPT FROM RICHARD LINKLATER'S
LETTER TO THE CAST

Fall 1993

Dear *Dazed* Cast,

Maybe some of you are wondering why *Dazed* never made it into more than 250 or so screens, or why it didn't seem to get the typical studio film "push." I truly hope all of you are on a higher level than me and don't let stuff like studio incompetence and politics bother you too deeply. Like I hope you don't wake up in the morning thinking about it.

I wish I didn't. I try but I can't. I can't work two years on something that is very personal to me and then watch a bunch of idiots not do their job properly at the final stage of it all . . .

Despite my attempts, they never got with the concept of pushing the characters (or the rebellious rock 'n' roll aspect) as a selling point of the film. They spent a fortune sending out bullshit like roach clips and *Dazed* rolling papers but never thought to make a big deal out of the ensemble cast . . . A little drug humor would've been okay and in the spirit of the '70s but it was never what this film was all about. Gramercy got carried away thinking they were being so cool. All of us in Austin started referring to most of their ideas as "The 45-year-old guy who wears a toupee will think it's hip!"

Maybe it wouldn't have mattered all that much. Russell at Gramercy was being such a fence-sitting wimp about what the film's commercial prospects were, and was intentionally low-balling it so as to play both sides with his bosses at the studio. He always promised me he was going to go wider with it, and even when it had a $5,000 per screen opening weekend (some cities without any television support) he said he wanted to hold off a little before going wider . . . Several weeks later, he "couldn't justify it." No guts, no glory . . .

Long before I knew anything about this nasty side of the business, I would've rolled my eyes at a filmmaker who got to make his film (something so few ever get to do) and have it actually "get seen" (i.e., I saw it) and then complained about some obscure business details of its distribution. Films have a relatively short economic life, and it truly affects only a handful of people anyway. Soon *Dazed* will take its rightful place as one of the more honest teenage movies and will continue to find a new audience. A few years down the road, they will be saying how *Dazed* had this line-up of young stars and wondering how we got them all in the same movie.

Until then, I remain,

Dulled and Confounded?

Seduced and Abandoned?

Dazed and Confused?

I Was Alive, and I Wasn't Afraid

"It was a crazed and biting purge, but it's an accurate reflection of my volatile mind of that time."

*A*n indie filmmaker who just completed his first studio film might want to ensure he'd have the chance to make a second one. But Richard Linklater wasn't too concerned about that when he published "*Dazed* by Days," a behind-the-scenes diary of his experience making the movie, on the cover of the *Austin Chronicle* on September 23, 1993—the day before the film came out.

The compromises he'd made were, constitutionally, too much for Linklater to bear. If he had to lose out to a Hollywood studio, he

could at least air his grievances. So he wrote a detailed account of the studio's attempts to clean up the cursing, their "slimy" dealings over the soundtrack, and the film's unceremonious handoff from Universal to Gramercy. He called out specific offenders by name. He broke a long-standing Hollywood rule that what happens behind the scenes doesn't travel beyond a psychiatrist's office. The tone of his article was sarcastic, brutally honest, occasionally hilarious, and possibly a little smug, which wasn't lost on Linklater.

"I know everyone thinks I'm the snotnose who got everything he wanted and was a real jerk in the process," he wrote at the end of the diary, "but they'll never really know, nobody will, and at the end of the day it won't matter. As I leave Los Angeles for the last time in relation to the production of *Dazed and Confused,* my thoughts drift to the words at the ending of Stanley Kubrick's most recent master-piece, *Full Metal Jacket:* 'I was in a world of shit, but I was alive, and I wasn't afraid.'"

Marjorie Baumgarten: When *Dazed* came out, we knew we had to do something with the movie at the *Austin Chronicle.* Rick had already been on our cover for *Slacker.* So we approached him about doing a story. It was his suggestion about providing us with excerpts from his diary.

Richard Linklater: The *Chronicle* asked me to write some-thing, and if you're going to do something, do it honestly—and do it all the way. I didn't really know another gear. Once I opened that door, I was like, "Holy shit!" It was a purge, man. It was a crazed and biting purge, but it's an accurate reflection of my volatile mind of that time.

Russell Schwartz: Richard was on a rant to blame everybody for everything.

Tricia Linklater: The article Rick published was *scathing.* I was like, "Do you ever want to work again?"

Richard Linklater: I was aware of how I was coming across. By the end I said, "They're going to see me as this little snot-nosed punk." It was portrait of someone who was inexperienced and para-noid, and I knew that, even at the time.

John Pierson: The piece was a seven-page breakdown of every piece of studio interference with the movie. With some added complaints about Robert Plant.

J.R. Helton: Rick was like, "Jimmy Page is the real talent, Robert Plant's just a dumb construction worker." I was like, "Fuck you!" Because I like Led Zeppelin. Plus, I *was* a construction worker!

Richard Linklater: We got a call from Plant's people: "How can an artist even talk about another artist like that?"

Plant had the unfortunate timing to be in Austin that very second, at a studio here. And I guess people who had read my thing were asking him about it. Margaret Moser from the *Chronicle*, who was a friend, goes, "Why didn't you let Rick use the song?" And Plant says, "Why do people keep asking me about that? We don't just whore our songs out to any old movie!"

It's funny, 10 years later, it came full circle in a way. I'm doing *School of Rock*, and I'm like, "Gotta get that Led Zeppelin song!" So we recorded Jack Black asking Zeppelin in front of a big crowd of people, and it worked. We got the song we were going for. But in my *Dazed* diary, I had written that Plant was "responsible for the assholes around him he's empowered to do this thinking," and Randy Poster, my music supervisor on *School of Rock*, said, "Oh, the guy in Plant's office says, 'Tell Linklater, the same asshole is still in the office.'"

I'm still embarrassed by what I said about Plant, and I learned not to take things so personally. He was actually living in south Austin for a while, not that long ago. I had friends who'd end up hanging out with him, making some music. They all talked about what a great guy he is. He'd be at Whole Foods and other spots around town. I was actually a little nervous that I might somehow end up in a situation where I got introduced to him. It never happened, but I dreaded seeing the expression on his face.

Marjorie Baumgarten: The reaction to that piece was instantaneous and swift. The *Chronicle* prints on Wednesday night, and we distribute in town on Thursdays. But first thing on Friday, the

reaction came in. I don't know who faxed it to the Universal people, and I can't remember who called me, but they objected to Rick's overt detailing of how they duped him.

Sean Daniel: I do remember hearing from [Tom] Pollock and others at a pretty high volume. This did not go undiscussed.

John Pierson: The studios didn't like that stuff in writing. On *Slacker*, Rick would fax memos to them like, "Here's what's wrong with the trailer," and they didn't like that, but at least he wasn't *publishing* it. Appearing in print was a big deal.

Richard Linklater: I was thinking, "I'm a nobody. Who gives a fuck what I say?" I did it in print, not online, and I did it in Austin. I counted on things not leaking out.

Kim Krizan: Rick positioned himself as David fighting the master Goliath. And Austin is the sort of place where a David and Goliath story will really be palatable to the people. It's a small, liberal city in the midst of the big, conservative, redneck state. The artistic, sensitive, liberal people congregate in Austin and wage battle with the rest of the state.

And there are limited opportunities in Austin. A great success is running the cheese department at Whole Foods. So there was a tremendous suspicion at the time that if one was successful, especially in a place like Hollywood, that person sold out. Definitely, it would help someone like Rick to create a narrative in which they're fighting the Man.

Sean Daniel: The diary hurt people's feelings. Not Jim's—Jim was a pretty thick-skinned guy. But Pollock's feelings were hurt. Nina's were. Russell's were.

Nina Jacobson: I must've blanked it all out. But listen, it's unusual to put your grievances out there, right as the movie enters the bloodstream. It's certainly not the best way to endear yourself to the studio that's trying to get people to see your movie. I can certainly imagine that Tom Pollock would've been pissed.

Richard Linklater: By the time the film came out, Nina and Tom had long ceased talking to me, so I wasn't going to be on their

call lists. But Jim called me first thing Friday morning. He wasn't happy, but he was more concerned about his reputation, because he was positioning himself to be the producer that indie filmmakers want to go to when they do their studio film. And, hey, Kevin Smith worked with him right afterward, so it didn't cost him anything. But he was worried, like, "If you tell everybody I'm an asshole, you might be fucking with my business."

I said, "Sorry, Jim, you were kind of an asshole! I'm not lying."

Jim just totally missed the point of the piece. He was like, "Rick! You have this line in here saying 'some producer' was going around telling all the actors not to say 'fuck.' I'm not 'some producer.' I'm *the* producer!" I'd belittled him by calling him "some producer." *That's* what bothered him.

Jim wasn't that upset. The only people who were really concerned were my own parents. They were living in Portland, in Oregon, and a local film person read my *Chronicle* diary and wrote an article. It said something about the piece being "a heart-wrenching, potentially career-ending diary entry." It basically said I was burning every bridge. And my dad said, "What's this potentially career-ending thing you've written?"

Russell Schwartz: I don't think a filmmaker had ever published a diary like that before. Certainly, many have since. Richard was always an initiator, and an instigator, so I would have no problem giving him credit for that.

Sean Daniel: Did he ever apologize for it? I don't remember.

EXCERPT FROM RICHARD LINKLATER'S LETTER TO RUSSELL SCHWARTZ, JIM JACKS, SEAN DANIEL, AND OTHERS

October 4, 1993

Dear *Dazed* Folks,
This is an official apology for any hurt feelings regarding the "*Dazed* diary" I wrote a while back that recently ran in my local

arts paper. These are the paranoid, sometimes funny, sometimes not-so-funny rantings of a filmmaker who at times along the way did in fact feel needlessly abused, and that his film was being ignored or dumped. I hope everyone will keep in mind that this is a small circulation, local entertainment weekly that is not read outside of the Austin arts and entertainment community . . .

Why put anything in print that even touches on anything negative? First you have to realize my local situation is very different from everywhere else. I obviously would never write such a piece for a larger publication. The editors of that paper are friends of mine and wanted more than what they saw as the press release version. I accepted their offer to give them my "real version" of my two years on *Dazed* because it was an opportunity to communicate the experience to friends in my community and answer in my own way the "sellout" that has naturally hovered around the film and me all along. We're talking local politics here. I wrote it in one 15-hour sitting and it was perhaps my most cathartic/coming-to-peace-within-the-film experience of the last year. And I stand by every word as an accurate depiction of my true state of mind at various points along the way.

Sean Daniel: Look, Rick really embodies a certain independent American artist spirit. And he's true to it. And I think that's where a lot of that diary comes from. The executives at the studio didn't think of themselves as soul crushers or philistines—and, in fact, they weren't. But they made a lot of wrong calls about *Dazed and Confused*. Nothing Rick said in that diary was wrong.

Frankly, Rick captured the excruciating pressure for a filmmaker working on his first big-budget movie. And he captured the struggle of having a big vision for a movie that you had to constantly figure out how to get made inside of budgets constraints. But Rick's struggle wasn't a new struggle. It wasn't his alone. When I reread his diary now, on one hand, I feel bad that I wasn't able to win more of those

battles for Rick, but on the other, getting the money to make the movie was a battle in itself. And the process resembled the process on every movie I've ever worked on. And a great movie got made.

Richard Linklater: Talk to any filmmaker about that early film where they're in the system for the first time. That's just how it fucking feels! When you're a young filmmaker on your first studio film, you hear stories about what happened to Sam Peckinpah, or Orson Welles, or John Huston, or Scorsese, who had to cut the happy endings sequence from *New York, New York* after it didn't test well. It seemed like every filmmaker I'd admired had been punked out by some studio at some point. This was nothing new in the perpetual art-versus-commerce collision. That is the film industry. Nobody sets out to make a bad movie, but you have to know you're just a few bad decisions away from that, and all a director does all day long is make decisions. It's precarious, and you have to have a really strong vision for what it is—and maybe, more importantly, what it isn't. And the less experienced you are, the more it feels like navigating a minefield that's threatening to blow up your whole movie. That piece is my trip through the minefield.

Marjorie Baumgarten: Well, I think Rick has learned not to be as free with sharing his diary.

Richard Linklater: No. I don't regret any of it. I've never had to write a diary like that again, because I've never had to fight a battle like that battle again.

Louis Black: Rick told me, "Next time, I've got to be a little bit more careful." But that's classic Rick. He didn't say there's not going to *be* a next time.

Part IV

The Legacy

Chapter 31

Amazed and Confused

"Y'all smoked too much pot. Now you're trying to make money off this guy?"

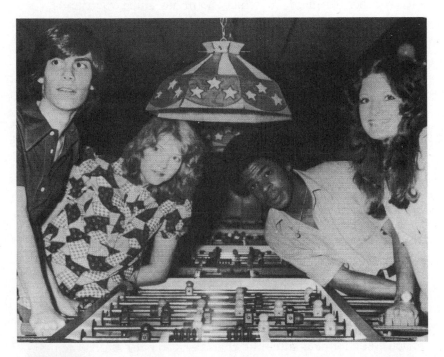

How would you feel if someone you knew two decades ago made a movie inspired by your high school? When *Dazed* opened in Huntsville, some of Linklater's former classmates didn't know what to think. Many of them had lost touch with him by then. Many had no idea he was making a film set in their hometown. Even the people who'd been closest to Linklater were surprised by the characters and events they recognized in the film. He'd played around with identifying details and phrases they'd used in everyday conversations. He had used real names.

The director wasn't making one-to-one comparisons between his classmates and fictional characters—like most fictional characters, they were composites of people he knew and things he'd made up—but he'd used their collective experience to make a movie that would be seen by people who'd never been to Huntsville and didn't know what it was like to grow up there.

Reactions in his hometown varied. Most people were flattered. Others were conflicted. One person stayed angry for a full 11 years after the film opened, at which point he and two friends sued Linklater for defamation and negligent infliction of emotional distress. When news of the lawsuit broke, it was hard for some to understand how being associated with a beloved character from a critically acclaimed movie might cause emotional distress. When the *Washington Post* wrote about the lawsuit, there was a sarcastic tone to the article. The headline was "Bummer, Man."

Richard Linklater: *Dazed* played in Huntsville. That was my dream! Russell did that as a favor to me, because films with that kind of release pattern don't ever make it to Huntsville. And it got reviewed in the local paper.

EXCERPT FROM *DAZED AND CONFUSED* REVIEW BY JANET DIAL

Huntsville Item, October 31, 1993

Don't look for plot, authentic characterization or drama the first half hour of Richard Linklater's *Dazed and Confused*.

The first half hour of this film directed by a former Huntsville High School and Sam Houston State University student is replete with the inartistic caricature of every head, jock and nerd ever portrayed in the recent spate of teen adventure movies.

Each individual, from the young, hiply dressed history teacher to the muscle-brained coach, is overdone.

Richard Linklater: You know how Neil Young made a book-let of all the worst reviews of his great albums? If you want to do that for *Dazed*, go to my hometown paper. That's the worst review I got. It was hateful.

And *Dazed* closed early. It didn't even make it one whole week in town. But by the last few nights of its short run, people had sort of picked up that it was based on Huntsville.

Mike Riley: It's written in a brilliant way, so that everybody who lived in Huntsville at the time sees themselves in one of the characters. You hear different opinions about, "Oh, that's so-and-so."

Julie Irvine Labauve: I heard the names and I went, "Wait a minute! This is uncanny." These were people I knew! "Pink" Floyd was a year older than me. He played football.

Richard "Pink" Floyd: I did play football, but I wasn't that popular. Actually, to be quite honest, I think that character was based on Richard Linklater, because he was the quarterback.

Richard Linklater: Ricky Floyd's nickname was "Pink," and I stole that, but Pink is me. And so is Mitch.

Excerpt from Dazed and Confused
Draft as of February 20, 1992

RANDY "PINK" FLOYD—runs with all crowds: jocks, stoners, poker group intelligentsia and acts accordingly . . .
MITCH KERR—Jodi's younger brother, popular, athlete, gets "busted" the worst by the seniors but ultimately gets lucky, ends up with Julie

Lydia Headley: Rick had that same bowl haircut as Pink. It was kind of startling the first time I saw the movie, like, wow, he really picked someone that physically looked like him!

John Pease: Clearly, the Pink character was autobiographical. But Mitch was reminiscent of Mitch Kerr. Mitch was a smart-ass

guy, two years younger than Rick. He played baseball. He's somebody that would inspire somebody older to want to put him in his place.

Don Dollar: The last day of school, we would go and pick up freshmen, and we literally did chase Mitch Kerr through the neighborhoods. I even had the same truck that "Don" has in the film.

Mike Riley: Mitch Kerr isn't alive anymore.

Richard Linklater: I never got to know Mitch Kerr. He was just a name. And he was in a similar boat to me because his older sister was very popular, and he was a freshman when she was a senior. People were gunning for him the way they were gunning for me because of my sister.

Don Dollar: Rick's sister, Trish, some of her friends' names were in the movie. There was a Shavonne Rhodes. Her name is Shavonne Conroy now.

Excerpt from Dazed and Confused
Shooting Script, June 25, 1992

SHAVONNE RHODES—boy crazy, popular, hot stuff

Shavonne Conroy: It's funny because I was *not* that girl in high school. I wasn't popular. I was a nerd. I was in theater. I didn't go to parties, because I was allergic to smoke. I was a virgin. So when I saw the movie, I was thrilled!

Don Dollar: Shavonne and I ended up in the fire tower, making out, one night in high school. She was the first girl I went skinny-dipping with.

Excerpt from *Dazed and Confused*
Seventh Draft, April 16, 1992

DON DOLLAR—cocky, charming, not smart, womanizer, fun guy, has a thing with Shavonne

Don Dollar: Some people have told me, "I think that character was emulating you." I did play football. And I was a teacher's pet. There's that one scene where Pink and Don are walking to a class, and the teacher comes out, and it shows Don hitting on the teacher. That was real. I used to flirt with teachers a lot.

Richard Linklater: There was a real Tony and a Mike. Those are friends. That was a shout-out to them.

Excerpt from *Dazed and Confused*
Shooting Script, June 25, 1992

TONY OLSEN—witty, intellectual, paper editor, poker group member, a bit shy around girls but ends up with Sabrina

Tony Olm: I was on the newspaper staff my senior year, and Rick wrote regular stories, concert reviews, sports. I had a column called "Left Is Right." It was not politically appropriate for a redneck town. You know that character who's talking about neo-McCarthyism? My junior English class, I did a research paper about McCarthyism.

Jay Clements: You know in the movie when Tony tells the story of the dream he had about Abraham Lincoln? Well, that was Tony Olm. His father was a history professor. That's what made it funny.

Excerpt from Dazed and Confused
Shooting Script, June 25, 1992

TONY

Okay . . . in this dream I was getting it on with
what had a perfect female body but . . .

MIKE

But what? What?

> *Tony changes his mind.*

TONY

I can't say . . .

MIKE

Oh, come on, you can't give a build-up like that
and then not deliver. Okay, so, a beautiful female
body, we're off to a good start . . .
He gestures for Tony to continue.

TONY

But the head of, uh, Abraham Lincoln.

Tony Olm: My grandparents were from Illinois, so one summer when I was 15 or so, I went to visit them in the Land of Lincoln and slept in a Lincoln-style bed and had that dream. What made it even worse was, that was my first wet dream, so I'm pretty much scarred for life. I didn't tell anybody about that until I was a senior and I confided in one of my friends during honors English class. By lunch, everybody heard about it. And then in college in intramurals, I'd get called Honest Abe. I *still* get a hard time about it.

When *Dazed and Confused* came out, I hadn't talked to Rick in a long time, and on the radio there was a promo clip with that line

about Abraham Lincoln. I said, "Daggum! I oughta charge you for that!"

Richard Linklater: There was a real O'Bannion.

Richard "Pink" Floyd: They called him O'Bannion in the movie, but his name was O'Bannon.

Richard Linklater: I remember getting licks from a guy who'd flunked and was going to be back in high school repeating his senior year. I thought, wait a minute, is this fair? But he seemed pretty sure it was a perk of his situation. I thought that would be just one more detail to make this O'Bannion character a little more of a bad guy.

Excerpt from Dazed and Confused Shooting Script, June 25, 1992

BENNY

Okay, all you freshman wimps, listen up! Any of you ever heard of Fred O'Bannion? He was the baddest senior last year. I would've been the baddest senior this year except O'Bannion just found out he's gonna be a senior again this next year. He flunked out, and he's really pissed off about it!

Jay Clements: I was surprised to find that, in the original draft of *Dazed and Confused*, Rick had used my dad's name as the coach's name.

Richard Linklater: I felt bad. In some of Joe Clement's obits, it was like, "He was portrayed as the coach in *Dazed and Confused*." And I was like, "No, that was never official!" It was Coach Conrad in the movie, not Coach Clements. The coach was a jerk in the movie. Coach Clements wasn't a jerk. I'm very proud to say I played for him. He was a legendary coach.

Jay Clements: The assistant coach was Bob Alpert, and that was the assistant coach's name in the original draft. Bob passed away some years ago, but that bit in the movie about, "My grandmother's tougher than you, 'course she's 6'3", 250, and runs a 4.5 forty"? That was one of Bob Alpert's lines in real life.

Don Dollar: Coach Alpert would walk around campus, and he'd tell you to break down. If you didn't break down, you ran your guts out on the football field during practice. That was true.

Julie Irvine Labauve: Not everybody from Huntsville loves that movie.

Richard "Pink" Floyd: Andy Slater was a really hard-core Linklater hater. He felt betrayed by *Dazed and Confused.*

Andy Slater: I knew zero about the movie before it came out. I rented it and I went, *What the fuck?* This guy Slater acts all stupid and doped up all the time. I didn't like that. That wasn't me. I did have a very good connection for marijuana in high school, and I got kind of famous for growing my own, out in the national forest, but I didn't smoke *that* much weed. I was just smoking it socially like everybody else was.

Kari Jones Mitchell: *Dazed and Confused* was a perfect representation of Andy Slater.

He actually drew the cover of our senior yearbook. It's got a knight riding a giant hornet—because we were the Huntsville Hornets—and some kind of castle off in the corner and all these weird little mushrooms. It's just a pot trip on paper.

We were in choir together and we were asking him, "Have you finished the yearbook cover?" And he takes it out of his backpack and hands us the piece of paper, and the paper *reeked* of pot. You could've rolled that piece of paper up and smoked it!

Andy Slater: I was quoted in the movie saying things that I did say. You know the part about him saying that George Washington grew marijuana? I had a dollar bill, and someone had taken a Sharpie and made a balloon over George Washington's head that said "I grew dope" in it. I was an advocate for marijuana. It pissed me

off that the football players would get drunk, but marijuana was not allowed. I thought it was very unfair that people are out there killing each other on the highways, drunk, while stoners, all they want to do is sit around at home and watch TV and eat junk food. So one of my arguments was, why outlaw this stuff when the father of our country smoked dope?

I didn't like it when I saw that in the movie. It felt like an invasion of privacy. I didn't even hang out with Rick that much. I don't remember Rick partying with us out at the fire tower more than once or twice. It felt like Rick must've been in the woods, and instead of partying with us, he was taking notes.

Richard "Pink" Floyd: Slater had work here in Huntsville, and he thought the movie was affecting his business.

Andy Slater: For a while, I was living in Austin and commuting to Huntsville. Huntsville is a small town, and everybody knows you. I do construction, and I'd get questioned about it on jobs. Like, "Are you a stoner? Because I don't want any drugs on the job site here." At first, I thought it would go away, but it didn't. It just got bigger and bigger.

It started to affect me personally. I was dating a girl who was in college, and she was living with her parents. I went to go pick her up, and she goes, "Andy, there's a little problem here. Slater from *Dazed and Confused*—that's you, right? He's a drug dealer!"

So I went, goddammit, I've had enough of this shit. At first, all I wanted was an apology. I wrote a letter to Rick. But that letter never got sent because I was approached by my landlord's son, who's a lawyer, and he said, "We might have a class action lawsuit here, Andy." So they called up Ricky Floyd and Bobby Wooderson.

Richard Linklater: Those guys sued me in 2004. It was Wooderson, Ricky Floyd, and Andy Slater.

Linden Wooderson: My dad was Bob Wooderson. He passed away in May of 2018. Ricky Floyd was his first cousin.

Kari Jones Mitchell: When you see the picture of Matthew McConaughey, his hair is exactly like Bobby's.

Andy Slater

Bobby Wooderson

Don Dollar

Keith Pickford

Ricky "Pink" Floyd

Leslie Warren

Mike Goins

Shavonne Rhodes

Tony Olm

Frances Robinson

Tricia Linklater

Jay Clements: I almost wonder how much of McConaughey's performance has overwritten my memory of Bobby Wooderson.

Richard "Pink" Floyd: When Bob passed away, I did one of the eulogies at his funeral. I got up there, and to break the ice, the first thing I said was, "Alright, alright, alright."

Keith Pickford: The stuff about the high school girls staying the same age—that rings a bell about Bobby Wooderson. Bobby was a womanizer.

Andy Slater: When asked kiddingly about when he was going to graduate, Bobby said he was just sticking around for the chicks.

Richard "Pink" Floyd: That was the running joke around our house: "Don't bring your girlfriends around, boys!" Because Bob was quite the charmer.

Tony Olm: There were plenty of older guys who hung around Huntsville and never were going to leave. "Yeah, I'm workin' for the city, got a little change in my pocket."

Linden Wooderson: Right out of high school, my dad went and worked for the city. He was in Huntsville all the way till he was 35, or maybe 40? Then he went to Houston for two years and came back to Huntsville.

Richard "Pink" Floyd: Andy Slater got the lawyers, and the lawyers came to us. At first, Bobby and I were like, "We don't know about this." But then we were at a family function, and we had a few beers in us, and we said, "Oh, what the hell." Bobby and I were both working paycheck to paycheck at the time. So if we had a chance to hit a gold mine, we wanted to see about doing that. We were kind of like, "What do *we* get out of this?"

Richard Linklater: Those guys saw an opportunity. Not much of an opportunity! An opportunity to get made fun of. There was a certain tongue-in-cheek quality to the story that was written about the lawsuit.

Peter Carlson: I was a feature writer in the Style section of the *Washington Post* in 2004, and I went to Huntsville and talked to the "*Dazed* Three."

I don't think any of them denied smoking weed. Slater did deny

making a bong in shop class. I said, "Well, yeah, that does seem a little far-fetched." He said, "Oh no, people did that! It just wasn't *me*."

Wooderson said his son went to Harvard, and he went there to see the kid, and all the Ivy League scholars were like, "Wooderson! Let's burn one!"

Every time the plaintiffs started talking about the movie, they would start laughing. The lawyers, of course, thought this was a very serious legal case, that there was absolutely no humor in it whatsoever. The lawyers wanted them to be serious about this whole thing so it would look like they were horrendously emotionally distressed.

Richard Linklater: I didn't even know those guys that well in high school! They were all older than me. I was friends with their younger brothers, Bubba Floyd and Tommy Wooderson, both very cool guys. I played with Bobby Wooderson on the same tournament baseball team, briefly one summer. He was a good catcher. I was in eighth grade, he had just graduated. He wouldn't remember me, hardly. And Slater, he was only a year older than me, and I think we might've been together at some concerts, but I didn't think he was any more of a stoner than anyone else. I just liked the name Slater.

Andy Slater: The lawsuit fizzled because the statute of limitations was about to run out. Eleven years was the cutoff point, and the lawsuit was happening right before that.

Peter Carlson: Why did they wait so long to sue?

Linden Wooderson: When the movie came out in theaters, it was such a dud, nobody really cared. People saw it, and then it was sort of forgotten. When I was in high school, it really wasn't that big of a deal. But then the DVD came out, and people started watching it, and by the time I went to college, everybody knew about it.

Richard "Pink" Floyd: The lawsuit wasn't a good decision on our part. In hindsight, I wouldn't have done it. All it did was end up giving us our 15 minutes of fame. On the internet, people were saying, "Y'all smoked too much pot. Now you're trying to make money off this guy?" And, well, it's true!

Richard Linklater: I think Tina Fey picked up on it. It was a *Saturday Night Live* thing, in their news section that week. She made a joke implying that they were so stoned, they didn't realize the movie was using their names until just now. Anyone can sue anyone in our legal system for anything. But then there's a process where they start judging the merits of your allegations. I gave depositions on a Saturday, and the judge threw out the case on a Monday, but that never makes the news.

Andy Slater: Everybody was mad at me because of the lawsuit. I ran into Rick's mom in a restaurant. We were both waiting in line to pay, and she said, "I understand you got a lawsuit against my son."

I said, "Yeah. He should have called me up. I probably would've said, 'Okay, no big deal.' But he didn't. And now my life is changed. And I didn't get anything out of that movie."

Rick's mom was a funny lady. She goes, "Well, I got a Cadillac and a house!"

Peter Carlson: Didn't the lawyers for the movie company make sure that he didn't use real names? Lawyers make sure that if you're using peoples' names, that they've agreed to be portrayed.

Richard Linklater: I didn't use anyone's first *and* last name. It was just the last name or the first name. I was told that, legally, you could do that.

Holly Gent: There was a memo I distributed while we were making *Dazed* that was literally switching out a ton of the original names Rick had chosen and mixing them up with different first or last names. But I think there were some he felt more of an emotional connection to. I think, at times, he just did what he wanted, regardless of the naysayers.

Peter Carlson: If he changed their first names, why the hell didn't he change their *last* names?

Richard Linklater: Well, it was personal. Either I just like the way the name sounds, or they're shout-outs to my friends. I do that in a lot of my movies. Hopefully, you're just messaging someone from afar, and people who were friends of mine took it as such. My

high school friends love the movie. Anyone who was anywhere near there feels like, oh yeah, that's about *me*.

I did the same thing with my movie *Everybody Wants Some!!* I used the name Plummer in the movie, and I told the real Plummer, "Hey, the only thing this character has in common with you is the last name. He's this drunk guy. You weren't that. He really doesn't have much in common with you at all."

Andy Slater: Rick was showing that movie at Sam Houston University in Huntsville, and I wasn't there, but somebody told me that he said, "Anybody that hears their name in this movie and doesn't like what they see, I apologize that I didn't contact you first-hand." That was like a stab in the eye, him apologizing to them. He never apologized to me!

Richard Linklater: If you have friends who are writers, buckle up. You're going to find yourself as some kind of a character in someone else's story, and it can be unnerving, how you're characterized in someone else's thing. We're all aghast when we see what a small part we play in other people's lives. We're all the lead character in our own lives, and we're only supporting characters in other people's lives, and that hurts. That's the dilemma we all live with.

Wading into the Shark Waters

"I kind of had to go and join the real world."

People often think of *Dazed* as a star-making movie, but with the exception of Matthew McConaughey, it took years before anyone was cast in a real breakthrough role. Relatively

few could find enough work. Even Parker Posey, who had a career-defining stretch in the mid to late '90s with *Party Girl*, *The House of Yes*, *Waiting for Guffman*, and *Kicking and Screaming*, remembers that era as the beginning of the end for her career as an indie darling. "The independent film world in the early nineties had a real independence from the Hollywood system, much like in the seventies," she wrote in her 2017 book, *You're on an Airplane*. "And then, *Time* called me the queen of independent cinema and that's when my career in independent cinema virtually ended."

Dazed also marked a turning point for some members of the crew. Lee Daniel, Clark Walker, Anne Walker-McBay, and D. Montgomery had worked with Linklater on *Slacker*, which felt to them—though, crucially, not to him—like a collective project. They helped Linklater, and they believed Linklater would help them. And he did, to a degree. He got them hired on *Dazed,* and on other projects for years to come. Clark Walker worked with him in various capacities until 2004, Walker-McBay until 2005, and Lee Daniel until 2009. D. Montgomery initially planned on joining Linklater as production designer on *Before Sunrise,* but when it became clear that she was struggling with a drinking problem, he had to replace her. From the set in Vienna, he sent her home to the U.S. and paid for her to go to rehab.

Over time, Linklater found new DPs, producers, and assistant art directors to work with him–or, rather, to work *for* him. No collective is really a democracy, at least not in the long term.

Joey Lauren Adams: When we were working on *Dazed*, we were all told, "You're gonna be stars! This is it!" And you'd have these moments like, "I'm never gonna have to audition again! Thank god!"

And then none of that happened.

Adam Goldberg: *Dazed* didn't launch anyone into superstardom. It didn't launch anybody into anything.

Anthony Rapp: If *Dazed* was your first thing—and it was the first thing for so many people—it's special in ways you probably didn't even realize were special, in terms of how well we were treated

and how included we were and how meaningful our contribution was. If that's your first foray into this business, and then you're wading in the crazy shark waters after that, it's tough.

Parker Posey: It was a big benchmark for all of us to then go into this Hollywood system and see something completely different from *Dazed*. Not as free, not as loose, not as joyous.

Sasha Jenson: Casting directors were like, "I don't want to see anybody from *Dazed and Confused*." This wasn't, like, *Less than Zero*, where every role was a star-making role. In those kinds of movies, the performances were clearly etched out, and with that comes actors that are very castable in other roles that are etched out. With *Dazed*, the lines were fuzzier in terms of what kinds of characters they were. It was like, "What do we do with this guy? It's not like we're going to put him in a sitcom."

Ben Affleck: The movie bombed, but the critical reaction was so strong at the time, it helped some people's careers. It just didn't help mine. When the movie came out, I was back to living in my apartment in Eagle Rock. In fact, I brought my puppy back to L.A. from Austin, and it got stolen out of my yard five months later. I was trying to cobble together what life I could with guest-starring in episodic shows and stuff. You just keep hoping each movie will propel you forward in this imaginary list of people who are all ahead of you in line.

Chrisse Harnos: Renée and Matthew and Ben, it took a good decade for their careers to become what they did. In the meantime, we were all just trying to work.

Jason London: On *Dazed*, we didn't make any money. I think we cleared eight grand each, if we were lucky.

Adam Goldberg: When I came back to L.A., I had done a day on the Pauly Shore movie *Son in Law*, because I needed $1,000. *Dazed* hadn't come out yet. So I was on the set in a full, bad Native American Halloween costume, and I had one line. And then *Son in Law* became a shameful blight on my résumé. But at the time, it didn't mean anything. I just needed to work. I *still* need to work.

Anthony Rapp: Right after *Dazed and Confused*, I was working at Starbucks. My landlord skipped town and the bank foreclosed on the building, and there was no one to pay rent to for two or three years, so I kind of lived there for free. I did little off-Broadway things, but no money gigs. Even when I got *Rent*, at that time, it was just the tent performance workshop of the show. It was enough to get me not having to work at Starbucks anymore, but money was still tight.

Adam Goldberg: After Nick and I did the fight scene in *Dazed*, we thought it was this life-changing experience. We both said, "We're never gonna do TV again! That's that! No more television shows! Only films!"

I didn't see Nick much after that, and then finally when I do see him, it's at an audition for a TV show called *Love & War*, which is a Diane English show with Susan Dey and Jay Thomas. And we're both auditioning for this fucking cheesy "punk" part. And we were like, "Hey." "Hey." Yeah, *we're never gonna do TV again*, huh?

Nicky Katt: We'd see each other at screen tests, wearing the same suit. Like, "Where'd you buy that, T.J. Maxx? I thought we said we weren't gonna do this."

Adam Goldberg: Nick and I were sort of this yin and yang. Someone wrote about *Dazed* recently and talked about how there was this weird similarity between the two of us. Over the years, we would ape each other's acting style.

Nicky Katt: When I sent in my audition tape for *Saving Private Ryan*, their feedback was, "Too much like Adam Goldberg." Our personalities started to meld to the point where it didn't matter who got the part anymore.

Michelle Burke Thomas: Before *Dazed* came out, I did *Coneheads* with Parker and Joey, and it was exactly the same as *Dazed*. They were *rude*.

Joey Lauren Adams: I don't have any recollection of that, but I don't remember Michelle making a huge effort to be friends with us, either. I don't know that it was our job to make her feel included.

Parker Posey: Not everyone has the same sense of humor. As a conscious adult now, I would've gone out of my way to be sweet to Michelle. I hope she's able to get over those feelings of being hurt.

Michelle Burke Thomas: Parker auditioned for the role of Connie. I think she really wanted that role. And she would've been great at it! But I got it.

Parker Posey: I knew I'd never get the part of Connie Conehead because I wasn't as pretty as Michelle and I didn't have boobs! Michelle is a knock-out. But I convinced Lorne Michaels that Connie needed friends. That was when Joey and I got our first "SAG + 15 percent" job. I was funny at the audition and getting to meet Lorne Michaels was how I got cast in *Waiting for Guffman*, which led to all that improvisational work with that ensemble.

Adam Goldberg: When we were doing the movie, we'd talk about who was gonna be the big star to come out of it. Jason London was the obvious one.

Greg Finton: I thought Jason London was gonna be the biggest star to come out of *Dazed and Confused*. I couldn't believe that Matthew McConaughey was the first one to come out of that a star. I was sure that Jason London would be huge. He had a twin brother who had some success, too. Whatever happened to them?

Jason London: When I went to my very first audition back in L.A. after *Dazed*, we'd just buried my sister.

It was traumatizing enough to lose my sister, and then my sister's seven-month-old baby—who had been born with all of these health issues—had lived through the car wreck, miraculously. This baby was a hemophiliac! He wasn't even supposed to be able to take a bump on the head! So then it was like, what's gonna happen with him? There was all this custody shit about who's gonna raise him. My life got so involved in that that I stopped caring about other things.

I strolled in late to the audition, and the casting director was really pissed off at me. I was trying to hold back from crying. I said, "I'm so sorry. I'm having a hard time. My sister died a few days ago. We just buried her."

And he said, "I don't give a *fuck*. You don't show up late to my audition."

I stood up and walked out. I said, "I just can't do this. I'm sorry to waste your time."

All of the things that had been important to me stopped being important. I probably could've had a different career if that hadn't happened, but the truth is, after my sister died, I didn't give a fuck.

Adam Goldberg: The other person we all thought would break out from that movie was Rory. He had been on the cover of *High Times* and he seemed like the poster child for the movie. The word on the street was that he was the next Sean Penn. But after the movie came out, he kept turning stuff down.

Ben Affleck: I remember him telling me that he wouldn't go in and read for this very, very famous actor who was directing his first movie, because Rory thought the script was bad. I was like, "Are you crazy? That's so-and-so!"

Rory Cochrane: I waited for a full year to find something that was completely different from *Dazed* that I really wanted to do. I got offered everything that was a stoner, and I was like, that's not what I'm trying to do!

Adam Goldberg: There was a *Dazed* rip-off that I auditioned for right after *Dazed*. It was called *The Stoned Age*, and I auditioned for the Rory part. Thank god I didn't get that. It's embarrassing that I even auditioned.

Rory Cochrane: Years later, they were still offering me stuff like *Dude, Where's My Car?* I mean, I did another movie for Rick called *A Scanner Darkly*, and I played a drug addict. And I'm like, "You know, Rick, I can play other things than a drug addict!"

Richard Linklater: I reached out to Rory to play the lead in *SubUrbia* a few years later! But he wouldn't really discuss it or read for it. He just acted cryptic, which is Rory anywhere near an audition. It ended up going to Marissa's brother, the wonderful Giovanni Ribisi.

Ben Affleck: Coming out of *Dazed*, Rory and Matthew were clearly the two people who were going to get famous, but Rory was

a little bit conflicted. He seemed to not want to be famous on some level, whereas Matthew seemed thrilled.

Don Phillips: After *Dazed* wrapped, Matthew went back to school. He finished his senior year in Austin.

Shana Scott: Right after *Dazed*, I was a casting assistant in another movie in Austin called *My Boyfriend's Back*, and Renée Zellweger and Matthew McConaughey are extras in that movie. They got paid $150. The movie was about a kid who became a zombie. Philip Seymour Hoffman was the one who hit the kid in the head and made him a zombie. It's a horrible movie.

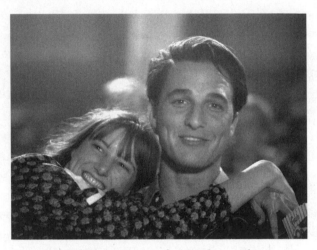

Matthew McConaughey in the zombie
movie *My Boyfriend's Back*

Richard Linklater: Within the year between us wrapping *Dazed* and the movie coming out, Matthew got cast in *Texas Chainsaw Massacre: The Next Generation*, in Austin. He and Renée Zellweger both got in that one.

Renée Zellweger: I played Jenny, the prom queen in the dirty prom dress, and I did my own stunts and flew down an unfinished tin roof without a safety design. The only stunt that I didn't get to do was jumping out of the window onto the crash boxes. I would land on the ground in the glass that they put there to make it look dangerous. It was an excellent workout.

Matthew and I shared an agent in Dallas, but I didn't really meet him on *Dazed and Confused*. I just knew there was this guy in Austin who was also at UT and who drove up to Dallas every week for auditions on the same schedule I did. My agent had suggested that we meet and ride together, but there was no way I was going to call an actor I didn't know and ride for four hours up to Dallas and back. It's funny, when I met him on *Chainsaw Massacre*, and we made the connection, we both had the same story. He'd been told about me, too, and he had thought to himself, "There's no way I'm calling that girl and get stuck in the car for four and a half hours!" We had a good laugh about that.

Richard Linklater: Matthew and I were driving to a Butthole Surfers concert when he told me about the Texas Chainsaw movie, and I was like, "Hey, Matthew, put it in your contract that if they ever promote this movie based on the fact that you're in it, they really have to pay you." He didn't, and he ended up having a weird experience on that movie. Years later, I was like, "Matthew, remember what I said?" And he was like, "Man, I knew you were gonna bring that up."

Wiley Wiggins: It was cool to see Matthew play a scummy, creepy character in that movie, especially in retrospect, since he went on to do that stretch of bland romantic comedies after that.

Adam Goldberg: In the *Variety* review of *Dazed*, they called Matthew a Dennis Hopper kind of guy. Parker's boyfriend, the producer Bob Gosse, was referring to Matthew as this Eric Roberts–looking dude, and I thought, *That's who he should be!* That's the kind of career I thought he was going to have. The one where he was going to play a fucking scumbag. Eventually he came back to that, and I was like, Oh, *there* you are!

Don Phillips: After he graduated, Matthew drove out to L.A. and moved in with me. He brought his truck, Old Blue.

Matthew McConaughey: I drove out August 12th, 1993, pulling a U-Haul. About 80 miles east of L.A., there is a road sign on the highway that says "Sunset Drive." You see that, and you're like, That's it! I'm going to hit the strip! but you're still 80 miles out of town. I put in the Doors' "L.A. Woman," and I had to play it over

and over, thinking I was going to arrive any second. I played it eight times until finally I was like, I'm not even close.

I pull into Don's place. I've driven 27-whatever hours. I knock on the door, and Don's not answering. I'm ringing the doorbell. All of a sudden, he comes to the door *buck naked*. He goes, "Do me a solid. Maybe come back?" I said, "Don, no. Go finish your business with that girl, but I just drove 27 hours to arrive here. You're the only person I know. I need your couch! I'm wiped, dude!"

Don Phillips: He came in, and then the phone rang and it was Sean Penn. Sean had just cleared out his past life with Madonna. He had a beautiful mansion in Malibu. Downstairs, they had a huge room that was a dance studio for her. He got rid of all that stuff and put in a regulation boxing ring. So, he called me and said, "Come on down. The boxing ring's finished." So I drove Matthew down to Sean's, and Sean proceeds to have a boxing match with his brother Chris. Matthew didn't say *one word*. After we were finished, ready to go back, Sean said, "Don, you're right! He's really cool." If Matthew didn't say anything, Sean thought he was cool.

Ben Affleck: Other casting directors, you have these vague relationships with them the first time you read, and then you meet the director, and you never see the casting director again. But Don fostered and maintained relationships with some actors during production, and afterward. People would stay at his house. He would make calls for people. He supported the actors and grew really close to a lot of them. Maybe even too close in some ways.

Matthew McConaughey: I'm there with Don three, four, five days. I only came out with a couple thousand dollars. I had coolers full of frozen loaves of bread and stuff. I can tell that this isn't going to last long. I'm like, "Man, I need to get an agent. I got to go get some work."

I found a place about eight doors down from him. I paid cash for it. I'm like, "Okay, my money is getting low . . ." Don jumped on me that night and said, "Matthew! Don't you worry about an f'ing agent! Wear your cutoff shorts. Water your plants. Drink your Bud Lite. Smoke whatever you smoke. Take your dog for a walk on the beach.

Read your *Greatest Salesman* every day. And you just f'ing relax. If this town smells somebody that's needy, you're done."

I went, "Whoa." I went down to my place. Three weeks after that, we were sitting there, having a beer, and Don goes, "You're ready. I got a meeting tomorrow for us at William Morris."

Don Phillips: Most actors come in and work for a boutique agency that couldn't get them arrested if their lives depended on it. But if you were at William Morris, especially 25 years ago? You're gonna get work. So I got him an agent. I got him a manager.

And I got Matthew an acting teacher, Penny Allen. I put Penny in *Dog Day Afternoon*, and she was married to the actor Charles Laughton [not to be confused with the Academy Award–winning British actor], who was also a great acting teacher who had only one student, and that one student was Al Pacino.

Jason Davids Scott: Don clearly had a special relationship with Matthew.

Lisa Bruna: Don was the consummate mentor. He was committed to getting me on set. He said, "I want you to know what everybody on the film crew does, everybody from the director to the cinematographer to the grips and production assistants." And I know that he did the same for Matthew. He would invite him on set often and have him understand the making of a film, from the ground up. And I know that he was very intent on making sure that Matthew met other producers and people who could help advance his career.

Matthew McConaughey: My first audition in Hollywood came about two weeks later, to play a guy named Abe Lincoln in a film called *Boys on the Side*, directed by Herbert Ross. I got the job.

The next audition I had was not an audition at all. I went out to Warner Bros. They were looking for young baseball players. Actually to *play* baseball. And I walked in a room on the Warner Bros. lot, about 2:30 in the afternoon, and the sun was shining in the door, and I opened the door. Evidently, I was backlit and I got a baseball cap on, and this producer goes, "Ah, look at you, all-American kid! Ever played baseball?"

"Yeah, I played baseball, 12 years."

He goes, "You got the part." Right there in the doorway!

So, I went out to Oakland and did *Angels in the Outfield*, and got paid $48,500.

Rory, Nicky, Cole, all of us partied at my place for a couple of days, on me.

Ben Affleck: He did *Angels in the Outfield* in that sort of laconic, Texas drawl again.

Adam Goldberg: I was with him in his little Malibu bungalow, and he said something like, "Wooderson's dead, man." We were stoned and I remember thinking, "No, I'm having a conversation with him right now." The guy was unbelievable in *Dazed*, but if you look at McConaughey's roles, I don't think he's ever *not* done that accent.

Rory Cochrane: Matthew got *Angels in the Outfield*, and then he got a bigger place. He was sort of set up.

Nicky Katt: When *Dazed* came out, my pal was Joel Schumacher's assistant, and he took Joel to see it. You know that moment when Wooderson pulls into the Top Notch and says "Alright, alright, alright," and all the lights from the Emporium light up? It's like in the "Billie Jean" video, where everything Michael Jackson steps on lights up. It's like he's Jesus.

Schumacher saw that, and it was like, "Here we go, here's the star." And that's how he got *A Time to Kill*.

Rory Cochrane: When *A Time to Kill* came out, Matthew's life changed in such a dramatic fashion, kind of overnight. He was on four magazine covers, and they were all like, "Number One Movie!" And I think he withdrew from being Matthew. I think anyone would. It freaks you out.

Nicky Katt: Matthew *wanted* that. He wanted to be this messianic figure. I mean, he said he was gonna do it! And he did. And then you know what happened when Ben Affleck met Kevin Smith.

Kevin Smith: Well, first I met Jim Jacks at the Sundance Film Festival right after *Clerks* won the Filmmakers Trophy, January 1994. And I'm like, "I know who you are! You produced *Dazed and Confused*!"

So my second movie, *Mallrats*, was with the same dudes that produced Richard Linklater's second movie. And then Richard did *Before Sunrise*, and then my third flick was *Chasing Amy*, which certainly wasn't me going, "I'm gonna do *Before Sunrise*!" but it was also the movie where everybody took me seriously again. So those first three movies, Richard was my role model.

Jason London: Rick and Kevin Smith, their brains work the same way. And I think Kevin Smith saw *Dazed and Confused* and was like, "I love all of these people. These are gonna be the people in my movies."

Joey Lauren Adams: One night, I was hanging out with Jim Jacks at the bar and he told me he was producing a film called *Mallrats* and would like me to be in it. Don Phillips was casting *Mallrats*, so I thought I had a good chance at a part. We had to do that "pizza party" thing again with *Mallrats*, and it was terrible then, too.

Adam Goldberg: I auditioned for *Mallrats*. Same fucking office at Universal as *Dazed*. I went in, and I got a call from Don on Friday night like, "It's you! It's between you and another guy, but it's basically you."

Then, like, radio silence. And then Jason Lee was at the pizza party and I wasn't. And it was like, *Thanks, Don*. Probably best not to make those calls after 5:00 p.m.

Jason Lee: *Mallrats* was my first movie. I don't know if Don remembered me at all. Gay Ribisi, my manager—Marissa and Giovanni's mom—basically called in a favor with Don.

Don Phillips: I made an agreement with Kevin that nobody from *Dazed and Confused* would be in *Mallrats*. Kevin and Rick both had the same attorney, and they'd both worked with me and Jim Jacks, so there was a little competition between them.

Richard Linklater: First I've heard that I'm competitive with Kevin!

Don Phillips: But we ended up with a lot of people from *Dazed*. There was a character who's really an asshole, so I said to Kevin, "There's no doubt in my mind that the best guy for that is Ben Affleck." Ben was the perfect asshole.

Kevin Smith: Ben didn't audition for the bully role. He was auditioning for the lead, the TS role. All the guys auditioned for TS and all the girls auditioned for Brandi. But because of his size, it was like, oh man, you'd be a great Shannon Hamilton. I think there was a trifecta of bully roles. There was O'Bannion. There was the *School Ties* anti-Semitic kid. And then Shannon Hamilton in *Mallrats*.

Ben Affleck: I remember Rick telling me a story about Quentin Tarantino, whose movie *Reservoir Dogs* I adored. Tarantino had left Rick a message going, "Who is that guy who played the bad guy in your movie, man? What an asshole!"

I didn't want Tarantino to think I was an asshole. Matthew and Rory and Jason London played these cool, sexy, funny guys in *Dazed and Confused*, and I was bummed out about being the only unappealing guy, which is probably why I did not want to do *Mallrats*. I was like, "Dude, people are going to see the movie and hate me." I started to become aware that the audience didn't necessarily appreciate, "Oh, what an effective and moving portrayal of a villain!"

Kevin Smith: Ben needed a job. It wasn't like he had many options at that point.

Joey Lauren Adams: They'd told me I got a part in *Mallrats*. And then I get a call from my manager telling me that I don't have the part, because it's going to Parker.

Kevin Smith: I'd written the Rene part in *Mallrats* for Stacie Mistysyn, who was on *Degrassi Junior High*, but Don was leaning toward Parker as Rene, and Jim liked Joey.

Joey Lauren Adams: Parker was visiting from New York at the time, so she happened to be standing right next to me when I got the news. And I hugged her and congratulated her, but I just *hated* her then.

Parker Posey: I didn't feel like doing *Mallrats*. That's something I couldn't do now. As a twentysomething-year-old actor, I could be like, "It doesn't resonate with me." Now it might be like, "Okay, you don't have a career anymore!"

Joey Lauren Adams: Shannon Doherty got that part. And I got a different part. And I had to show my tits.

Kevin Smith: Jim Jacks really liked Joey. Like, *liked her* liked her. Jim was like, "She was hired to do nudity! If she's not gonna do nudity, we're gonna hire someone else!"

So Joey was like, "Let's talk about it. How long does this have to be?"

And I was like, "I don't know. As long as you want it to be!"

And she just opens her shirt real fast—like *foomp, foomp!*—and she goes, "Is that fast enough?"

And I'm looking at her face! I don't look down or anything, because I'm a neck-up guy to begin with, but also it was so fuckin' *fast!* So I go, "Oh my god, of course! That's way too much!" And then we went and shot it.

I don't know if Jim was ever happy with the amount of nudity that was in the film. It was the first moment that I was like, Ewww, the movie business is so *dirty.*

Joey Lauren Adams: When I first showed up to do *Mallrats*, Kevin and I were having our initial conversations, and he said something about me dating Jim Jacks. And I was like, "What are you talking about? We're not dating!" And I turned around and cussed Jim Jacks out.

Jim never tried to sleep with me or anything, but I had to have *several* dinners with Jim before getting that role, and I guarantee that Ben Affleck never had to do that. None of the guys did. But I had to maintain that relationship. Had I not met Jim Jacks, I don't know that I would have done *Mallrats* and met Kevin Smith, and I wouldn't have done *Chasing Amy.*

When Kevin started writing *Chasing Amy*, it was going to be some kind of John Hughes–type high school film at Universal. Ben and I were gonna play high school teachers, and the high school student was going to be gay. That was the gist of the story. But once *Mallrats* tanked, Kevin decided he was going to go back to doing indie film again, and that script changed.

By then, Kevin and I had started dating. He had issues with my past—not that I was gay, but, like, that I was really good friends with a guy I had slept with. It was just little things, like that I had lived

with an artist in Bali for six months, and Kevin was this kid from New Jersey who'd never left. One time he got really upset, because he had this girlfriend who he'd dated all throughout high school, he told me he was gonna go to her college graduation and I was like, "That's awesome!" And he lost it and started crying, like, "Why aren't you jealous?"

He'd write certain scenes from *Chasing Amy* after fights like that. In some ways, that movie is a huge apology to me.

Anthony Rapp: Joey was really good in *Chasing Amy*. And Parker was working a lot during that time, too.

Kevin Smith: Throughout the early '90s, Joey and Parker were often up for the same roles.

Joey Lauren Adams: Parker and I had a falling out later. For a lot of reasons. I was always her sidekick and I needed to get out from under that.

Parker Posey: Friends part ways when there's an imbalance—it gets competitive and jealous—and that's human, and understandable. I loved Joey as a friend and the "being actors" part was secondary, for me. We'd go out dancing and I'd stay with her when I was in L.A. The falling out was over the career part.

Joey Lauren Adams: When she was doing *Clockwatchers*, she called me and said something very condescending. It was like, "You should take this other role in *Clockwatchers*! It's a ditzy blonde role, so it's perfect for you!"

Parker Posey: This was a great role that Lisa Kudrow ended up playing—she's genius at ditzy blondes. I remember Nora Ephron asking me how my friendship was with Joey—this was a decade later, maybe more. I'd introduced Joey to Nora when I was on the set of *Mixed Nuts* [in 1994] and she cast Joey in *Michael* with John Travolta [in 1996]. When I told Nora we'd had a falling out, she said we'd be friends in our 40s.

Joey Lauren Adams: When I had *Chasing Amy* at Sundance, they were giving Parker some award for *Clockwatchers*, and she was mad at me that I didn't go watch her accept the award. And I was

like, "I have my own movie that I have to be there for!" Parker had like three movies that year, and it wasn't enough for her to have three movies when I only had one. She also had to get a special award for one of them.

Parker Posey: That was a crazy year at Sundance for me— three films and not a lot of time to do anything but press. The special acting award, for *The House of Yes,* was something I was alerted to *that day.* I wanted support from a friend, not for her to watch me. I had no idea what to say about accepting an award. I'd never gotten one, and really wanted to hide. I was freaking out.

J.R. Helton: Parker Posey and McConaughey, I remember thinking, "Oh, these two people could *definitely* keep doing this." But I didn't even know Ben Affleck was in *Dazed* until somebody told me.

Valerie DeKeyser: I came out to L.A. in '95. Ben and I had talked now and again since *Dazed,* and he was having a party with his roommates, and he's like, "Come to the party." So, my sister and I parked at the bottom of the hill. Beautiful house, Hollywood Hills, by the Bowl.

Ben Affleck: Matt Damon and I got a house, and Cole was always over there, too. I remember McConaughey over at that house one night. People were sleeping in the closets. It was like, we were 22 and we were in Hollywood! Every night was fun.

And we were hanging out with another group of guys, which was the Vince Vaughn/Jon Favreau crew, and I went to parties with them—parties that literally became the story of *Swingers.* That $250,000 movie was very *Dazed*-influenced.

Valerie DeKeyser: Ben introduced us to Matt Damon. And I'm going, oh, he's a frat boy. That's all I'm thinking. And Ben's like, "We're doing a little work on this film."

It's Hollywood! Of course, you're working on a film. It was like, "Yeah, whatever."

Ben Affleck: When I auditioned for *Dazed,* I was aware of a trend that was happening, with the Sundance Film Festival and certain

filmmakers. Like, Rick Linklater had made *Slacker*, and Quentin Tarantino had made *Reservoir Dogs*, and the idea was starting to emerge that you could do it on your own, or do it on the cheap, or do it in a way that didn't require studio gatekeepers to give you approval that they would never give you in a million years. And that was an exciting time to be part of, to be a struggling actor in Hollywood.

Kevin Smith was one of the guys in that movement that I was really interested in. And then Kevin made *Clerks*, and he wanted me to be in *Mallrats*, and it was like, these were the people I want to be working with, and I want to learn about directing and making movies on that scale. When I worked with Kevin, *Good Will Hunting* was basically dead. And I gave it to Kevin, and he single-handedly resurrected it by giving it to a Miramax executive named Jon Gordon. I don't think *Good Will Hunting* would have ever been made if I hadn't handed it to Kevin Smith in the Mall of America in Minnesota, in 1994, on the set of *Mallrats*, which never would have come about had I not been cast as O'Bannion by Rick Linklater in 1992. My life has got these weird connections that go back to *Dazed*.

Richard Linklater: After *Dazed*, I did *Before Sunrise* with Castle Rock. I got a call, about '94 or '95, from Martin Shafer at Castle Rock. Martin says, "What do you think of Ben Affleck?"

And I was like, "He's a great guy, really smart, good actor. Why do you ask?"

"Oh, there's this script, *Good Will Hunting*."

Castle Rock ended up buying it. So, I'm thanked in the movie, I guess for answering the phone.

Ben Affleck: In the letter Rick had sent us for *Dazed*, he had said, "If this movie is produced as written, it will be a massive underachievement." That stuck with me so profoundly that I showed it to Matt [Damon], who I was living with when I got cast in *Dazed*. When Matt and I made *Good Will Hunting*, we used that line over and over again with the actors. Minnie Driver's role was written American, but we wanted her to play her more natural, comfortable self as a

British person, and we encouraged her to improvise. Because of Rick, we were aware of the fact that actors had something to add to a project, and that it could make it better.

And *Dazed* also taught me that people tend to be like, "I don't like that person who played the villain, but I do like the person who played the hero." So that was an education in choosing roles in Hollywood, and that's why I wrote *Good Will Hunting*. I wanted to play a character who was lighthearted and kind and supportive of his friends. He wasn't beating people up.

Jason Davids Scott: I worked at Castle Rock at the time, and I was in development, and I read this script. They'd taken the cover off it, so I did not know who wrote it, but seven pages into it, I said, "It's like I'm reading a conversation between Cole Hauser and Ben Affleck." Then at the premiere of *Before Sunrise*, Ben was there. And he was like, "Remember I told you that I was gonna write a script? I wrote a script! Castle Rock bought it!" And I'm like, "Oh my god, that was you? I loved that script!"

The next time I saw Ben, he was coming into the office and I was going out, and he was parked on the street. And he pointed to a big SUV and he said, "I just bought that car because of you."

Anthony Rapp: We were all these young actors, circling each other. When *Dazed* came out, I was doing this play, *Sophistry*, with Ethan Hawke and Steve Zahn, and they came to a screening of *Dazed* and were really crazy about it. It really made an impact on Ethan especially.

Ethan Hawke: I felt a kinship with the film, as do a lot of people. I saw the whole thing as a modern-day Chekhovian comedy.

Anthony Rapp: And then of course Ethan went on to work with Rick on *Before Sunrise*, and Steve ended up being in *SubUrbia*.

Nicky Katt: For a minute there, I thought I was gonna be Rick's Robert De Niro. But then he found Ethan Hawke.

Jason London: I thought Rick and I were gonna have this life-long bond. But as soon as Rick met Ethan Hawke, my days working with Rick were over.

Parker Posey: Rick found a real collaborative bond with Ethan, and that was it. Rick needed a star to facilitate *Before Sunrise,* and Ethan's been a star since *Dead Poets Society.* Rick wouldn't have been able to do that with us. I'm not a big enough star.

Ben Affleck: Rick never wanted to use me again for anything after *Dazed.* For a long time, I felt disappointed and a little resentful, like, "God, he went and hired everybody else! I guess he didn't like what I did."

Richard Linklater: In the late '90s, I approached Ben with what I thought was a good part about a factory worker who was also a writer. It was funny and real and had a political dimension. I thought Ben would have been great in it, but I never heard anything back from him. I guess I figured he'd moved on to another level.

Kevin Smith: It wasn't until I hung out with Ben on *Mallrats* and got to know him as a person that I was like, "Oh! He's funny and charming! Someone should make him a leading man!" That was where we split, me and Richard. He didn't write anything for Ben. So I wrote *Chasing Amy.* I remember on *Chasing Amy,* Ben said something like, "Well, Matthew has Richard. I'm lucky that I've got you."

Adam Goldberg: Obviously, everyone's had varying degrees of success since *Dazed.* Some were insanely successful, and some quit acting altogether.

Wiley Wiggins: *Love and a .45* was the first thing I did after *Dazed,* and it was also the first bad review I ever got.

Shana Scott: *Love and a .45* was a poor man's version of *Bonnie and Clyde,* but funnier. It was shot in Texas.

Wiley Wiggins: The guy in the Austin *American-Statesman* said that in the space of one movie, I'd lost all of the naturalism that Rick managed to get out of me. This was a goofball, arch, exploitation true crime movie—why would it be naturalistic? Plus, I didn't know what the fuck I was doing. I was 16!

Shana Scott: Renée Zellweger and Rory Cochrane were also in *Love and a .45.*

Renée Zellweger: The momentum of how your career evolves, that didn't start with *Dazed and Confused* for me. It started with *Chainsaw*. When I was working on *Chainsaw*, the crew were talking about working on another movie in Texas, and the script was floating around set, and that's how I heard about *Love and a .45*. We did *Love and a .45* in summer of '93, and I moved to L.A. in December of '93. I started dating Rory Cochrane when I moved to Los Angeles.

Adam Goldberg: I mean, Rory has a type. Rory came back to L.A after *Love and a .45*, and I was genuinely confused. I saw Renée coming toward me and went to hug her because I thought she was Joey. I think that happened a lot to Renée in the beginning of her career.

Rory Cochrane: I didn't actually meet Renée during *Dazed*. We met in Texas, and then she came back to L.A., and she was trying to get her foot in the door with proper agents, and I think she found her manager in Adam Goldberg's building.

Renée Zellweger: Yeah, that was through Rory, actually. I wasn't picking up my phone at my place—you had to call up from downstairs and I was in the shower—so Rory went to wait at Adam's, across the street. But Adam wasn't home. So [talent manager] John Carrabino saw Rory wandering the hallways and offered to let him use his telephone. John said, "Who is your girlfriend?" And Rory explained, and John said, "I know her! She's the girl from *Love and a .45*. Give me the phone."

He said, "Renée Zellweger from Texas?"

And I said, "Yes?"

And he said, "Walk to the window right this minute, so I can see you." And I walked to the window, and he was in the window across the street, waving. And that's how it started.

Rory Cochrane: She was very ambitious. It's not surprising to me that she got what she wanted out of the industry. She wasn't going to take no for an answer.

Ben Affleck: I remember Rory talking about how he was dealing with Renée becoming really famous. *Dazed* was this pure time

before it all got kind of infected by ambition and fame and money and competition and narcissism and all the negative parts of Hollywood.

Shana Scott: Both Renée and Rory were cast in *Empire Records*.

Rory Cochrane: I didn't want to do that movie. I asked for more money than I had ever made before and real stupid, specific stuff, like, "I want a green BMW! And I want a house on the beach!" I was just trying to be a dick so that they would say no, but they were like, "Okay." And when I got there, there was a green BMW.

Richard Linklater: I wasn't at all surprised when Renée got cast in another thing, and another and another. I told her, "Had you been one of the main *Dazed* people, you probably wouldn't have gotten *Jerry Maguire*, because you wouldn't have been a fresh face. You would've just been the girl from *Dazed*."

Michelle Burke Thomas: I was one of the contenders for *Jerry Maguire*, and Renée got it, and I was so upset that I didn't get it, because I was a mom! If there's anyone that can play that role, it's me. I was like, How did *she* get that fucking role?

I was the second choice for *everything*. It was always me against Winona Ryder. *Reality Bites*—Ben Stiller called me at home and said, "I'm so excited, I can't wait to do this movie with you. I've got to tell you, I'm meeting with Winona Ryder this weekend, but I don't want her. I want *you*." And later when I auditioned for *Cable Guy*, he said, "I'm really sorry, but the only way I was going to get my movie made was if I used her."

Wiley Wiggins: I was up against Leonardo DiCaprio a few times, but I didn't stand a chance. The first time was *What's Eating Gilbert Grape*. I also auditioned for *The Quick and the Dead*, which Leo got. I auditioned for *To Die For*, and got really far. I was in a room with Buck Henry and Nicole Kidman, and Nicole Kidman pretending to go down on me while I read lines, which was *wild*. Gus Van Sant took pictures. But Joaquin Phoenix got the part.

Deena Martin-DeLucia: After *Dazed*, my father had a heart attack. I was out in L.A. for pilot season, and Matthew McConaughey

and Brad Pitt let me stay in their places while my father was in the hospital. Matthew had just got a big film, and then Brad was off filming *Interview with the Vampire*. I ended up staying in Los Angeles for a while. My agent finally got me *Swingers*, but then the auditioning dropped off. Eventually, I packed everything up in my truck and I drove back across the country to Delaware. I've been there ever since.

Christin Hinojosa-Kirschenbaum: I got some roles in some very low-budget, silly little TV shows and movies of the weeks. I never did anything like *Dazed* again, which is why I left L.A. I wanted to do something more meaningful with my life.

Chrisse Harnos: I ended up getting a role on *ER* not long after *Dazed*, playing Anthony Edwards's wife. And I was cast in a movie called *Remembering Sex*, about a woman who'd been raped in college. I was really proud of it. I was going around to festivals, and women were coming up to me afterward in tears saying, "This was my life!" But then the director wasn't able to sell it for the amount she wanted to. I had a contract that said she couldn't include scenes with me that involved nudity, but she recut it with nudity, and they changed the name to *Getting Off*, and it was an awful experience. And this was a female director! After that, I stopped auditioning. It was just like, I'm not doing this anymore.

Sasha Jenson: As an actor, I never got a big money job. But the funny thing is, I sold some scripts. I sold a script to Disney, with Oliver Stone attached, in '97. It was called *A Day at the Zoo*, and the premise was, a Forrest Gump–like zookeeper who has worked at the zoo forever has been fired, but he refuses to leave the zoo. He holds the zoo hostage. They ask him for his demands, and he says he wants a boat to take the animals away with him. It's like Noah's ark but framed like a *Dog Day Afternoon*.

It never got made, but that was the first time I'd made real money. I did a few of those, and then I did some art direction in advertising.

I kind of had to go and join the real world.

Esteban Powell: For a while, Sasha became a set dec. I think he was working in advertising. I would see him out in Los Angeles,

and I just remember him being completely different than the person I remember. He was just a person with a normal job, and he wasn't dying to reminisce about old times.

Jason Davids Scott: *Dazed and Confused* was such a once-in-a-lifetime type of experience. People were so creatively invested, because they had nothing to lose. Maybe, theoretically, Milla Jovovich had a career to protect, but for everyone else, it was the only thing they had—and still is, for a lot of them. Shawn didn't do much after. Deena didn't do much. They didn't all go on to be Matthew and Ben. The only people I stayed in touch with were Jason and Chrisse. It's not like I need Ben Affleck's phone number, but I always wonder: Does everyone else remember the same things I do? Do they remember how close everyone felt?

Richard Linklater: It's always sad when the circus leaves town and we all go our separate ways, but the actual making of movies is very ephemeral. I've never totally gotten used to it. People's lives eventually change. Priorities change. People get husbands and wives, and you're not in a marriage with the people you work with, so you're not legally bound to them. It might've felt like a family, but it was a family with a few months' lifespan. And by the time *Dazed* came out, I already had my own family. My daughter Lorelei was born on May 29th, '93. I went straight from her birth, in San Miguel, Mexico, to the *Dazed* premiere in Seattle.

I didn't think having a kid changed me that much at the time. I'm not one of those people who's like, "When I'm a father, I'm going to be different." I didn't spend any less time on my films, and I still had all of these stories from youth that I wanted to tell. After *Dazed*, I made *Before Sunrise*, and the characters were only like five years older than the kids in *Dazed*. But I wouldn't have done *School of Rock* if I hadn't had a kid. I never would have done *Boyhood*. I would be a very different person, making very different movies. But I didn't know that at the time. It wasn't until years later that I figured that out.

Holly Gent: So many of the people from *Dazed and Confused* have gone on to do so many projects with Rick. I looked at the crew

list the other day, and it's like, Sandra Adair, she's still his editor; and Kari Perkins, who was the costume designer on *Dazed*, has done many of Rick's films; and Vince [Palmo Jr.] and I worked on *Dazed* together, and we've been married for 26 years, and we still work with Rick all the time. We're making a film with him now. Rick is a loyal person for sure.

Richard Linklater: I don't really work with Anne and Lee anymore. I don't know if my relationships with them changed when we made *Dazed*. Maybe they just matured a little. We had gone through something together, and worked our asses off, but I think, long-term, I had my journey and they had their own. To everybody else, *Dazed* wasn't a project like *Slacker*, where I was making it feel like some communal thing. To me, outside of the scale of it, it felt exactly the same in the artistic approach. But to them, it was much more overtly "Rick's movie," and everyone sort of had to buy into that and make their peace with it. Or maybe they didn't, I don't know.

Clark Walker: On some recent projects related to Linklater's career, I've noticed that Lee and Anne have chosen for personal reasons not to participate. I think both are extremely proud of their contributions to *Dazed*, which were integral to the film's eventual success on deep levels, and felt generally supported and uplifted by this project and the director. We were all unified as a team during the shoot, but years later, many projects later, both Lee and Anne eventually fell out with Linklater over complex matters.

Richard Linklater: With Anne, it didn't feel like a big breakup, it was kind of a slow fade. I don't know why she retired from the "Rick industry," but she's the one who took the hiatus from me, you know? You'd have to ask her.

Jonathan Burkhart: Yeah, Anne says she doesn't want to be interviewed.

Richard Linklater: With Lee, I just slowly realized, oh, it's not typical to work with the same DP all the time. There's different sensibilities and different skill sets. I started to think of crew people

like casting. Maybe they're good for one project, but maybe they're just not right for another one.

Bill Daniel: I think the challenge for you with this book will be to explain and describe Lee in a way that's truthful but not too hurtful. How do you do that? I think you have to say that Lee's an addict now. It stems from an automobile accident he had after *Dazed*, in 1995. He lost the use of his left arm, and it left him with a condition of random phantom pain. It was extremely debilitating.

He continued to work on films. He did handheld documentaries with one arm. But after the accident, there were a lot of experimental surgeries and weird drugs, and he became an addict. It's been happening for a long, continuous period, just kind of steadily getting worse, so he's in really bad shape right now. That's why there's no way you could talk to him.

Richard Linklater: I feel horrible about it. Everything about Lee has this layer of sadness to it, like this slow-moving tragedy. Maybe he can still turn it around. Nothing would make me happier, but it's really up to him.

Kal Spelletich: D. Montgomery passed away in 1997, from Hodgkin's disease. I spent a lot of time with D. at the end of her life. At that point, she was alone, besides her amazing sister, Judy. She had moved to L.A. to be with her sister, and she reached out to me. She said, "I'm so depressed and lonely. I miss everyone so much."

Richard Linklater: D. was receiving experimental treatment at UCLA, which ultimately failed. D. told me that, at best, it was going to extend her life five years, which sounded good to her. I always think of that—her being hopeful for five more years of life, as a best-case scenario. I was visiting her at what turned out to be the end, and I was the last person to have a full conversation with her. The timing of that made me feel like I was a representative of her Austin friends and her life there, and we had a soulful goodbye, and a nice "I love you," before they wheeled her away to ICU as she was suffering organ failure. I gave the eulogy at her service. It was one of the hardest things I'd ever done.

Bill Daniel: Here's a thought that I have that I know I'm not alone on. The story of that group of friends has become the Rick story, and as the Rick story goes on, it sheds supporting characters, and Rick's name just gets bigger and bigger and bigger.

Louis Black: It's a little awkward. I wrote a piece on *Dazed* for *Texas Monthly* back in 1993, and the first draft included stuff about everybody who was involved in making it, including everyone from *Slacker*, and it was three times too long. And the second draft mentioned everybody but was incoherent and too long. And the third draft was just about Rick.

Kal Spelletich: The outside world, they want one hero. They don't want to interview six people. They don't understand the concept of a collective. I don't want to fault Rick for what the media is foisting on him, saying, "You did it. *You!*" It's not like he grabbed the microphone. It's more like they foisted it upon him, saying, "Answer the question, Rick!"

Louis Black: Over time, all the focus went to one guy. But that was how it should have been, to be honest. Rick didn't take away anything from anybody else. They could've done stuff on their own. It really was Rick.

The New *Rocky Horror Picture Show?*

"Every time Wiley touched his nose, they drank."

How was *Dazed and Confused* transformed from a box office underachiever into a modern classic? Film studios would probably love to know the answer to this question, if only to amass data for some algorithm that determines what, exactly, makes films successful. But the explanation is neither scientific nor mysterious: *Dazed* simply grew in stature, and profits, very slowly, through something no studio or marketing team can really manufacture: word of mouth.

In 1993, the film got a small initial release and made a modest $8 million at the box office. It might've seemed like it was destined to disappear forever. But according to Gramercy's research, the movie tested really well with young men in college, or younger, and, luckily, many of the theaters where it did play were in college towns. By the time *Dazed* came out on video in March 1994, young people were renting the movie over and over again, often with George Washington's favorite herb at their side.

Over the years, any time someone from *Dazed* got cast in a big movie or won an award, it generated a round of press mentions and a new wave of interest in the actor's early work. In 1996, *A Time to Kill* boosted the profiles of Matthew McConaughey and his co-star Nicky Katt, regenerating interest in *Dazed.* So did 2012's *Argo,* which reunited director Ben Affleck with actor Rory Cochrane and won an Oscar for Best Picture. In 2020, when Renée Zellweger won an Oscar for her role in the Judy Garland biopic *Judy,* journalists were still asking her questions about *Dazed*—which is ironic, since she is barely in the movie.

Every few years, as a new crop of high schoolers graduates, new generations discover *Dazed.* The fact that it doesn't really have a plot means it holds up better with repeat viewings. You aren't watching for the story. You're watching to hang out with the characters. Quentin Tarantino, who counts *Dazed* among his all-time favorite films, once said that renting the movie from a video store cured his loneliness during a stretch of time when he lived alone in Amsterdam. "You really get to know this whole community of people in the film," he said. "Those people have become my friends."

Long-term, *Dazed* is far more beloved than some of the films that were box office hits in 1993. The week that *Dazed* was released, the number one movie in America was the Macauley Culkin drama *The Good Son.* No one's writing an oral history of that movie.

Russell Schwartz: You could say that the theatrical life of *Dazed* was what set it up for extraordinary success in the long run. What happened with *Dazed* is similar to what people are doing now

with smaller independent art movies, which can't really play theatrically anymore. Now, they'll open those movies in 10 theaters, get some good reviews, and then go right on to their streaming platforms. That's not what we planned for *Dazed and Confused*, but that's basically what happened. The fact that *Dazed* was only out on 300 screens really set up the film for what happened when it went to DVD and everybody watched it.

Richard Linklater: If *Dazed* had made $100 million at the box office, it probably wouldn't have had the same longevity. If it's a huge hit, and being shoved at you, do people think it's *theirs*? Probably not.

Nicky Katt: In a weird way, it deserved to be a cult film, something that people could discover on their own, like a good stash. Like, "Hey, check this out, you've never heard of this?"

Rory Cochrane: High school and college kids were the ones that made the movie popular. All of these college kids watched it in the theater, and they told their younger brothers and sisters to watch it, and it started to become a cult classic.

Richard Linklater: First, we became a midnight film. We would play for an entire year at certain theaters. They would turn it into a mini-concert where you go in the theater and you could smell pot smoke.

Jason London: I heard stories about how we'd kicked *Rocky Horror* out of its venues because people wanted to get in to watch *Dazed and Confused* instead.

Anthony Rapp: There was a thing called the Brew and View in Chicago, where they served beer and put up a screen at different venues. And I don't know if it was as orchestrated as a *Rocky Horror* thing, but every time Wiley touched his nose, they drank.

Wiley Wiggins: That will *kill* you! Don't do that!

Jason London: I did a movie with Susan Sarandon, and she said, "I saw your movie two nights ago, but we didn't realize you needed to smoke a joint first, so we're going to get blazed and go see it again tomorrow." That's when I started to realize, this could be *big*.

Wiley Wiggins: It wasn't until *Dazed* came out on VHS that it became a thing.

Richard Linklater: We caught the video age, and then we caught the DVD age, but I always say, Universal really tried hard not to make money on that movie. I think they undershipped the video. You'd go into a Blockbuster, and there'd be 87 copies of the new Arnold Schwarzenegger movie, and then there'd be one or two *Dazed and Confused*. But *Dazed* sat there on the new release shelf for a couple of years, because they keep videos on that shelf when they're always checked out.

Jim Jacks: For a long time, *Dazed* had the record for most video turnovers per copy. It was just some ridiculous amount. I had a lot of friends tell me they could never find it at the video store because it was always rented.

Richard Linklater: At the time, the videos themselves cost $79, and the stores had to pay $50 for every video. The studios were making a fortune, but at that big price, it's not really a consumer item, it's just for the stores. You're not going to pay $79 for a video unless you're rich. But a year or two in, they discounted it, where you could buy the video for $19. Then people started buying it themselves.

Cole Hauser: I'll never forget the moment that I was at Blockbuster and I saw that *Fast Times at Ridgemont High* and *Dazed and Confused* had been packaged together in a box set. And I was like, *Holy shit!* Because *Fast Times* was my film growing up. So when I saw that, I thought, that's probably getting people to see *Dazed* who might not have seen it before.

Richard Linklater: It found its audience. Nobody would prefer that to a big box office, but I guess it helps its cult status. It became something that got passed around.

Jay Duplass: Oh my god, people got obsessed with the movie. I have friends who still watch it yearly, like, "Let's just get drunk and watch *Dazed and Confused*!" And I think that's because high school is a pretty wonderful time for a lot of people, and they want to revisit

it. The movie is all about cutting school and making out and going to parties and smoking weed and drinking beer. Who doesn't want to go back to that? I mean high school can also be horrendous, but Rick made it look pretty fucking fun.

Robert Brakey: Why do people keep watching *Dazed* over and over? I mean, why do people keep going back to high school reunions?

Wiley Wiggins: For about a couple of years after it came out on video, I entered into some sort of *Twilight Zone*.

Marissa Ribisi: The first time I could tell *Dazed* was a thing was when I was shopping at American Rag [in L.A.] and these people were following me around in the store, and I was like, *Oh my god, they think I'm shoplifting! How do I fucking tell them that I'm not stealing shit?* And just as I was about to yell at them, they came up to me, like, "Were you in *Dazed and Confused*? We loved that movie!"

Sasha Jenson: I went to a Halloween party dressed as Buster Poindexter, and some friends were like, "There's a *Dazed and Confused* party down the street, you gotta go!" I walked in, and they had the movie playing, and the bartender was a spitting image of McConaughey. I was like, if I ever get a free drink, it's gonna be today, here.

Wiley Wiggins: People would ask me to touch my nose or put my hair behind my ears. They would ask me if I had a joint. People would try to get me to smoke weed with them, and I don't really smoke pot. I have anxiety problems.

Rory Cochrane: I went to an ESPYs party and Peyton Manning and Eli Manning were there. Apparently, Peyton Manning had dressed up as Wooderson and Eli had dressed up as my character at a Halloween party.

Jason London: People thought I was Pink in real life. I had a grown man crying his eyes out because he said, "I was bullied in school, and I just want to thank you for being the person who was nice to everybody!" And I was like, "C'mere dude, give me a hug."

Christin Hinojosa-Kirschenbaum: I've had people track me down and call me at work. I think that because my character was kind of a vulnerable character, people feel a connection to it. *Men* do. Everybody's like, "Oh, you're just like my first love!" Like they see *me* as that person.

Wiley Wiggins: There's now been about eight or nine famous baseball players who are skinny with long hair, and every time there's a new one, I have to close Twitter because there's literally hundreds of people making the same joke about how, you know, Chuck Corndick is the new Wiley Wiggins. It never gets old for those people! Tim Lincecum was the first guy. It just turned into this running gag that people would call him Wiley Wiggins. It got so bad that I actually did an interview with the *Wall Street Journal* about it. The headline was "Unfazed by Confusion with Lincecum."

Adam Goldberg: After maybe a decade, you're like, "Oh, okay, it's got a permanent place in film history." Maybe that's why everyone started to talk about a sequel.

Dazed and Confused: The Series

"Ashton Kutcher is the dumb Randall Floyd."

*L*inklater never wanted to make the '70s look cool. But when *Dazed and Confused* opened in Dallas, he found himself at a '70s-themed after-party filled with young fans wearing period-appropriate clothes. "Omigod, I'm contributing to this," he wrote in a *Dazed* press tour diary for the *Austin American-Statesman*. "I'm helping give a reason for this to exist again."

Nostalgia tends to kick in every 20 years, so Linklater was slightly ahead of his time when he looked back at 1976 from the vantage point of 1993. Only seven months after *Dazed* came out, the *L.A.*

Times reported that the young playwright Justin Tanner was adapting Linklater's film for the USA Network. The series never got picked up, but within a few years, the '70s nostalgia wave Linklater had anticipated would kick in as a trend: a glam-rock revival, a craze for vintage fashion, a wave of period films including *Boogie Nights*, *The Ice Storm*, and *The Virgin Suicides*.

By 1998, Linklater and the cast were talking about making a sequel. It never happened. The closest thing the world got was Linklater's 2016 college baseball movie, *Everybody Wants Some!!*, which the director often describes as a "spiritual sequel" to *Dazed*. Inspired by his college years at Sam Houston State, it takes place during the '80s. Linklater says the timing is intentional: Mitch and the kids on his baseball team in *Dazed* would be the right age to become the characters in *Everybody*. There's even a character named Willoughby (played by Kurt Russell and Goldie Hawn's son, Wyatt Russell) who's a lot like Wooderson. Toward the end of the movie, Willoughby reveals (spoiler alert!) that he's actually an older man, hanging out with college kids so that he can relive his college baseball years.

On Reddit, one fan theorized that the character is named after the *Twilight Zone* episode "A Stop at Willoughby," in which a man dreams of an idealized past that no longer exists. It's a good theory, and possibly true, but then again, that's how the past always works, for Linklater and everyone else. Regardless of how you feel or what you remember, you can never go back.

Richard Linklater: At one point in the mid-'90s, Jim Jacks and I got approached to do a TV show based on *Dazed*. They used to do this kind of thing all the time. Remember, they did a show after *Animal House* called *Delta House*, but it didn't really catch on.

Sean Daniel: It was like doing *Happy Days* after *American Graffiti*.

Richard Linklater: I said, "I don't wanna be the capitalist who's trying to do anything for a buck. No." And then Fox made *That '70s Show*. I'm not 100 percent sure *That '70s Show* was made by the same people who were approaching us, but I like to think it was the

same people. That helps my glib story. Especially since it's a damn good show—the perfect cast.

Mark Brazill: I was a co-creator of *That '70s Show*. Funny thing is, two of the exec producers I hired to work on it said they'd had a meeting at Universal, and there were three or four pilots being written that were set in the '70s, so there's no denying the effect that Richard Linklater had on the entire '70s resurgence.

Years before *That '70s Show*, I had been working on *In Living Color*, and I got in an argument with one of the other writers because I didn't like the ending of *Dazed and Confused*. They said to me, "Well, if you don't like the movie, why don't you make your own fucking movie about the '70s?" And I had forgotten about that conversation, but I guess, ultimately, I did.

But *That '70s Show* was really based on my life, not *Dazed and Confused*. I was in high school from '76 to '80, so everybody I wrote about was a group of my friends. I was basically Eric Forman. Kelso is still one of my best friends.

Jason London: *That '70s Show* was basically *Dazed and Confused: The Series*. Ashton Kutcher is the dumb Randall Floyd. When I saw that, I couldn't fuckin' believe it. It's like, Pink is a complete moron?

Melanie Fletcher: A lot of the clothes that we bought for *Dazed* ended up going right back to Universal, and they all showed up on *That '70s Show*. I remember watching it and thinking, "I bought that shirt!"

Melina Root: Actually, no. I love that movie, but mass-produced clothing from the '70s is all over the place, and costumers use many of the same vintage sources. Since *That '70s Show* was set in Wisconsin, a lot of what I sourced was bought from dealers in the Northeast, or Midwest. Chances are there are many items from *That 70's Show* that are out there being used on many movies and TV shows as we speak. Hollywood costumes are a big recycling machine.

Richard Linklater: There was a moment in '98 or so when I did have a vague, too-much-time-on-my-hands interest in a sequel.

Jim and Sean were asking about it. Other people wanted it. So I had little stories for all of the characters, fun things they would be doing five years later.

Jason London: Rick was like, "If we did do a sequel, the very first play of the very first football game back at school senior year, Pink would get wiped out and injured. And the career that he thought was gonna happen wasn't gonna happen. And the coaches are upset about it, but Pink is not."

Richard Linklater: Because Wiley was a little computer nerd in real life, I told him, "Mitch is gonna be the guy in your dorm room who's taking gray market computers, wiping them, and selling them via mail." I had him as, like, Michael Dell.

Jason London: Yeah, Wiley is still really into computers. Ten years ago, I got a brand-new Mac laptop, and I called Apple. A guy answers and says, "Hi, what's your name?" And I said, "Jason London." And he goes, "Jason London! It's me, Wiley!"

Wiley Wiggins: He's like, "Wiley! You're a Mac Genius now?" And I was like, "No, not a Mac Genius. I work for AppleCare. It's different."

Matthew McConaughey: Rick and I talked about, "What would Wooderson be doing in the sequel?" Well, he's got a little community radio station and he's the DJ, and he works nights. He's got a voice made for it, and they probably want him to go to Dallas, but he'd rather stay right there in his local community and play the music he wants to play.

Richard Linklater: There was something about Parker and Joey being disco instructors.

Parker Posey: Rick was like, Darla moves to San Francisco and becomes a women's studies major.

Nicky Katt: Clint and Wooderson own a chain of auto-repair shops, and Clint is a happy, sober family man who is being stalked by Adam Goldberg's character, Mike, who has unraveled, near insane.

Richard Linklater: Mike has built their high school fight up in his head, and Clint doesn't even remember it. But Mike's there to

kill him. The story is mixed up with *Crime and Punishment*: "Can I kill someone? Am I one of those special people who's above the law, who can take a life?" Mike's sort of entrapped in that.

Anthony Rapp: Rick asked if I thought Tony might wind up being gay. And it's like, yeah, maybe. I do not think that Tony and Sabrina wind up having a relationship.

Jim Jacks: Rick was thinking about the sequel culminating in a big Aerosmith concert.

Ricard Linklater: Oh gosh, I don't remember that. I think Jim might have riffed on the idea a little bit too much.

Michelle Burke Thomas: Everybody had their own ideas for what the sequel should be and what would happen to our characters in the future. Chrisse and I had the idea that Matthew McConaughey's character would die, and everybody gets together for his funeral, kind of like *The Big Chill*. We figured Matthew would be the hardest one to get back in the movie, so we thought, "Okay, we'll kill him off."

Adam Goldberg: We had a thread where we were all discussing the sequel, and I pitched Rick the idea that it takes place on September 11th, 2001. I thought it would be interesting if, like, my character is working as the lawyer in New York and McConaughey is the gas station attendant who sees it on the news, and there's some unifying event that brings us together. But I never heard back from Rick.

Jim Jacks: Rick said, "The way we should do the sequel is a seven-week shoot," because everybody was at a certain level in the business, and it would take them off the market for other films.

So I said to Rick, "Why don't we set it up that half the cast works the first three weeks, and half the cast works the last three weeks, and everybody works the middle week, for whatever scenes we need everybody for—the final Aerosmith concert, or whatever it was gonna be."

I was sitting with Nicky, Cole, and Rory at the time, and they said, "What if we want to stay the whole time?"

Jim Jacks: Universal didn't want to do a sequel. They were willing to make the movie for maybe $15 million, but they weren't

willing to give Rick 20 percent of the gross, or whatever his lawyer was asking. Rick and his lawyer were treating the sequel as if *Dazed* was a blockbuster, and it wasn't. This would be a sequel to a cult movie.

Richard Linklater: We never got anywhere near the "deal" stage with the studio! Jim probably called up my lawyer, John Sloss, and started being aggressive.

Jim Jacks: A different studio, Paramount, was excited as hell about doing the sequel. The only problem was, they needed approval from Universal, and they would never be given approval.

Sasha Jenson: For a minute, when there were rumors of a sequel, I went surfing up in Zuma. I was putting my wet suit on and some guy's running by, yelling my name. I was like, "Who is that?" And it was McConaughey, jogging on the beach.

I was like, "Are we gonna do this sequel?" And he was like, "It will probably never happen. And you know what? It's probably better that way. Leave it alone! It's perfect as is."

Chapter 35

The 10-Year Reunion

"You can't hold on to that thing forever."

*T*en years after *Dazed and Confused* was released, it had become one of the defining high school movies of the decade. There was even a 10-year reunion, which feels appropriate for a movie about high school.

The Alamo Drafthouse celebrated the film's anniversary on May 31, 2003, by hosting an outdoor screening and keg party at Walter E. Long Park in Austin, where the beer bust at the moon tower was

shot. A local cover band played '70s songs from the soundtrack. It was a lot like a real school reunion, except there was also a VIP tent, and a red carpet, and thousands of people in the audience watching the cast come together for the reunion of a high school they didn't attend.

The fact that some people had become stars made it harder for everyone in the cast to interact in a natural way. Matthew McConaughey, who'd become a leading man thanks to *The Wedding Planner* and *How to Lose a Guy in 10 Days*, arrived wearing a "JK Livin'" shirt, and had to ward off screaming fans. And yet, he says he doesn't remember much about the reunion. Parker Posey, who'd broken into the mainstream with parts in *Scream 3*, *You've Got Mail*, and *Josie and the Pussycats*, was trailed by paparazzi. Ben Affleck, who was co-starring with his fiancée, Jennifer Lopez, in *Gigli*, didn't show. Everyone else hugged and caught up and some got a little more intoxicated than they should have. And just like a real high school reunion, things got awkward.

Sasha Jenson: For the reunion, we all met up at Rick's place, just outside Austin. He's got a full-on artist's compound, an enormous amount of land with a baseball park and a fishing lake and a swimming pool and different bungalows. He houses people when they're writing scripts. Nicky was staying there for a while. I think Rick bought it for $1 million after he did *Before Sunrise*.

Richard Linklater: It was 38 acres for $132,000. And funny, like *Sunrise* was some big money-maker? It cost less than half as much and made about half as much as *Dazed*!

Sasha Jenson: The whole thing was completely surreal. It felt like what happens when they develop a small town into a big city, and then there's, like, a mall where something else once was. It was like, we'd all done this magical thing together, and it was organic and small. And then 10 years later, Matthew McConaughey had bodyguards.

Richard Linklater: Matthew's not a bodyguard kind of guy! There might have been a designated driver, or the Alamo proba-

bly had some security for the event. This is why guys like Matthew maybe shouldn't, and usually don't, go to stuff like this. Everybody projects all their shit on you: "He's arrogant and changed so much!" Matthew has no axe to grind or anything to prove, so why the hell would he be like that? He wasn't. I remember Matthew in a nice, generous mood the whole time, cooking for everyone.

Christin Hinojosa-Kirschenbaum: Matthew was kind of the ringleader at the reunion. Adam wasn't there. Ben wasn't there. Cole wasn't there. Chrisse wasn't there. But pretty much everybody else was there.

Jason London: I wish Chrisse had been there. Still to this day, I don't think I've ever been more in love with somebody.

Michelle Burke Thomas: I'd like to imagine that Cole didn't go to the reunion because he was too heartbroken to see me. After *Dazed*, Cole told me, "Wait for me, and when my relationship ends I'll come find you." And he did, a few years later. The next time I saw him, he came to my house, and my boyfriend—who's now my husband—opened the door, in a towel, fresh out of the shower. There were very few words exchanged. I've heard from other people that it really devastated Cole. I wonder if that's why he didn't come.

Cole Hauser: Fuck no! I had to work! And I have nothing but fond memories of Michelle.

Ben Affleck: At the time, 10 years seemed like a long time. I felt kind of disconnected and weird. It took me a long time to stop feeling insecure about things like that.

Adam Goldberg: I think I had a scheduling conflict, but, it's like, the people you want to stay in touch with, you stay in touch with. You don't need to go to a reunion. The same goes for high school, right? After 10 years, you would probably just be seeing people you'd wanted to ignore by that point.

Jason London: We were all at Rick's house, but I felt like a complete stranger. Everybody else was so close, man. Rory and Rick and Nicky and Matthew were all hanging out together, laughing like

they'd spent tons of time together, and no one even wanted to talk to me except Parker. People were being so weird. McConaughey cooked a bunch of burgers for everybody, but he would talk *at* you without even looking at you. He was like, "Randall Pink Floooooyd! Randall Pink Floooooyd!"

I was like, "No. I'm Jason London. Remember me?"

Parker Posey: We all went from Rick's place to the park, where we watched the movie in the grass with 5,000 to 10,000 people, and they were all talking back to the screen, jamming along to the music, and quoting it back to us.

Sasha Jenson: We got there late, and it was so weird. They'd been acting out this experience we'd had, without us.

Priscilla Kinser-Craft: It was like Woodstock, all these people with their blankets. They sold VIP tickets to get in. Parker got bombarded by a lot of people who wanted to take her picture. I think I even asked her, "Does this make you anxious?"

Parker was doing selfies with people before selfies were a thing. Everyone had cameras, and she was saying, "Look! It works better if I hold the camera." She would literally turn it around and click it, like, let's not waste time getting someone else to take the picture. She had that *down*.

Parker Posey: I was kind of bummed that there were cameras there. I wanted more time to chill out. I think I would have preferred a retreat. It was so special, that time. It deserved more than just an "event."

Priscilla Kinser-Craft: You had McConaughey walking around with two security guards. All these girls were wanting to get at him. Matthew picked me up and he squeezed me really hard, and when I was trying to get back to my car, all these girls wanted to touch me. They were like, "You touched Matthew McConaughey!" I'm like, "No no no! It doesn't rub off."

Jeremy Fox: I sat next to Linklater, and McConaughey was on the other side. At one point I had to walk up to where the restrooms were, and this guy—I *swear* it was Alex Jones—started chasing me,

wanting an audio recording. He's like, "I run this radio show here out of Austin!" And he demanded that I give him an audio recording of one of the lines from *Dazed and Confused*.

He said I was his favorite character 'cause he was heavyset when he was in school. He wouldn't leave me alone until I said my line from the movie: "Man, I had my hand up her shirt!" It's like, come on, guy!

Catherine Avril Morris: After the movie, we were doing the Q and A, and all of the questions were directed to Matthew McConaughey and Parker Posey.

Michelle Burke Thomas: We all got paid the same for doing *Dazed*, and we all got the same honey wagons, and we all flew to Austin on the same coach ticket. It was a favored-nations deal. That means there was no negotiating, everybody got the same thing. So it felt wrong that at the 10-year reunion, the whole emphasis was on the ones who became celebrities. It was only about McConaughey and Parker Posey, and people were mentioning Renée Zellweger.

Priscilla Kinser-Craft: You know how, now, you go to a Comic-Con panel and it's nicely organized? This was like a *free-for-all*, in terms of whoever got there to ask a question first. We weren't sitting up there in seats or anything. We were all just standing there. I was drinking a beer on stage.

Michelle Burke Thomas: I'd been hanging out with the audience, and they were like, "Have a shot of vodka! Have a shot of whiskey!" And I was like, sure! And of course by the time I got on stage . . .

Jason London: Michelle was a little drunk.

Michelle Burke Thomas: I got up there and somebody asked me if Jason was a good kisser. And I said, "Well, I don't know. He was a good kisser back then. Pink, are you still a good kisser?"

Jason London: She wanted to kiss me and, in front of a thousand people, I had to be like, "*Stop*. No. *No*."

My wife was standing right there in front of me in the front row

with her arms crossed, looking at me like, "You do it, you DIE." I got really angry with Michelle.

Mark Vandermeulen: We were all drinking at the pre-party at Rick's house, and the movie was over at like 11:00, so we didn't even get to the after-party until midnight, and then we drank until 4:00 in the morning. It was a marathon.

Sasha Jenson: There was a party at a restaurant after the screening, and by that point, it had turned into a bit of a celebrity fest. Sandra Bullock was there.

Christin Hinojosa-Kirschenbaum: Sandra and Matthew were dating.

Michelle Burke Thomas: Sandra Bullock and I were both up for the lead role in *Speed*. That was a hard one, because I was like, this movie is stupid, I don't even *want* this movie, but I'll go in anyway. And then she got it and it made her a *huge fucking star*. So everybody at the party was like, "Oh Sandra Bullock! Sandra Bullock!" And I was just like, *Grrrr*.

Sasha Jenson: It turned into one of those nights where everyone splintered off back into their high school dramas.

Jason London: I went back to my hotel after that reunion and cried like a baby. It was hard, because when we were doing the movie, my sister and my mom and my stepdad came down and I got to see my sister's baby for the first time. All of those guys from *Dazed* had met my sister and her baby. After she died, I thought for sure that Richard Linklater, Don Phillips, and McConaughey would go out of their way to reach out, especially since I'd been with McConaughey so much after his father passed. But not a single one of those bastards ever called me. And then I was there at the reunion, and everyone looked like they were still so close, and I didn't feel like I was part of that anymore.

When we were making the movie, I remember being on the boat with everyone, and I was getting *emotional*. I was talking to Cole, and I said, "I just don't understand how I got so lucky to be a part of this unbelievable group of people who I feel like I'm not even

Jason London

worthy of even being around." And he said, "London, you're our fuckin' Pink. Shut the fuck up."

But I didn't feel like their Pink anymore. It didn't feel like family anymore.

Richard Linklater: It's so heartbreaking to hear Jason's feelings about this! I remember him in the swirl of things like everyone else, but you never know what anyone's actually experiencing inside. He seemed a tad melancholy, but I figured that's just Jason. I feel bad that I didn't call him after the tragedy with his sister, but I had never met her, and didn't hear about it until a while later—we were in the ol' communication dark ages. I just kinda felt awkward reaching out so much later, but as you slowly learn, or need to learn, better late than never.

Nicky Katt: What's that quote with Lorne Michaels, where they're asking him about John Belushi? They're like, "Can you talk

to us about how you felt about John? That must've been such a massive loss." And he's like, "Well, you know, things change . . ." And he starts to get choked up and they cut away.

It's like that. You can't hold on to that thing forever.

Parker Posey: God, I'd love to get together with everybody. Whenever I run into people from *Dazed*, it's like, that was just a pure, untouched, bittersweet feeling. But you lose that, you know? You lose that.

A God-Awful Failure of an Anti-Nostalgia Movie

*"People always want to return to something
they recall being pure."*

Linklater believed *Dazed and Confused* contradicted the no-
tion of nostalgia. He thought he was documenting small
changes in the culture, and that his depiction of the '70s as
boring and oppressive would stop people from lionizing the past.
What he failed to realize was that the reality he'd reconstructed was
not that different from what was still happening in most of America.
When teenagers saw *Dazed and Confused* in 1993, they were still
driving around, listening to rock music, making out, getting busted
for weed.

Today, it feels like the teenage culture represented in the movie
didn't just change, it totally disappeared. The number of teenagers
who have a driver's license has sharply declined. No one under the
age of 18 really listens to rock music anymore. Weed is legal in many
states, but opioids are killing young people. If you believe the polls,
teens aren't having much sex, and their parents spend so many
hours per day with them that it's hard to imagine when they'd even
have this much unsupervised time to mess around.

In retrospect, if you're a certain type of (likely white, likely male,

likely Gen X) person, you're going to long for the era you see on-screen in *Dazed and Confused* because of what has happened since—which, of course, Richard Linklater never could have anticipated.

Looking back, it seems ironic that Linklater wanted it to be an anti-nostalgia movie. Without nostalgia, *Dazed* wouldn't exist. Universal was interested in the project in part because the studio head, Tom Pollock, had fond memories of *American Graffiti*. Many people watched it because they were nostalgic for their own high school years in the '70s. The costumes and the soundtrack gave viewers a temporary time machine.

Just as the *Dazed* cast glamorized the '70s, today's high schoolers are obsessed with the '90s. Like Linklater says, every generation thinks all the cool stuff happened before they got there. Crowds still gather in Austin every five years or so to celebrate *Dazed and Confused* anniversaries and dress as their favorite characters. At the 25th anniversary party, people were handing out inflatable paddles. Women in "Seniors" T-shirts walked through the crowd yelling "Air raid!" Fans were fetishizing the exact same experiences that had made Linklater's high school years feel like hell.

A lot of people are still incredibly nostalgic for an anti-nostalgia film. And no one's more nostalgic than the cast.

Richard Linklater: I swear, I tried to make the movie immune to nostalgia. I even had the characters say the '70s sucked. I thought it would be impossible to look back fondly on the '70s. I would never want to go back to that.

Rory Cochrane: I don't think it's an anti-nostalgia movie. I think it's a *complete* nostalgia movie. How is it an anti-nostalgia movie?

Matthew McConaughey: Well, it's obviously *seen* as a nostalgia movie.

Mark Duplass: Oh, it's a god-awful failure of an anti-nostalgia movie! I mean, it's a fucking great movie, but from the minute Rick goes into slow motion at the moon tower and you hear that Lynyrd Skynyrd song, "Tuesday's Gone," it's like, "Come on, Rick. Like it or

not, you are telling us this party is ending, and you're feeling melancholic about it, and you *miss* this." I was 16 when I saw it, and I was nostalgic for days that weren't even over yet!

Kevin Smith: That was the thing Richard Linklater fucked up royally: We can't pick what the movie is. The movie's gonna be what *the audience* says it is. And *he* might've felt it was anti-nostalgic, but it was nostalgic for lots of people.

Christin Hinojosa-Kirschenbaum: At the 20th reunion, I saw the whole crowd of people watching the movie, and I wanted to say, "Hey! Pay attention to what Jason London says on the football field! 'If I ever start referring to these as the best days of my life, remind me to kill myself.'" I think a lot of people hold up *Dazed* as, *This is when life was great!* I just want them to realize that they've missed the message.

Richard Linklater: Now, I don't think it's possible to make an anti-nostalgic movie. That's just the power of cinema.

Do you remember in the book *Jarhead*, all the guys are sitting around watching *Apocalypse Now* and *Full Metal Jacket*? And it's like, wait, these are anti-war movies! But the soldiers are just like, "Yeahhhh!" There's a disconnect there. Cinema can't help but glamorize. Cinema doesn't give a shit if you're nostalgic or not. It's a nostalgia creator.

Jason Davids Scott: When I think of *Dazed and Confused* now, I don't think of it as being nostalgic for the '70s. I think of it as being nostalgic for the '90s.

Jason Lee: I really miss the '90s.

Brian Raftery: When *Dazed* came out, we were always being told that the boomers were the greatest generation. The whole story of Gen X is basically an entire generation growing up wondering when the hell they'll get the chance to actually talk about themselves. Now, that's all we're doing. We're all looking back at the '90s going, "Hey, we had a pretty good culture back then."

Tom Junod: The rock and roll culture that was extolled in *Dazed and Confused* was just about to come to an end in the '90s

when it was released. People in the '90s didn't know that rock and roll music was going to lose its force as a galvanic power in pop culture, but that was all there in *Dazed and Confused*. Maybe we were missing it before we knew we were missing it. That's the essence of nostalgia.

Brian Raftery: Nowadays, if you were 15 and you watched the movie, you might be like, "This music sucks. Why are there guitars? What *are* guitars?"

Tom Junod: Studio movies like *Dazed and Confused* were about to come to an end, too. Smaller, personal films were just about to get swallowed up by the demands of the Cineplex and the Disney/Marvel empire.

Richard Linklater: The window was probably closing and I didn't even know it. Six years after *Dazed*, Hollywood was starting to figure out, "Oh, we don't give $6 million to little upstarts with their indie films. Fuck you."

Joey Lauren Adams: Not long after the 10-year reunion, around 2005, all the studios started closing their indie divisions.

Cole Hauser: You couldn't do casting like that anymore, either. When they had the pizza party thing at Universal, everybody was young and full of life and wanting to make something special, and Rick and Don could watch us and be like, how do these kids work together?

Today, there's a different method. You just put yourself on a tape and send it in. No great director or actor would do that back then.

Adam Goldberg: I don't even fucking *meet* directors anymore. They don't even show up. It's pretty bad.

Wiley Wiggins: The casting process for *Dazed* spoiled me, frankly. It should be studied, that organic process of a director and a casting director getting to know a person, then finding the aspects of the person that can be the character—rather than, like, expecting somebody to tap-dance and talk like a pirate.

In the early days of indie cinema, people were looking for interesting performances from nonprofessional actors. Now, the same prin-

ciples of indie movies have fed into reality TV, and now *all we have* is reality TV. Everything good will get used for evil at one point.

Parker Posey: In the independent film world, there's been a collective grieving of the culture that was supposed to support character actors.

Jason London: You know that song "Video Killed the Radio Star"? Well, digital killed the movie star. Not only is it cheaper to make movies now, the world is so saturated with people who want to do it, they go, "We've got these actors who've made all these films, but they require us to pay them money. There's a million people out there that we don't have to pay. Let's just hire one of them."

Joey Lauren Adams: Now you can just find someone that's got a million followers on Instagram and cast them.

Cole Hauser: When we made *Dazed*, it was not only a special moment in Hollywood but also a special moment in our lives, because of the freedom we had. Nowadays, you can't go into a hotel and sit in the lobby and smoke grass and cigarettes and congregate there and create scenes and not have the police show up. But we could do that at the Crest.

Mark Duplass: There's this theory amongst a lot of storytellers right now that if you're creating a television show or a movie, you should set it before the year 2000, because people really want to live in worlds where social media doesn't exist. It's the biggest wish fulfillment you can offer audiences right now. And I think that might relate to the legs on *Dazed and Confused*, particularly now.

Jay Duplass: In the movie, they're sneaking out of class, trying to steal beer, trying to destroy mailboxes, trying to find the party, trying to hook up, trying to get in a fight. There is so much that they're doing! If you made that movie now, all those scenes would be, like, kids looking down at their phones.

Cole Hauser: You could never make that movie now. I hate to say it, but if you made *Dazed and Confused* today, it would be pretty boring. You could never have that bullying stuff. All those kids would be sent to juvie!

Mark Duplass: The nature of the way you connect with your friends is totally different. They're stuck in this smaller town, and they're hanging out with people that they don't necessarily like, but they do it anyway, just because they kind of need something to do. Whereas if I'm a teenager now, and I'm in that position, and I don't like those people? Dude! I got options galore on my computer and my phone to entertain myself. I'm probably not gonna throw myself in the car and cruise around for 80 minutes. We're just not that desperate anymore.

Sasha Jenson: Now, my kids don't even *want* to drive a car. They just want to Uber.

Samantha Hart: *Dazed* came out during a time when high school was just fucking *fun*. And a few years after it came out, there was Columbine. And now it's Newtown and Parkland—I've lost count. That was the last moment in history when kids went to school and the worst thing that could happen is they got busted for pot. It really makes *Dazed and Confused* a time capsule.

Jason Reitman: Watching it when you're older is a completely different experience, but that's the genius of it. Because, frankly, how did Linklater know? He made it while he was young. He didn't make it when he was old. He somehow knew what was coming. As young people, we are keenly aware that there is this time limit, and something is quietly dying inside of us, something really special. It's like that line in *Breakfast Club*: "When you grow up, your heart dies."

Jay Duplass: I'm terrified to go back and watch it, because I'm realizing it's going to make me feel super fucking old. I was 20 when it came out. Most of those actors would have been older than me. To go back and realize that they all looked like babies would just be fucking devastating.

Marissa Ribisi: When I first saw the film, I was like, Is that what I look like? I'm never seeing this fucking movie again! It was like, That's how I talk? That's what my chin does? Like, everything! I cried when I first saw the movie.

One day I said to my kids, "Okay guys, I'm gonna show you the

movie I did when I was 17." And for the first time ever, it was like, "Oh my god, what was I thinking? *I was so fucking cute!* Why did I think those crazy things?"

Ben Affleck: Now I see pictures of Rick, and he has gray hair. I'm like, "How the fuck did we get so old?" I still kind of half expect to see that kid from *Dazed* looking back at me in the mirror, and there's a middle-aged guy there.

Jason London: It's strange to see yourself immortalized at that permanent age. You don't realize what you have in the moment. It's years and years before you realize what you had, and what an incredibly special time it was.

Renée Zellweger: *Of course* I'm nostalgic for that time. Life in Austin in the early '90s, there was nothing better. It was still a small town, and everybody was given a shot. It felt like a very easy time to be creative and express yourself with whatever it is that you want to be part of. Like, "Let's start a band!" Or: "We're going to build this bike park, because we don't have a place to ride our BMX bikes." It was a really rich time to be a young person in Austin. And I think Rick really tapped into that. I'm so grateful to have been part of that community at that time. It still feels like it's what defines me.

Adam Goldberg: It's hard not to want to go back. A year after that movie was made, I was sad that we were getting further away from that time, and now almost 30 years have passed. I mean, we're talking about a much bigger issue here. We're talking about aging and dying. I can't even have an emotionally connected conversation about it because it's way too depressing.

Jason London: One of the hardest things about watching *Dazed* for me is that when I watch the movie now, I know that my sister hadn't died yet when I made it. So, the spirit that I had, the energy that I had, I look back on that and I think, it'll never be that way again.

Adam Goldberg: Nothing will ever be that exciting again. I won't ever come home from an audition and say, "I got it," and have that

mean what it meant back then. I won't have that sense of optimism, or that sense of joy, again. Now, when I want to do a movie, it's like, they want me to go to Canada, but I've got my kids, and I have to leave on Halloween, and do I really want to do this? It becomes *that*.

Ben Affleck: My brother made me a lovely gift when *Dazed and Confused* came out. He framed the *New York Times* black-and-white double-truck ad for the movie that had all the reviews. This was back when that kind of thing was a serious expense for us. I hung it up in my room. And I still have it to this day.

In fact, to this day, I still have the original *Dazed and Confused* poster that Rick gave us, the one that he wanted to use, with the car and the yearbook photos. I only have two posters of my own movies up anywhere in my office or house. One is *Argo*, and one is *Dazed and Confused*. When I made *Argo*, I had all the people who played the hostages live together in the house, to create the effect that we had had on *Dazed and Confused,* where everybody was living together and working together. I experienced something totally revolutionary with *Dazed*, and it stayed with me for the rest of my life. It helped define my own philosophy of filmmaking.

There is no movie that has affected me more, or stayed with me longer, or shaped me as a filmmaker more. And I never ever, ever, had as much fun again. Now, years later, I see that it was probably the most profound creative experience of my life.

Anthony Rapp: It's my favorite movie I've ever worked on.

Catherine Avril Morris: It was the best summer camp ever.

Deena Martin-DeLucia: It was the best summer of my life.

Matthew McConaughey: There's nothing like the first movie. The first time really is as pure as possible.

Kahane Cooperman: Everyone has such good memories of that time. Except Rick.

Richard Linklater: You know, if you talk to any boxer who won any championships, they always say, "It's not the championship fight that made me who I was. I became who I was in some fight

along the way that no one even would recognize as important. That's the one that made or broke me." There's always that moment where your whole life could have gone either way at that moment, and that's how *Dazed* goes down in my book. It was a 15-round bout, but it didn't kill me. I survived. And so did my movie.

Epilogue

Sandra Adair has worked consistently with Richard Linklater since *Dazed and Confused*. She earned an Academy Award nomination for Best Achievement in Film Editing for *Boyhood* in 2015.

Joey Lauren Adams continues to act. She wrote and directed the film *Come Early Morning* in 2006, and her second feature film, *Star Theater*, is currently in development.

Ben Affleck won an Academy Award for Best Original Screenplay for *Good Will Hunting* in 1998, and another one for Best Picture for *Argo* in 2013. He continues to act.

Shawn Andrews was unavailable to be interviewed for this book. According to IMDB, the last film he appeared in was the 2012 indie *My Little Hollywood*.

Autumn Barr is a singer-songwriter and works in the music industry.

Robert Brakey continues to edit. He's known for his work on *All I Wish*, *The Throwaways*, and *The Runaways*.

Lisa Bruna works in marketing and communications.

Jonathan Burkhart is a film and television producer and a cofounder of the Nantucket Film Festival.

John Cameron is an Emmy-winning television producer. He's best known for his work on the TV series *Friday Night Lights* and *Fargo*.

Rory Cochrane continues to act. He's known for playing Tim Speedle on *CSI: Miami*. He last worked with Richard Linklater on 2006's *A Scanner Darkly*.

Kahane Cooperman has won multiple Emmys for her work as a producer on *The Daily Show*. Her short documentary *Joe's Violin* was

nominated for an Academy Award in 2017. She continues to direct and produce documentary films and non-fiction series.

Lee Daniel has worked as a cinematographer on documentaries such as *You're Gonna Miss Me* and *The Dungeon Masters*. He last worked with Richard Linklater as a director of photography on 2014's *Boyhood*, though he left the project around 2010.

Sean Daniel is a motion picture and television producer. He is currently producing the Amazon series *The Expanse*, the Netflix series *The Witcher*, and the feature *Scary Stories to Tell in the Dark* with Guillermo Del Toro.

Valerie DeKeyser runs her own design firm.

Katherine Dover is semi-retired from her career as a costume supervisor for film and television. Her work has been featured on such series as *Criminal Minds* and *American Horror Story*.

Greg Finton is an Emmy-nominated and ACE-Eddie award-winning editor. He's best known for his work on documentaries such as *Waiting for "Superman,"* *He Named Me Malala,* and *Robin Williams: Come Inside My Mind*.

Heyd Fontenot works as a visual artist.

Jeremy Fox works in tech.

John Frick writes screenplays and lectures about production design at the University of Texas and Texas State University. In 2019, he worked with Richard Linklater on the design of a replica of the *Dazed and Confused* moon tower, which was installed in the Pompidou Center in Paris for a retrospective of Linklater's work.

Sheri Galloway continues to edit, though she plans to retire soon and "tool around the country" in her RV. She last worked with Richard Linklater on 1995's *Before Sunrise*.

Harry Garfield has retired from working at Universal. He has since been focused on making an album of eco-minded children's songs under the name Mother Earth Toons, and developing a corresponding animated series.

Erika Geminder Drake works as a chef instructor and a children's yoga teacher.

Holly Gent and her husband, **Vincent Palmo Jr.**, are screen-writers. They have co-written three of Richard Linklater's films: 2008's *Me and Orson Welles*, 2019's *Where'd You Go, Bernadette*, and his upcoming, as-yet-untitled biopic of the con man John Brinkley. Palmo has also been Linklater's assistant director for more than 25 years.

Adam Goldberg continues to act. He has also written and directed three films: 1998's *Scotch and Milk*, 2003's *I Love Your Work*, and 2015's *No Way Jose*. He last worked with Linklater on 2001's *Waking Life*.

Chrisse Harnos is the executive director of the charitable organization Circus Remedy, which brings circus performers to children's hospitals, refugee camps, and war zones. She recently co-produced *Halo of Stars*, a feature film that is set against the backdrop of a traveling circus.

Samantha Hart owns and operates Wild Bill, a creative studio where she produces and directs branded content. She is the author of the book *Blind Pony*.

Cole Hauser continues to act. He plays Rip Wheeler on the Paramount Network series *Yellowstone*.

J.R. Helton is a writer who has published several books. His movie memoir, *Below the Line*, published in 2000, includes a detailed recounting of his experience working on *Dazed and Confused*.

Christin Hinojosa-Kirschenbaum works in social justice and environmental activism.

Tracey Holman teaches art to middle school students. She credits her experience as an extras costumer on *Dazed* for inspiring her to teach art to teens.

Don Howard is a Guggenheim fellowship-winning filmmaker. He also works as an associate professor in the Radio/Television/Film school at the University of Austin.

Jim Jacks died in his home from a fatal heart attack in 2014, after producing such films as *Tombstone* and *The Mummy*. He was 66. At the end of Richard Linklater's film *Everybody Wants Some!!*, the director paid tribute to his former adversary: "In Remembrance: Jim Jacks, a guy who loved movies."

Nina Jacobson is an Emmy-winning producer and founder of the production company Color Force. She's best known for her work on the *Hunger Games* films.

Robert Janecka works as a gaffer on commercials and the occasional film.

Katy Jelski has been working as a writer, a director, and a script supervisor.

Sasha Jenson owns the film rights to Rin Tin Tin and is currently co-producing a feature about the character.

Milla Jovovich continues to act. She plays Artemis in the 2020 film *Monster Hunter*, directed by her husband, Paul W.S. Anderson.

Nicky Katt continues to act. He has appeared in multiple films by Richard Linklater, including 1996's *SubUrbia*, 2001's *Waking Life*, and 2003's *School of Rock*.

Priscilla Kinser-Craft runs a shop that sells vintage and collectible items. She credits *Dazed* for inspiring her love of everything vintage.

Kim Krizan is an Academy Award–nominated writer. She co-wrote *Before Sunrise* with Richard Linklater and received a co-story credit on *Before Sunset*.

Jason Lee continues to act. In 2019, he appeared in *Jay and Silent Bob Reboot*, alongside his *Dazed* friends Joey Lauren Adams and Ben Affleck.

Richard Linklater has been nominated for five Academy Awards, including Best Adapted Screenplay for *Before Sunset* in 2005, Best Adapted Screenplay for *Before Midnight* in 2014, and Best Picture, Best Director, and Best Original Screenplay for *Boyhood* in 2015. He serves as the Artistic Director of the Austin Film Society.

Tricia Linklater continues to work in film, in the post-production sound department.

Jason London continues to act. He plays Jack in the horror feature *Campton Manor*. He is also helping his twin brother, Jeremy London, teach acting classes in Mississippi.

Deena Martin-DeLucia co-runs a charitable organization. She is also a Christian minister.

Matthew McConaughey won an Academy Award for Best Actor for *Dallas Buyers Club* in 2014. He continues to act.

Peter Millius is the CEO of Flowency, a digital currency company, and the founder and chairman of InnoVet, a veteran-operated business delivering digital engineering solutions to make the world a safer place.

D. Montgomery passed away in 1997. Linklater dedicated his 1998 film *The Newton Boys* to her, with a postscript: "We miss you, D."

Catherine Avril Morris works as a romance novelist and freelance writer and editor.

Christopher Morris works in theater in Austin.

Kelly Nelson stopped working in 2016, after she was injured on a job and developed a disability. She misses doing hair.

Justin O'Baugh is a lieutenant at the Pedernales Fire Department in Texas.

Deb Pastor worked for many years as a tour manager for rock bands such as Pavement, Dirty Three, and Sebadoh. She now serves as development and communications manager at a nonprofit that enhances water quality and riparian habitat.

Kari Perkins continues to work as a costume designer. She has worked consistently with Richard Linklater since *Dazed and Confused*.

Don Phillips has retired from casting. The last film he worked on was 2008's *Surfer, Dude*, which starred Matthew McConaughey.

Tom Pollock died from a heart attack in 2020. He was 77.

Parker Posey continues to act. She recently played Dr. Smith in the Netflix series *Lost in Space*. She last worked with Richard Linklater on 1996's *SubUrbia*.

Esteban Powell says he "trolls the internet for low-paying jobs to make up for his lack of health insurance."

Anthony Rapp continues to act. He plays Lt. Cmdr. Paul Stamets on the CBS All Access series *Star Trek: Discovery*.

Marissa Ribisi is raising two teenagers.

Russell Schwartz is a co-principal at Pandemic Marketing Group.

Jason Davids Scott is the interim director and associate professor of Film at the New American Film School at Arizona State University.

Shana Scott is a founder and content creator at mOdat Video Productions. In 2008, she won a Daytime Emmy for her work as a segment producer on *The Tyra Banks Show*.

John Swasey is a voice actor. He's best known for his work in the anime series *Fullmetal Alchemist, Black Butler, One Piece,* and *Evangeleon*.

Michelle Burke Thomas builds houses. She's also a writer and producer.

Mark Vandermeulen practices real estate law.

Heidi Van Horne works as an actress and producer. She also writes a column about classic cars for the Houston *Chronicle* and other Hearst Media publications.

Clark Walker last worked with Richard Linklater on 2004's *Before Sunset*. He also co-wrote *The Newton Boys* with Linklater. He and Anne Walker-McBay are no longer married.

Anne Walker-McBay runs a home care business. She last worked with Richard Linklater as an associate producer on 2014's *Boyhood*.

Deenie Wallace works as a web developer and is creating virtual reality experiences.

Wiley Wiggins studies media art and design at UCLA. He last worked with Richard Linklater on 2001's *Waking Life*.

Bill Wise continues to act. He last worked with Richard Linklater on 2014's *Boyhood*.

Renée Zellweger won an Academy Award for Best Supporting Actress for *Cold Mountain* in 2004 , and another one for Best Actress for *Judy* in 2020. She continues to act.

Acknowledgments

*W*hen I first emailed Richard Linklater to tell him I wanted to write this book, he told me he was kind of sick of talking about *Dazed*. But he admitted that he had "a weakness/sympathy for writers/artists trying to do anything in this world they're passionate about." Over the course of the next year and a half, he ended up meeting with me in person, on multiple occasions, including the 25th anniversary of the movie in Austin, and for a while, he regularly called me on nights and weekends for lengthy conversations about, say, his baseball stats in high school, or the songs that played on the jukebox of his local pool hall. All of this happened while he was juggling multiple projects of his own. Some of our best conversations took place over the phone, late in the evening, while he was driving back home after a long day of work. I'm extremely grateful for his honesty, his memory, and his time.

I'm also deeply indebted to my agent, Daniel Greenberg, who brought up the subject of *Dazed* with me over lunch many years ago, and to my editor, Jennifer Barth at Harper, who oversaw the whole project with great patience and enthusiasm and encouraged me to make some crucial changes. Many thanks to everyone at Harper who helped make this book better—assistant editor Sarah Ried, creative director Leah Carlson-Stanisic, production editor Nate Knaebel, assistant general counsel Trina Hunn, and senior designer Caroline Johnson—and also to copyeditor Michael O'Connor and the illustra-

tor Carolyn Figel, whose art appears on the cover. I'm also grateful to the Harper team who supported the book from acquisition through publication: Jonathan Burnham, Doug Jones, Leah Wasielewski, Katie O'Callaghan, and Rachel Elinksy.

I'm especially appreciative of everyone who agreed to comment for the book, whether they simply emailed me a quote, or spent long hours fielding very specific questions about things that happened nearly 30 years ago. This includes Sandra Adair, Joey Lauren Adams, Ben Affleck, Wes Anderson, Gary Arnold, Autumn Barr, Chris Barton, Marjorie Baumgarten, Rodney Becker, Charles Ramírez Berg, Burt Berman, Robb Bindler, Louis Black, Rob Brakey, Mark Brazill, Rick Broussard, Lisa Bruna, Andrew Bujalski, Jonathan Burkhart, John Cameron, Peter Carlson, Jeffrey Charbonneau, Priscilla Kinser-Craft, Jay Clements, Rory Cochrane, Shavonne Conroy, Kahane Cooperman, Douglas Coupland, Sloane Crosley, Jenny Day, Bill Daniel, Sean Daniel, Brett Davis, Valerie DeKeyser, Deena Martin-DeLucia, Scott Dinger, Don Dollar, Katherine Dover, Erika Geminder Drake, Jay Duplass, Mark Duplass, Jesse James Dupree, Roger Earl, Cecil Evans, Greg Finton, Keith Fletcher, Melanie Fletcher, Thomas Flight, Richard "Pink" Floyd, Heyd Fontenot, Jeremy Fox, Kim France, John Frick, Sheri Galloway, Harry Garfield, Holly Gent, Owen Gleiberman, Mike Goins, Adam Goldberg, Chrisse Harnos, Roderick Hart, Samantha Hart, Cole Hauser, Ethan Hawke, Lydia Headley, J.R. Helton, Terry Hoage, Tracey Holman, Don Howard, Steven Hyden, Nina Jacobson, Robert Janecka, Katy Jelski, Sasha Jenson, David T. Johnson, Tom Junod, Nicky Katt, Jeffrey Kerr, Christin Hinojosa-Kirschenbaum, Eric Kops, Kim Krizan, Julie Irvine Labauve, Sam Lawrence, Jason Lee, Tricia Linklater, Jason London, Alison Macor, Michael MacCambridge, Matthew McConaughey, Peter Millius, Kari Jones Mitchell, Catherine Avril Morris, Christopher Morris, Chale Nafus, Kelly Nelson, Lonnie Nelson, Justin O'Baugh, Tony Olm, Tommy Pallotta, Vince Palmo, Deb Pastor, John Pease, Kari Perkins, Don Phillips, Keith Pickford, John Pierson, Tom Pollock, Parker Posey, Esteban Powell, Gary Price, Brian

Raftery, Anthony Rapp, Jason Reitman, Marissa Ribisi, Mike Riley, Shana Scott, Jason Davids Scott, Russell Schwartz, Greg Sims, John Slate, Andy Slater, Kevin Smith, Frances Robinson Snipes, Steven Soderbergh, Kal Spelletich, Don Stroud, John Swasey, Teresa Taylor, Michelle Burke Thomas, Peter Travers, Heidi Van Horne, Mark Vandermeulen, Deenie Wallace, Leslie Warren, Don Watson, Scott Wheeler, Wiley Wiggins, Monnie Wills, Bill Wise, Bob Wooderson, Linden Wooderson, Stephanie Zacherek, David Zellner, Nathan Zellner, and Renée Zellweger. A few of these people did not end up in the book, for reasons that had nothing to do with them, but I can promise you that all of them were highly quotable.

A special thanks to everyone who helped me with my research and shared their private letters, memos, yearbooks, photos, and interview tapes, including Joey Lauren Adams, Sandra Adair, Autumn Barr, Gary Arnold, Michelle Burke Thomas, Jonathan Burkhart, Erika Geminder Drake, Nicky Katt, Jason London, Richard Linklater, Chale Nafus, Brian Raftery, Anthony Rapp, Kari Jones Mitchell, Heidi Van Horne, and Wiley Wiggins. Amy Epperson helped me retouch photos I'd previously thought were ruined. Kirsten McMurray and Arielle Slatus helped me access Linklater's archives at Detour Filmproduction. Brett Davis, Don Dollar, Lisa Dreyer, Jeff Giles, Britt Hennemuth, Gregg Kilday, Eric Kops, Greg Korte, Jesse Lochs, Lian Lunson, Danielle Nussbaum, Cheryl Pollack, Eli Saslow, Liana Satenstein, and Jason Davids Scott helped me track down sources. John Spong suggested I contact the Witliff Collection, where Katie Salzmann, Stephanie Forsythe, and Lauren Goodley helped me pore over transcripts of Spong's interviews with *Dazed* cast and crew. Special credit is due to Spong, who wrote "The Spirit of '76," a short but fantastic oral history of *Dazed and Confused* that ran in *Texas Monthly* in 2003. Reading it made me wonder if there were enough untold stories for a much longer book.

My first reader on many drafts of this book was Rob Tannenbaum. His feedback improved everything about it, including the structure, the introductions, the chapter titles, and my general mood. Rex Sor-

gatz also took the time to read an almost-done version, sent it back with some really illuminating notes, and totally understood the book.

While I was working on this book, so many people gave me good ideas and good advice. Thank you Diana Bormuth, Keith Bormuth (who took my author photo), Laura Cooke, Mike Dawson, Michelle Dozois, Nathaniel Friedman, Lizzy Goodman, Sean Howe, Katherine Kendall, Maris Kreizman, Christine Maerz, Jennifer Maerz, Michael Maerz, Julie Perini, Jenny Raftery, Sophie Rai, Phoebe Reilly, Kerry Sparks, Rick Sparks, Denice Thomsen, and Mat Sletten. And thank you to my husband, Chuck Klosterman, for encouraging me to quit my day job, taking the kids to the playground when I needed to work, and discussing this book endlessly with me at times when he probably just wanted to watch TV. Having long talks with him—about *Dazed* or anything else—will always be my most favorite thing to do.

Image Credits

Pages xii–xiii: Richard Linklater, Shawn Andrews, Jeremy Fox, Milla Jovovich, Matthew McConaughey, Esteban Powell, Mark Vandermeulen. Courtesy of Richard Linklater. Joey Lauren Adams, Adam Goldberg, Christin Hinojosa-Kirschenbaum, Deena Martin-Delucia, Catherine Avril Morris, Anthony Rapp, Marissa Ribisi. Courtesy of Jonathan Burkhart. Ben Affleck, Rory Cochrane, Chrisse Harnos, Cole Hauser, Sasha Jenson, Parker Posey, Wiley Wiggins. Courtesy of Jason London. Michelle Burke Thomas. Courtesy of Universal Studios Licensing, LLC. Nicky Katt. Courtesy of Nicky Katt. **Page 7:** Parker Posey. Courtesy of Jason London. The hazing scene from *Dazed*. Courtesy of Richard Linklater. **Page 8:** (*clockwise from top*) Deena Martin, Parker Posey, Marissa Ribisi, and Chrisse Harnos. Photography by Anthony Rapp. **Page 14:** Richard Linklater's yearbook photo, freshman year, 1976. Courtesy of Kari Jones Mitchell. **Page 20:** "Freshmanizing" in Huntsville, 1976. Photography by Kari Jones Mitchell. **Page 40:** Richard Linklater and Lee Daniel on the set of *Slacker*. Courtesy of Orion Pictures/Photofest. **Page 60:** (*left to right*) *Dazed* producers Jim Jacks and Sean Daniel, with Richard Linklater and script supervisor Katy Jelski. Photography by Anthony Rapp. **Page 72:** Richard Linklater and Lee Daniel. Courtesy of Richard Linklater. **Page 77:** Lee Daniel. Courtesy of Jonathan Burkhart. **Page 78:** Clark Walker and Anne Walker-McBay. Courtesy of Jonathan Burkhart. **Page 80:** (*clockwise from left*) Joey Lauren Adams, Rory Cochrane, Marissa Ribisi, and Adam Goldberg. Photography by Anthony Rapp. **Page 85:** (*left to right*) Wiley Wiggins, Richard Linklater, and Don Phillips. Courtesy of Wiley Wiggins. **Page 95:** Jason London. Photography by Anthony Rapp. **Page 98:** Richard Linklater and Matthew McConaughey. Courtesy of Richard Linklater. **Page 113:** top photo: (*from left*) Christin Hinojosa,

Michelle Burke, Chrisse Harnos, Deena Martin, and Richard Lin-
klater. Courtesy of Richard Linklater; bottom photo: *(from left)* Joey
Lauren Adams, Adam Goldberg, and Chrisse Harnos. Courtesy of
Richard Linklater. **Page 114:** *(clockwise from top left)* Ben Affleck, Sasha
Jenson, Cole Hauser, and Rory Cochrane. Courtesy of Jason London.
Page 120: *(left to right)* Jason Lee, Cole Hauser, and Rory Cochrane.
Courtesy of Michelle Burke Thomas. **Page 125:** *(left to right)* Jason Lon-
don, Wiley Wiggins, Sasha Jenson, and Shawn Andrews. Courtesy of
Richard Linklater. **Page 137:** *(left to right)* Joey Lauren Adams, Sasha
Jenson, and Parker Posey. Courtesy of Jason London. **Page 139:** Adam
Goldberg and Marissa Ribisi. Courtesy of Jonathan Burkhart. **Page
147:** Anne Walker-McBay, Deb Pastor, Clark Walker, and Jonathan
Burkhart. Courtesy of Jonathan Burkhart. **Page 155:** Chrisse Harnos
and Jason London. Courtesy of Jason London. **Page 158:** Parker Posey
(left) and Anthony Rapp *(right)* with stand-in Stella Weir. Courtesy
of Richard Linklater. **Page 162:** Jason London and Michelle Burke.
Photography by Anthony Rapp. **Page 168:** Renée Zellweger *(top left)*
and other senior girls hazing incoming freshmen. Photography by
Anthony Rapp. **Page 172:** Parker Posey. Courtesy of Jonathan Bur-
khart. **Page 178:** *(left to right)* Priscilla Kinser-Craft, Heidi Van Horne,
and Erika Geminder Drake. Courtesy of Richard Linklater. **Page 180:**
Shawn Andrews and Milla Jovovich. Courtesy of Richard Linklater.
Page 188: Jim Jacks, checking his watch. Courtesy of Jonathan Bur-
khart. **Page 194:** Cole Hauser shooting at Red's Indoor Range. Cour-
tesy of Nicky Katt. **Page 199:** Rory Cochrane *(left)* and Cole Hauser.
Courtesy of Jason London. **Page 202:** *(left to right)* Sasha Jenson, Ben
Affleck, Cole Hauser, and Jason O. Smith. Courtesy of Universal Stu-
dios Licensing, LLC. **Page 207:** *(left to right)* Esteban Powell, Mark
Vandermeulen, and Wiley Wiggins. Courtesy of Richard Linklater.
Page 212: Ben Affleck with *Dazed* crew member (and future direc-
tor) Athina Rachel Tsangari. Courtesy of Richard Linklater. **Page 217:**
Deenie Ellis and Jeremy Fox. Courtesy of Richard Linklater. **Page 223:**
(left to right) Sasha Jenson, Wiley Wiggins, and Parker Posey. Courtesy
of Jason London. **Page 225:** Matthew McConaughey. Courtesy of Uni-

versal Studios Licensing, LLC. **Page 230:** *(left to right)* Deena Martin, Michelle Burke, and Chrisse Harnos. Courtesy of Universal Studios Licensing, LLC. **Page 240:** *(left to right)* Parker Posey, Chrisse Harnos, Adam Goldberg, and Joey Lauren Adams. Courtesy of Michelle Burke Thomas. **Page 241:** Christin Hinojosa. Photography by Anthony Rapp. **Page 244:** Sasha Jenson, Matthew McConaughey, Jason London and Wiley Wiggins. Courtesy of Universal Studios Licensing, LLC. **Page 252:** *(left to right)* Shawn Andrews, Jason London, Rory Cochrane, and Wiley Wiggins. Courtesy of Universal/Photofest. **Page 259:** Milla Jovovich. Photography by Anthony Rapp. **Page 264:** Richard Linklater and Matthew McConaughey. Courtesy of Richard Linklater. **Page 270:** *(left to right)* Joey Lauren Adams, Rory Cochrane, Matthew McConaughey, and Jason London. Photography by Anthony Rapp. **Page 276:** Kahane Corn (now known as Kahane Cooperman) in her pregnancy costume. Courtesy of Jonathan Burkhart. **Page 279:** Top photo: Unidentified *Dazed* cast member cliff jumping in Austin. Bottom left: Rory Cochrane. Bottom right: Wiley Wiggins. All three photos. Courtesy of Jason London. **Page 281:** *(left to right)* Rory Cochrane, Jason London, Sasha Jenson, and Richard Linklater. Courtesy of Richard Linklater. **Page 296:** Wiley Wiggins and Jason London pose with KISS statue. Courtesy of Richard Linklater. **Page 313:** Rory Cochrane. Photography by Anthony Rapp. **Page 322:** Frank Kozik's *Dazed and Confused* poster. Courtesy of Frank Kozik. **Page 331:** Richard Linklater. Courtesy of Jonathan Burkhart. **Page 338–339:** Jason London and Matthew McConaughey. Courtesy of Jonathan Burkhart. **Page 341:** Huntsville High School students playing pool at the Emporium. Courtesy of Kari Jones Mitchell. **Page 350:** *(clockwise from top left)* Jason London, Adam Goldberg, Deena Martin, Milla Jovovich, Parker Posey, Michelle Burke, Marissa Ribisi, and Anthony Rapp. Courtesy of Universal Studios Licensing, LLC. **Page 351:** Huntsville High school students. Courtesy of Kari Jones Mitchell. **Page 356:** Ben Affleck with the puppy he bought during *Dazed*. Courtesy of Richard Linklater. **Page 362:** Matthew McConaughey in the zombie movie *My Boyfriend's Back*. Courtesy of Jonathan Burkhart. **Page 382:** Wiley Wiggins. Cour-

tesy of Joey Lauren Adams. **Page 388:** *(left to right)* Joey Lauren Adams, Jason London, Chrisse Harnos, Matthew McConaughey, and Rory Cochrane. Courtesy of Jonathan Burkhart. **Page 394:** Matthew McConaughey with two security guards at the *Dazed* 10th anniversary party. Courtesy of Wiley Wiggins. **Page 400:** Jason London. Courtesy of Jason London. **Page 402:** *(left to right)* Deena Martin, Chrisse Harnos (kneeling), Adam Goldberg, Parker Posey, and Marissa Ribisi. Photography by Anthony Rapp.

Notes

Introduction: If I Ever Start Referring to These as the Best Years of My Life, Remind Me to Kill Myself

2 "Everything went up in flames": Tom Shone, "Richard Linklater's Nine-Year Itch: The *Before Midnight* Director on Revisiting (and Revising) the Past," *Vulture*, May 11, 2013, https://www.vulture.com/2013/05/richard-linklaters-nine-year-itch.html.

Chapter 1: Oh My God, This Movie Is My Life!

9 "My whole working premise was that nothing really changes": "Director's Commentary." *Dazed and Confused*, directed by Richard Linklater, Disc 1, Criterion Collection, 2006. DVD.

Chapter 2: Old People in Your Face, Fucking with Who You Are

15 "It's as if a 17-year-old was making this movie": "Linklater before Shooting." *Dazed and Confused*, directed by Richard Linklater, Disc 2, Criterion Collection, 2006. DVD.

Chapter 3: The Hardest Working Slackers in Austin

41 "set a tone for the rest of my 20s": Michael Koresky and Jeff Reichert, "A Conversation with Richard Linklater," *Reverse Shot*, July 2, 2004.

41 "The '80s were a great time to be underground": Pat Blashill (Introduction by Richard Linklater), *Texas Is the Reason: The Mavericks of Lonestar Punk* (Brooklyn, Bazillion Points, 2020).

42 "*Slacker* is a work of divine flakiness": Hal Hinson, *Slacker* review, *Washington Post*, August 23, 1991.

42 "In a sense, we were all slackers": Richard Linklater, *Slacker* (New York: St. Martin's Press, 1992), 14.

Chapter 4: How to Pitch an Unpitchable Movie

60 "the big bang of the modern indie film movement": Peter Biskind, *Down and Dirty Pictures: Miramax, Sundance, and the Rise of Independent Film* (New York: Simon and Schuster, 2004), 53.

61 "I didn't even know how to put the tray up": "Making *Dazed*." *Dazed and Confused*, Disc 2.

62 "Jim looks the exact opposite . . .": Richard Linklater, "*Dazed* by Days," *Austin Chronicle*, September 24, 1993.

Chapter 5: Don't Lead with Your Ego

73 "I think our hope was that one of us": Alison Macor, *Chainsaws, Slackers, and Spy Kids: Thirty Years of Filmmaking in Austin, Texas* (Austin: UT Press, 2010), 96.

73 "fucking sellout": Ibid., 154.

73 "To me we were so much more of a team": Ibid.

Chapter 6: A Truffle Pig for Talent

81 "There's no way there's not tons of interesting young actors": Linklater, "*Dazed by Days.*"

Chapter 9: Maybe the '70s Didn't Suck?

126 "You want me to tell you what's interesting": "Affleck and Cole Hauser." *Dazed and Confused*, Disc 2.

Chapter 10: If You Don't Like Your Character, Change It

140 "Dad was probably a high school football player": "Character interviews: Randall 'Pink' Floyd." *Dazed and Confused*, Disc 2.

140 "He probably fears his old man": "Character Interviews: Fred O'Bannion," *Dazed and Confused*, Disc 2.

140 "it was very, very difficult and scary to live with him": Amy Spencer, "Ben Affleck Talks Raising Kids with His Ex, Facing His Demons, and Tackling His Most Personal Movie Role Yet," *Parade*, February 28, 2020.

140 "His father's probably a drunk": "Character interviews: Benny O'Donnell," *Dazed and Confused*, Disc 2.

Chapter 11: The New Kid Versus the Old Guard

148 "They've determined to do their little jobs all the better and tighten their belts": Linklater, "*Dazed* by Days."

148 "By the time we're in production, we're at war": Ibid.

Chapter 12: We Were All Hormonal

156 "weird hair": Nathan Heller, "Why Richard Linklater Makes Movies," *New Yorker*, June 23, 2014.

Chapter 15: Anyone Who Had a Cell Phone Was Instantly an Asshole

188 "Our ridiculous schedule means": Linklater, "*Dazed* by Days."

189 "Whether this is an okay movie or a great movie": "Making *Dazed*." *Dazed and Confused*, Disc 2.

Chapter 19: Dumb and Horny and Mean and Drunk

218 "You know what's really terrible": "Cast and director interviews: Wiley Wiggins and Catherine Morris." *Dazed and Confused*, Disc 2.

Chapter 21: She Called You a Bitch and You a Slut

232 "And then the scene with the girls": "Behind the scenes interviews: The girls." *Dazed and Confused*, Disc 2.

Chapter 24: Shawn and Milla Self-Destruct

260 "It sucks—they're totally exploiting my image": "Fazed and Misused," *Vox* (UK), October, 1994.

Chapter 29: Seduced and Abandoned
314 "Not one person in the entire": William Goldman, *Adventures in the Screen Trade: A Personal View of Hollywood and Screenwriting* (New York: Grand Central Publishing, 1989).

Chapter 30: I Was Alive, and I Wasn't Afraid
332 "I know everyone thinks I'm the snotnose": Linklater, *"Dazed* by Days."

Chapter 32: Wading into the Shark Waters
357 "The independent film world in the early nineties": Parker Posey, *You're on an Airplane: A Self-Mythologizing Memoir* (New York: Blue Rider Press, 2017).

Chapter 34: *Dazed and Confused*: The Series
388 "Omigod, I'm contributing to this": Richard Linklater, "'Dazed' on the Publicity Trail," *Austin American-Statesman*, September 24, 1993.

389 "The young playwright Justin Tanner": Richard Stayron," Theater Review: Twisted, Funny Visions of Reality in 'Pot Mom,'" *Los Angeles Times*, April 15, 1994.

Index

About the Author

Melissa Maerz has worked as an editor at *Spin* and *Rolling Stone*, a staff writer for *Entertainment Weekly* and the *Los Angeles Times*, and a supervising producer on HBO's *VICE News Tonight*. She was a founding editor of *New York* magazine's Vulture website. She lives in Portland, Oregon, with her husband and two kids.